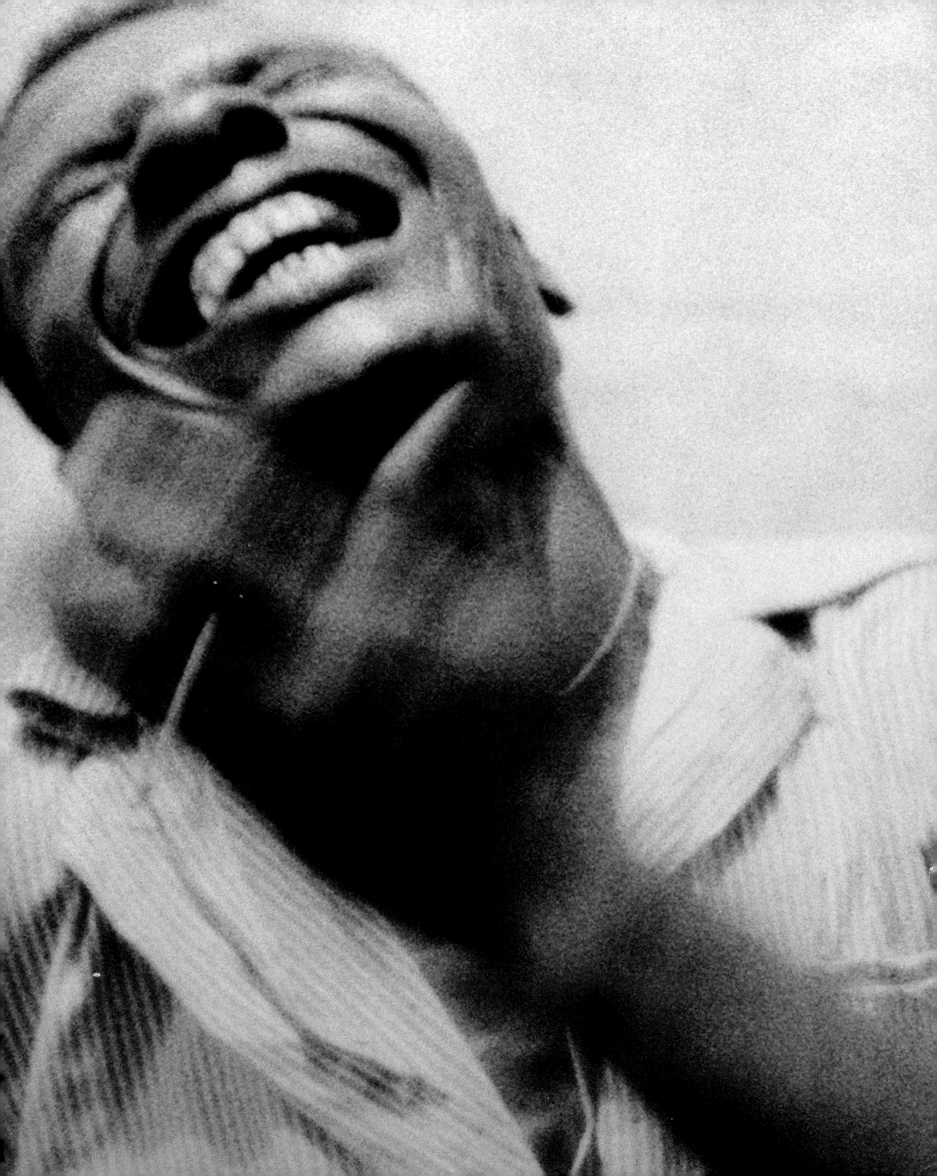

WILLIAM CLAXTON

Jazz
seen

TASCHEN

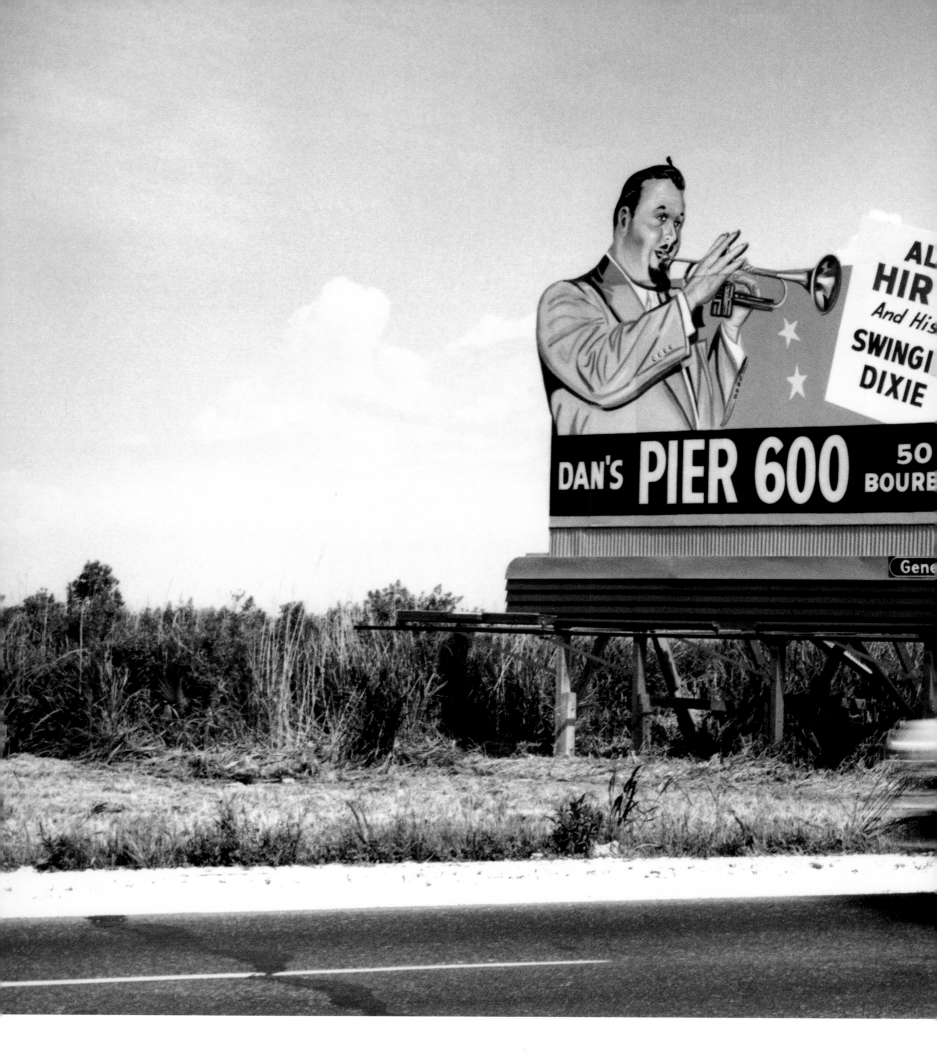

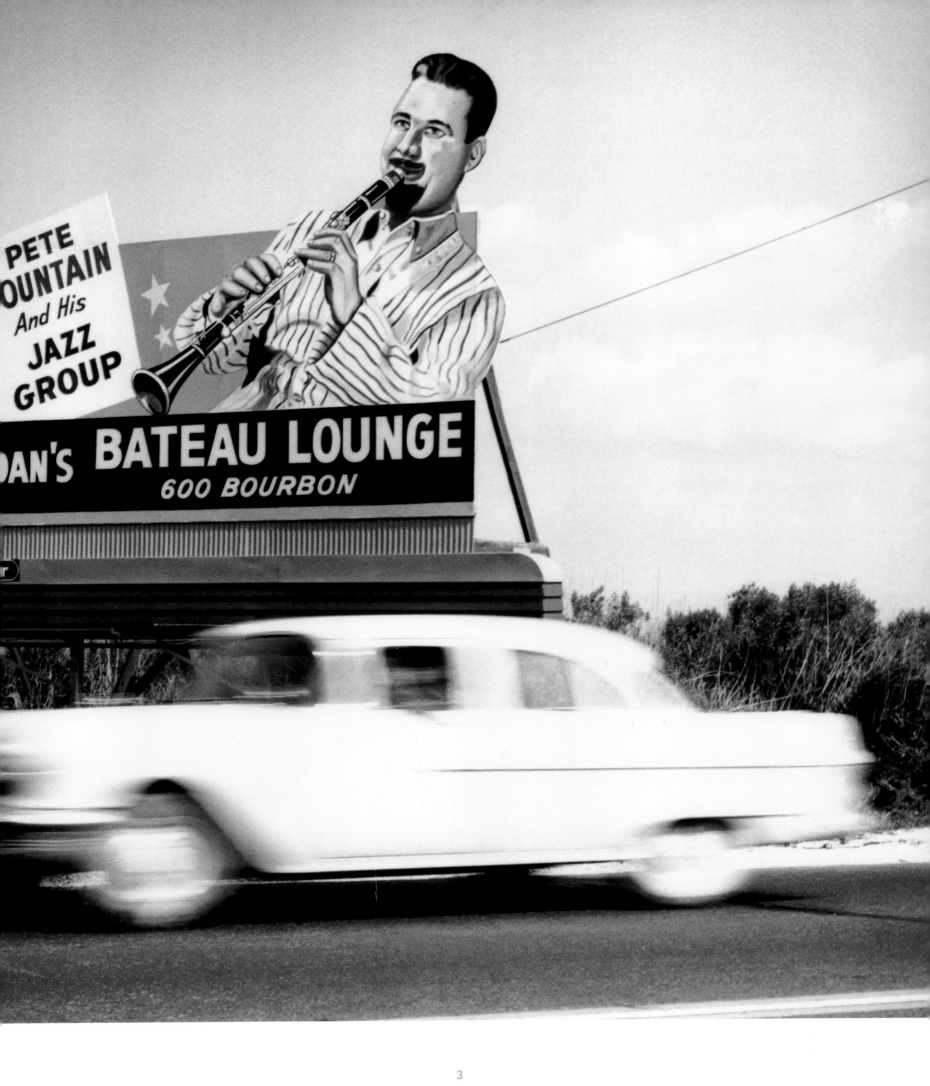

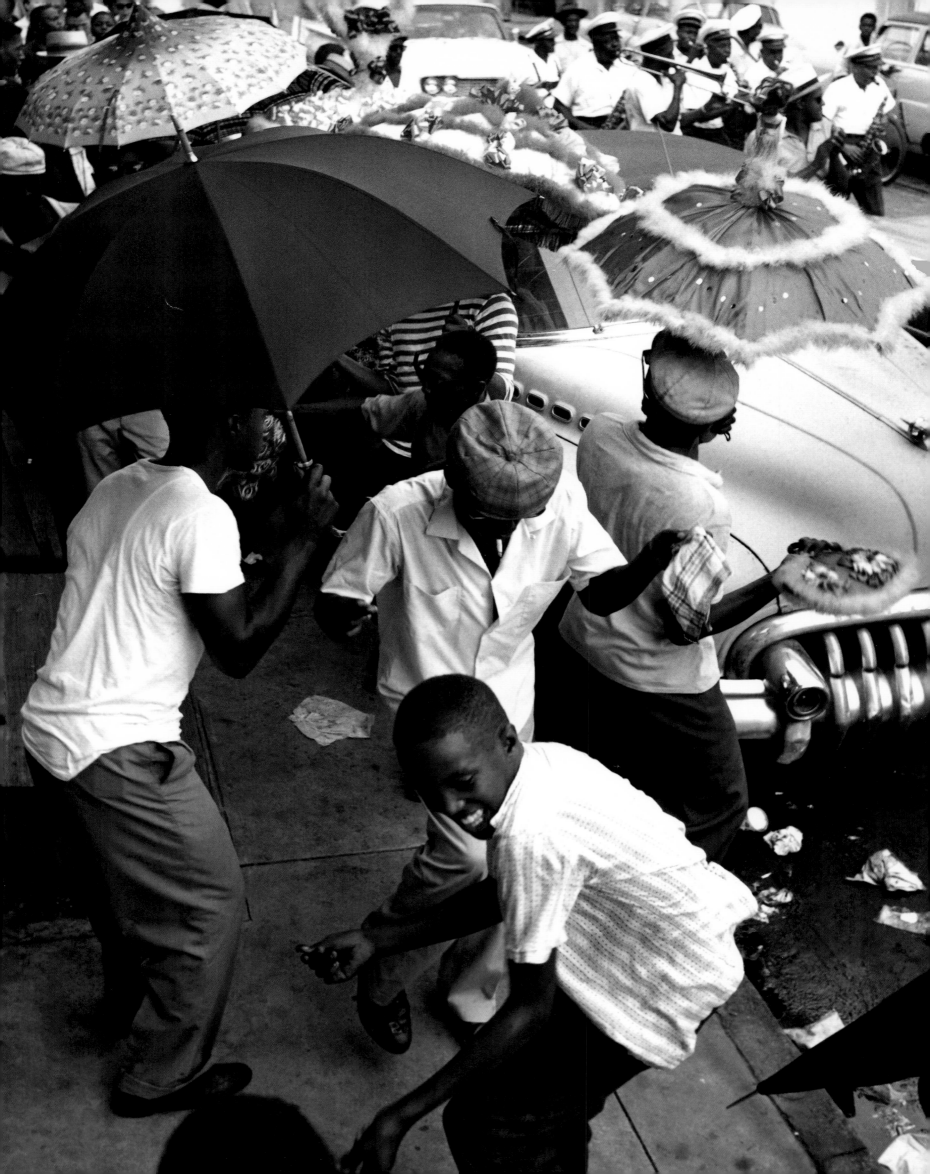

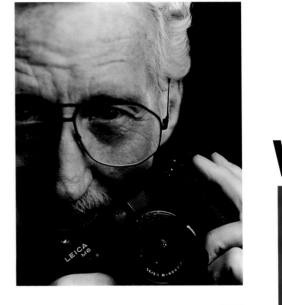

WILLIAM CLAXTON
Jazz
seen

FOREWORD BY

Don Heckman

WITH PHOTOGRAPHS AND WRITINGS BY

William Claxton

EDITED AND DESIGNED BY

Armando Chitolina

W I L L I A M
Jazz

By Don Heckman

Jazz and Photography. Two seemingly distinct and different arts. The one aural, the other visual. Yet, beneath the superficial distinctions and differences, there are striking similarities. And nowhere are those similarities more clear, more revelatory of the linkages between the two arts than in the extraordinary photography of William Claxton.

Claxton has been the photographer of choice for jazz musicians since the 1950s. And with good reason. Jazz musicians, with their seemingly inherent capacity to cut to the quick, to be unfazed and undeterred by superficialities, have recognized Claxton as a creative soulmate almost from the very beginning.

Jazz may be the most mysterious of all the musical arts. At first glance, it appears almost deceptively simple: the fundamental musical elements of melody, harmony and rhythm, manipulated in a spontaneous, improvisatory fashion, energized by the propulsive feeling musicians describe as "swing". But the mystery remains – in the substance, the spirit and the manner in which these elements come together. Look at it this way: A jazz musician, first of all, must possess enormous mechanical skills, a sheer technical dexterity comparable to that required for the most rigorous classical music. The player must be able to execute rapid-fire passages at breakneck, high-speed tempos, then suddenly shift gears to articulate slow passages with a rich, emotional density.

But mechanical virtuosity in itself is not enough. A jazz player must also be able to apply that virtuosity to the spontaneous invention of music. He or she must do so within the structural framework of the music (standard song form, blues, free playing, etc.), and do so instantaneously. In a song such as the standard, *Cherokee*, or a jazz line such as John Coltrane's *Giant Steps*, a jazz player is obliged to react to enormously complex harmonic demands in mere fractions of a second. How do they do it? Therein lies the mystery – the unanswered, and perhaps unanswerable question – of how jazz players are able to blend the seemingly contradictory elements of mechanical, technical skill with the completely subjective, highly personal, sudden, inventive creation of extemporaneous art.

And it is both curious and fascinating that this mystery and the unanswered questions it poses apply equally well to the art of photography. The photographer, like the jazz musician, works with an instrument, which can be cumbersome, demanding and difficult. "For the photographer," says Claxton, "the camera is like a jazz musician's ax. It's the tool that you would like to be able to ignore, but you have to have to convey your thoughts and whatever you want to express through it."

And the photographer, again like the jazz musician, must react in a split second, immediately organizing all the technical data of his art – exposure, focus, lighting, lens opening – into an instantaneous reaction. His goal at this point is almost identical to that of the jazz musician: the goal of bringing skill and

"Bulldog drummer", Artists' entrance, Hollywood Bowl, 1958 8
9
10
11
12

CLAXTON
SEEN

virtuosity to the service of capturing a moment in time; a brief, unrepeatable moment of insight into the heart of intimate, emotional reality. "This is where jazz and photography have always come together for me," says Claxton. "They're alike in their improvisation and their spontaneousness. They happen at the same moment that you're hearing something and you're seeing something, and you record it, and it's frozen forever."

The camera has captivated Bill Claxton since he was a tall, lanky college student in Pasadena, California in the late 40s and early 50s. With a mother who was a semi-professional singer and a brother who played boogie-woogie piano, it was understandable that Claxton would be drawn to music. At the age of seven, he put together a scrapbook devoted to Duke Ellington, Count Basie, Cab Calloway, Lena Horne and Fred Astaire and Ginger Rogers. In his teens, he heard such legendary performers as Fats Waller and Art Tatum.

"One of my dreams at that time," recalls Claxton, "was to have a night club that looked like a set in a Fred Astaire/ Ginger Rogers movie, where everything is black and white except for the people who are of every color. So I guess I was showing signs even in those days of the things that have come to interest me as an adult."

Claxton studied psychology and art at the University of California, Los Angeles (U.C.L.A.). But, irresistibly drawn to jazz, he showed up at every jazz club he could persuade, bluff or cajole his way into. Initially, he worked with a cumbersome Speed Graphic camera and, even with that not particularly forgiving instrument, managed to produce some of the compelling images in this book.

A youthful encounter with the legendary saxophonist Charlie "Bird" Parker helped solidify Claxton's connection with jazz. He recalls the incident, which took place when he was barely out of teens, with fondness. "I don't know where I got the nerve," says Claxton. "But when I went to hear him, I asked if he wanted to come out to my house in Pasadena to relax after the show. And I was amazed when he said, 'Okay.' So I guess you can say I was one of the few, if not the only, white kid who ever brought Charlie Parker home to visit."

On a school break, Claxton took a trip to New York with a girlfriend who was a model, and met Richard Avedon. Impressed with Claxton's youthful enthusiasm, Avedon spontaneously gave him one of his old Rolleiflex cameras. The unexpected gift encouraged Claxton's already burgeoning interest in photography and jazz, and his life's career rapidly began to take shape.

"I love the music," he says. "Always have. But I've always been fascinated by the way it's produced, as well, by the way it looks. By the body language and the movements of musicians as they play, by the way the light strikes their faces."

Like Degas, who painted the real life of ballet in the backstage, warm-up poses of dancers, Claxton looks for the heart of jazz by photographing musicians in unguarded, casual moments.

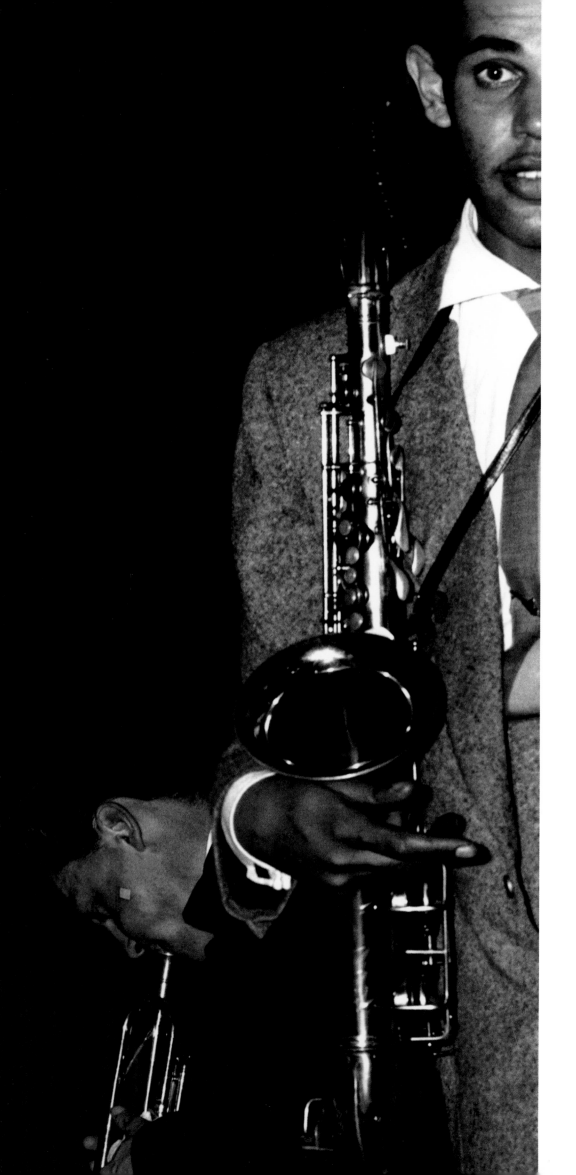

"That's what's fascinating," he says, "the way they look when they're not playing, in other aspects of their lives – practicing, rehearsing, smoking, standing around talking, even eating and using dope. I guess you could say I listen with my eyes."

In 1952, he worked with producer Richard Bock to form Pacific Jazz Records, becoming the Art Director and Photographer for a company destined to play a vital role in the emergence of West Coast jazz. Claxton's innovative, full-cover photos of musicians, with their open, airy lifestyle qualities, became almost as important to the West Coast jazz movement as the music itself. By taking such inherently photogenic performers as Chet Baker and Art Pepper out of the traditionally dark, shadowy environment of the jazz clubs, and photographing them in the softer-toned settings of the California outdoors, Claxton perfectly captured – probably even helped to establish – the look and the feel of a unique jazz decade.

"Photographing record covers in a 12 inch by 12 inch format, which, of course, was the old vinyl album format," says Claxton, "was a complete joy, completely different from shooting in the CD, 5 by 5 format. Back in the old days, in the 50s, when the LP was the hot thing, shooting a cover was a relatively simple and delightful experience. The only real concern was the title or the theme of the album. You discussed the jazz player's wardrobe, and then you met him and shot the session – either in the warm California sun or the studio."

"But it's a lot different now from the way it was when I was shooting those covers for Pacific Jazz," he continues. "When you shoot a big star now, you have endless discussions and meetings with creative directors, art directors, artist and management attorneys, and record company executives.

Then you have wardrobe fittings, make-up people, stylists and groomers. Finally, after all that, you might finally get to sit down with the guy and shoot everything in a few hours. It's an overly complicated way of doing things, when it used to be so simple."

Although he shot virtually all the covers for Pacific Jazz, he found plenty of time for other work as well. Nearly every major record company in the 50s – Capitol, Columbia, Fantasy, Decca, RCA Victor, among others – used his photographs, and one could make a convincing case for Claxton's role in transforming the jazz album cover into a powerful, point-of-purchase sales tool.

"Claxton," wrote the late jazz critic Leonard Feather, "has an eye for more than the obvious picture presented by his subjects. Often, along with the settings in which he showed them, they became metaphors for the Zeitgeist, for a whole era of musical evolution."

Feather was right about that. It was Claxton's good fortune to come to creative maturity at a time when jazz was experiencing a remarkable surge of sheer innovation. But it was his own innate talent, his sensitivity to the energies coursing through jazz in the 50s and 60s that make his visual chronicles of the period so effective. Understanding the music, receptive to both the individual personalities of the players and the essence of their musical quest, he matched the power of their music with the insight behind his visual images.

Before long, however, it was not just jazz which would receive the benefit of Claxton's photographic scrutiny. In the 60s, much of his creative energy was also devoted to fashion photography. His work began to appear in most major magazines, from *Time* and *Newsweek* to *Vogue*, *Harper's Bazaar*, *Paris Match* and dozens of others.

Claxton's photograph of his wife, actress and model Peggy Moffitt, wearing designer Rudi Gernreich's daring, topless swimsuit created a sensation in the 60s. "The Rudi Gernreich Book" (Rizzoli, 1991, reprint Benedikt Taschen, 1999), a pictorial history of the avant-garde designer's fashion creations, was a collaboration between Claxton and Moffitt spanning nearly two decades of working with Gernreich. In 1967, Claxton and Moffitt created *Basic Black*, a fashion film about Gernreich – now referred to as the "father of the fashion video" – which was enormously influential upon the emerging fashion multi-media industry.

Claxton's busy career has moved well beyond jazz, with work directing television shows and commercials, a stint as one of the founders of the National Academy of Recording Arts and Sciences (NARAS), and an array of current entertainment world activity that includes shooting the advertising art for such films as Spike Lee's *Mo' Better Blues*. His photos are prominently featured in ads for The Gap stores, and his work appears regularly in periodicals such as *Interview Magazine* and *GQ Magazine*.

"Every year," says Claxton, "English *GQ* assigns me to take a group of jazz musicians of my choice, and do a fashion story using all different ages and ethnic kinds of guys, photographing them in the current men's fashions." Claxton's photographs have been displayed in prestigious galleries throughout the world, in New York, London, Paris, Zurich, Berlin, Tokyo, San Francisco and Los Angeles. Limited editions of his photographs have become prize collectibles. Despite his still high-visibility reputation as one of the A-list entertainment world photographers, Claxton would be the first to admit that his heart has always been in jazz and jazz-related music. And the best evidence of that life-long affection lies within the pages of this stunning collection – a kind of overview of the rich creative diversity of a photographer's life in jazz.

Each of us will undoubtedly find a favorite photograph in this rich and thoughtful assemblage. But there are many that will surely turn up on everyone's list. Consider, for example, the thoughtful John Coltrane (p. 16/17) as he encounters abstract expressionism at the Museum of Modern Art, his face filled with determination to understand this unfamiliar artistic phenomenon – a determination every bit as focused and driven as the energy that constantly propelled his improvisations.

Notice, too, how Claxton has perfectly positioned Nat "King" Cole (p. 72), standing in front of ornamental ironwork, elegant in a beautifully tailored tuxedo, cigarette in hand, and an enigmatic, Mona Lisa-like smile (apt, given his great success with the hit song of the same name) on his face.

Equally focused, but in a very different fashion, there is Maynard Ferguson (p. 144/145) at a rehearsal of his big band, cheeks puffed, knees bent, determinedly in search of one of his patented high notes. And Claxton's backstage picture of Joe Williams (p. 188/189) suspends a moment in time, when the veteran blues and jazz vocalist, eyes closed, fingers to his temples, seems to be tapping into precisely the right sounds before he moves on stage.

A youthful-looking Ornette Coleman (p. 211), whisper-thin, tightly gripping his white plastic alto saxophone, is another example of Claxton's capacity to find the right moment, the right emphasis, for his subjects. By focusing on Coleman's luminescent eyes as they stare intensely, straight into the camera's lens, Claxton makes an instant connection with the intensity of Coleman's insistent vision of improvisational freedom.

In contrast, a collection of Duke Ellington photographs (p. 218–219) shows the cool and controlling demeanor of the masterful composer/bandleader as he works his wiles with his orchestra. The images, alternately jocular and serious, offer a quick, snapshot view of Ellington's complex interaction with his talented sidemen. Equally prepossessing, in his own utterly unique manner, pop singer and rap original Isaac Hayes (p. 234/235) literally dominates the frame of Claxton's photograph. Wrapped in a massive fur jacket, with powerful-looking jewelry hanging down his chest, Hayes emerges into view with the same dark, masculine sense of attitude that dominated his many hit recordings of the early 70s.

The collection also provides some attractive pairings – some in the same photograph, some in juxtaposition on the page. Notice the wonderful, caught-in-action, cutting-up between two masters of subtle humor, Louis Armstrong and actor Danny Kaye (p. 40, 41). By focusing upon the movement and interplay between this gifted pair Claxton underscores the gentle whimsy so characteristic of both.

A few pages later, singer Diana Krall (p. 64), not yet the major jazz star she would soon become, is a blonde center of light, her enthusiastic grin countered by the gentle smile and coy pose of Sylvia Syms (p. 65).

11

Ray Broome (trumpet), Dexter Gordon, Los Angeles, 1951 12

13

14

15

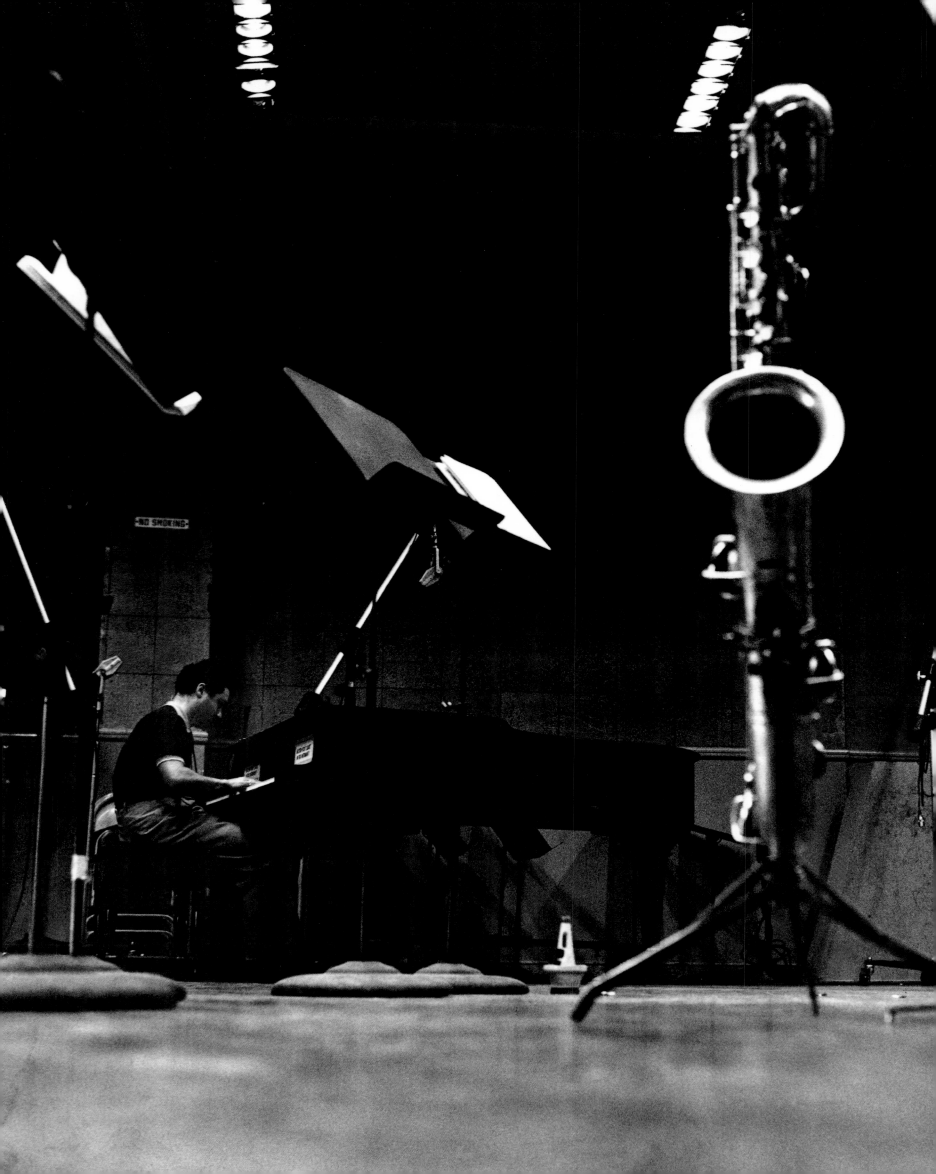

And what is the musical joke taking place between Gerry Mulligan and Ben Webster (p. 148/149), as the corpulent Webster counts off a beat, and the ever-slender Mulligan responds, smirking mischievously as he plays. Whatever it is, Claxton was there to capture the essence of the action.

The pairings continue: Two quick snaps of a concentrating Diana Ross (p. 157) and a puckered-lipped N'Dea Davenport (p. 156). Pensive shots of two disparate singers – Barbara Carroll and Odetta (p. 174, 175) – similar enough in thought and manner to bypass their musical differences. A look at Sonny Rollins then and now (p. 184, 185), that underscores the divergences between his youthful vigor and his magisterial maturity.

Appropriately, a characteristically moody view of Miles Davis (p. 187; one of hundreds Claxton has taken) is paired with an unusually buoyant shot of a smiling Gil Evans (p. 186) – not only Davis' favorite arranger, but his best friend, as well. And only Claxton would have thought to pose the roguish Frank Sinatra (p. 198) peering out of an angelic harp case, and then counter the image with a shot of a relaxed Bing Crosby (p. 199) working his recording studio magic.

Three sets of couples are also worth mentioning, each unique in their own way. Singer Cassandra Wilson and pianist Jacky Terrasson (p. 202), a highly compatible musical couple, are side by side with Jackie Cain and Roy Kral (p. 202/203), one of the jazz world's longest tenured pairings, in both music and marriage. And by placing Wayne Shorter (p. 240) and Herbie Hancock (p. 241) on the same page, both smiling, both clearly enjoying themselves, Claxton has delineated the lifelong friendship – musically and personally – that continues to exist between the two veteran artists.

Aside from the collection's endlessly fascinating array of individual photographs and intriguing pairings, there are a few sequences that stand on their own. There is, for example, a segment in which Claxton explores New Orleans in the 1960s (p. 98–108). As happens so often with the best photographers – Cartier-Bresson and Claxton among them – he was in the right place at the right time. 1960 was the cusp of a new era, the year in which John F. Kennedy was elected President of the United States, a year in which the civil rights revolution was swinging into high gear. Claxton's stunning images of a 2nd Line band, swinging its way home from a New Orleans funeral, capture a peaceful moment, still resonating with traditions of the past, at a time when the complex, contentious, often violent future that the 60s would bring was simmering on the horizon.

Another grouping (p. 126–135) has the appropriately grainy look of television kinescopes. Appropriately, because its distant-looking images preserve a brief period when jazz was still welcome on television, when a night's viewing might actually produce captivating moments from the likes of Billie Holiday (p. 131), Peggy Lee (p. 134/135), June Christy (p. 132/133), Buddy DeFranco (p. 128) or Jimmy Giuffre (p. 130).

Other, briefer segments, are equally enchanting: The Chet Baker images (pages 137, 138/139, 140), especially the photograph which memorializes the trumpeter's full, sensuous lips, underscoring the eroticism that paralleled his trumpet playing as intrinsic elements in his appeal. Note, too, the tricky images (p. 245–254), a few of Claxton's rare excursions into photographic effects, such as the juxtaposition of a thoughtful-looking Brad Mehldau (p. 248/249), captured and reflected in the mirrored insides of his piano.

Ultimately, because photography and jazz are so intrinsic to the American experience – from Matthew Brady's Civil War photographs to the music of Duke Ellington, from the parallel social and historical impacts of *Life Magazine*, Swing music and 52nd St. – Claxton's work is more than a collection of appealing images. What emerges in the pages of this endlessly captivating book is an insight into the American essence comparable to the finest work of Walker Evans and Robert Frank. The energy and the almost inherent individualism that emanates from the faces, the movements and the intensity of the jazz musicians, the sense of community in Claxton's sweeping views of life in New Orleans, illustrate what is best about America.

Individualism, community, imagination, spontaneity and creative joy are elements that are often swept aside in the nation's sometimes inflated self-image as the world's sole remaining superpower. But they are essential elements in the real America. And by capturing them with his vision and with his camera, Claxton has preserved and memorialized America at its best.

13
14 *Shorty Rogers, Hollywood, 1955*
15
16 *John Coltrane, Guggenheim Museum, New York City, 1960*
17

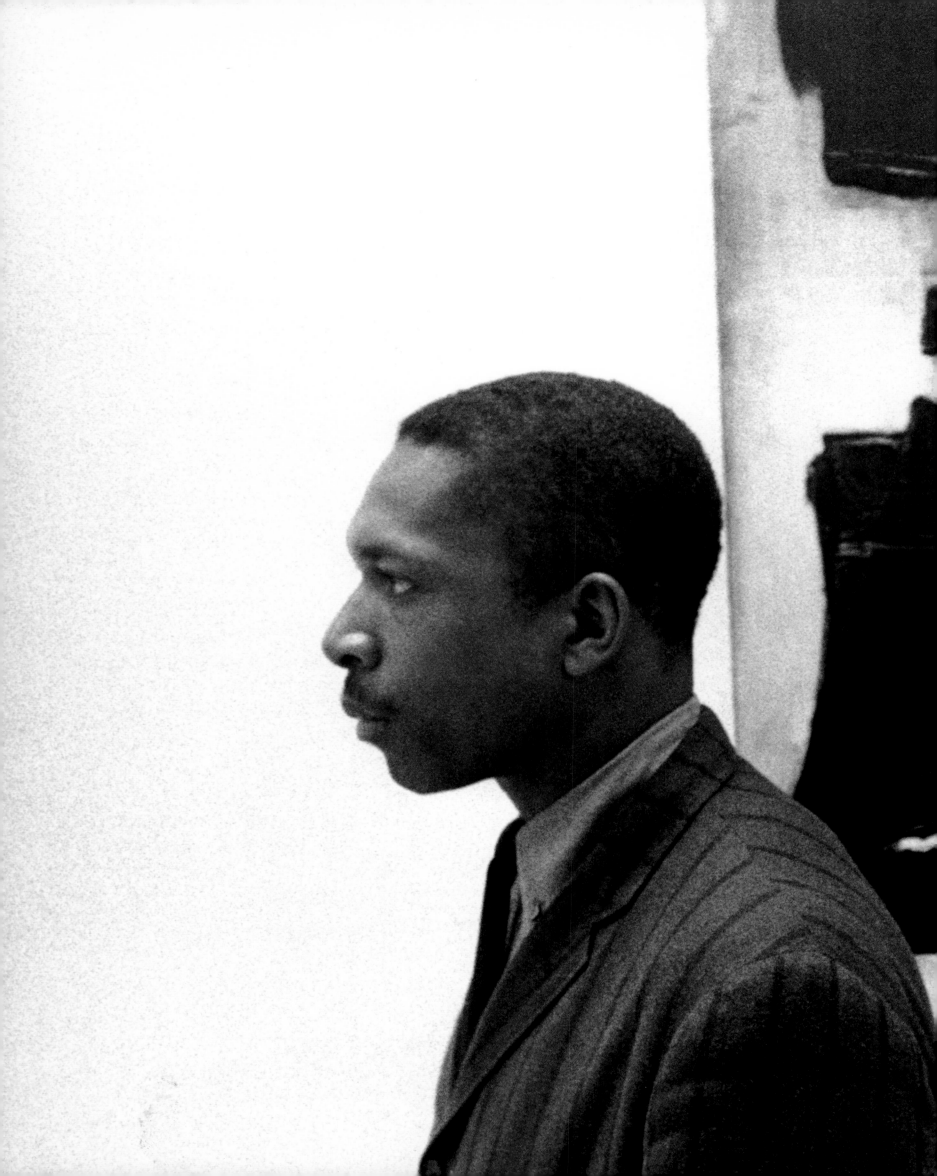

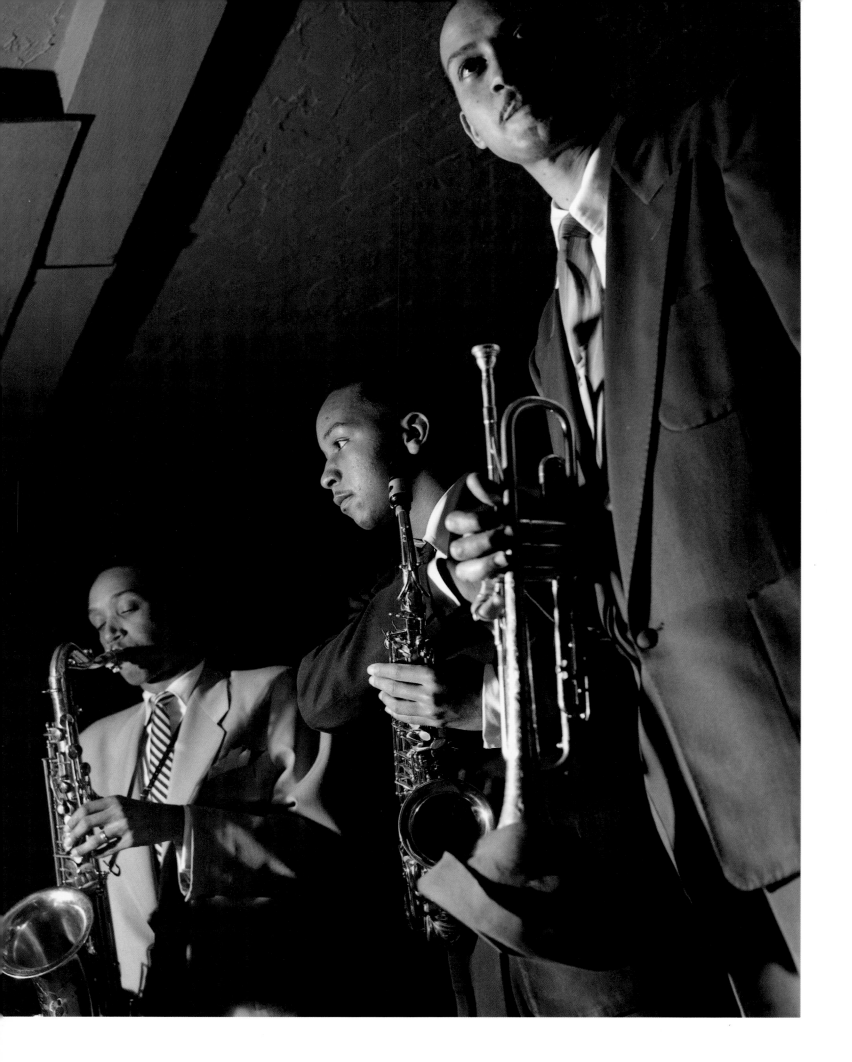

Wardell Gray, Frank Morgan, Ernie Royal, Los Angeles, 1951

Teddy Edwards, Hollywood, 1955

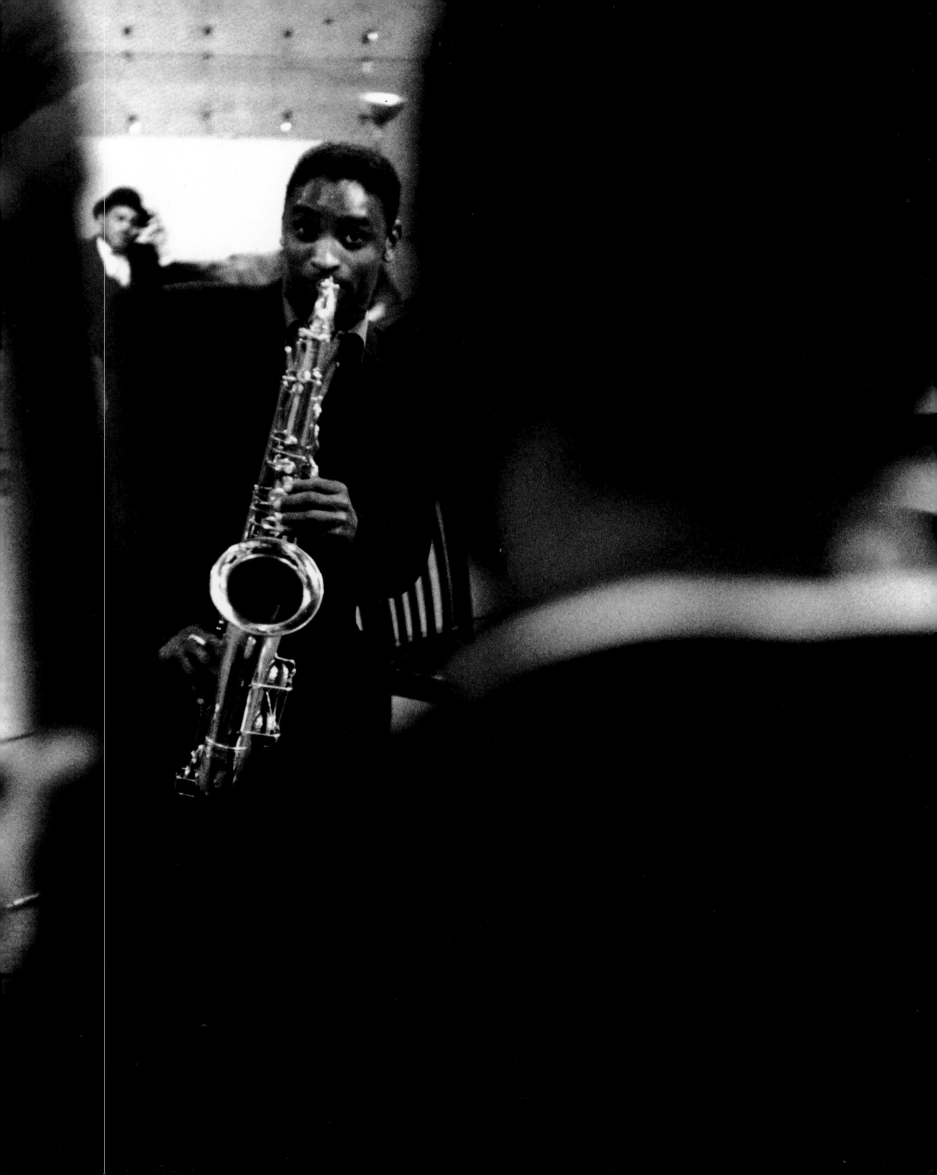

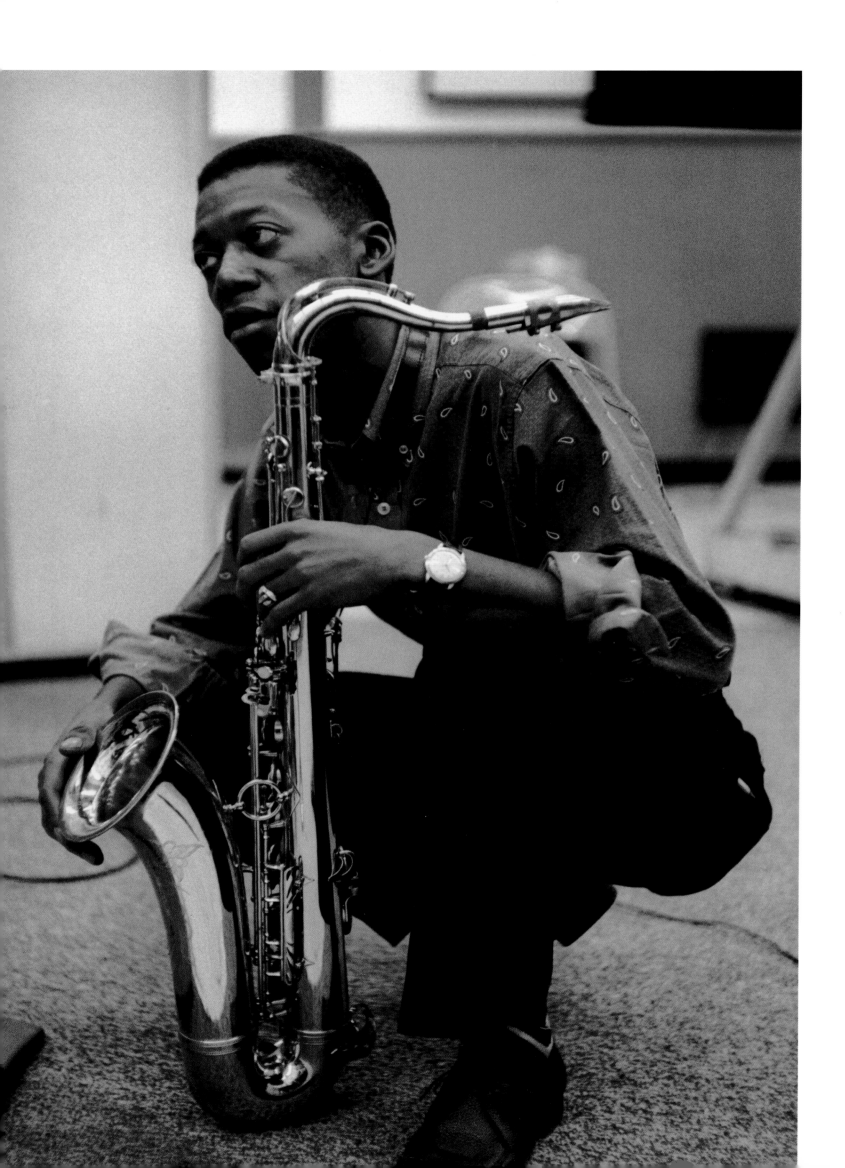

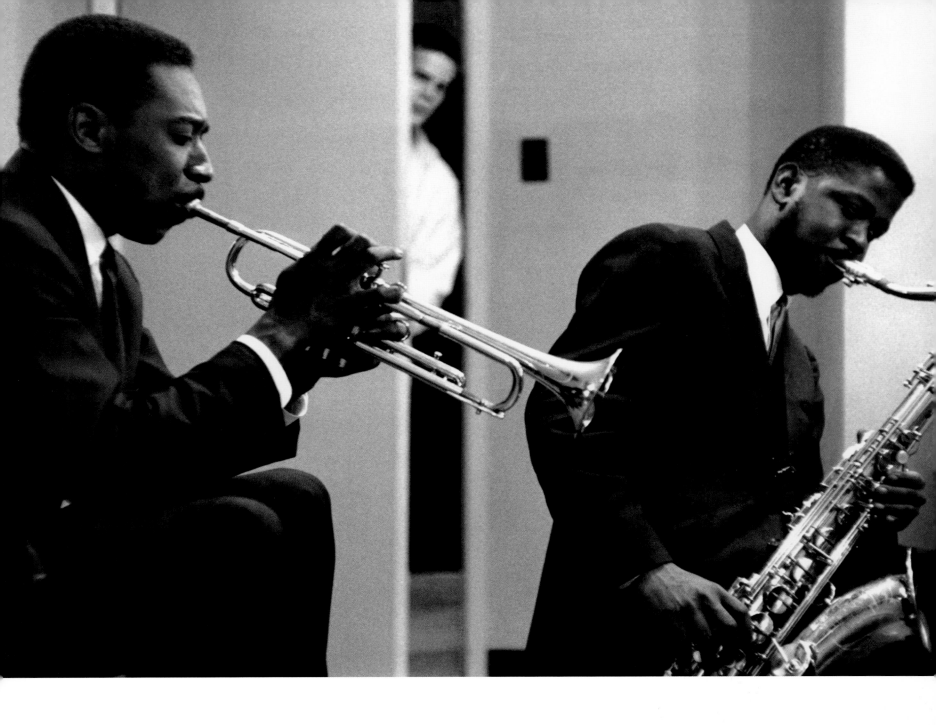

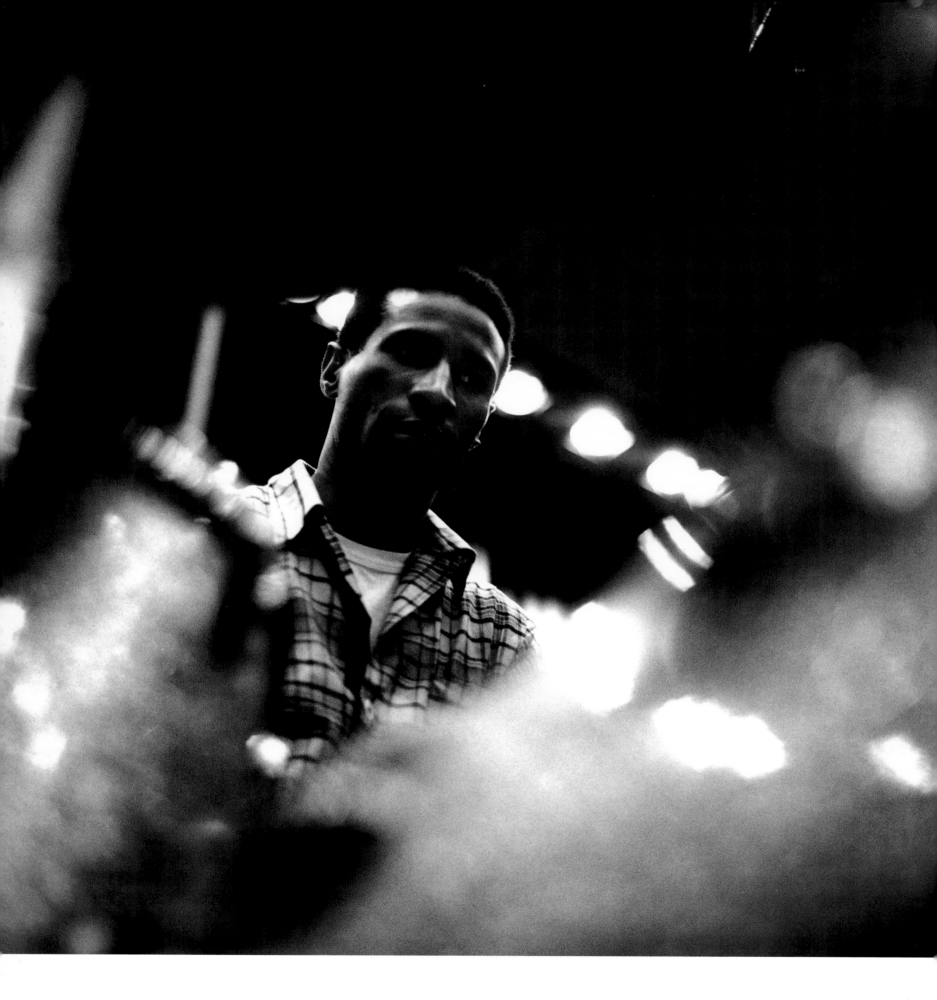

If I were asked, "What jazz musician would you most like to be with stranded on a desert island?": Without hesitating, I would most likely say, "Bird," the jazz genius of our era. But then after thinking it over briefly, what with Charlie Parker's drug problems and complications, I would have to say, Paul Desmond.

Paul was one of the wittiest, funniest, warmest musicians I have ever met. He was an outrageous punster and "wordsmith", brilliant at word games, and an inventive and charming satirist. While sitting on that desert island, in between the hilarious moments, Paul could play his beautifully lyrical and subtly swinging alto saxophone.

One hot, rainy night in Washington D. C., Paul and I snuck out of a jazz festival to go see a strip show in the seediest section of Baltimore. We left Dizzy Gillespie, Gerry Mulligan, and Thelonious Monk on this quest. To our utter amazement, the last stripper on the bill undressed down to her G-string, appeared with a clarinet and played Artie Shaw's signature tune *Nightmare*, all the while bumping and grinding away in front of us and four other men in raincoats. I guess there's no escaping jazz.

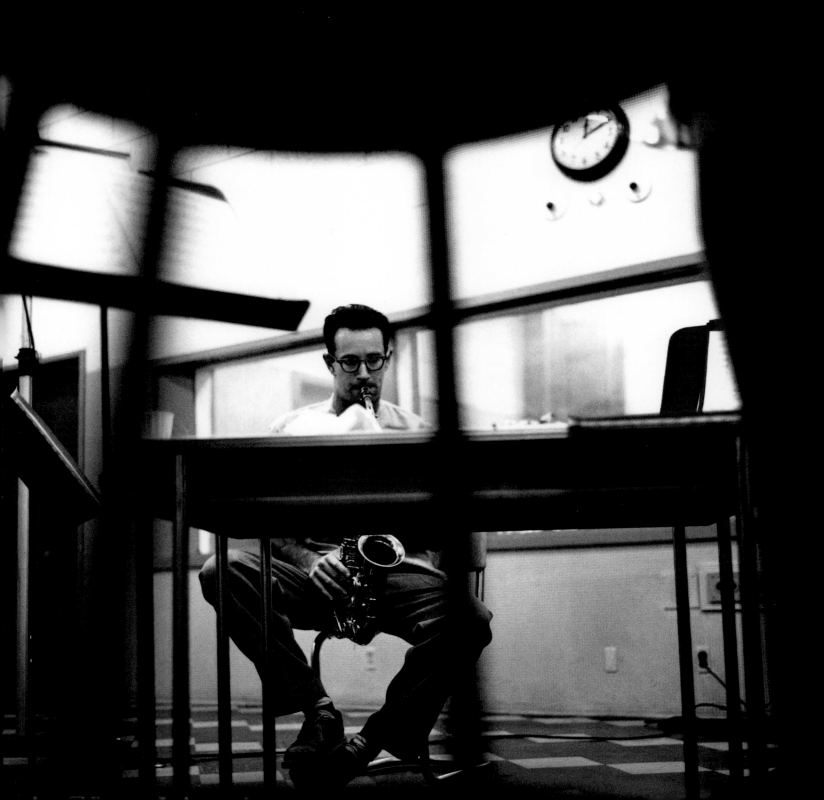

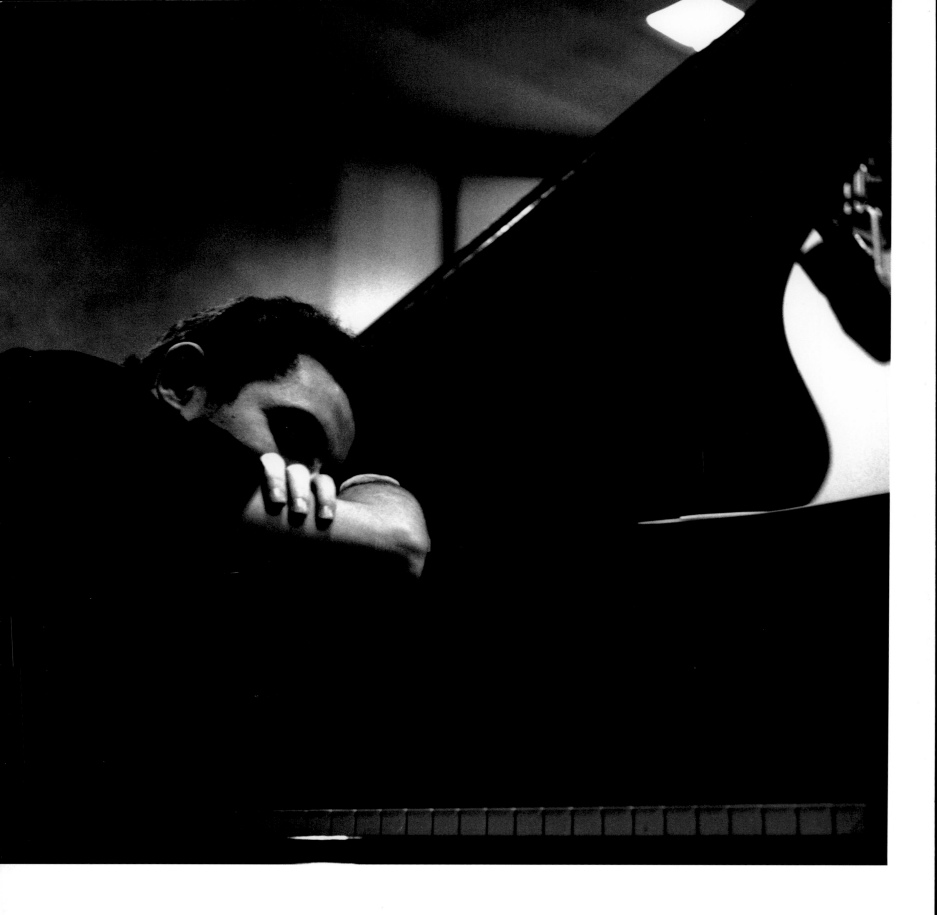

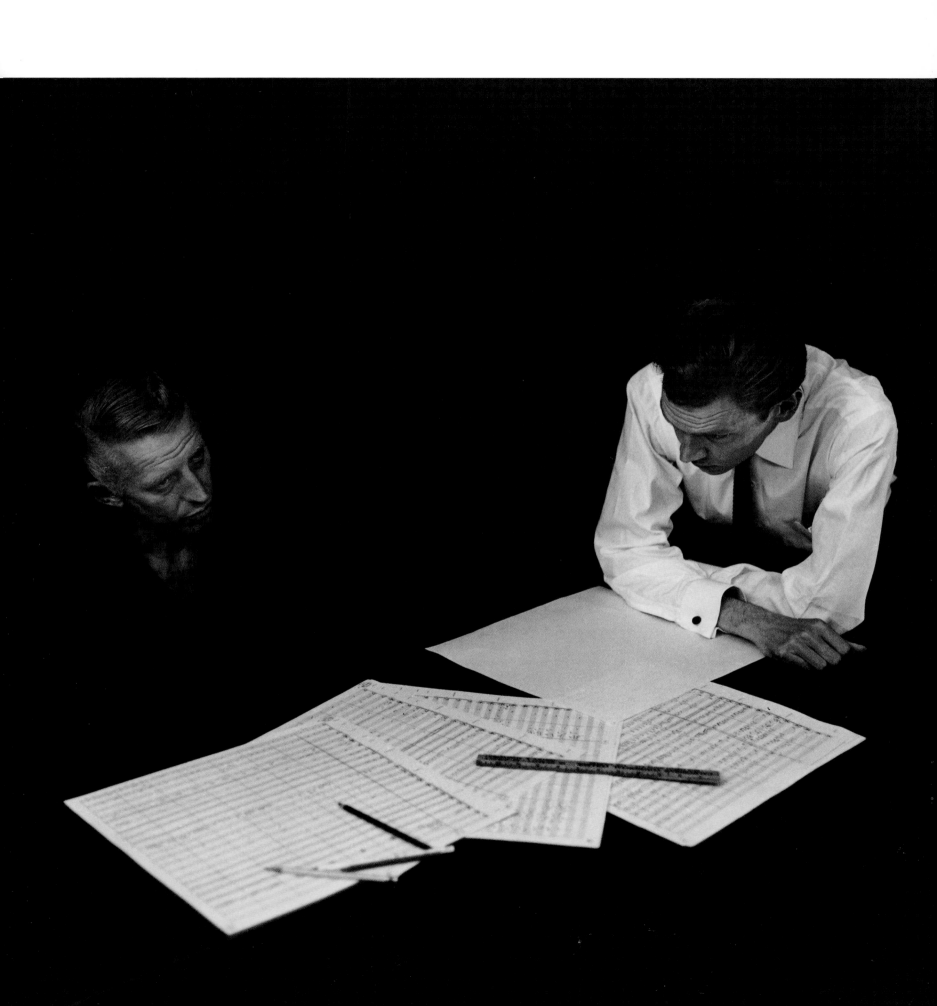

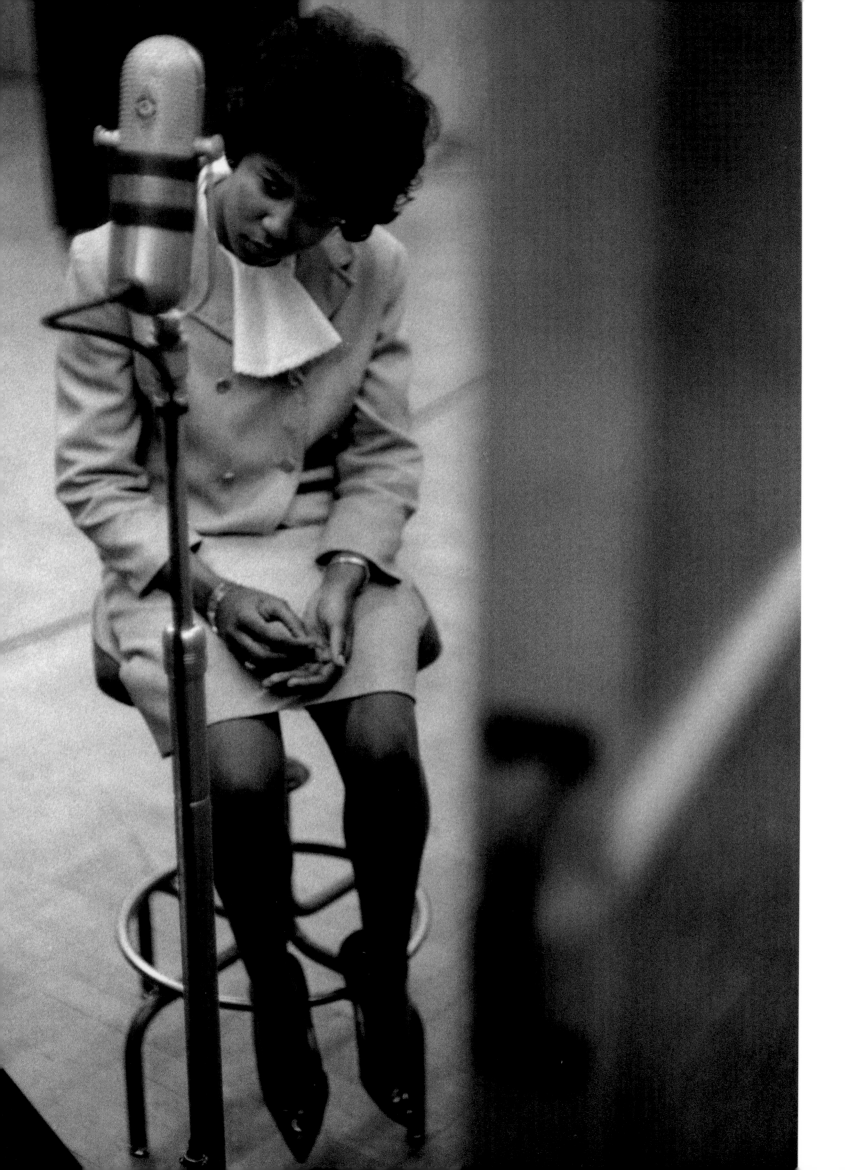

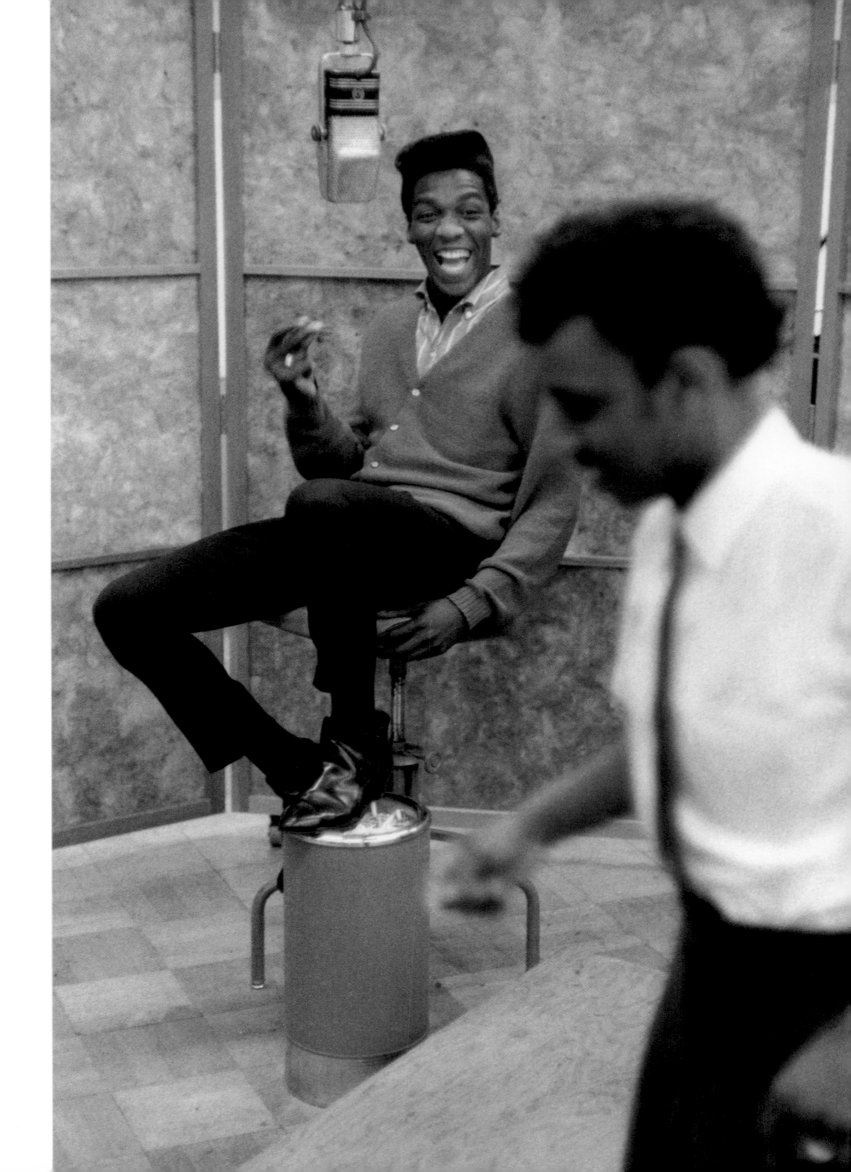

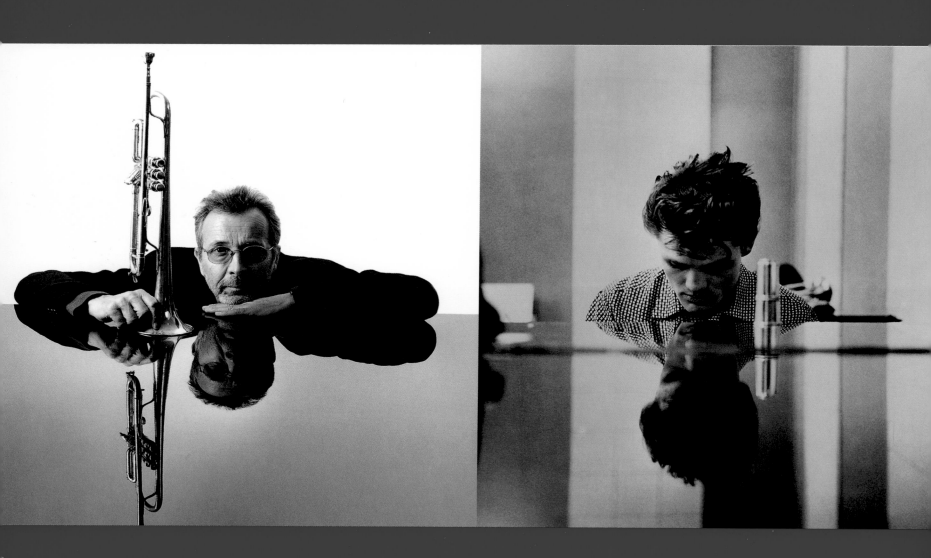

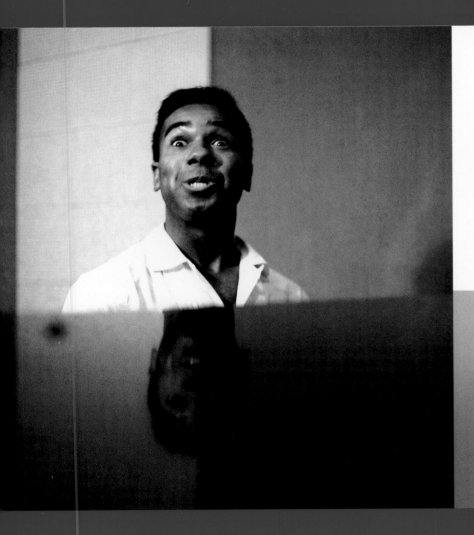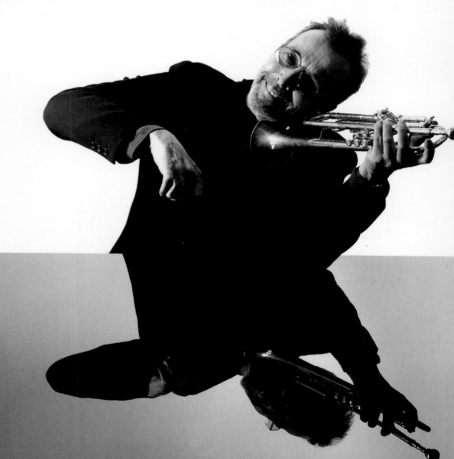

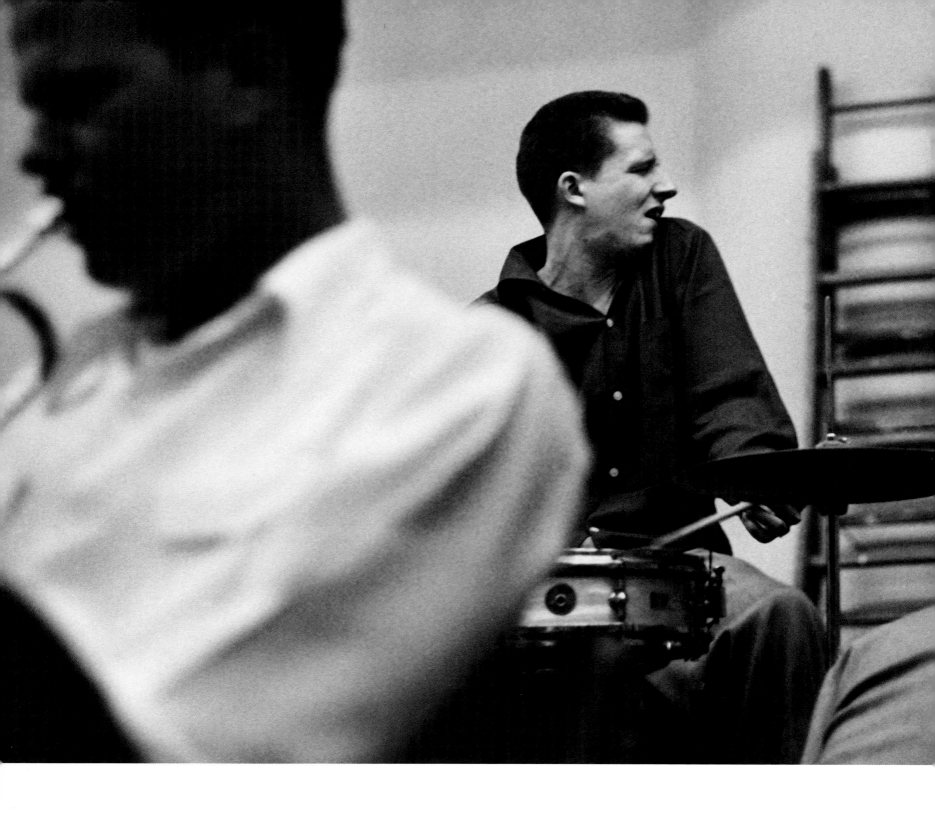

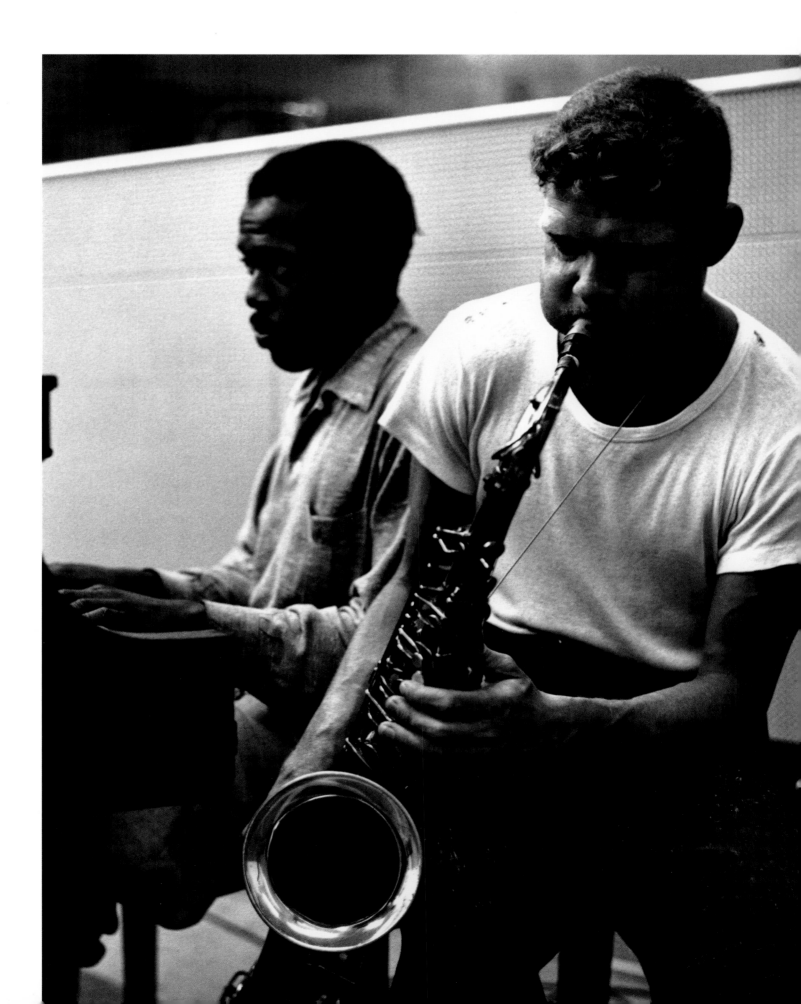

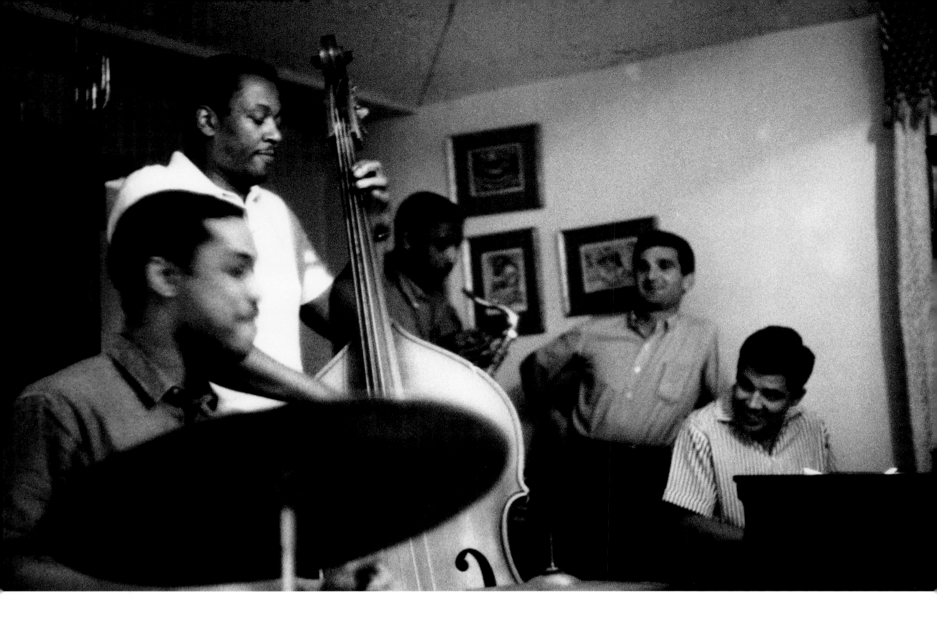

30
31
Jam session at Falcon's Lair: **32**
Billy Higgins (drums), Leroy Vinnegar (bass), Teddy Edwards (tenor sax), **33**
Conte Candoli and host, Joe Castro (piano), Beverly Hills, 1955 34

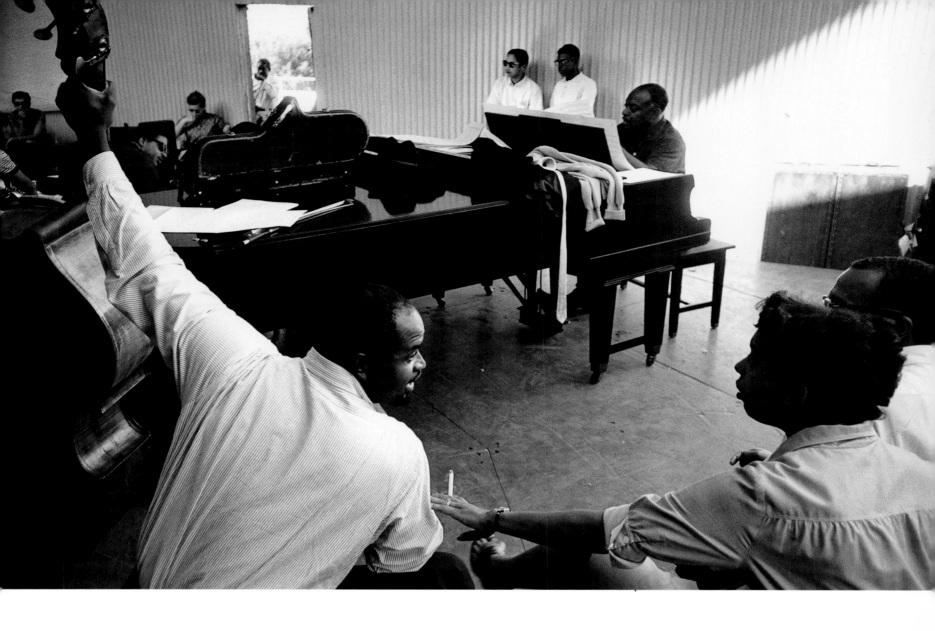

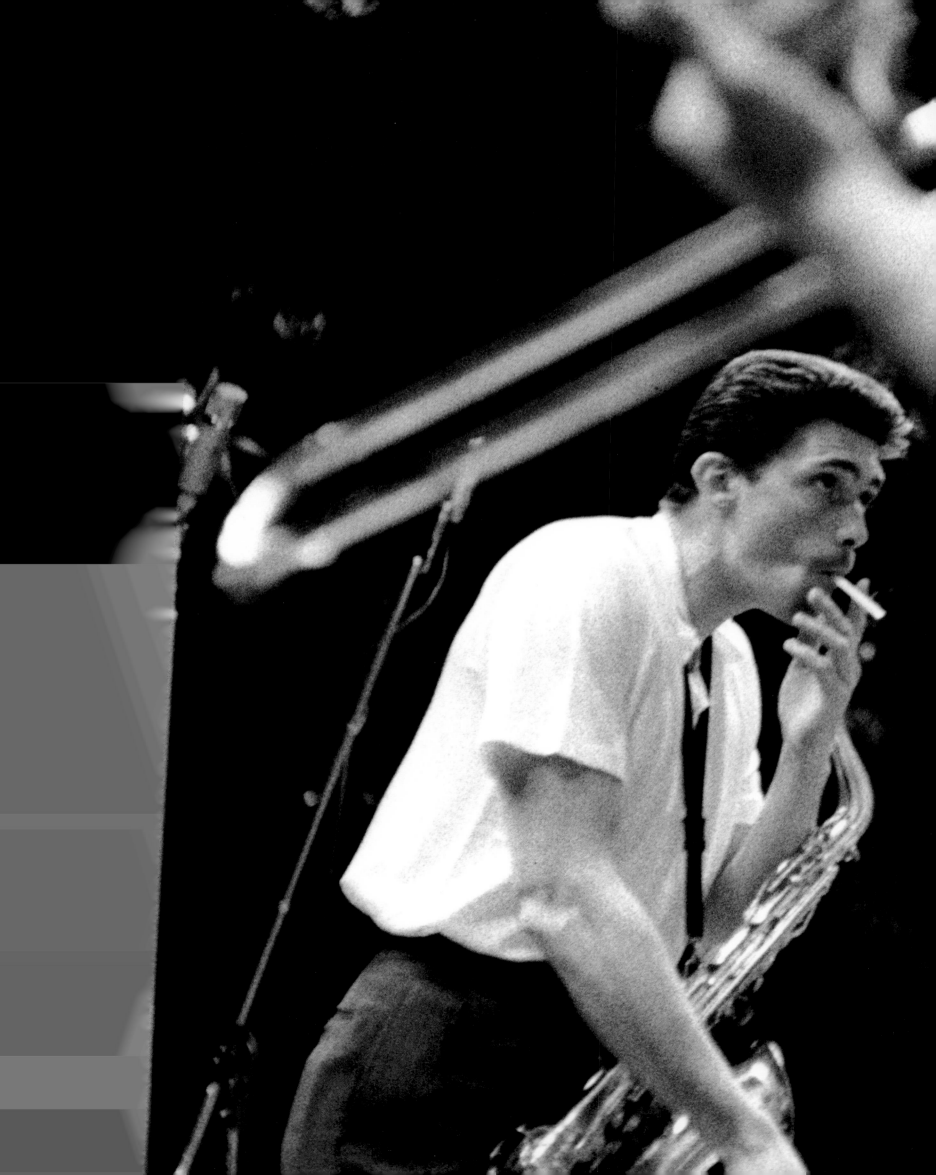

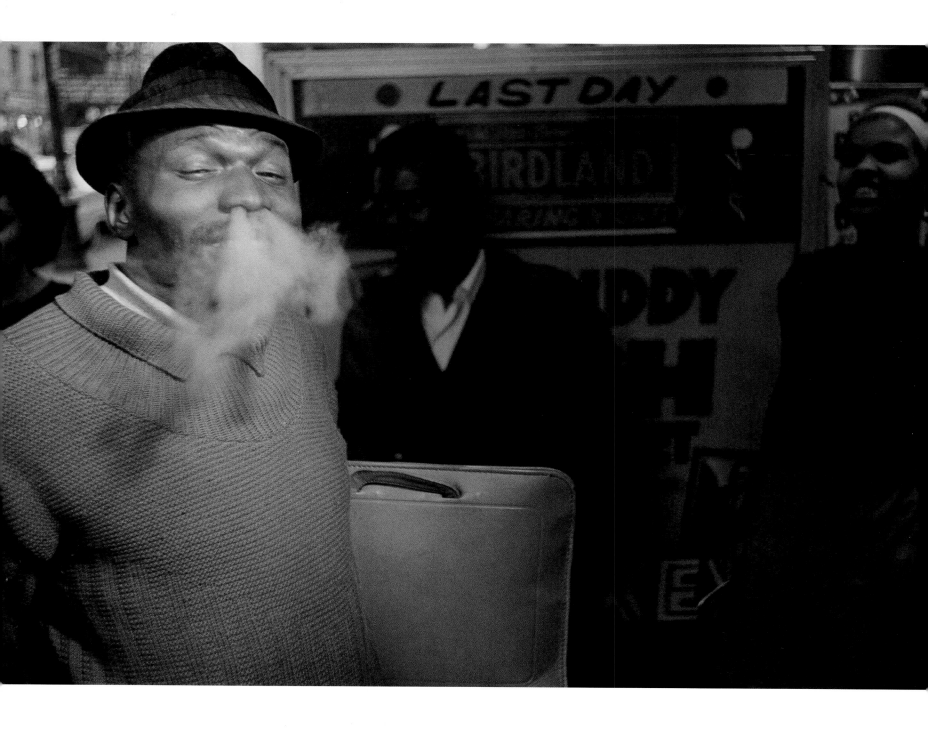

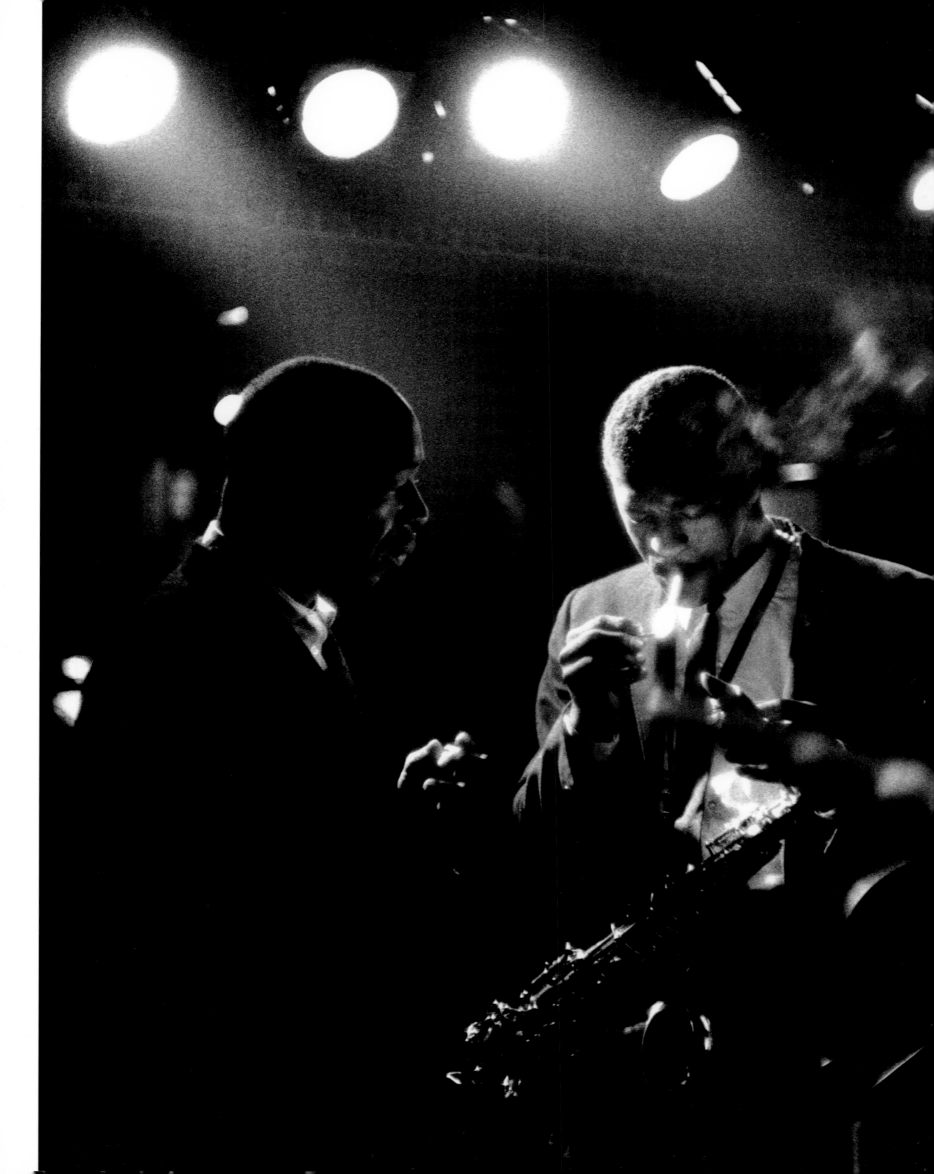

TAKE YOUR OWN PHOTOS

4 PHOTO POSES 25¢

DELIVERED IN 2 MINUTES.

CARD VENDER

PERMITS

GET A PERMIT HERE
THE SKY IS THE LIMIT

VINEOLITE CASES

Protect Your Photos
with
VINEOLITE
CASES
2 FOR 10¢
FOR YOUR
Photos

Charlie Mariano, Toshiko Akiyoshi, Times Square, New York City, 1960 **38**

39 *Cannonball Adderley outside Apollo Theater, New York City, 1960*

37
40
41

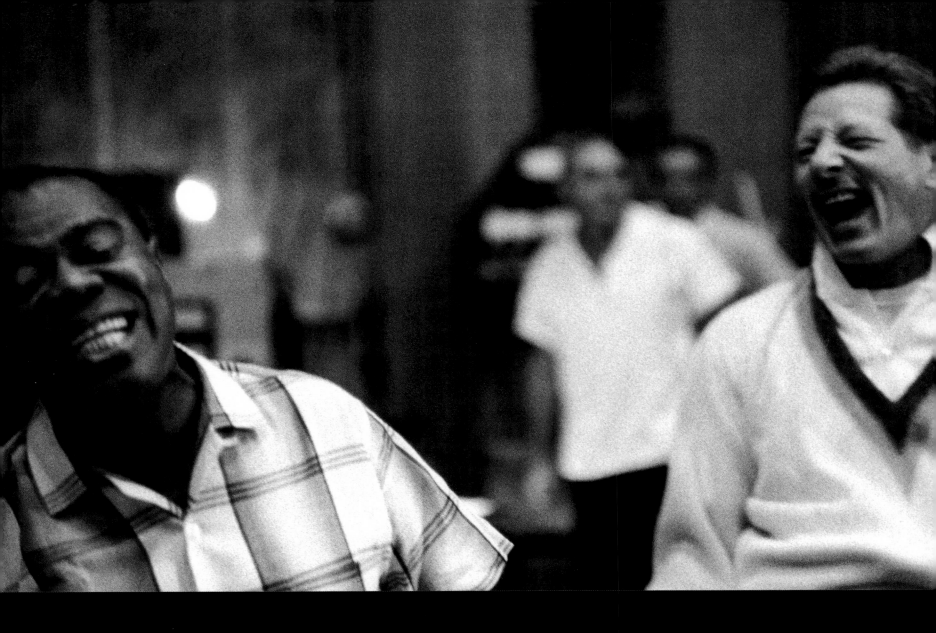

Louis Armstrong, Danny Kaye, Paramount Studios, Hollywood, 1957

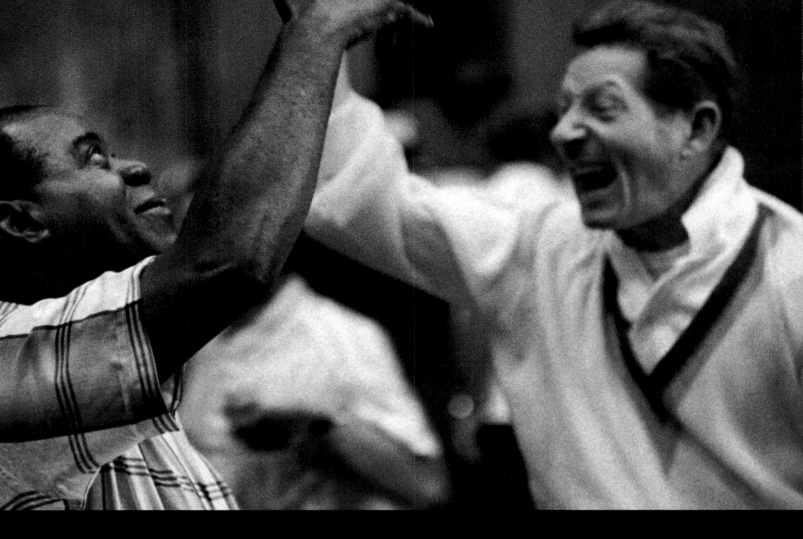

LOUIS ARMSTRONG, DANNY KAYE

This was during a rehearsal for the soundtrack for the film *The Five Pennies* which was a musical biography for cornetist Red Nichols and his Five Pennies. Red Nichols, played by actor Danny Kaye, taught Kaye the fingering on the cornet and performed the dubbing for the soundtrack. In the meanwhile, Louis Armstrong and Danny Kaye had fun with each other on the sound stage.

39

41 *Louis Armstrong, Danny Kaye, Paramount Studios, Hollywood, 1957*

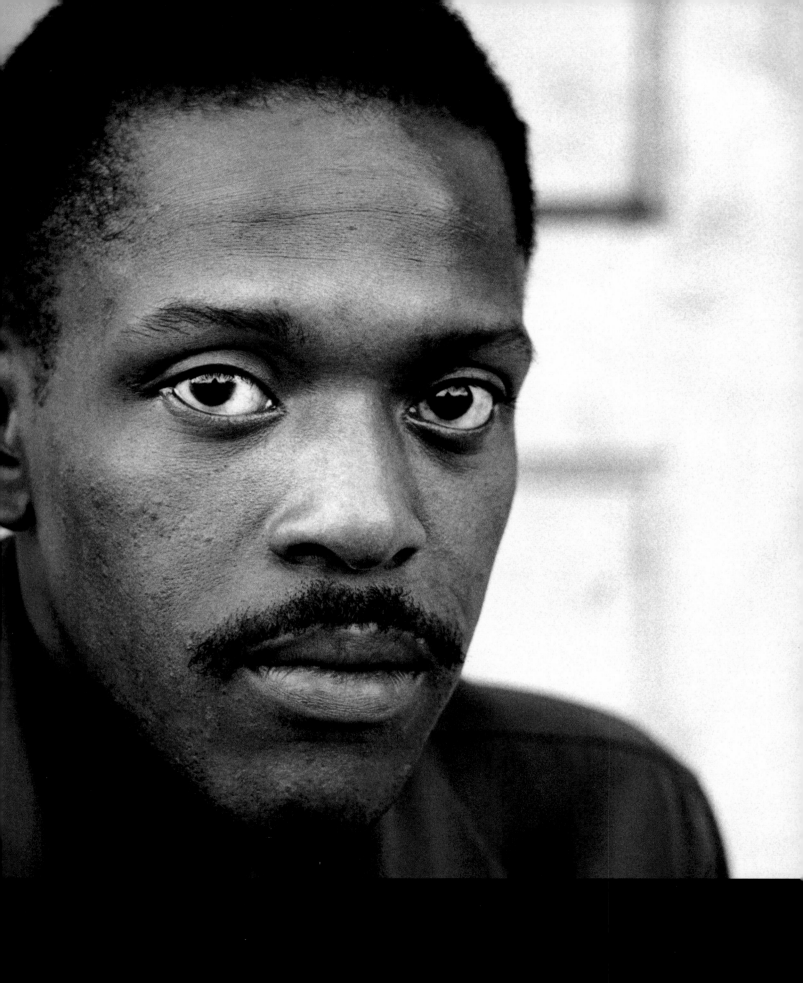

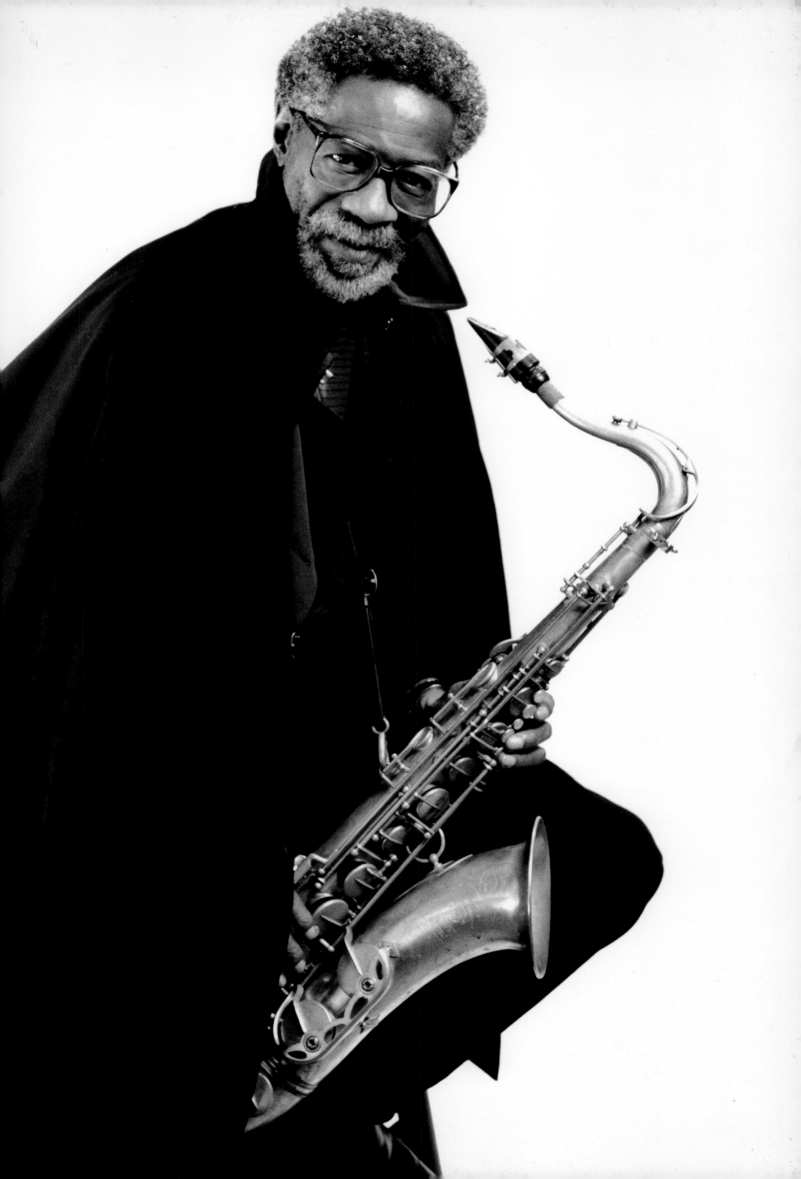

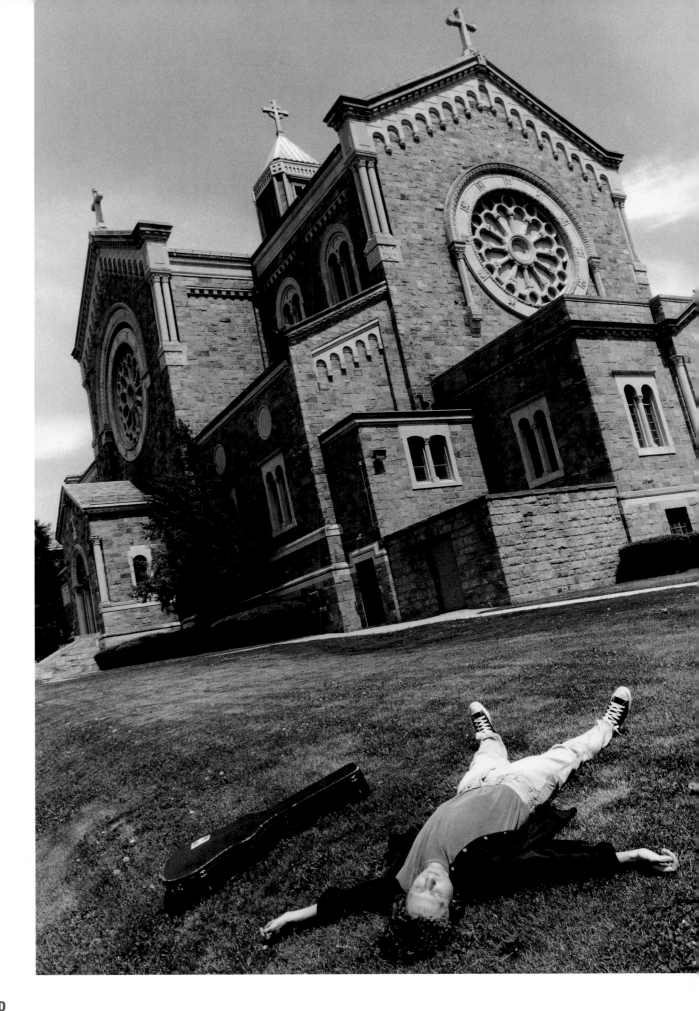

DILLON'S WORLD

Dillon O'Brian grew up in Baltimore. BMG/RCA Records had me go there and shoot him for a record cover. Dillon and I hung out together. We walked about the town, and he reminisced about the influence that the city and especially the Church had had on his life and music. After a pleasantly long liquid lunch, we returned to the Church of his childhood. He lay prostrate beneath the enormous neo-gothic structure.

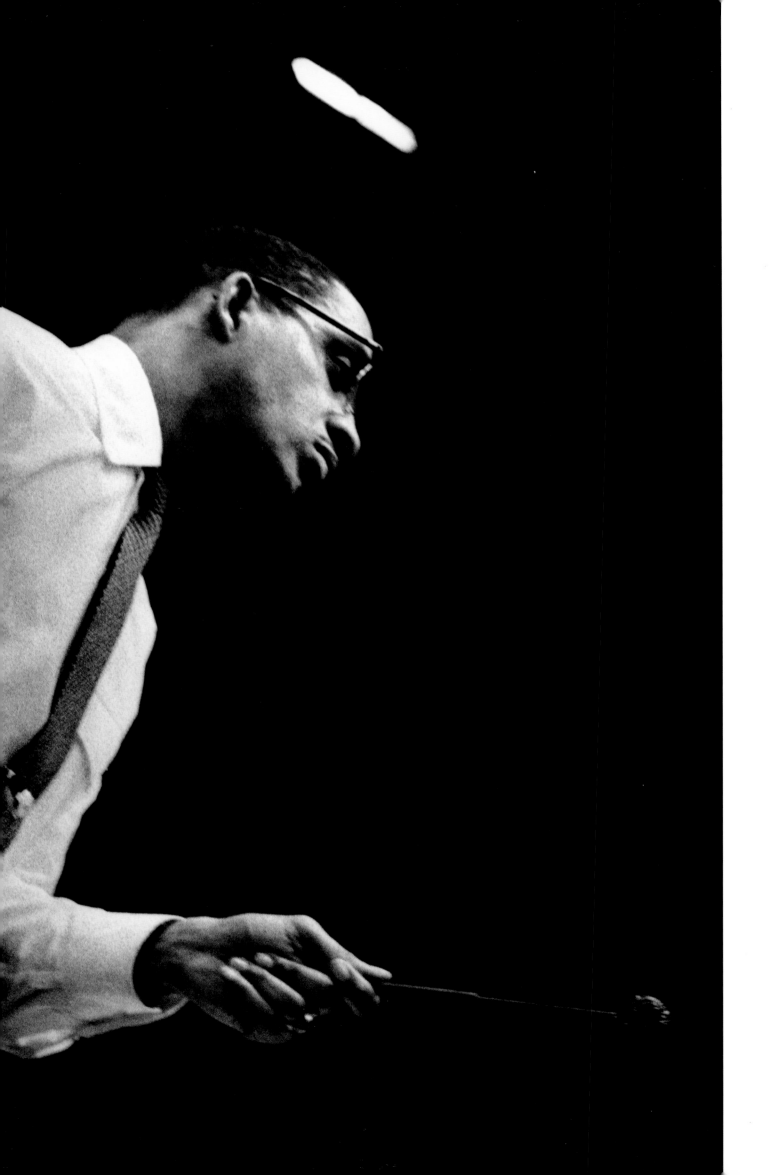

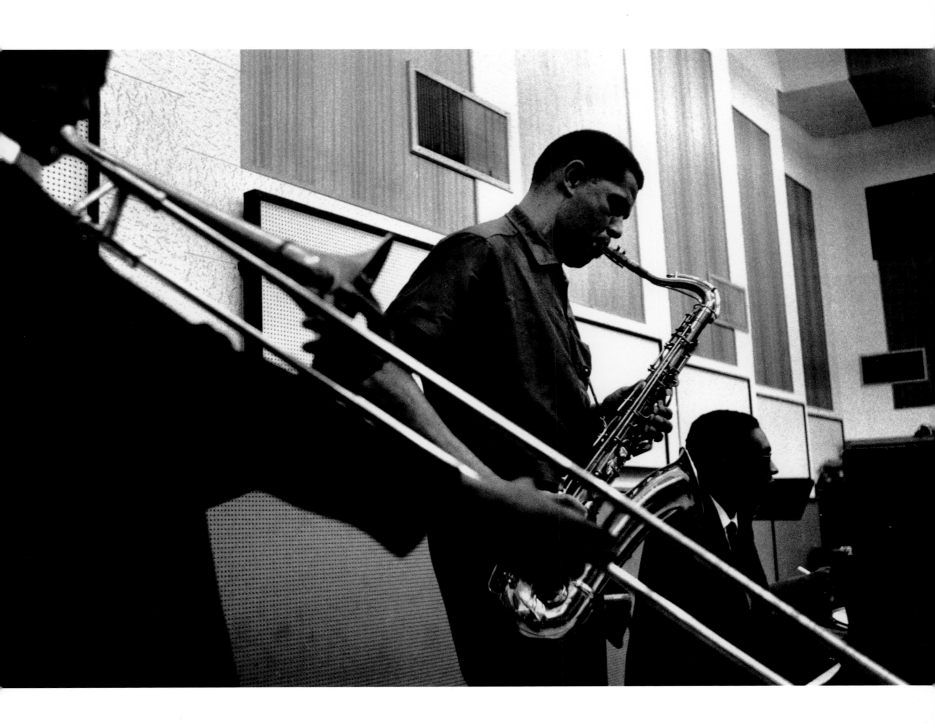

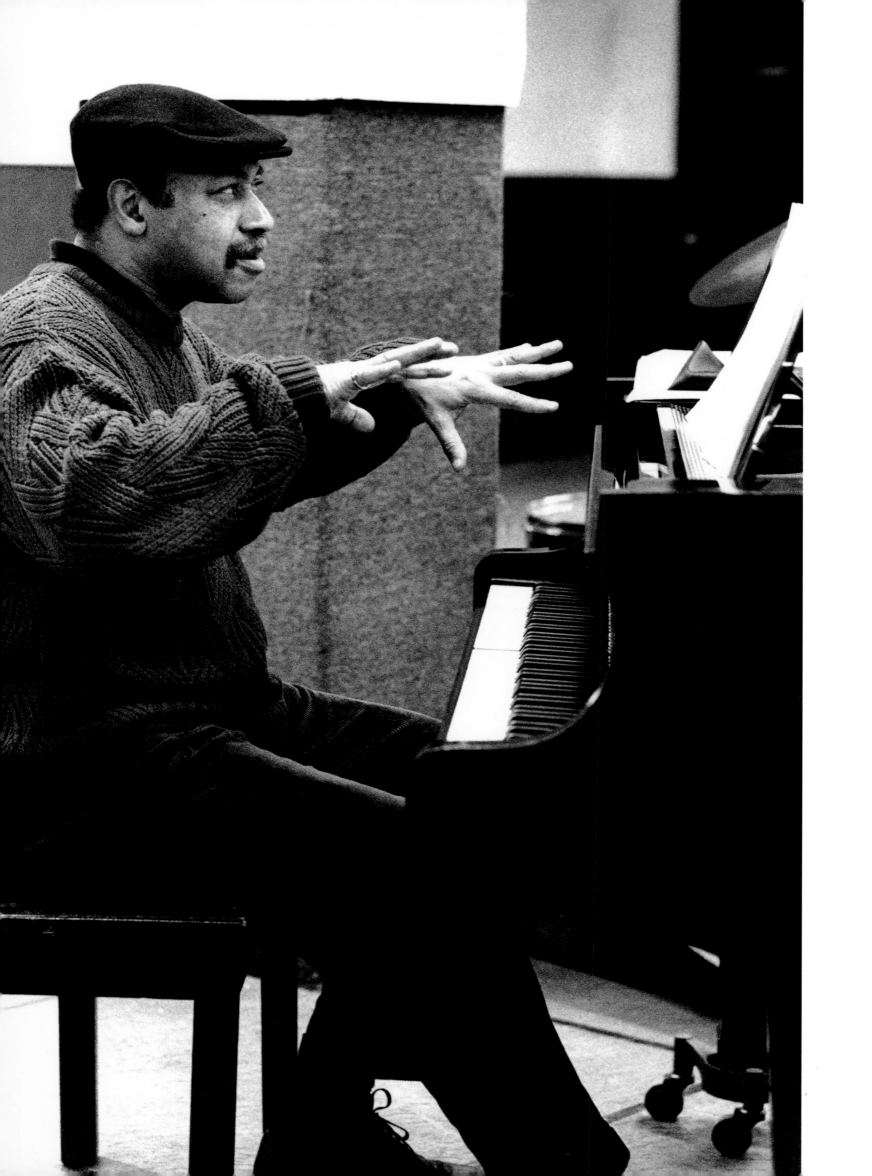

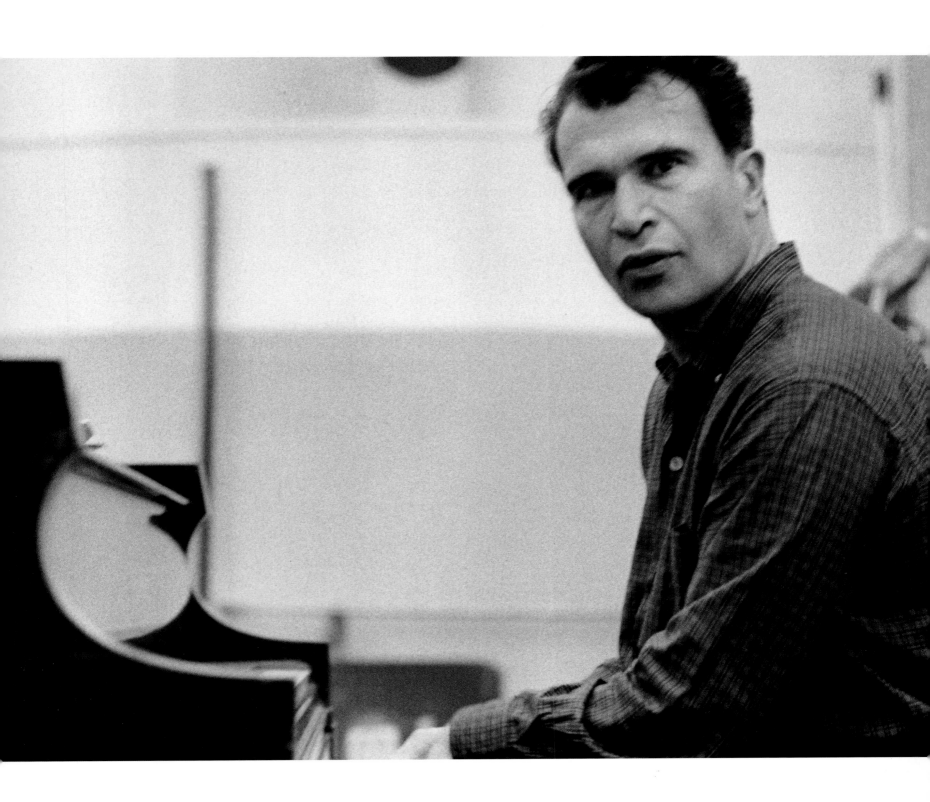

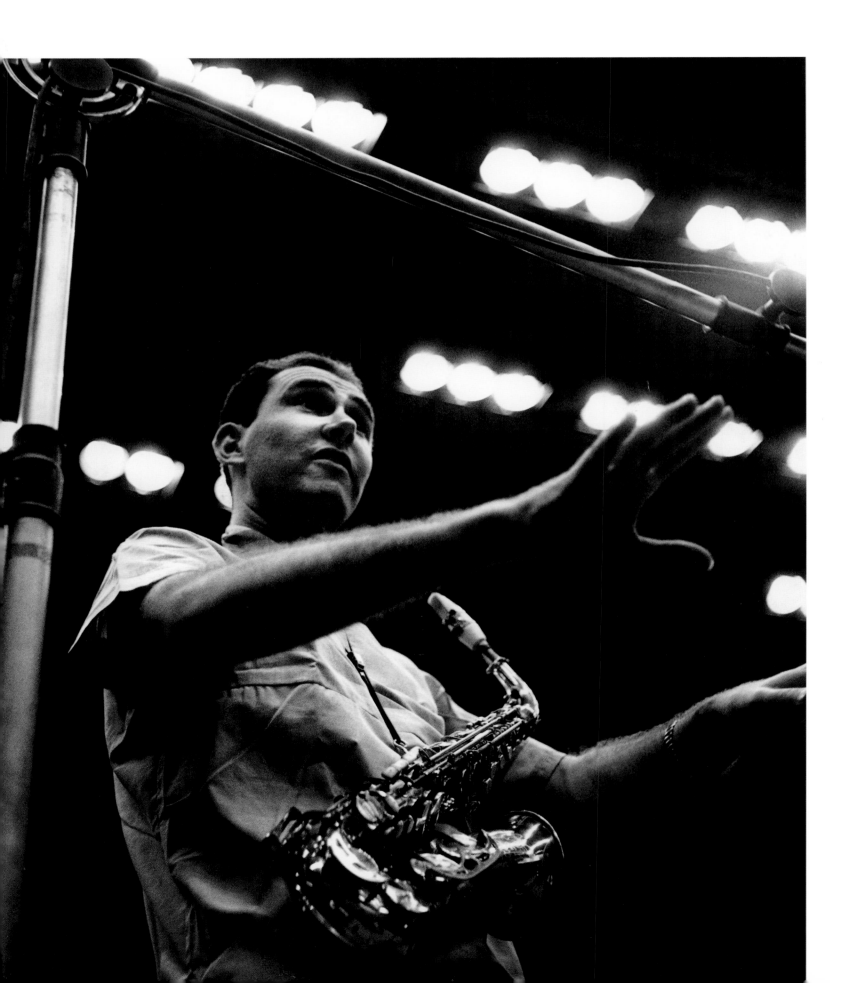

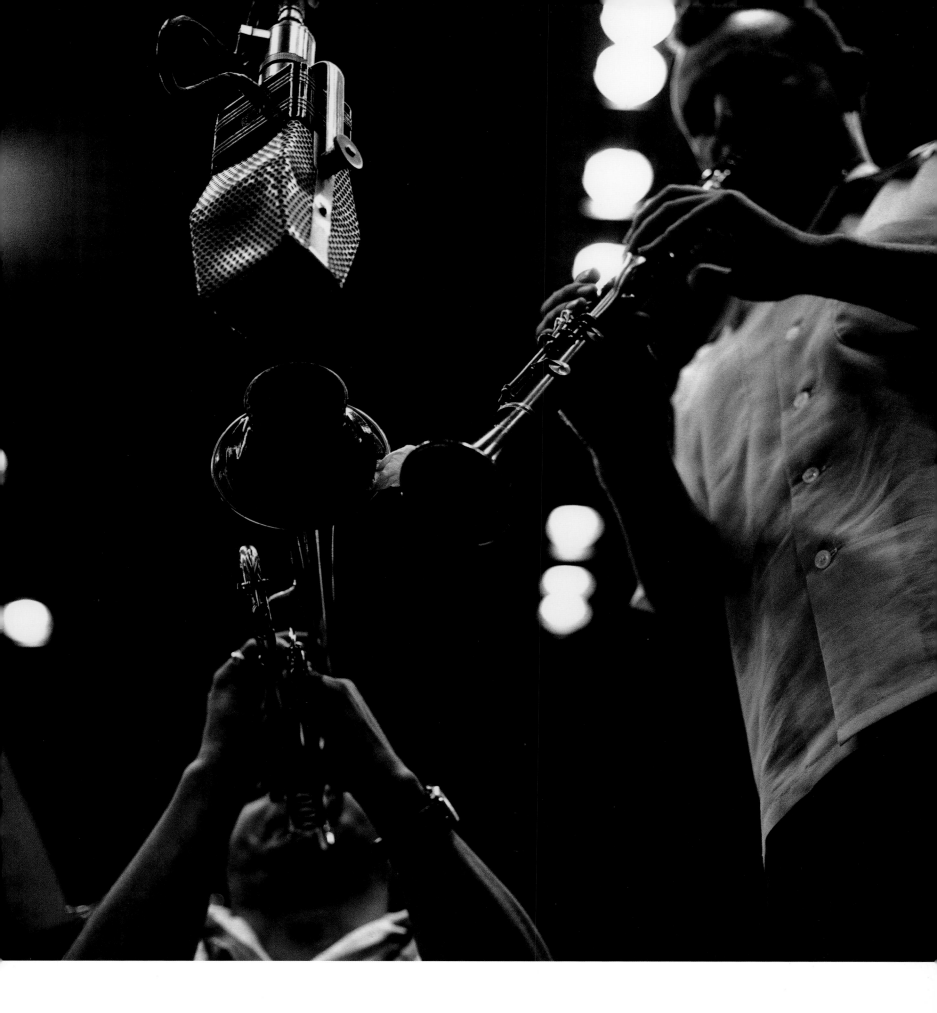

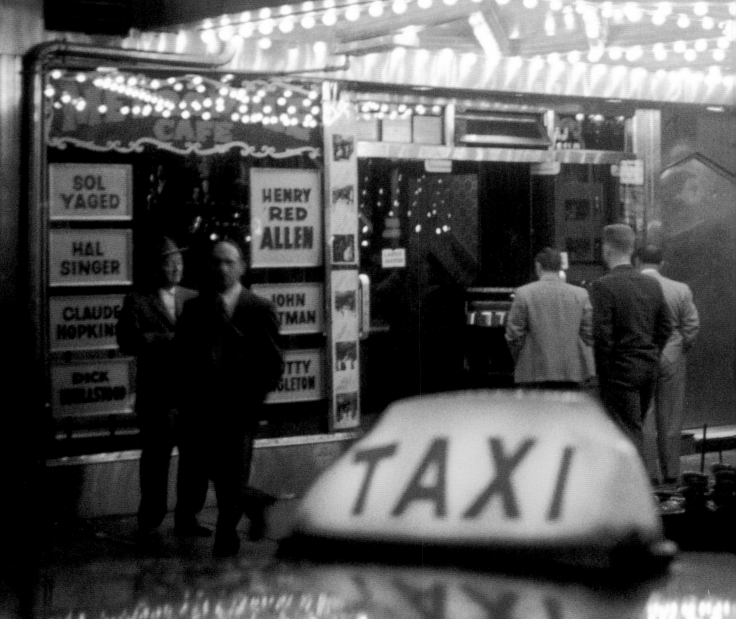

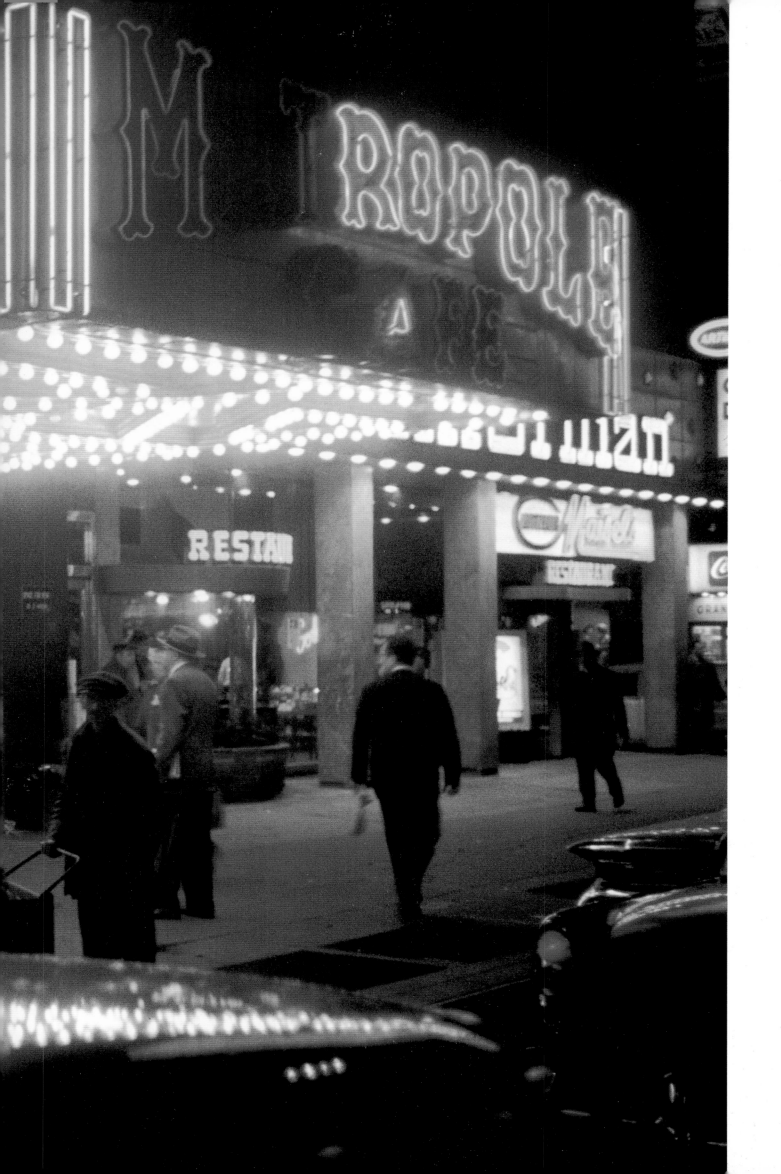

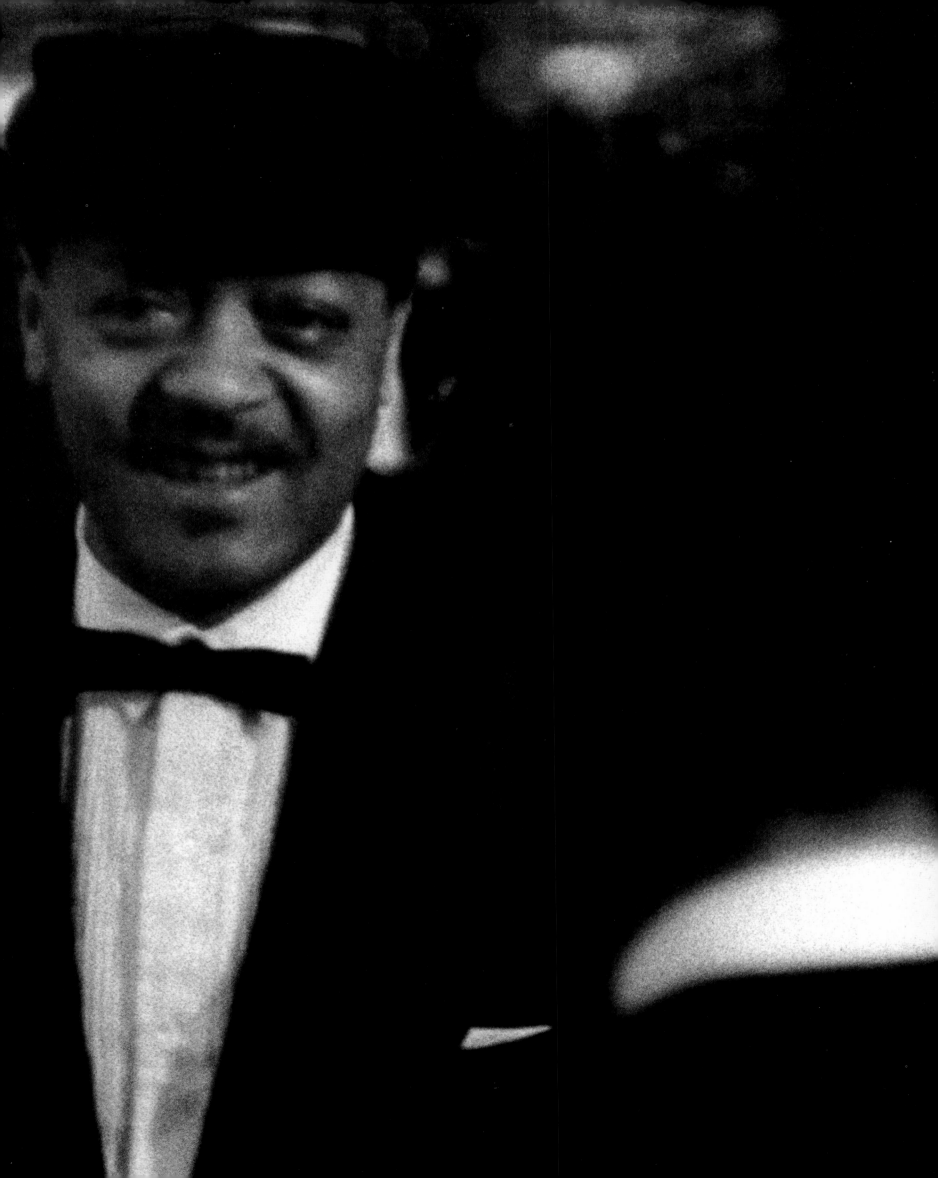

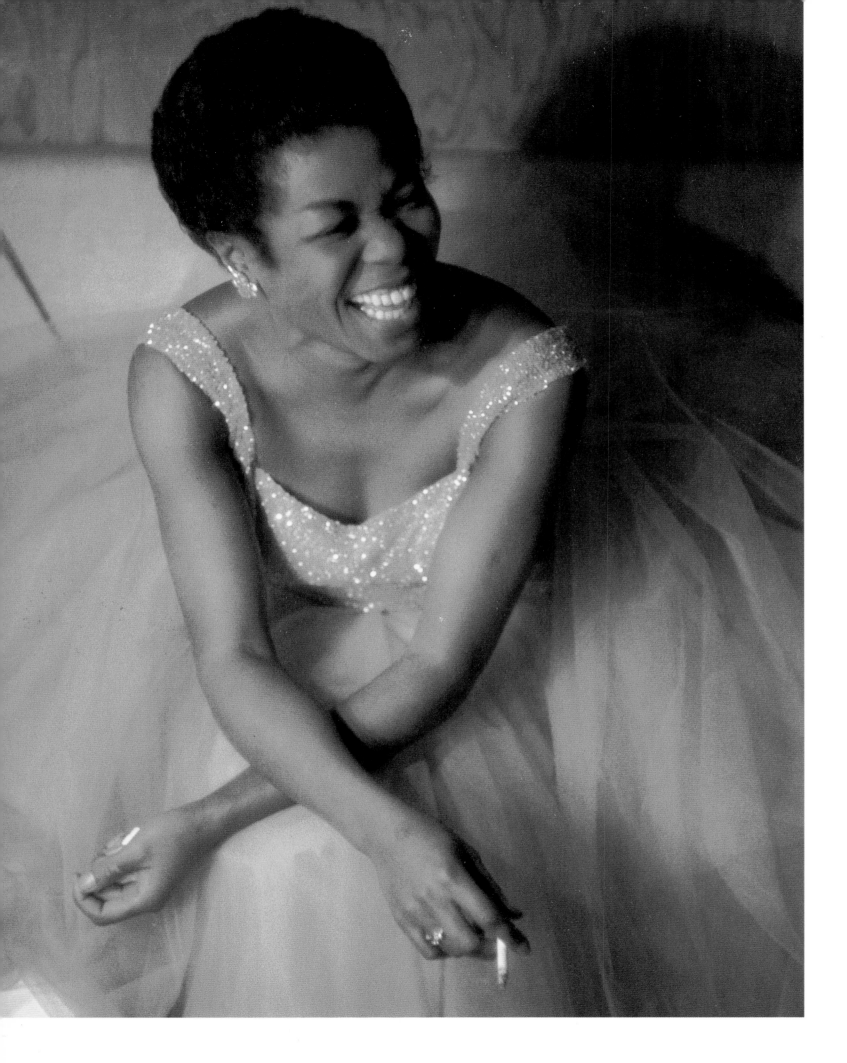

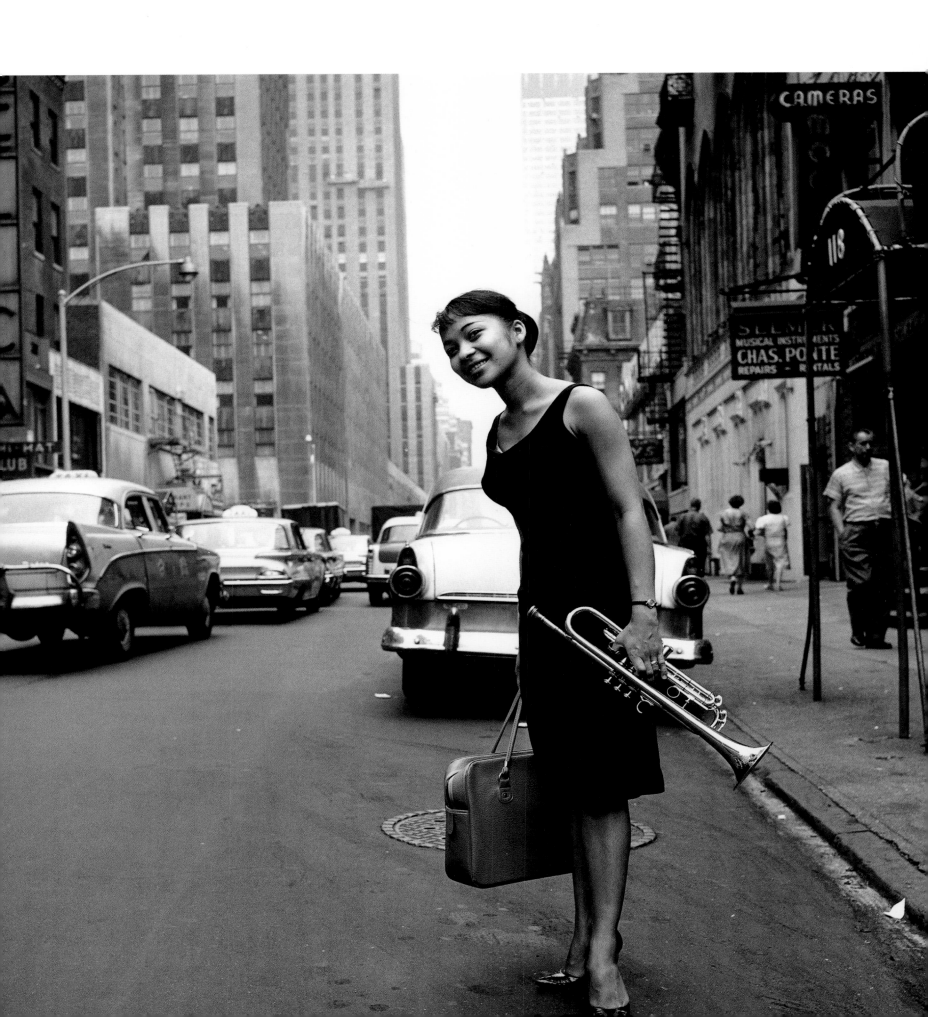

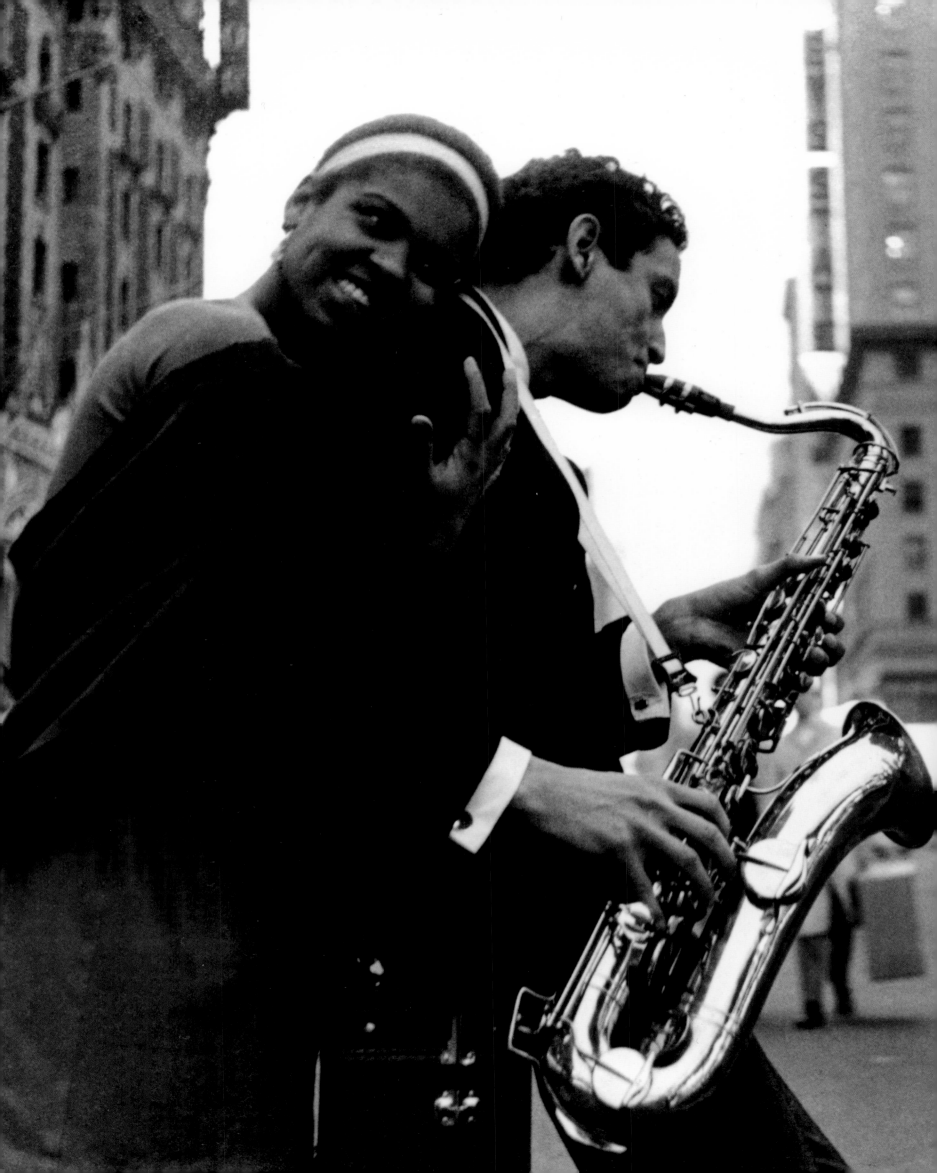

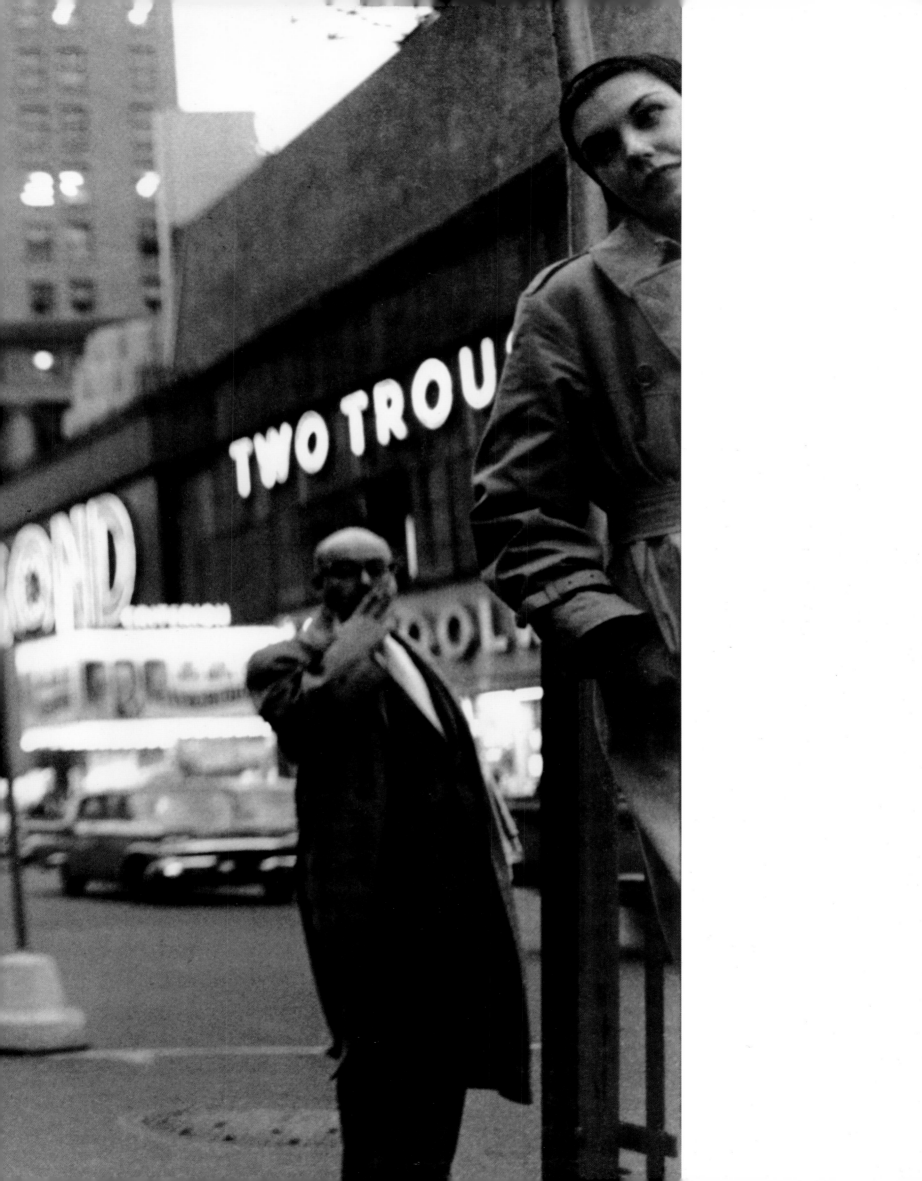

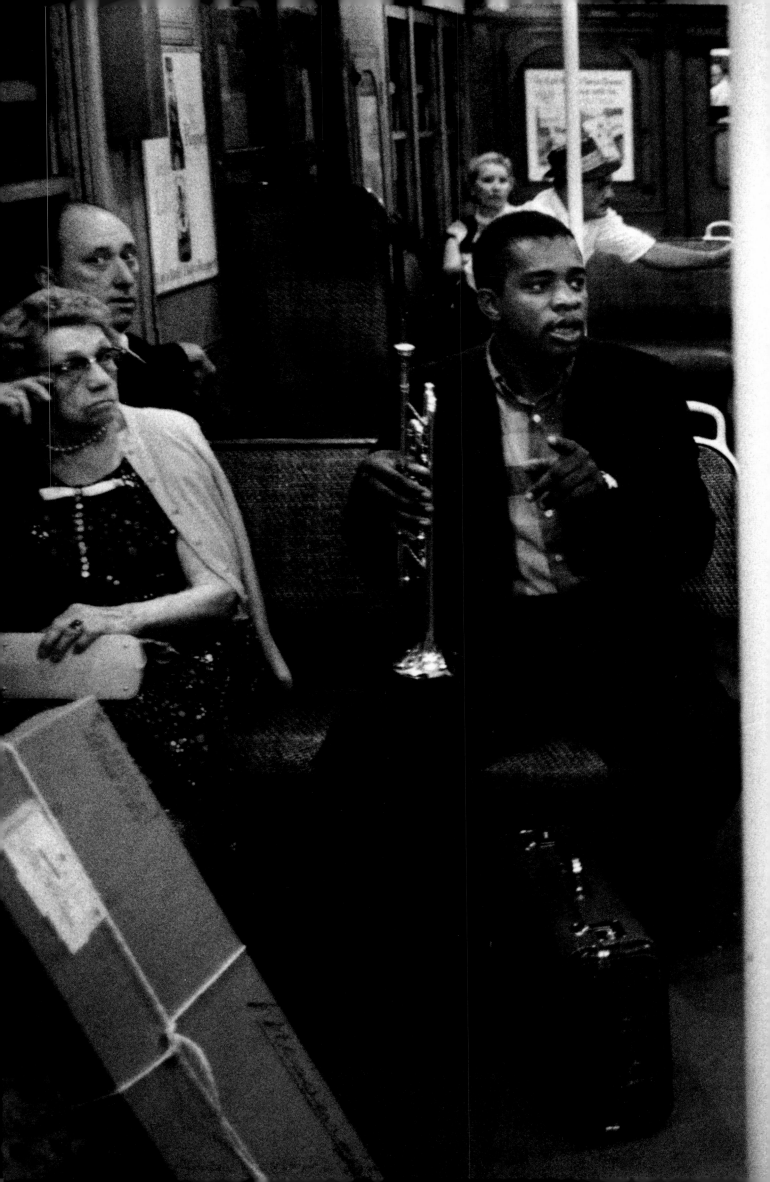

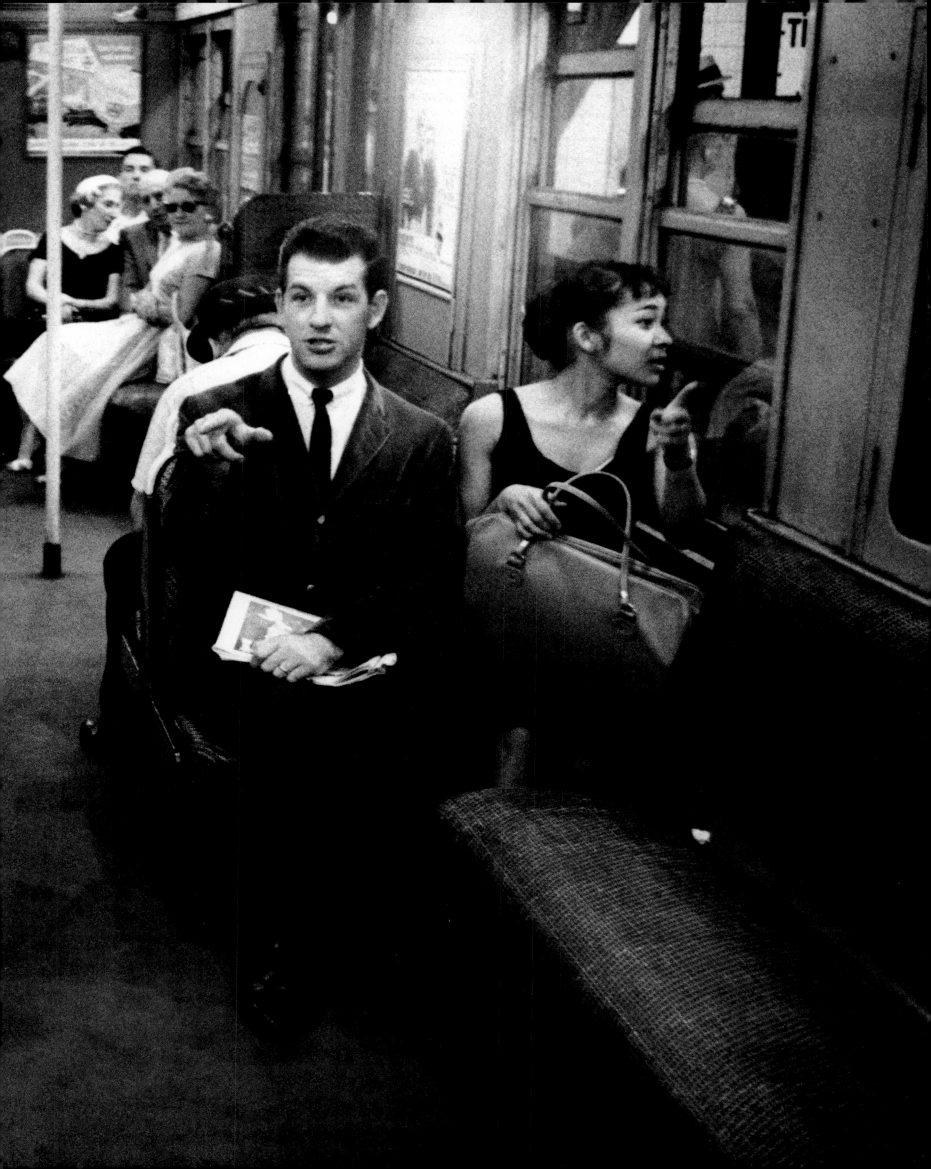

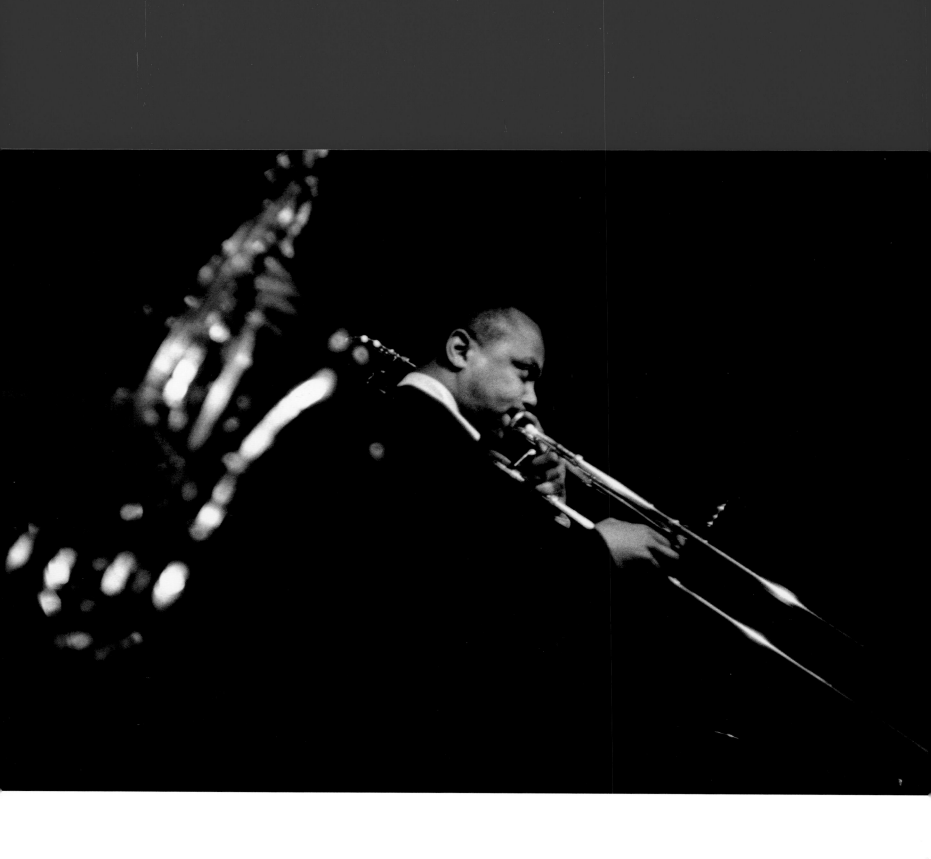

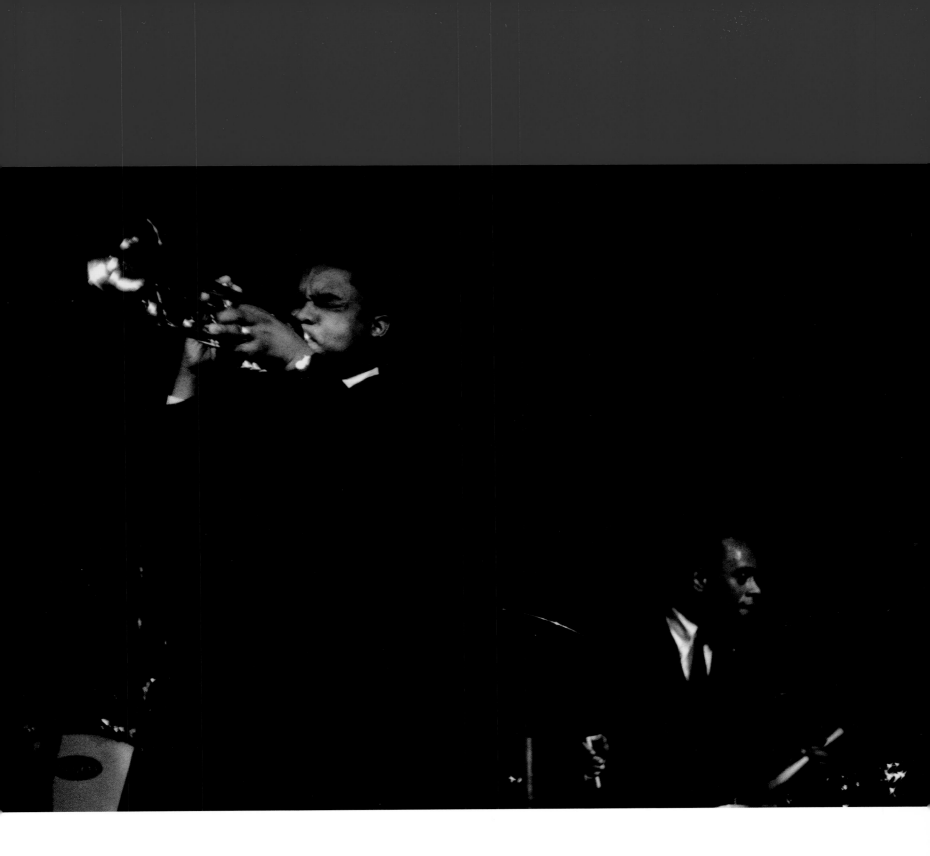

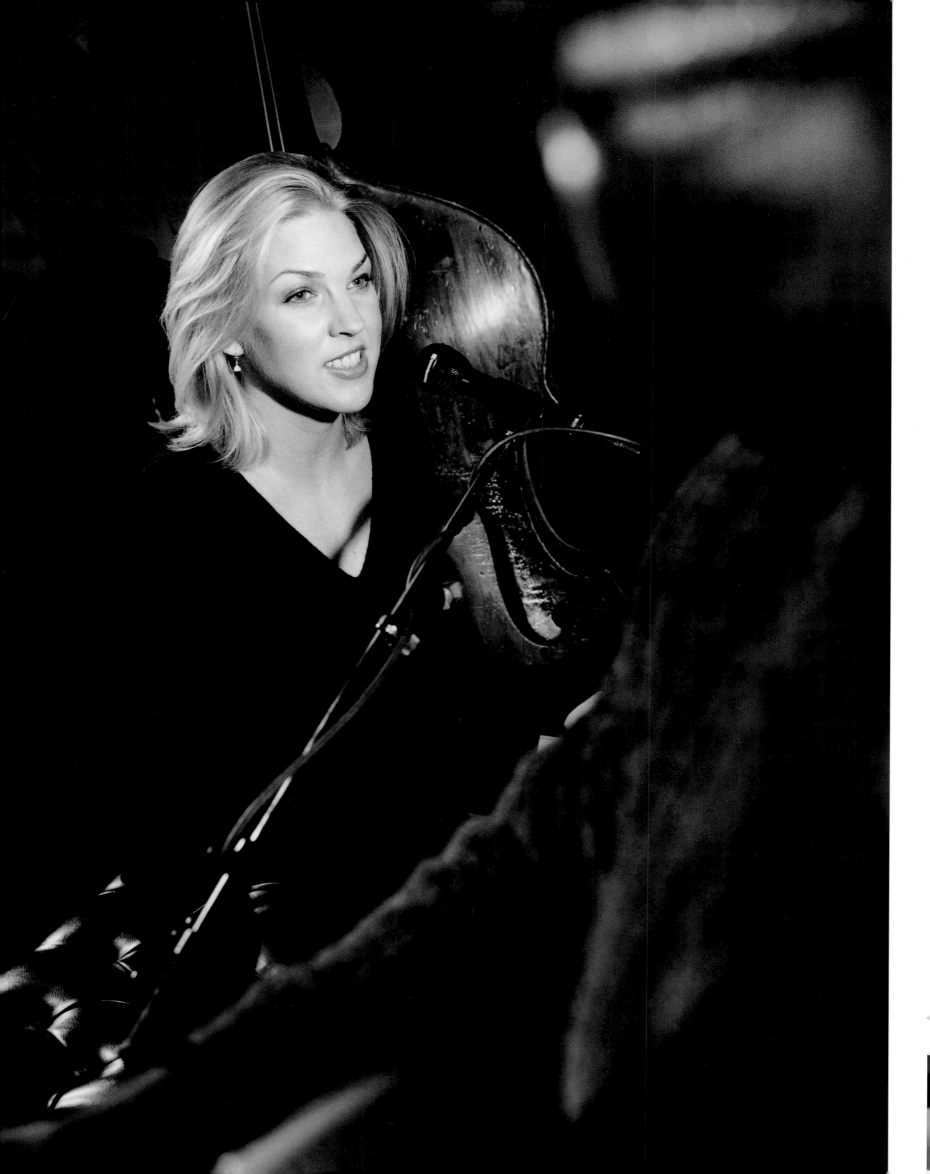

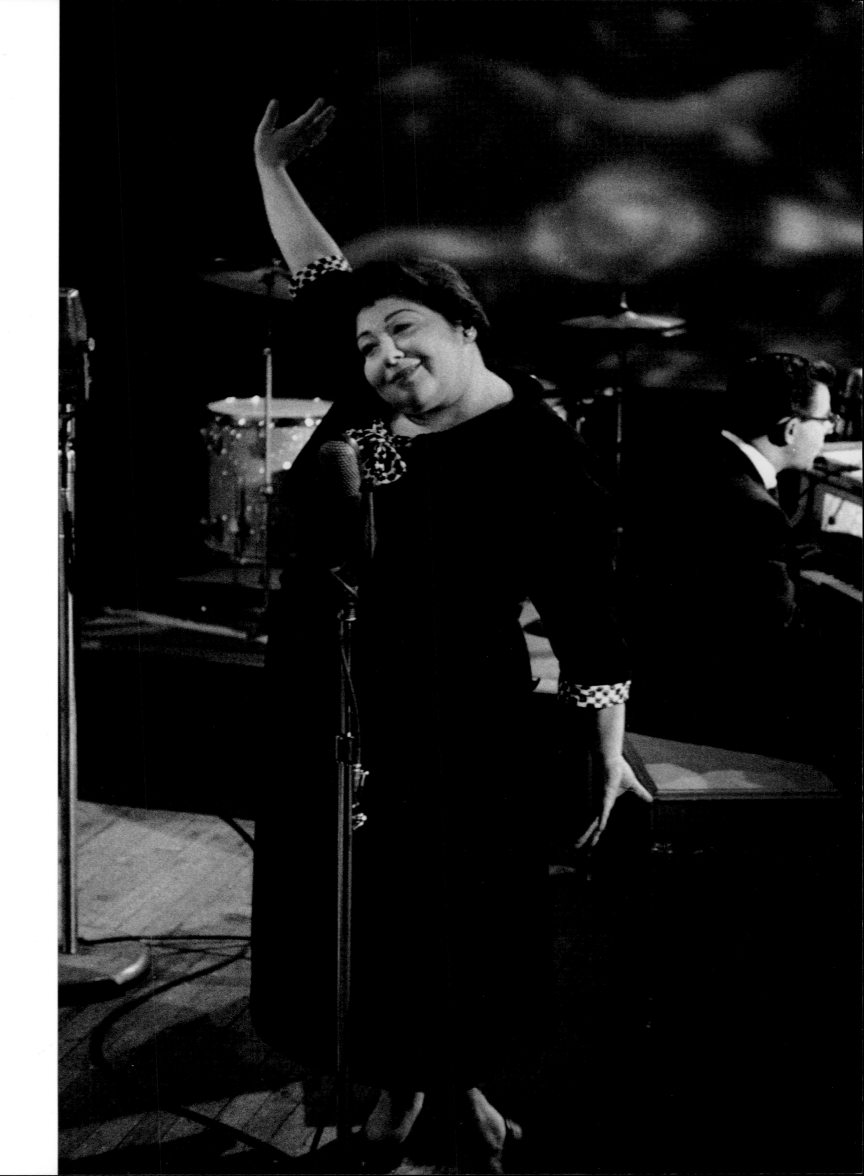

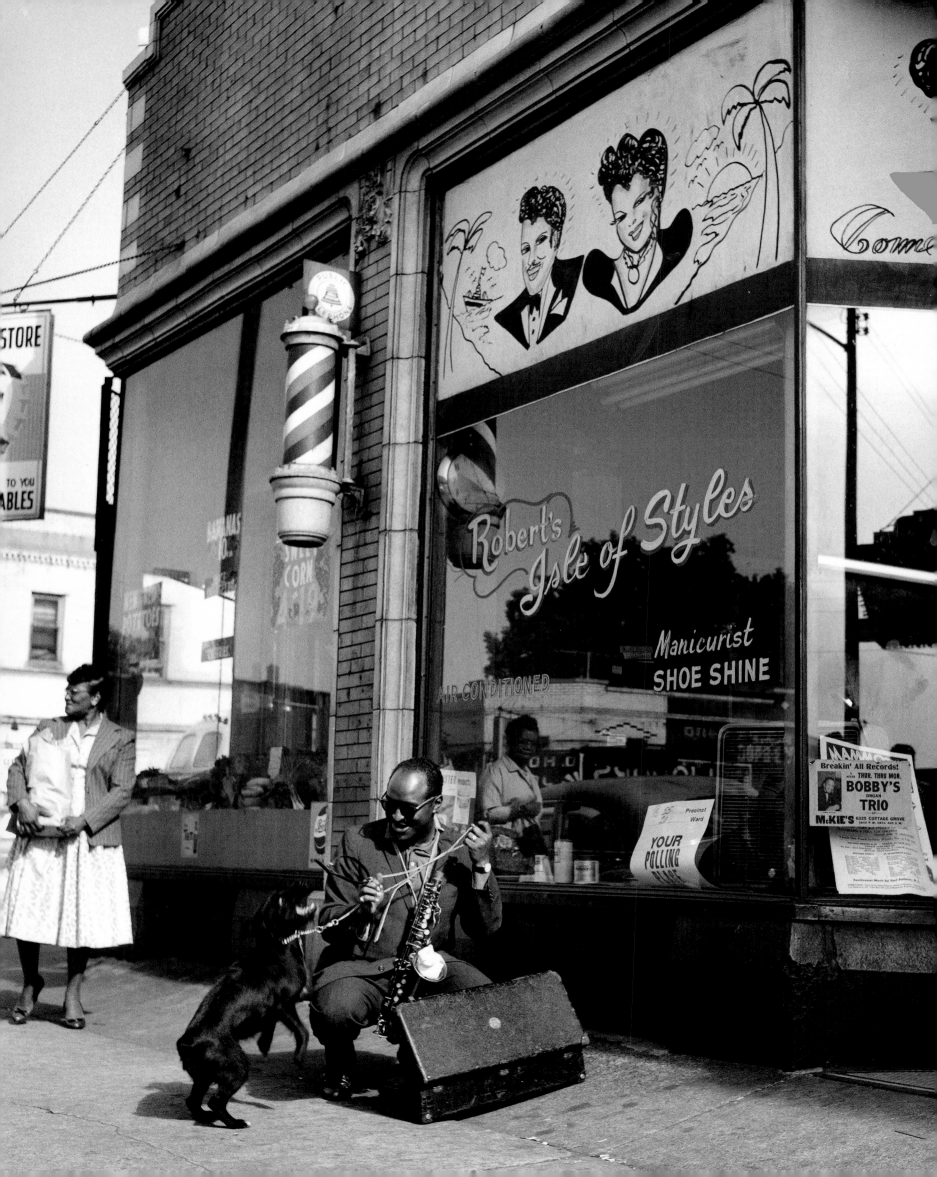

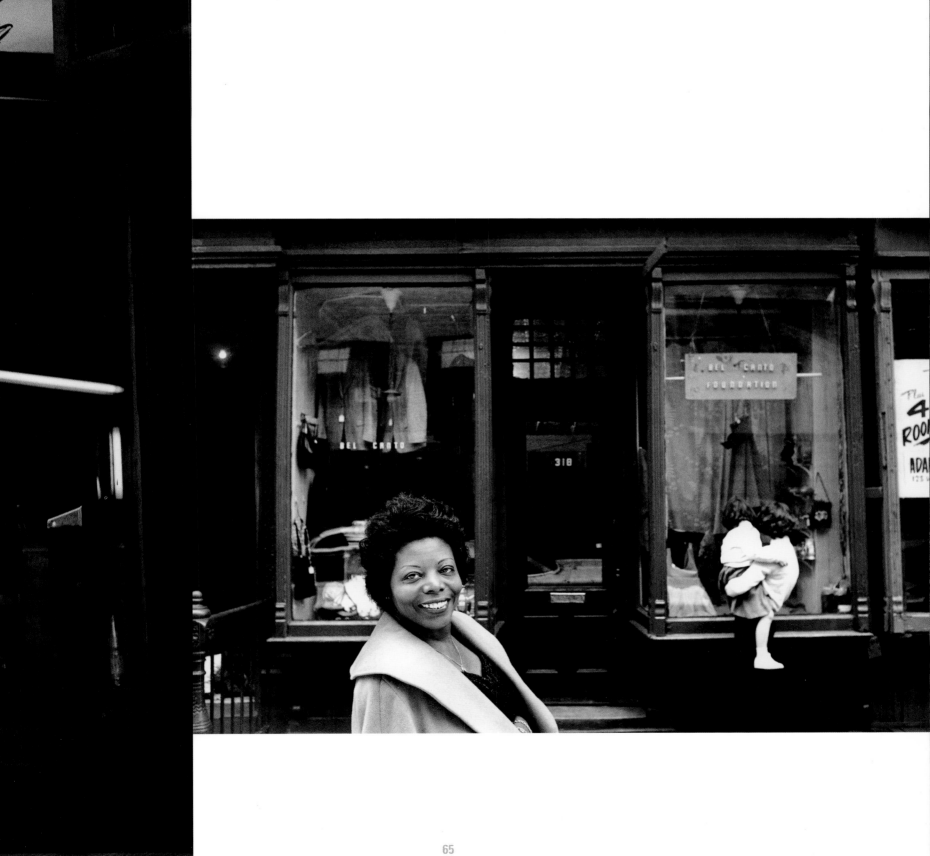

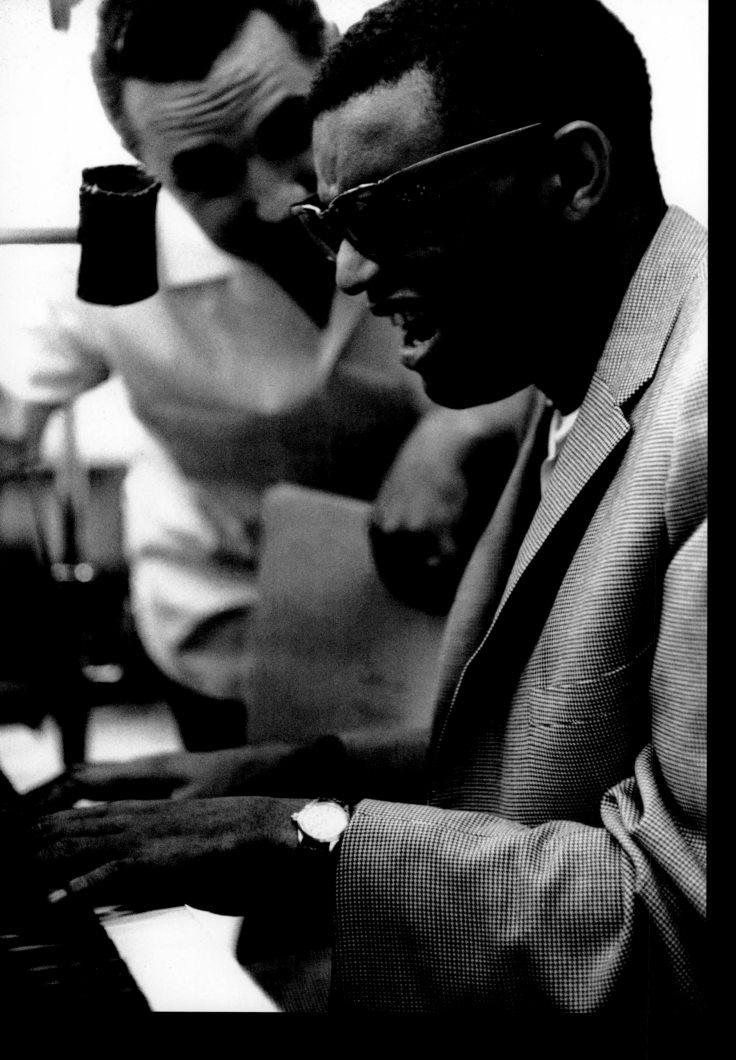

*Ray Charles with arranger-conductor Marty Paich
during the famous country-western recording session, Hollywood, 1962* *Ray Charles, Hollywood, 1962*

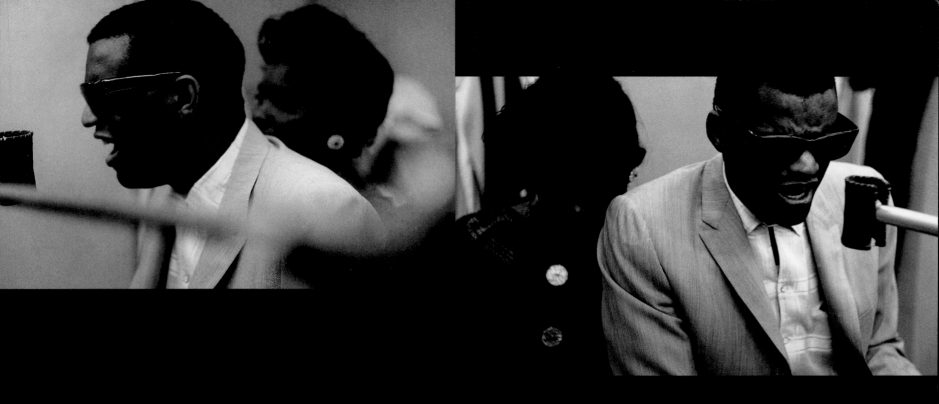

RAY CHARLES, HOLLYWOOD, 1962

This was shot during a recording session for Atlantic Records at the United Studios in Hollywood. I recall two interesting incidents during the hours of this session:

At one point in time a coffee break was called so that the enormous band and the Raylettes could have a rest. I suddenly realized that in the quiet, empty studio, only two people remained: The blind musician Ray Charles and I. I walked over to him. He took my arm and asked me to take him over to the harp. We went to the harp, and he felt it all over, and said, "I've never seen a harp up close like this." Then we went over to the tympany and he did the same thing; and then the french horns, etc. It was a beautiful experience.

The other incident was a social and fun event: At one point in the evening in walked Frank Sinatra with Marilyn Monroe on his arm. Sinatra was in a black tie and she was covered in white fur and dripping with diamonds. They came to dig the "Genius of Soul". One bad note: Sinatra's henchmen would not permit photographs.

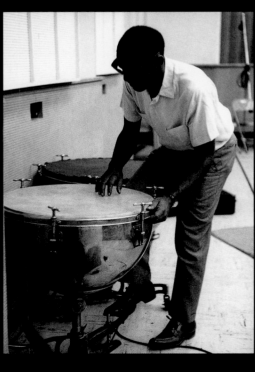

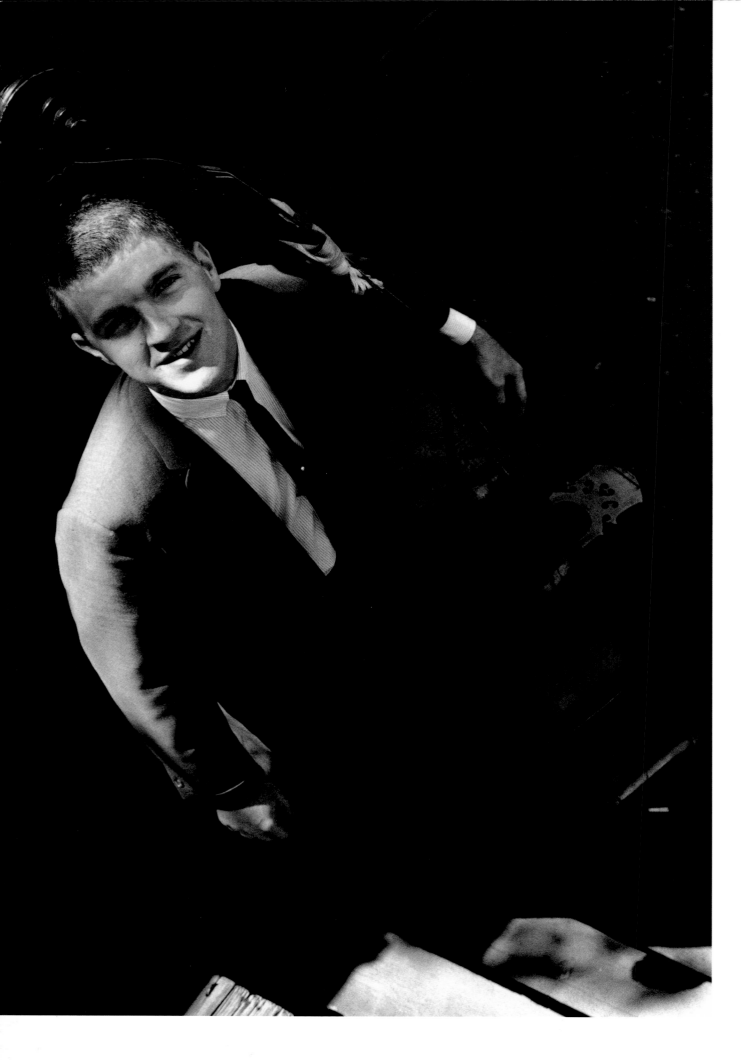

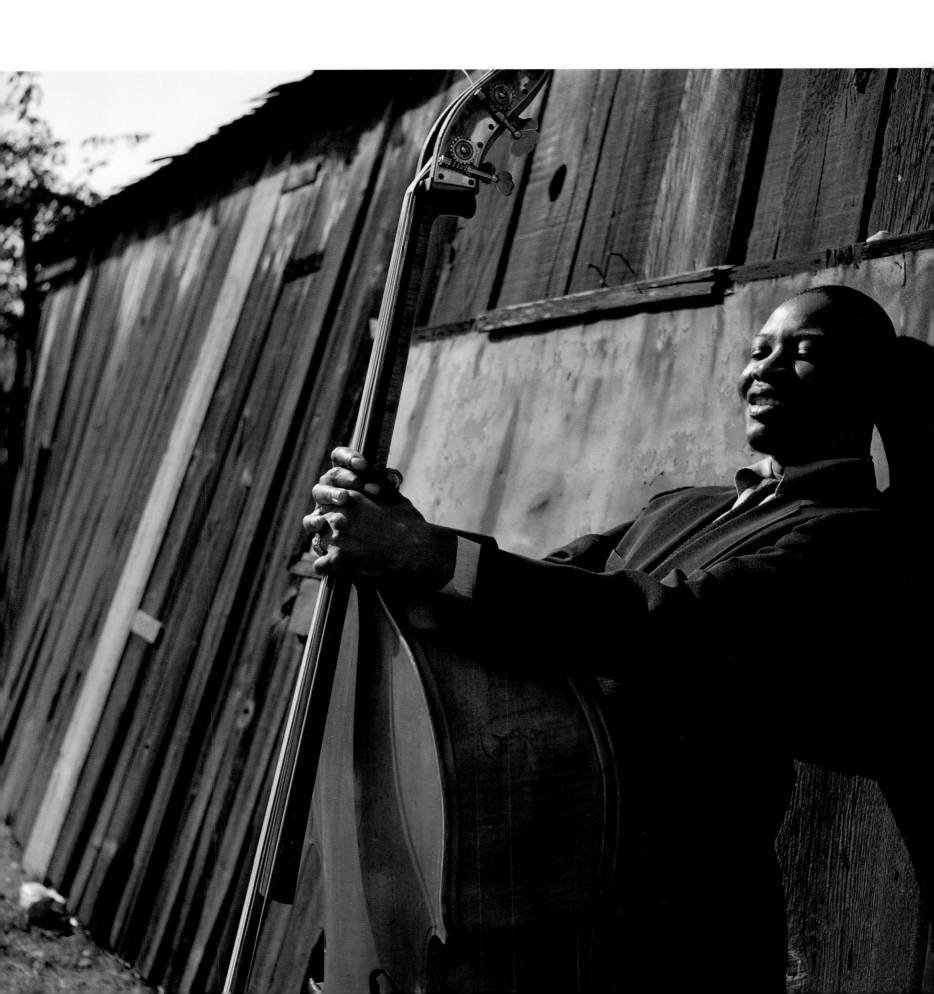

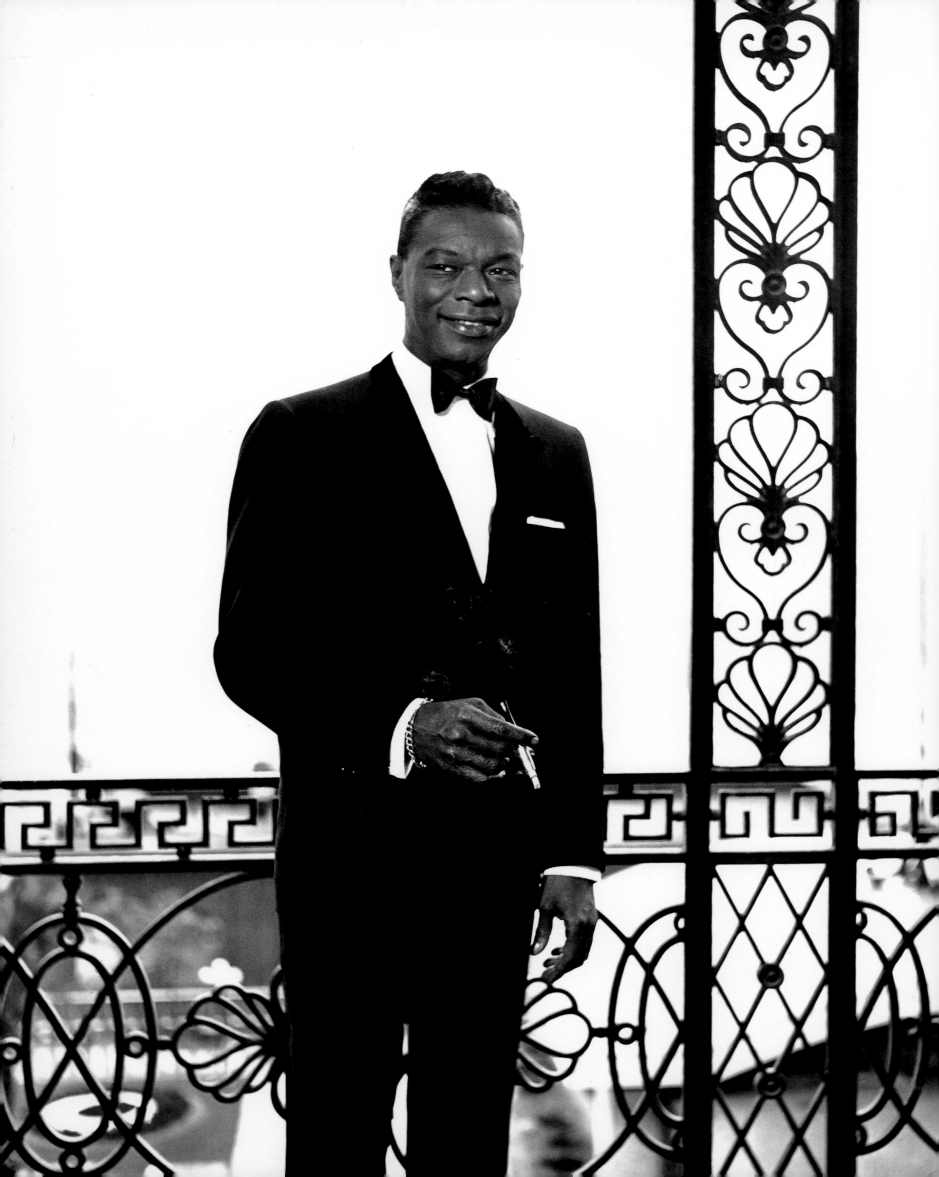

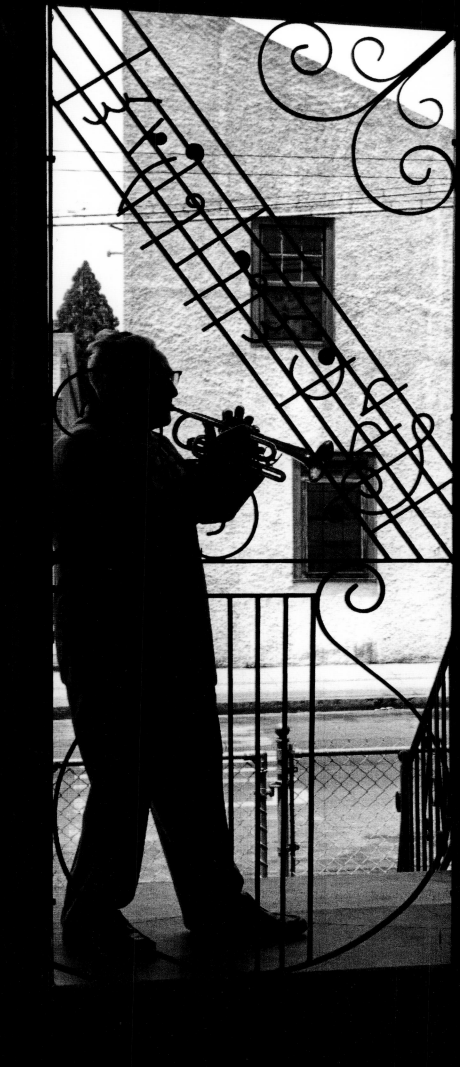

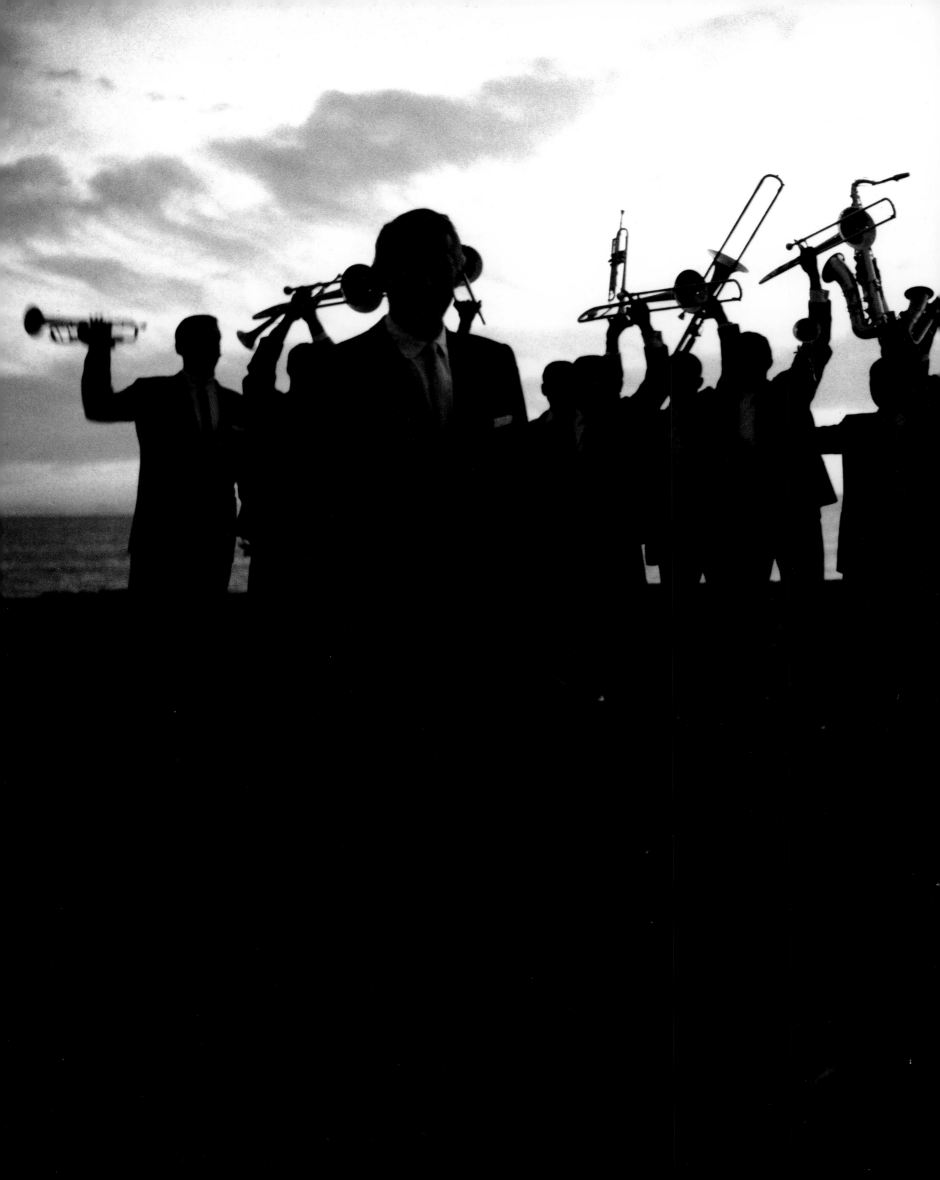

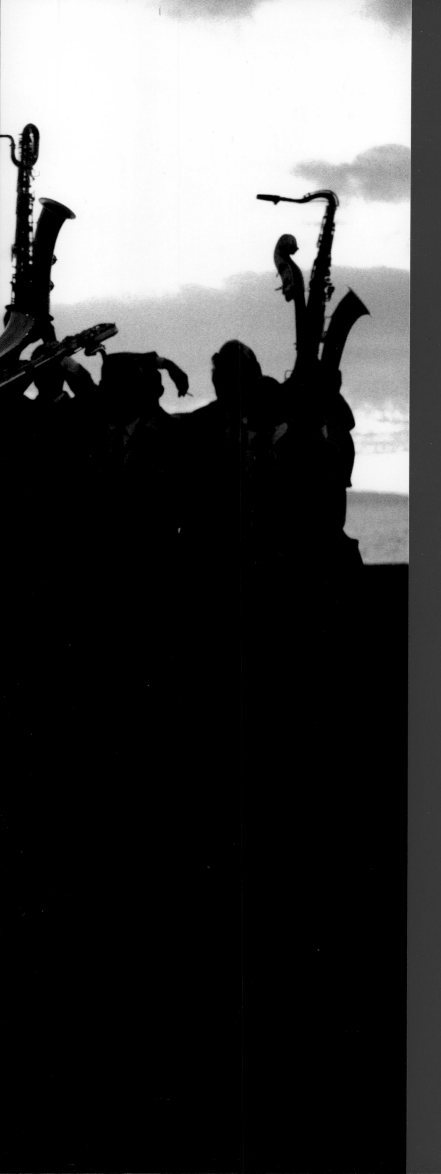

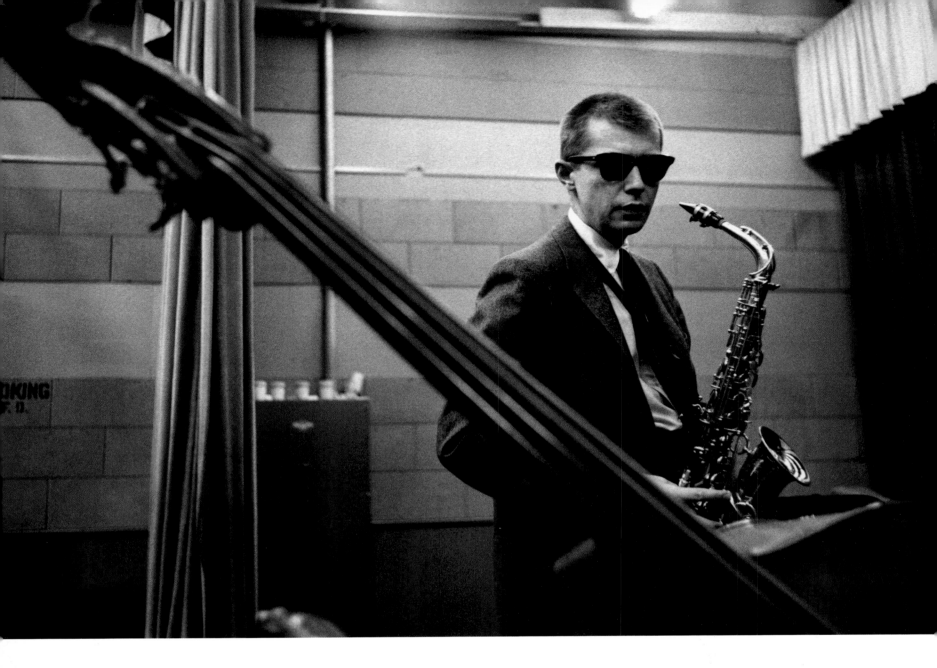

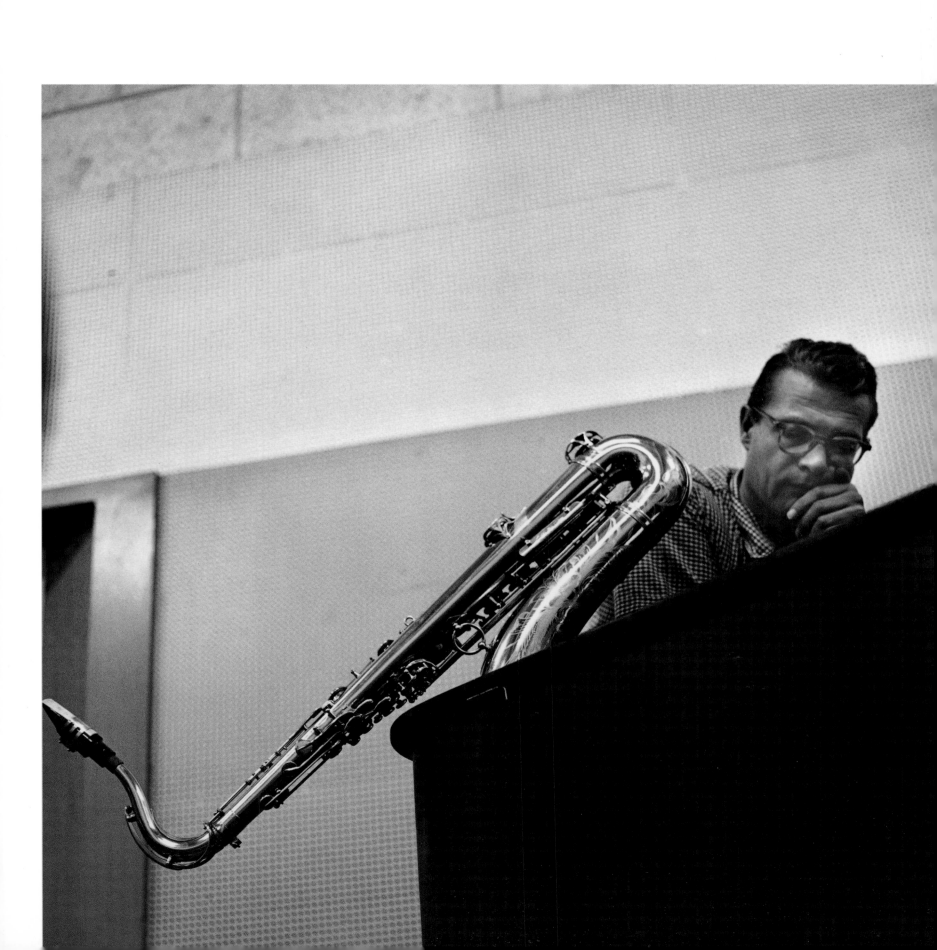

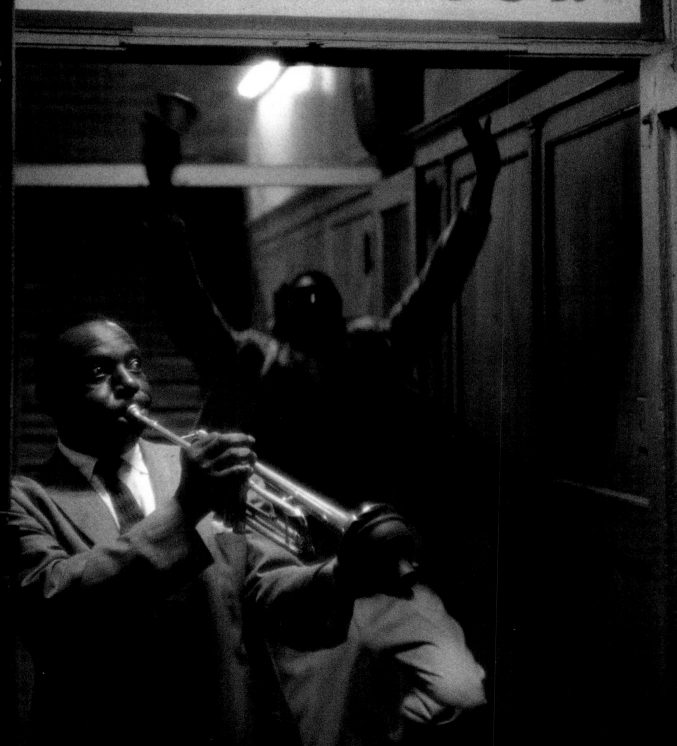

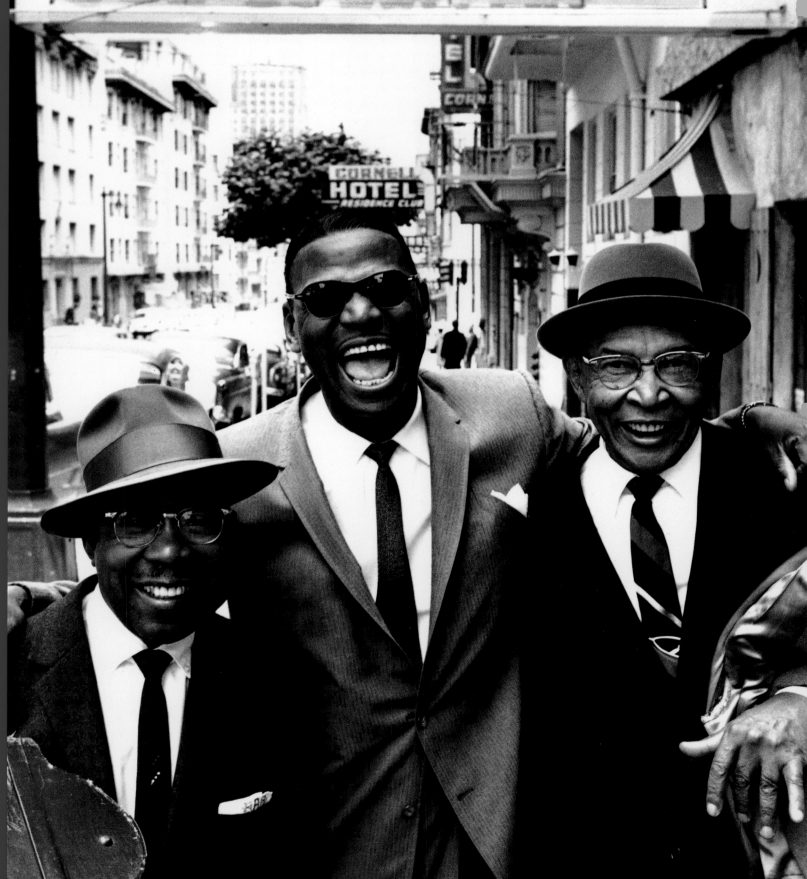

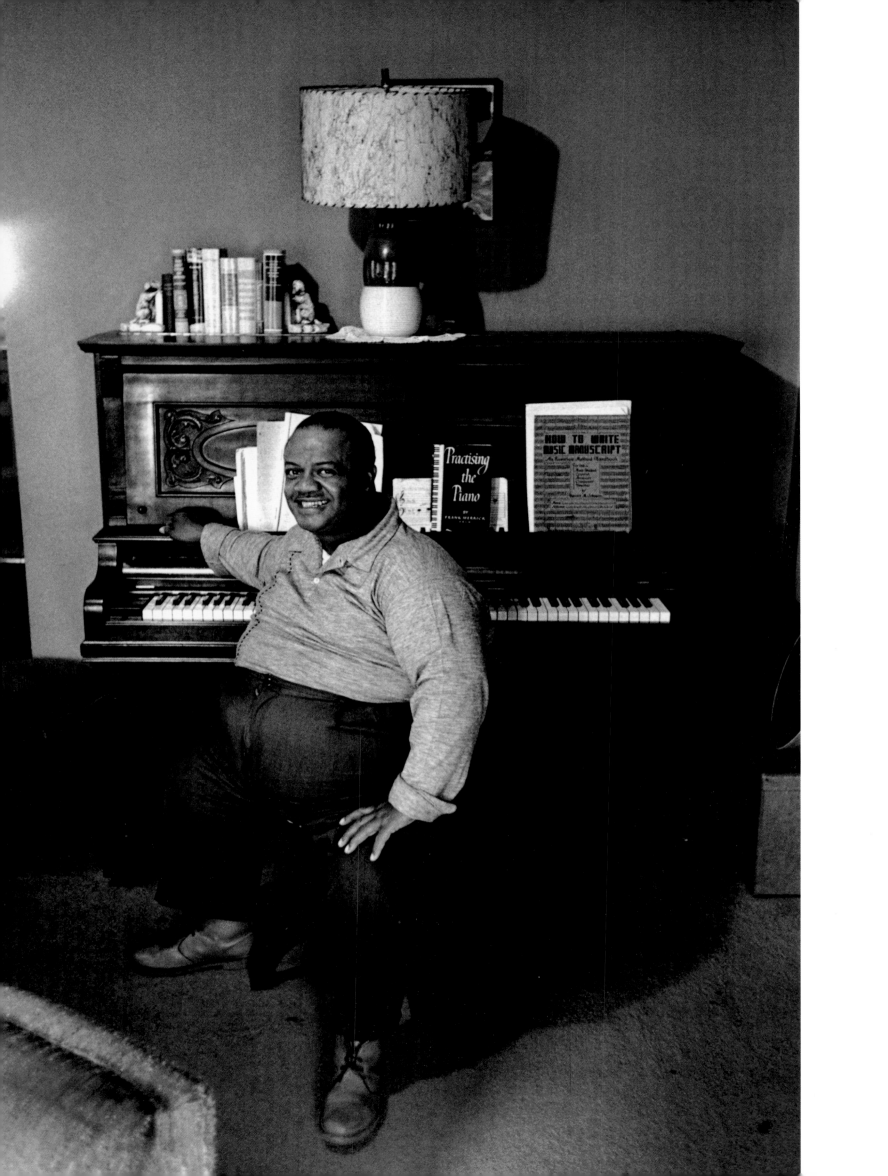

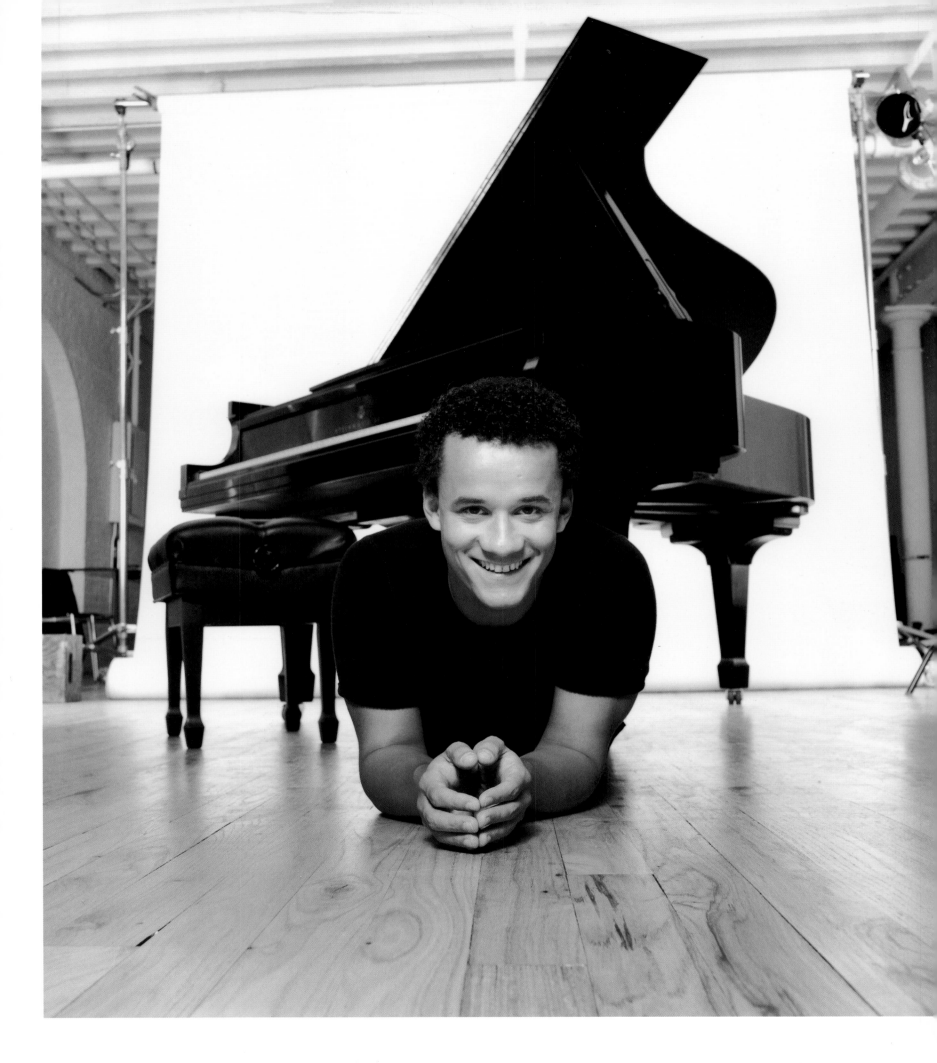

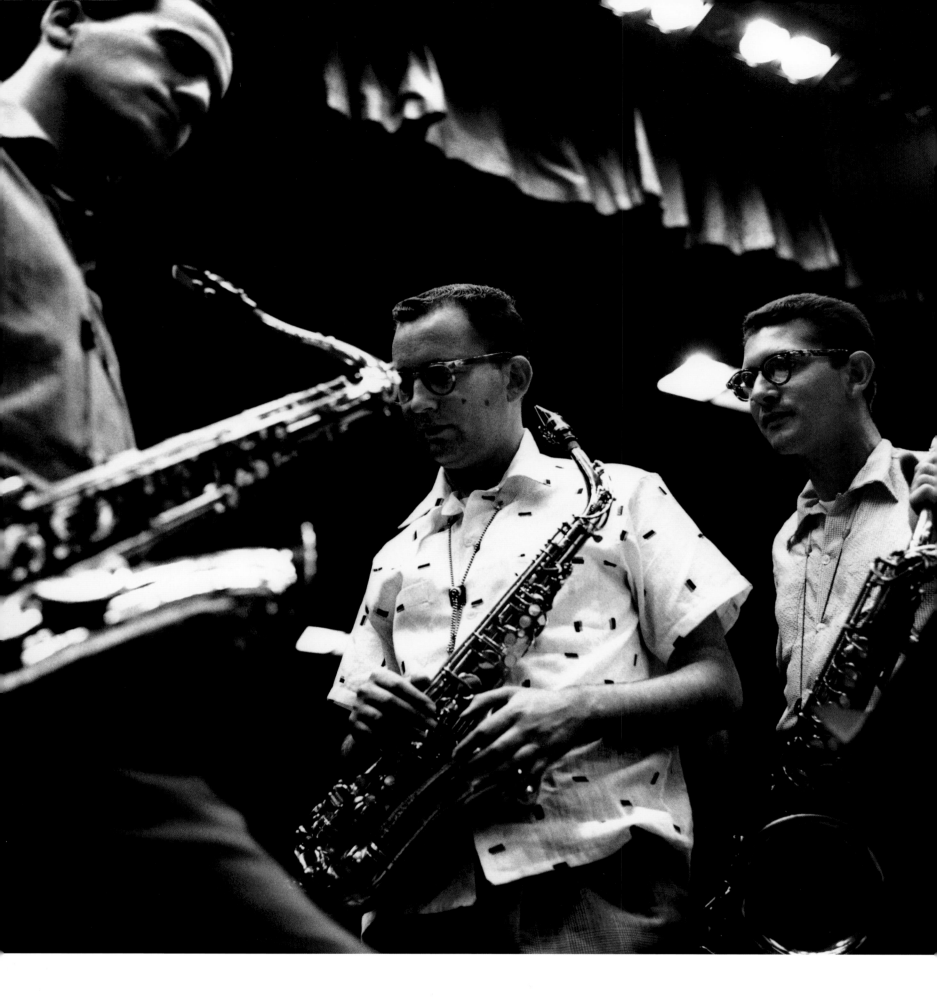

Jack Montrose, Lennie Niehaus, Bob Gordon, Hollywood, 1954

Bill Perkins, Hollywood, 1954

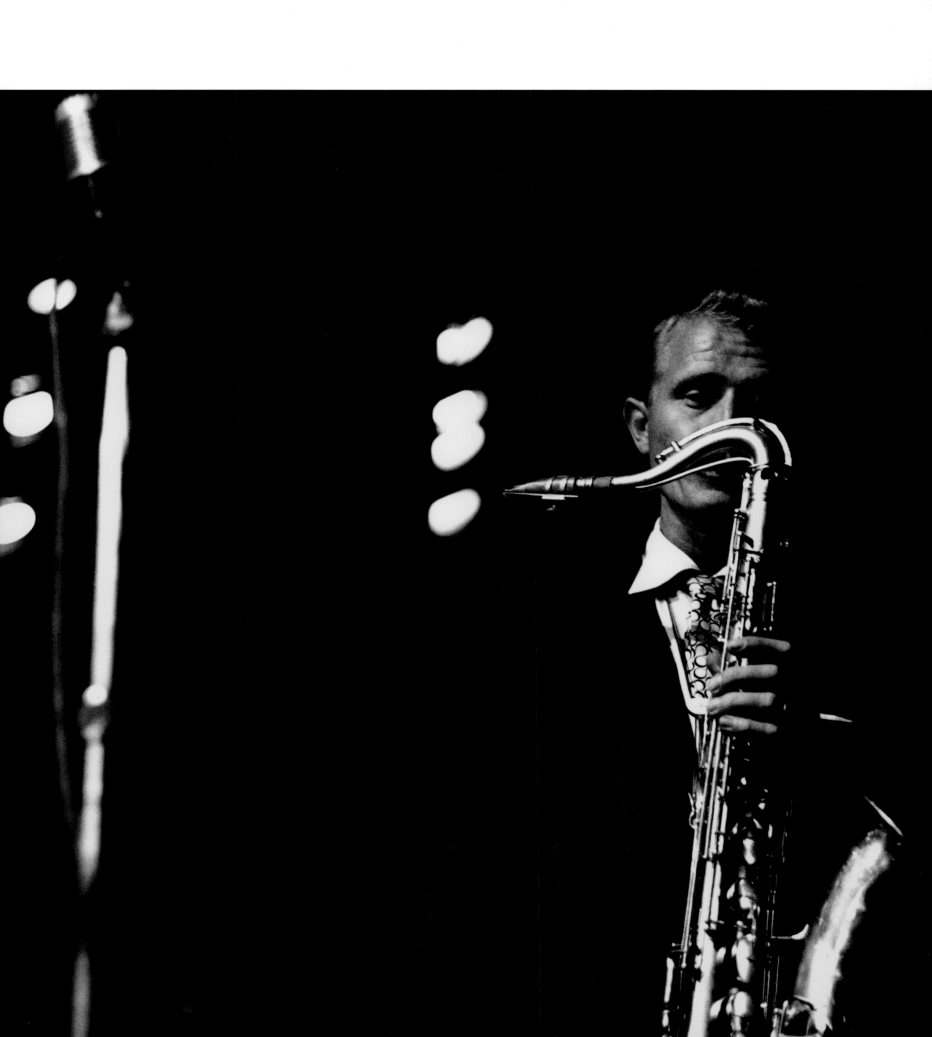

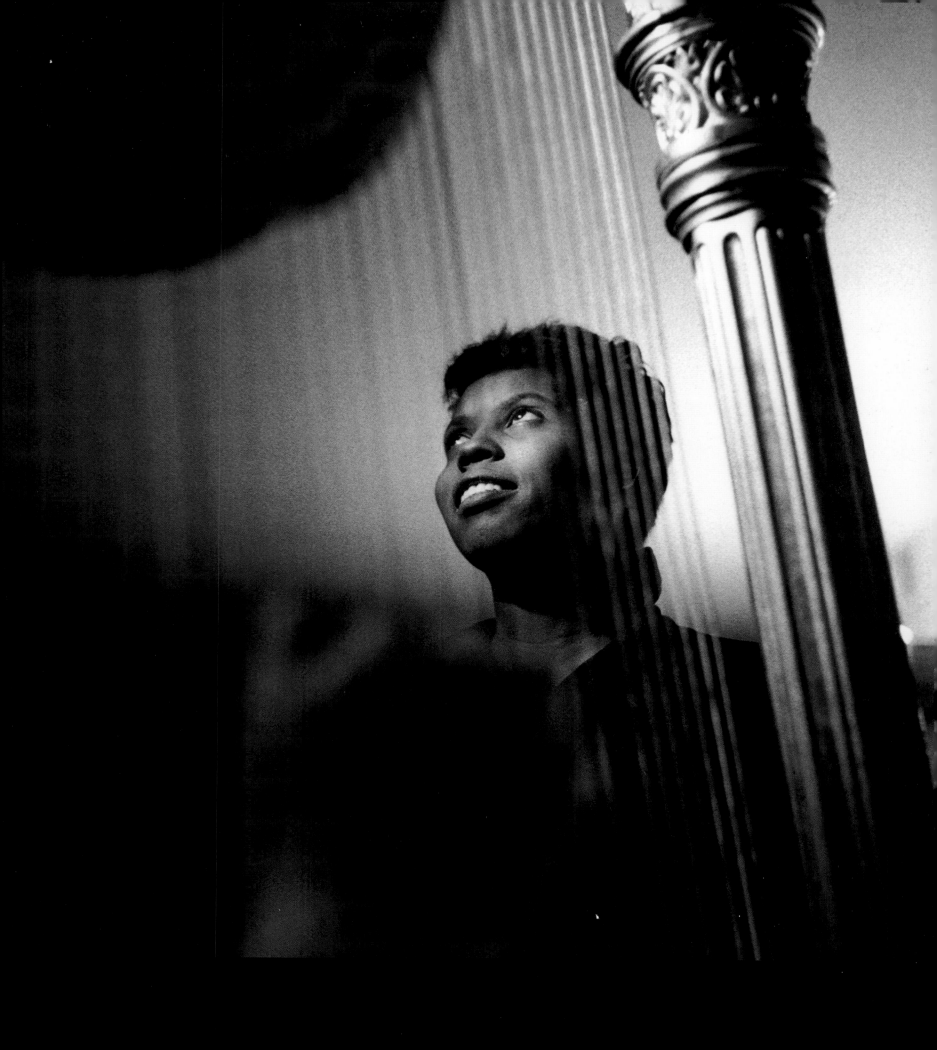

Joe Mondragon, Los Angeles, 1953

Kitty White, Hollywood, 1956

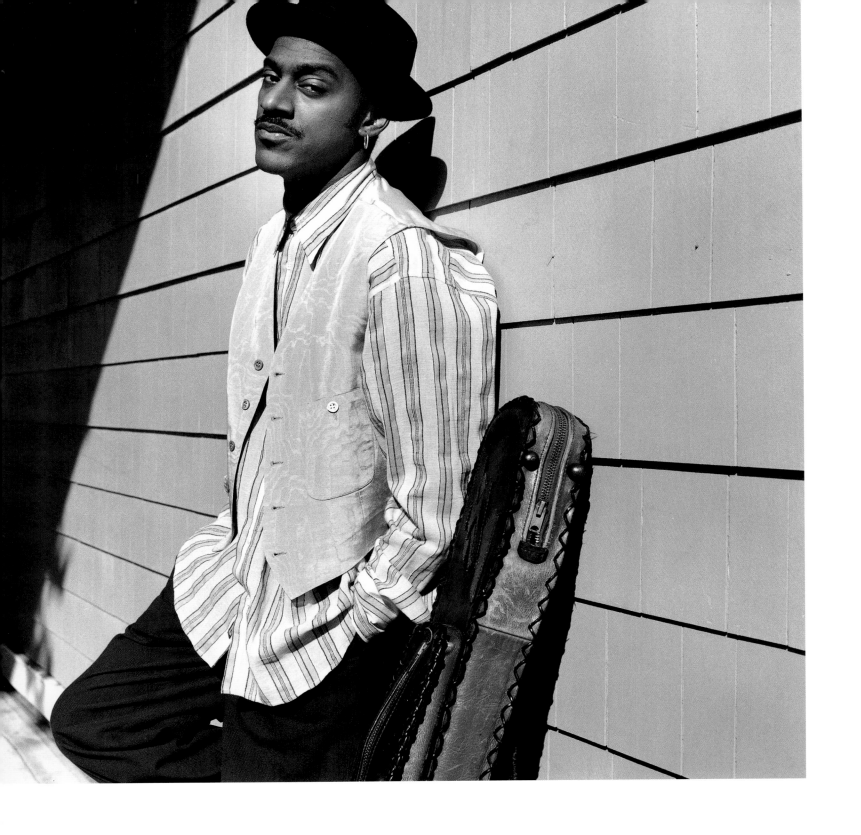

Marcus Miller, Santa Monica, 1995

Kelvin Loster, David Allen Jr., of "Dread Formation", San Francisco, 1996

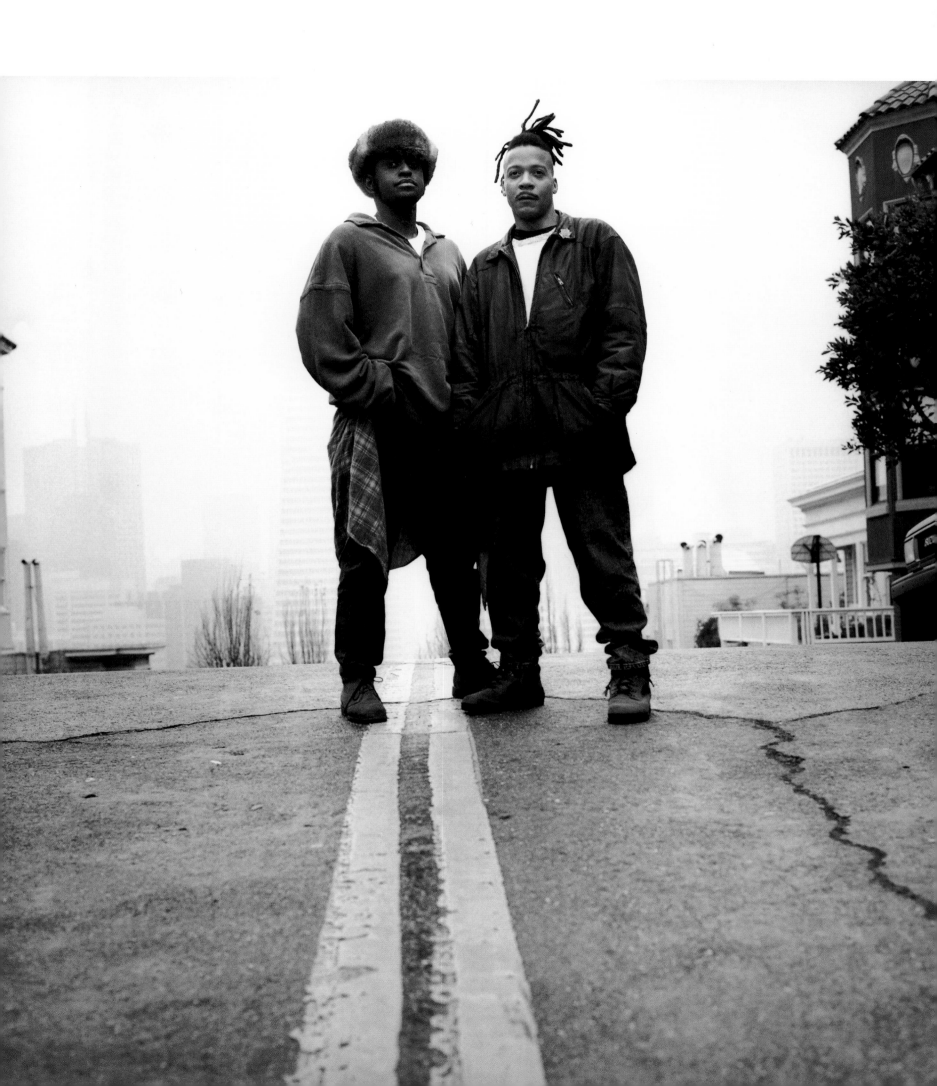

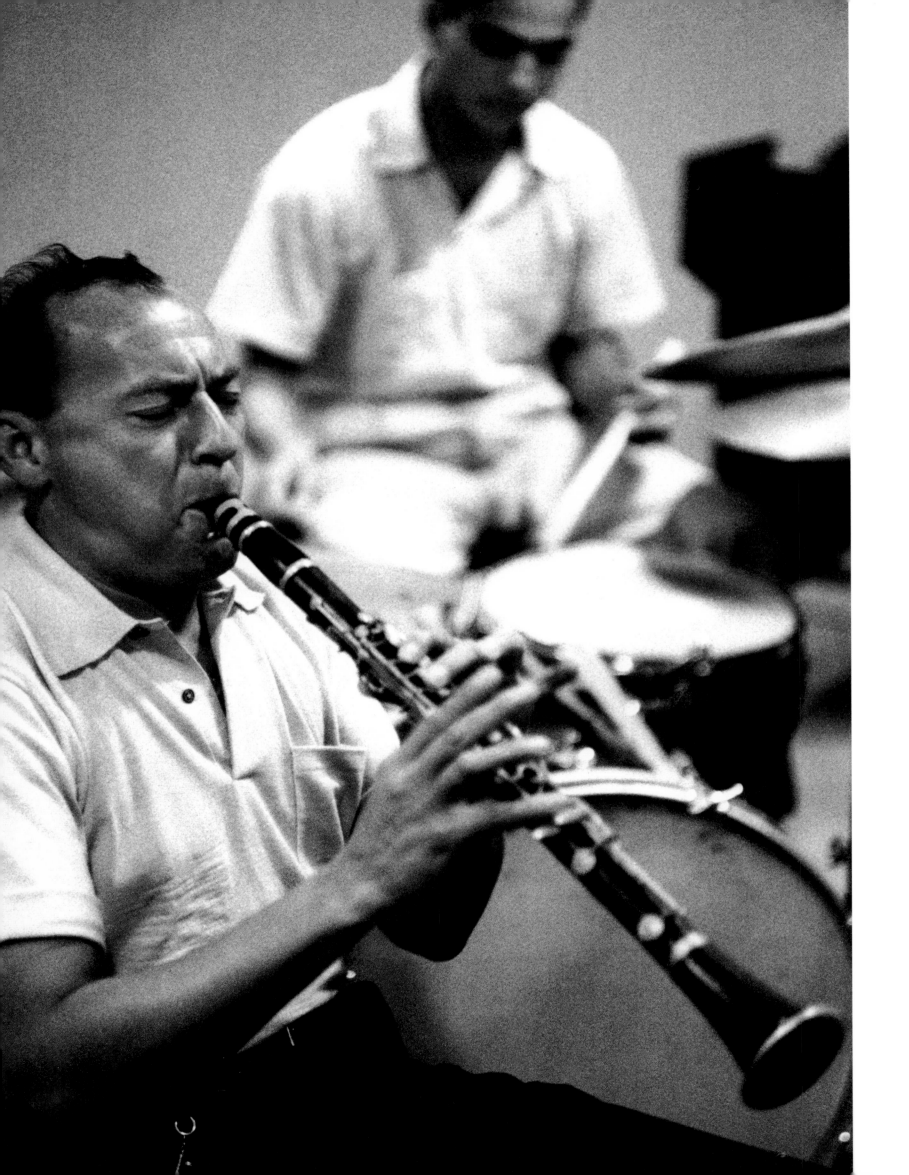

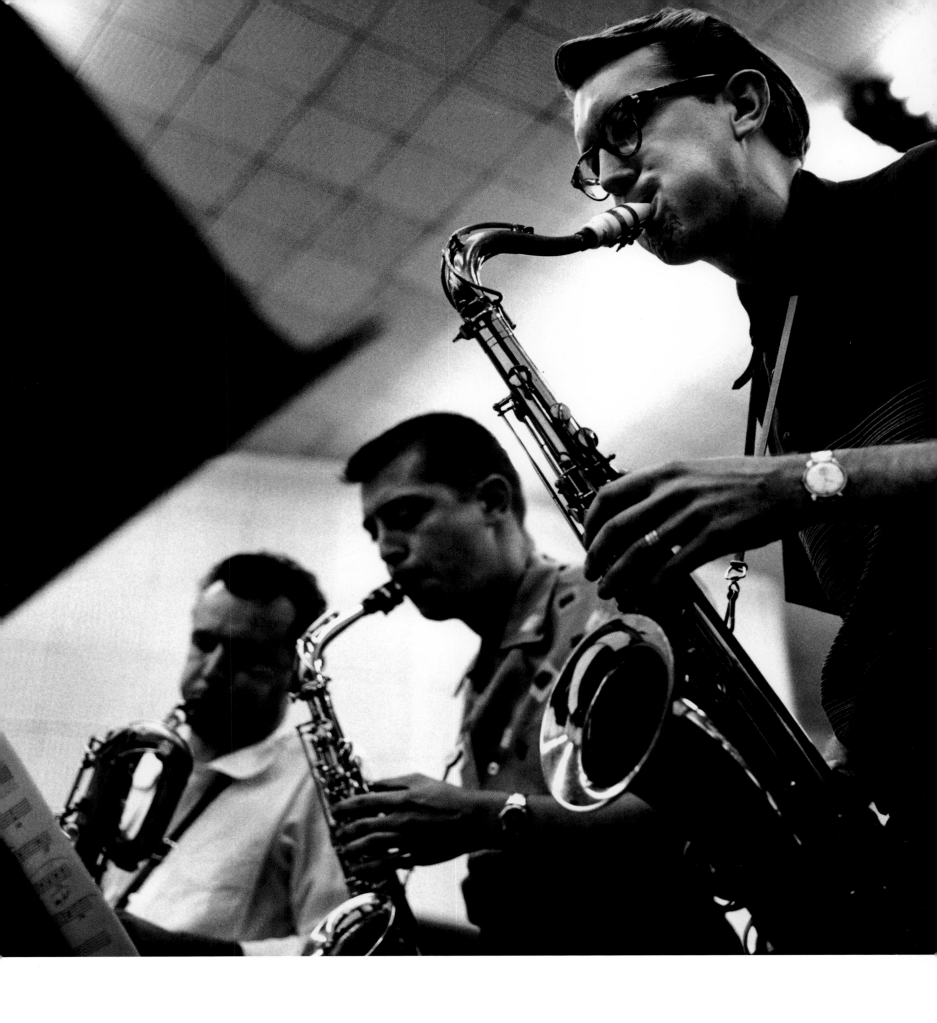

Woody Herman, Chuck Flores (drums), Hollywood, 1957 **90**

91 *Jimmy Giuffre, Bud Shank, Bob Cooper, Hollywood, 1955*

The Modern Jazz Quartet & The San Francisco Little Symphony, Monterey, 1958 **92**

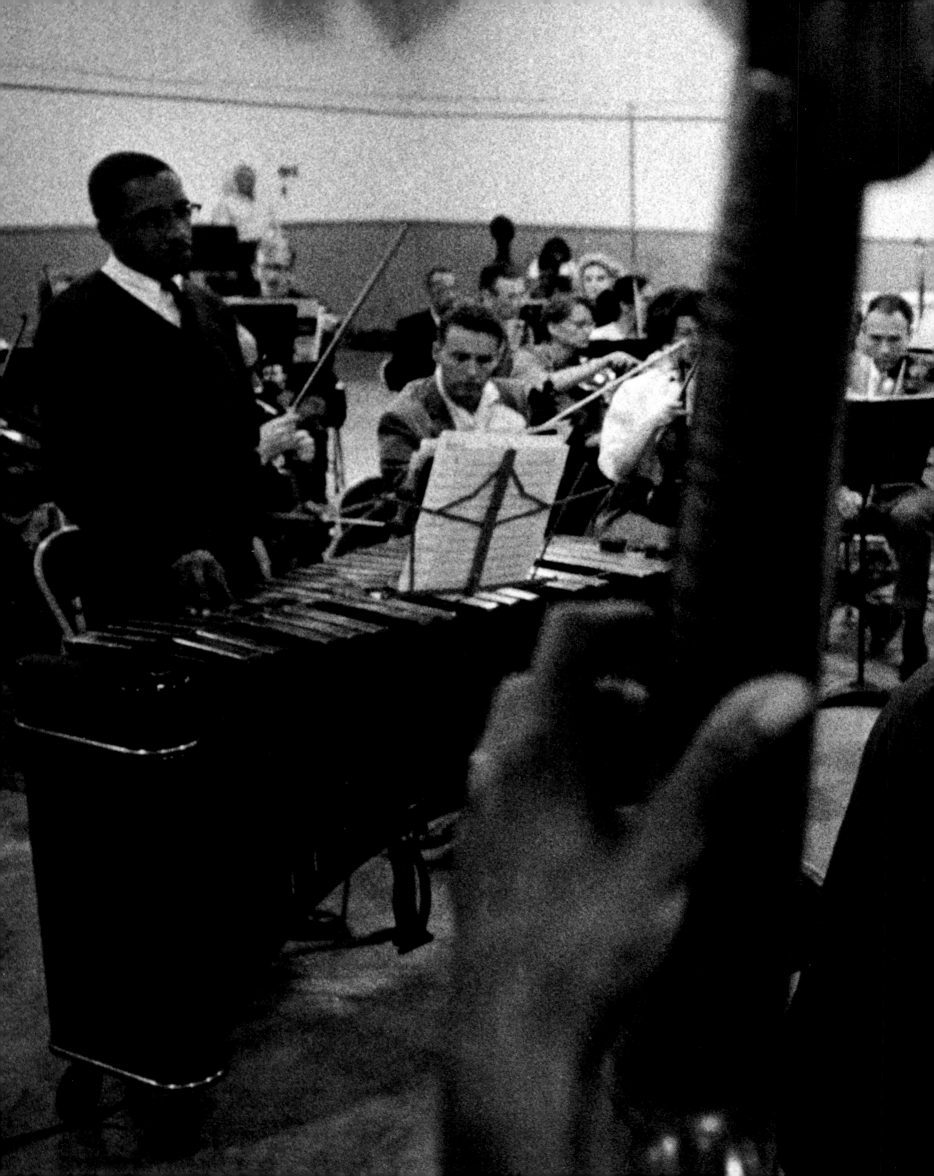

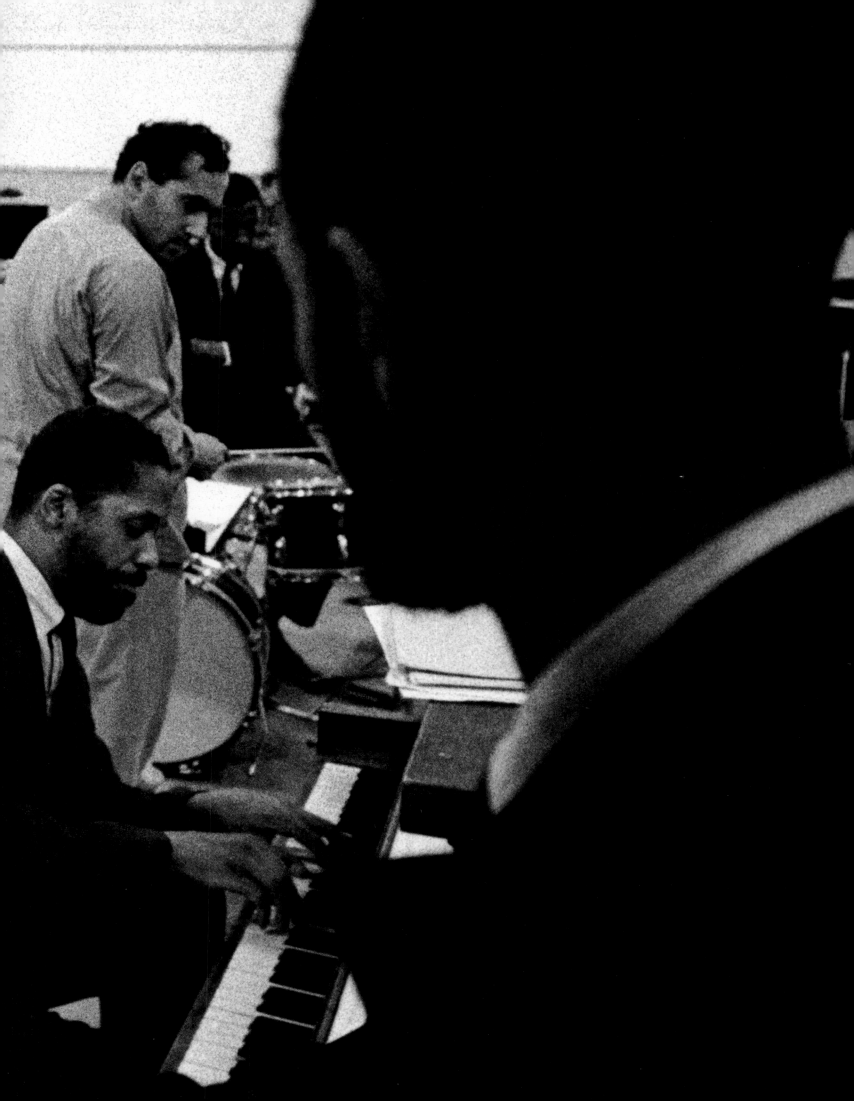

In 1959 I was commissioned by a large German publisher to travel around the United States with the music-historian writer Joachim-Ernst Berendt (Joe) and to record all kinds of American music – blues, folk, gospel, and of course, jazz. We visited churches, schools, theaters, night-clubs, shacks in the backwoods and prisons to record and photograph these varied musical people.

It was in the Louisiana State Penitentiary in Angola, Louisiana, that we were greeted by the warden and his staff. We were told that we could visit either the "white" section of the prison or the "colored". The warden's men stated that they 'never heard any music coming from the "white man's yard", so, we chose the "colored" area. We were also told that we would not be escorted by any of his men, because the warden could not "spare any of his guards" for such a visit. Joe and I found ourselves surrounded by the black inmates the moment we walked onto the prison yard. We explained why we were here – to hear some music and take photographs of the musicians. Immediately one of the more enterprising inmates volunteered as a guide stating he knew all the "boss talent in the yard". His name was "Hoagman", and he played guitar.

On this journey through the prison we met all kinds of musical talent. But one of the most striking and unique musical prisoners that we came across was a convicted murderer named Roosevelt Charles. He sang a cappella in a wonderfully bluesy style and composed songs about his prison life. One of the more compelling songs told the story of his being struck by lightning two times in one day while working in the fields:

'Now, the good Lawd spoke to me an' he say,
Charles, you is a different kinda' man,'
He struck me once, and He struck me twice
with his pow' ful golden hand.
Oh, the good Lawd spoke to me an' he say,
Charles, you is a different kinda' man,'
His firey hand struck me cold,
But I burned inside with da shine o' gold.
Yeah, the good Lawd spoke to me and he say,
Charles, you is a special kinda' man.'
Well, I knows I is a better man now 'cause
is still alive and I is still hurt' n
by His hand.

Amen."

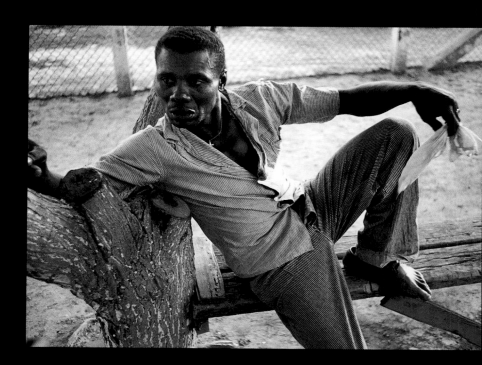

Roosevelt Charles, Louisiana State Penitentiary, Angola, Louisiana, 1960

Roosevelt Charles, Louisiana State Penitentiary, Angola, Louisiana, 1960

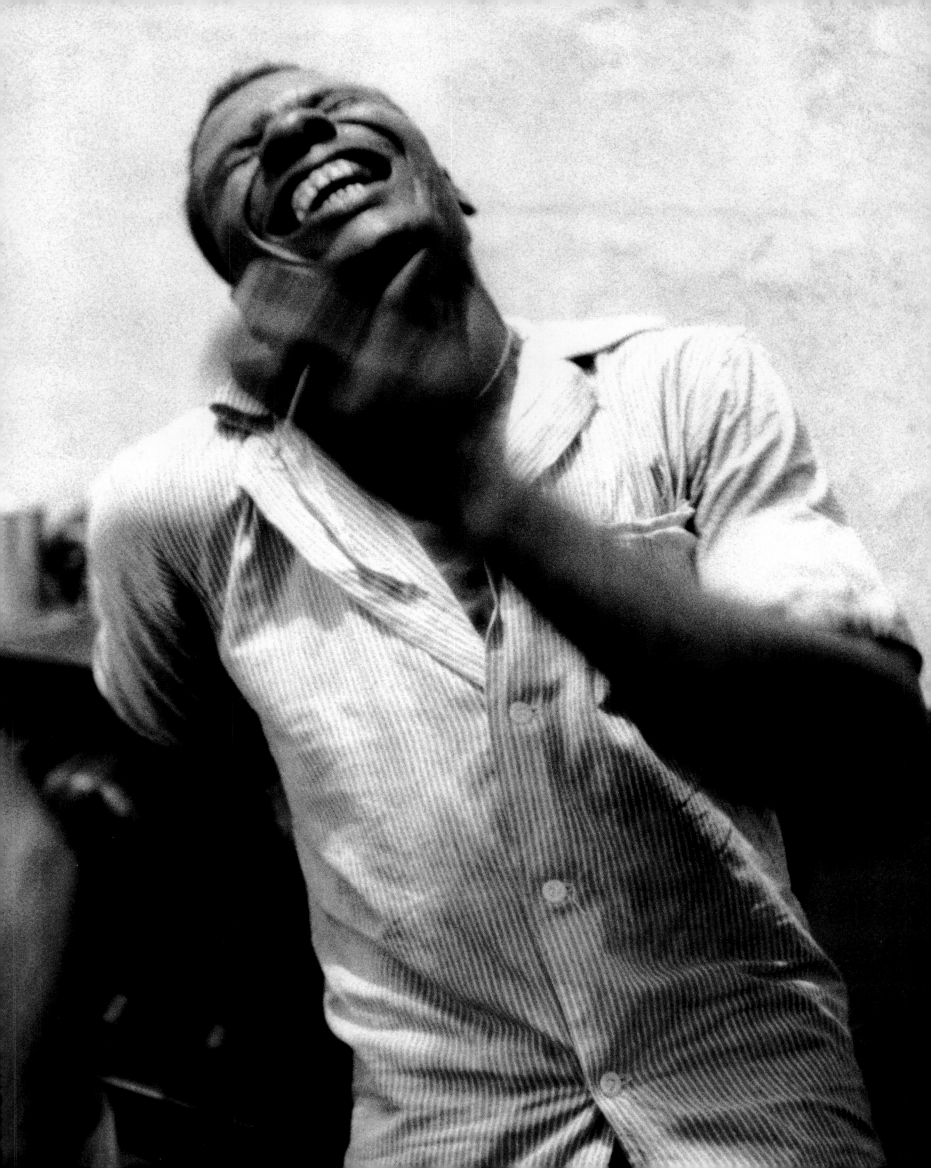

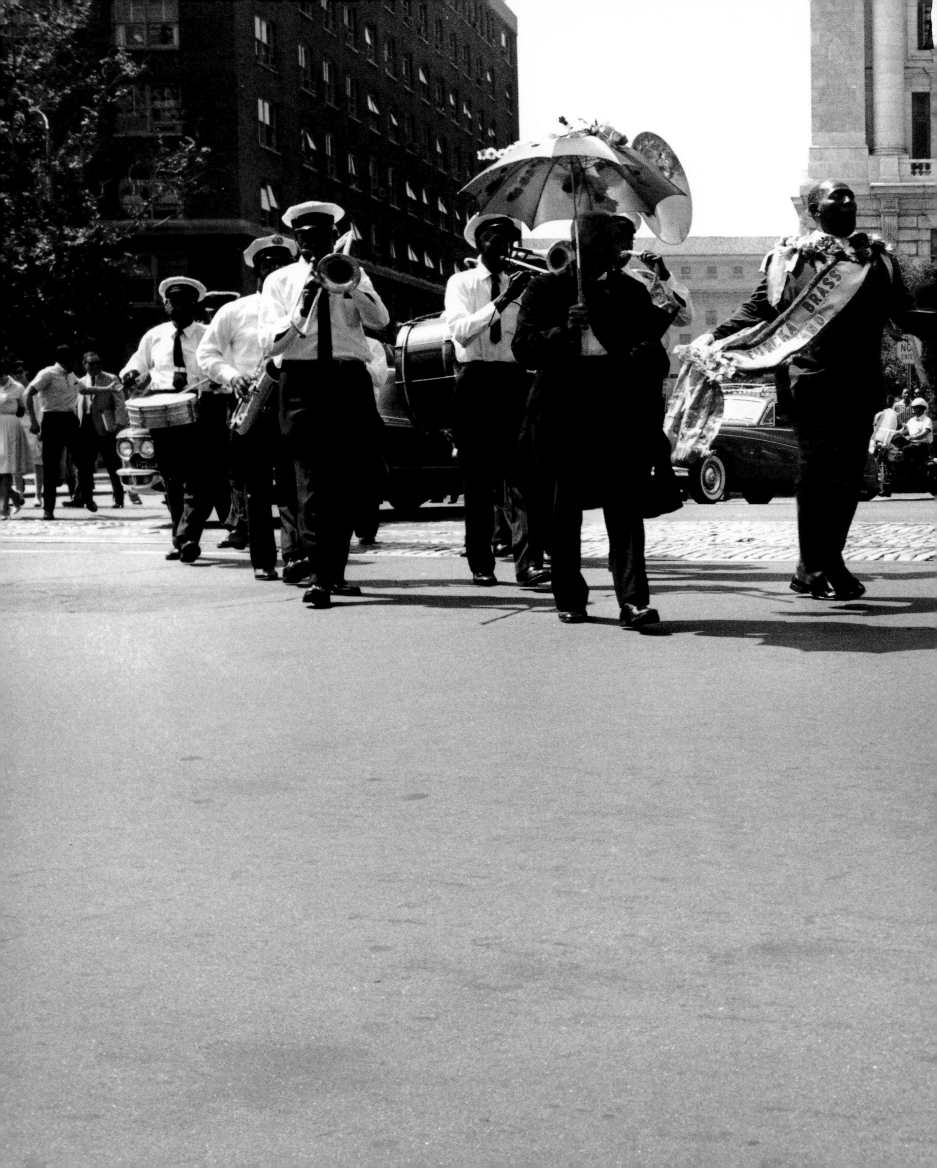

NEW ORLEANS MARCHING BANDS, 1960

As part of our trek around the United States of America photographing for our book JAZZLIFE, Joachim Berendt and I spent about two weeks in New Orleans. Probably the most important and unique jazz experience was seeing and hearing the great marching bands of that city. It is a tradition for the marching brass bands to play during a funeral procession when one of their lodge members or band members has died. These members would be buried with all the dignity of a full marching band, playing a dirge en route to the burial site and happy, joyous jazz tunes on the way back. During this happy, swinging return march, the Second Liners would follow the band, dancing, singing and strutting to the music. These Second Liners were the tough guys who couldn't play instruments but wanted desperately to be a part of the activity. It was not easy to find out just when these funerals or celebrations of life were going to occur. Thanks to our friend Richard Allen who teaches jazz history at Tulane University and is a virtual walking encyclopedia of these bands and their members, we were able to attend three such events involving the three most prominent brass bands of that time. They were the Tuxedo Brass Band, the Eureka Brass Band and the George Williams Brass Band.

The Eureka Brass Band up from New Orleans to perform for a jazz festival in Washington D.C. sponsored by President and Mrs. John Kennedy, 1963

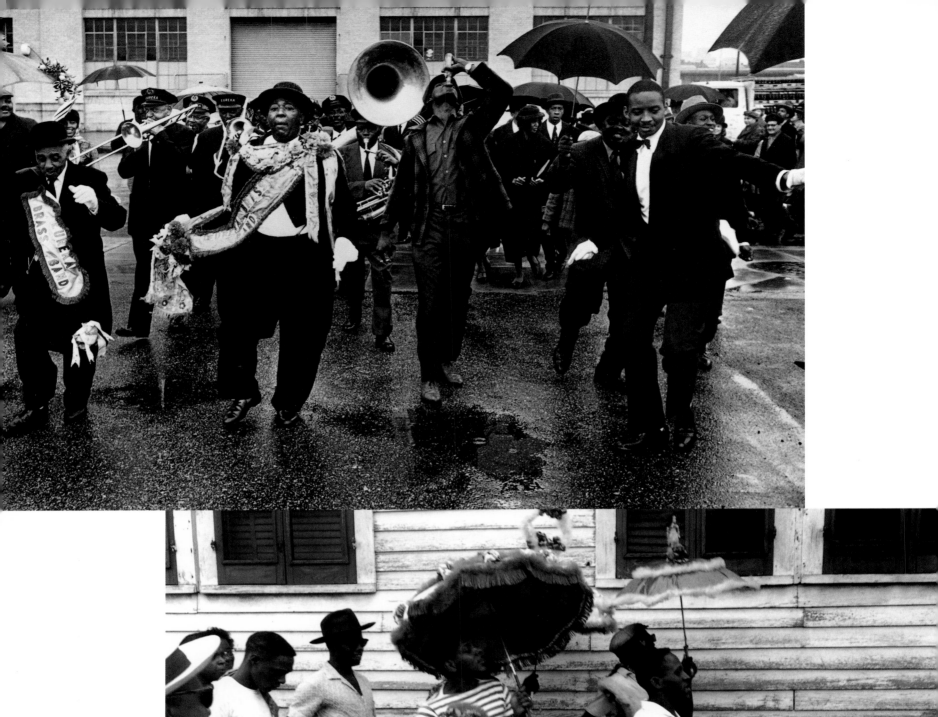

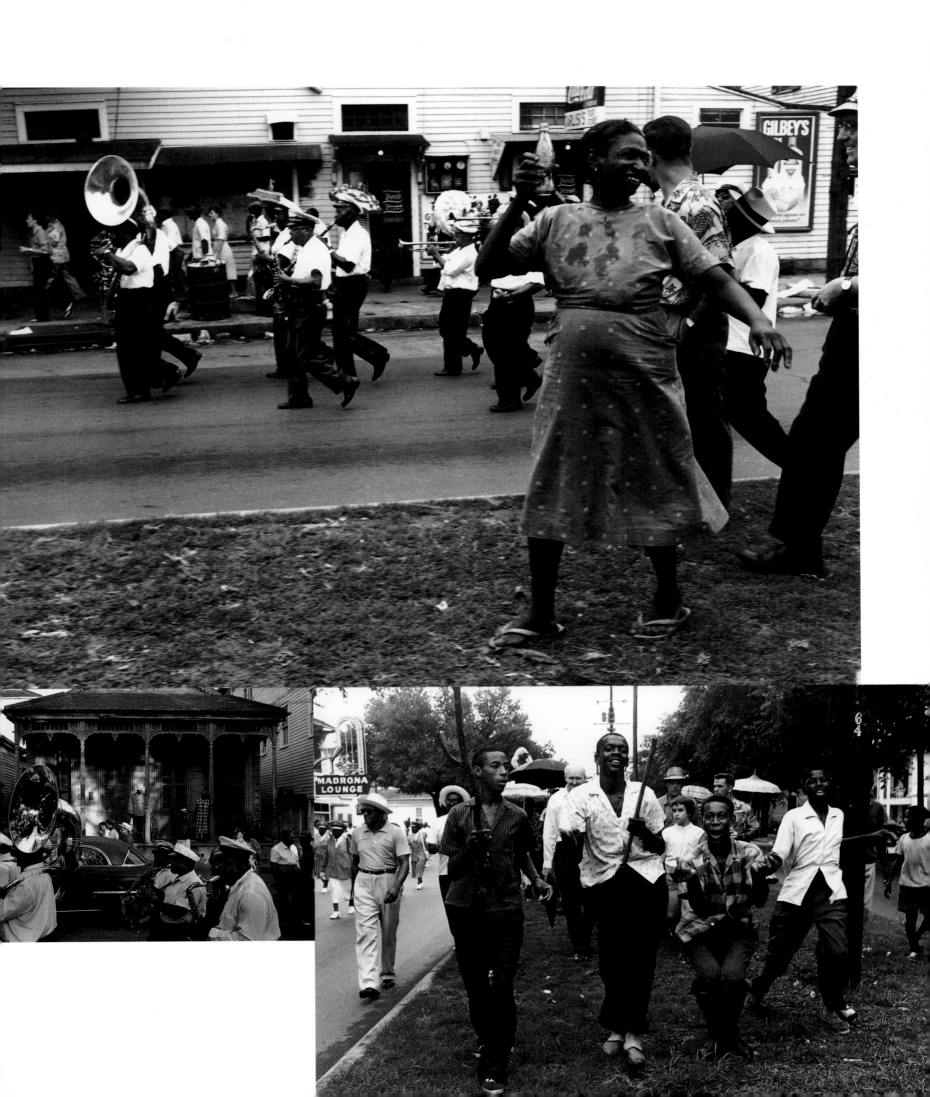

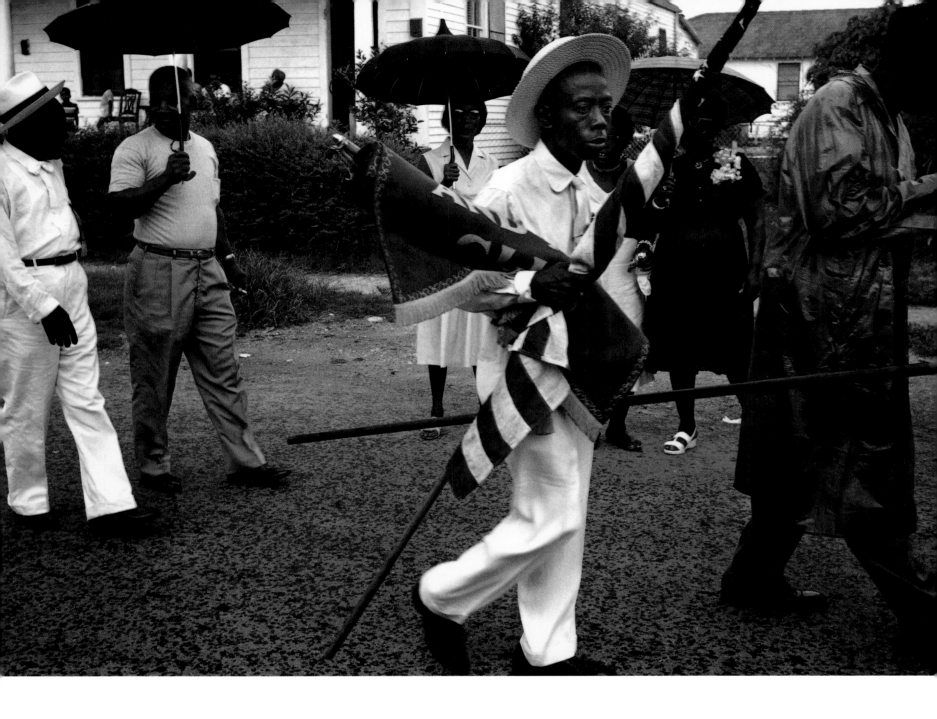

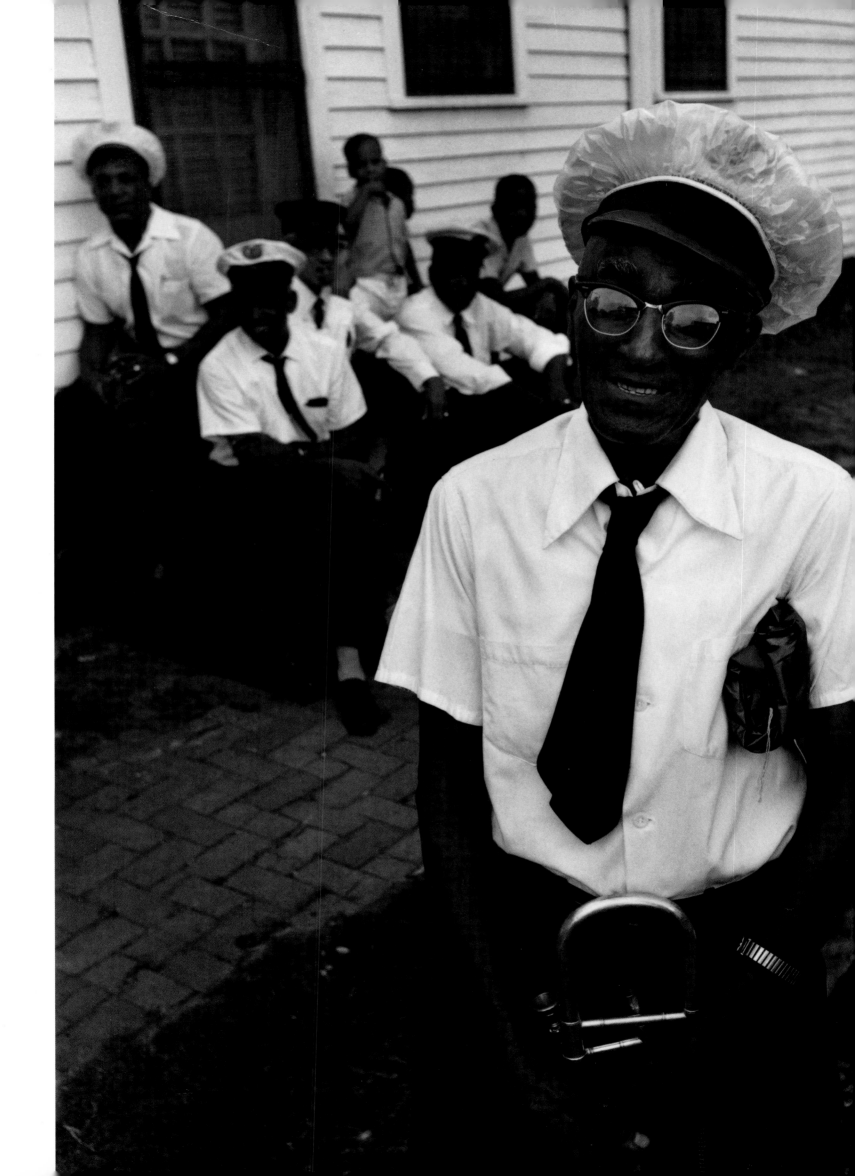

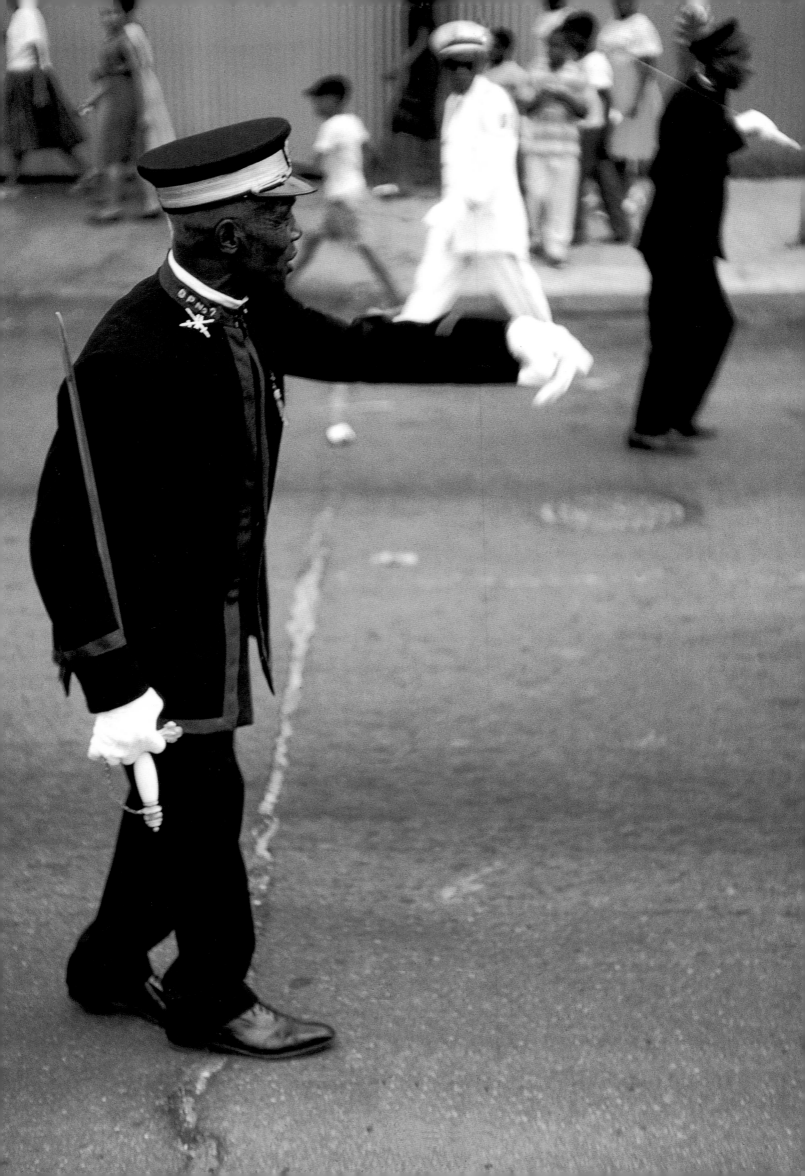

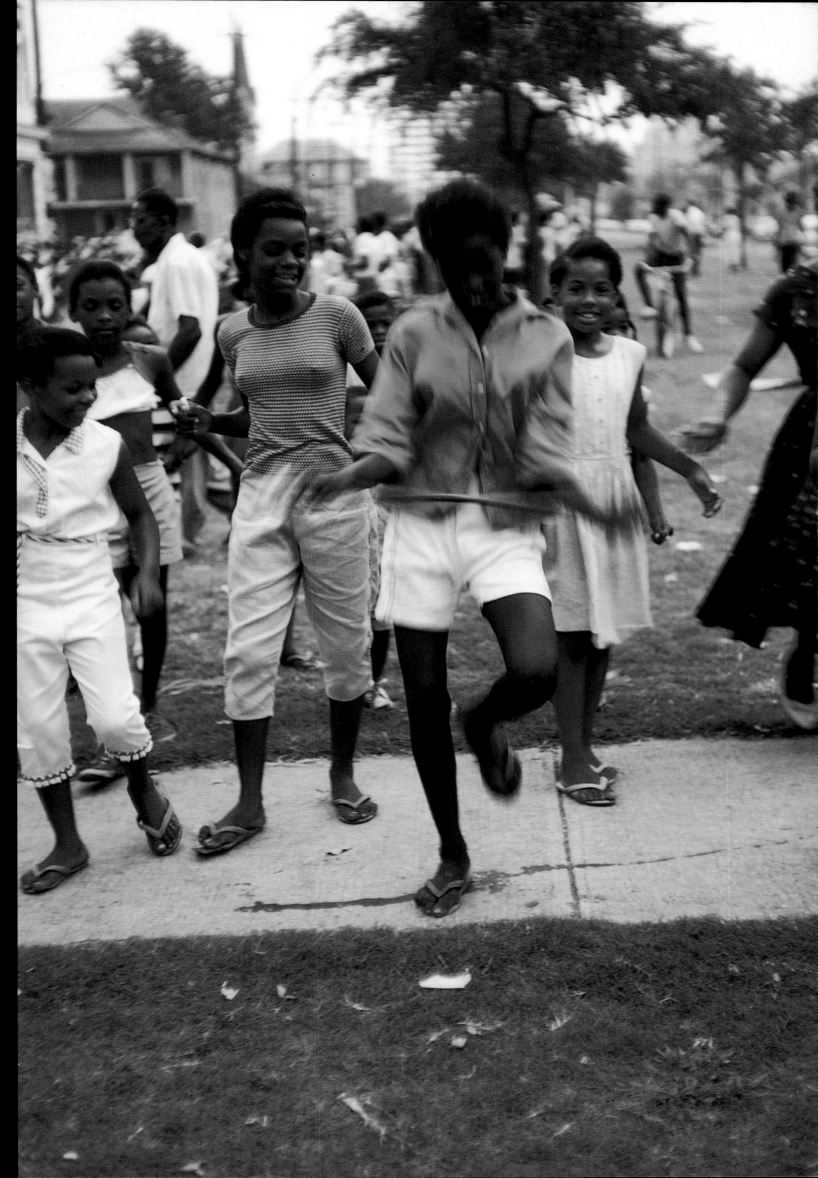

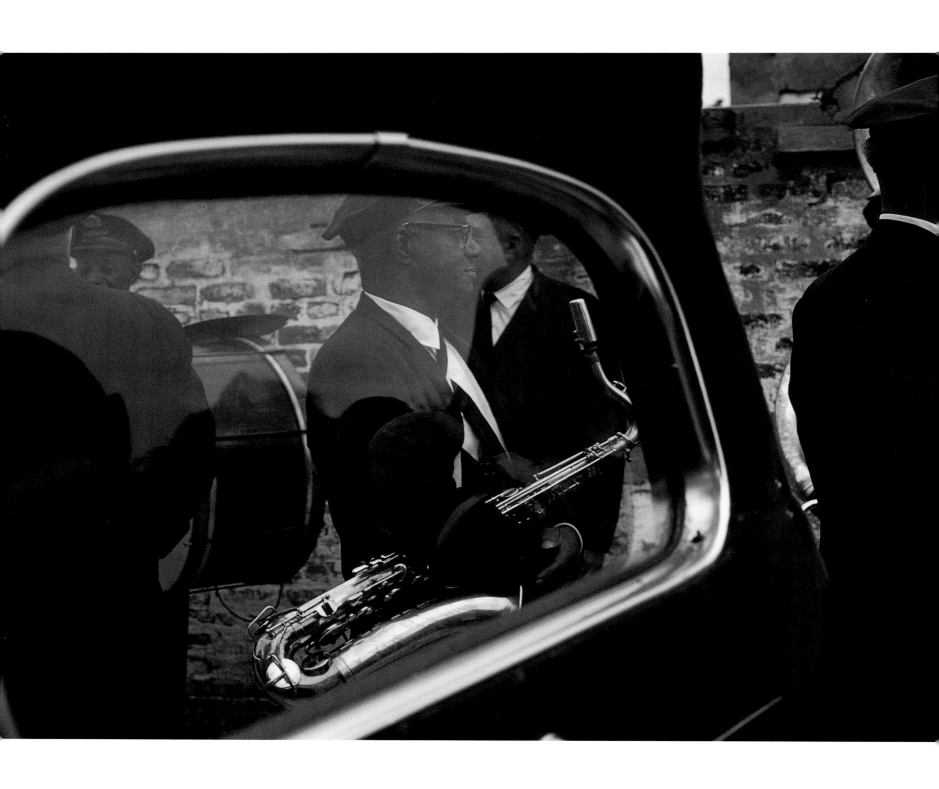

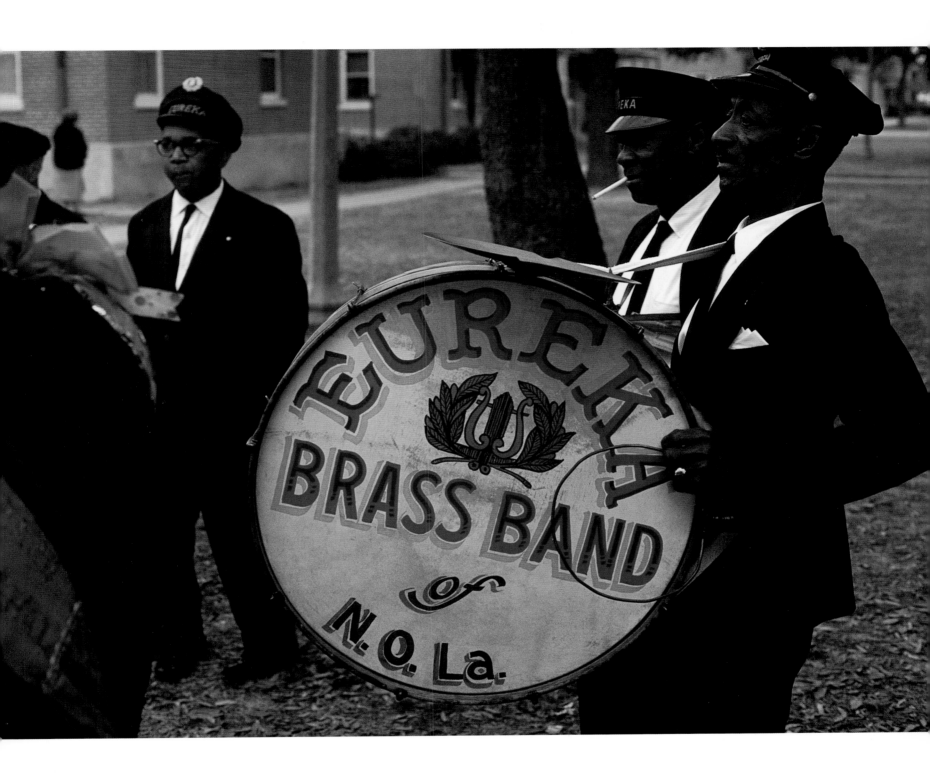

105 *Funeral procession, New Orleans, 1960*

George Williams Brass Band, New Orleans, 1960 **106**

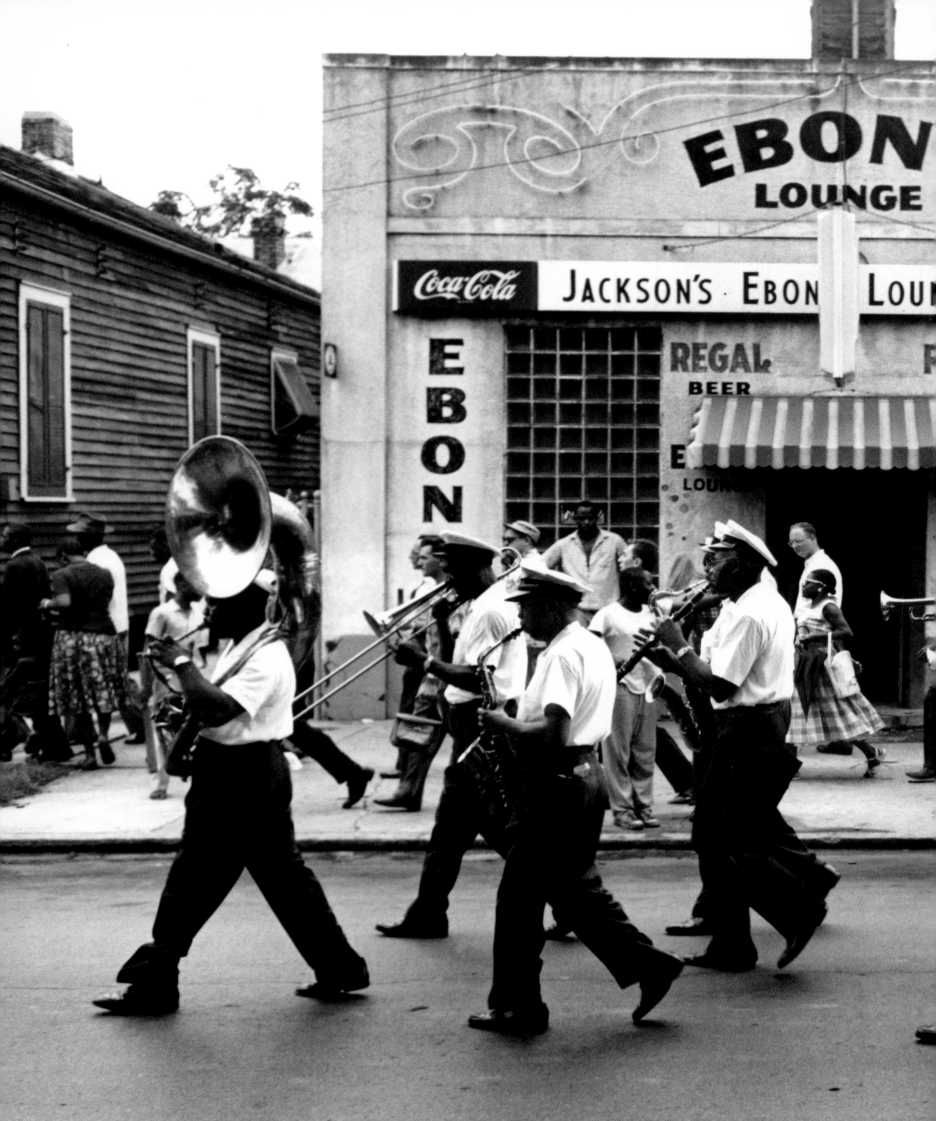

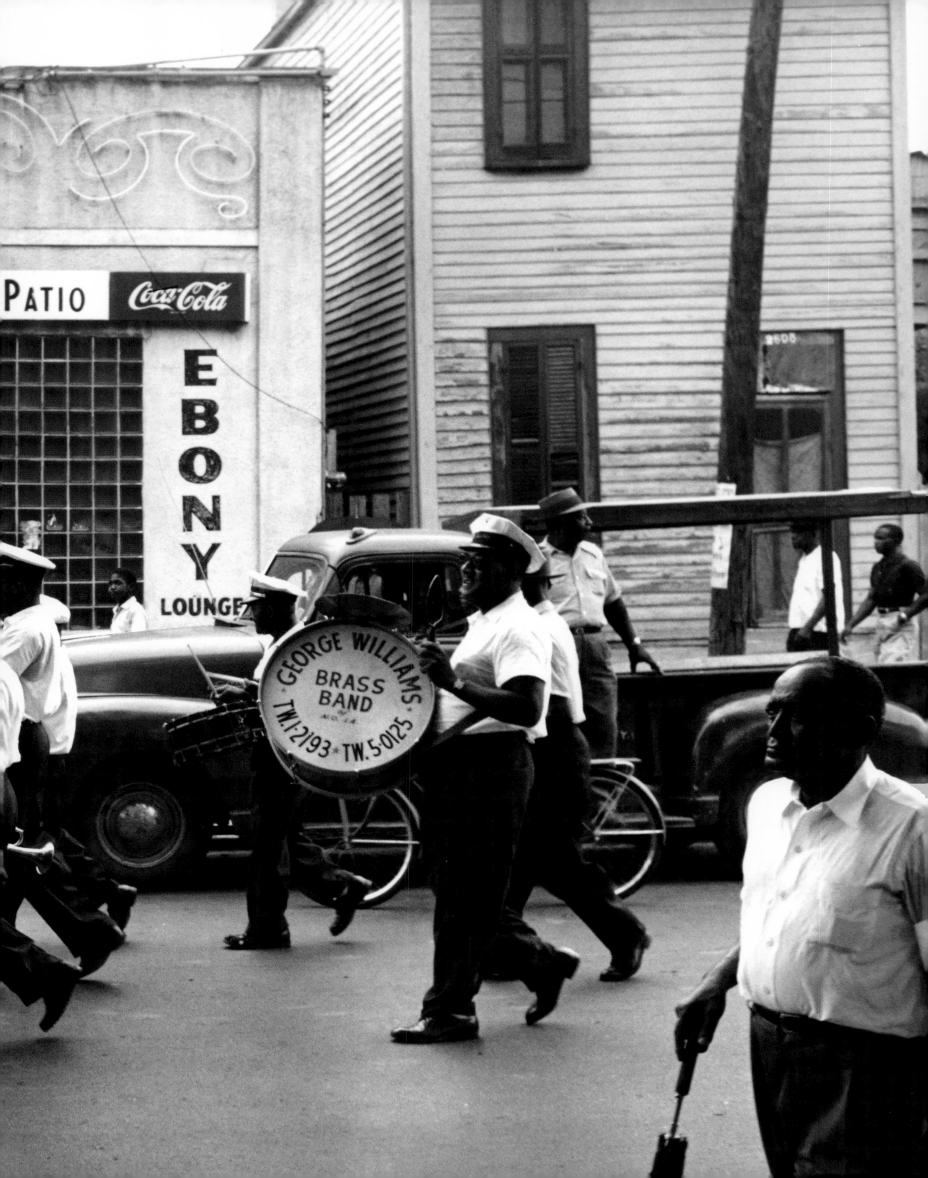

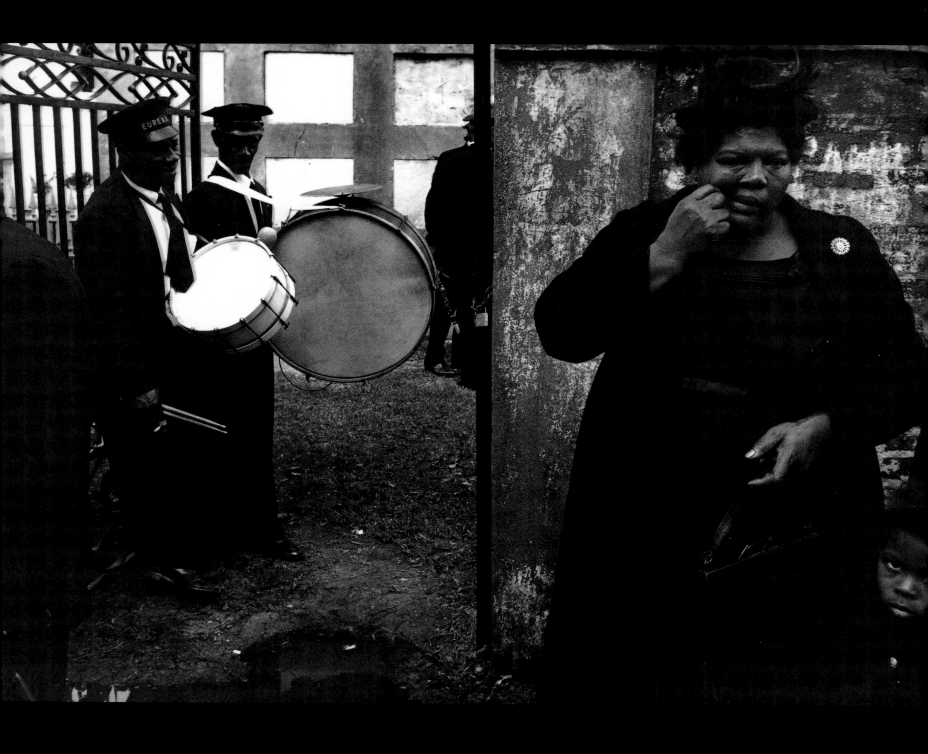

The Eureka Brass Band outside a cemetery, New Orleans, 1962

Muddy Waters, Newport Jazz Festival, 1956

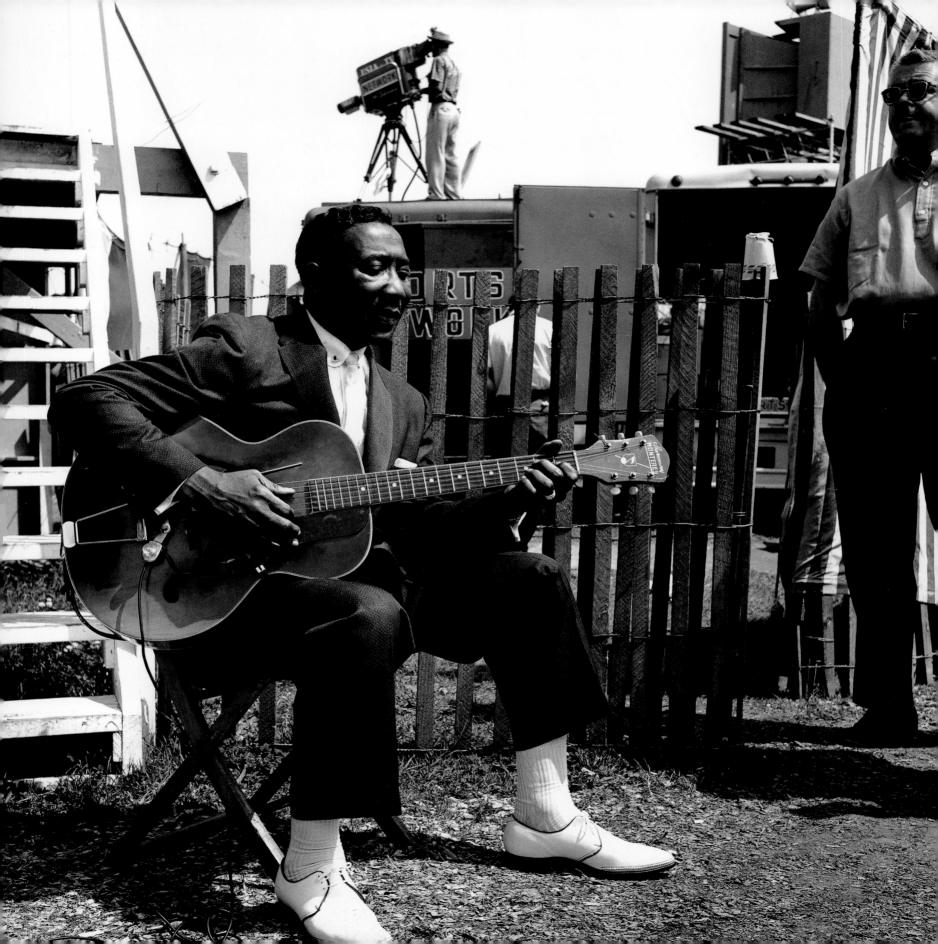

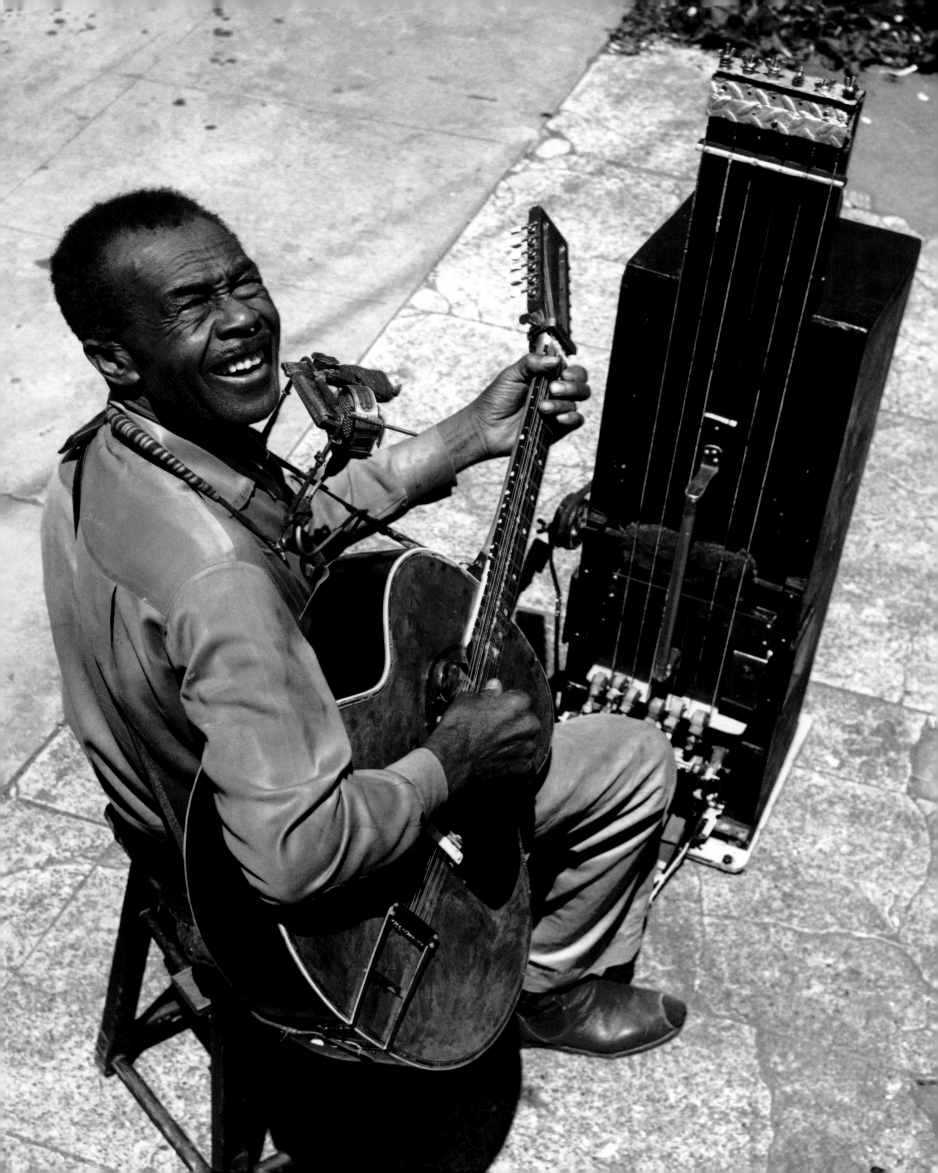

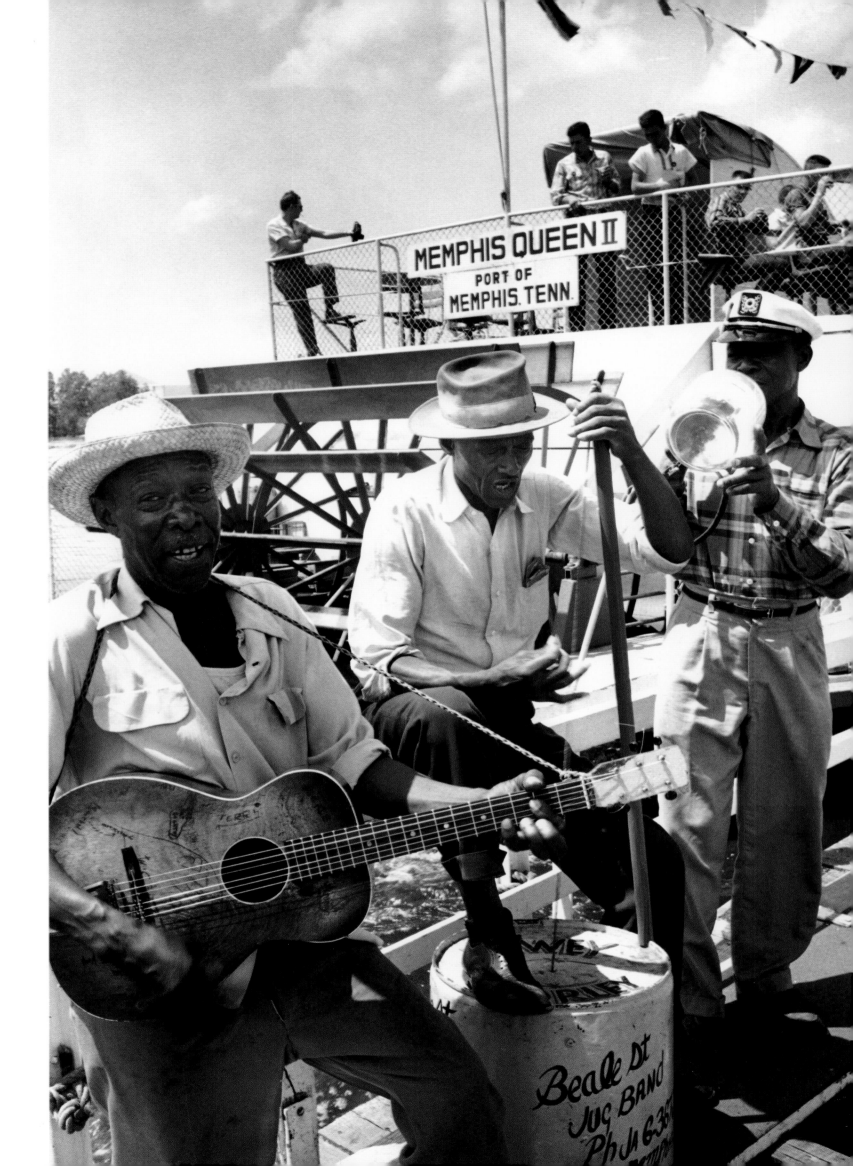

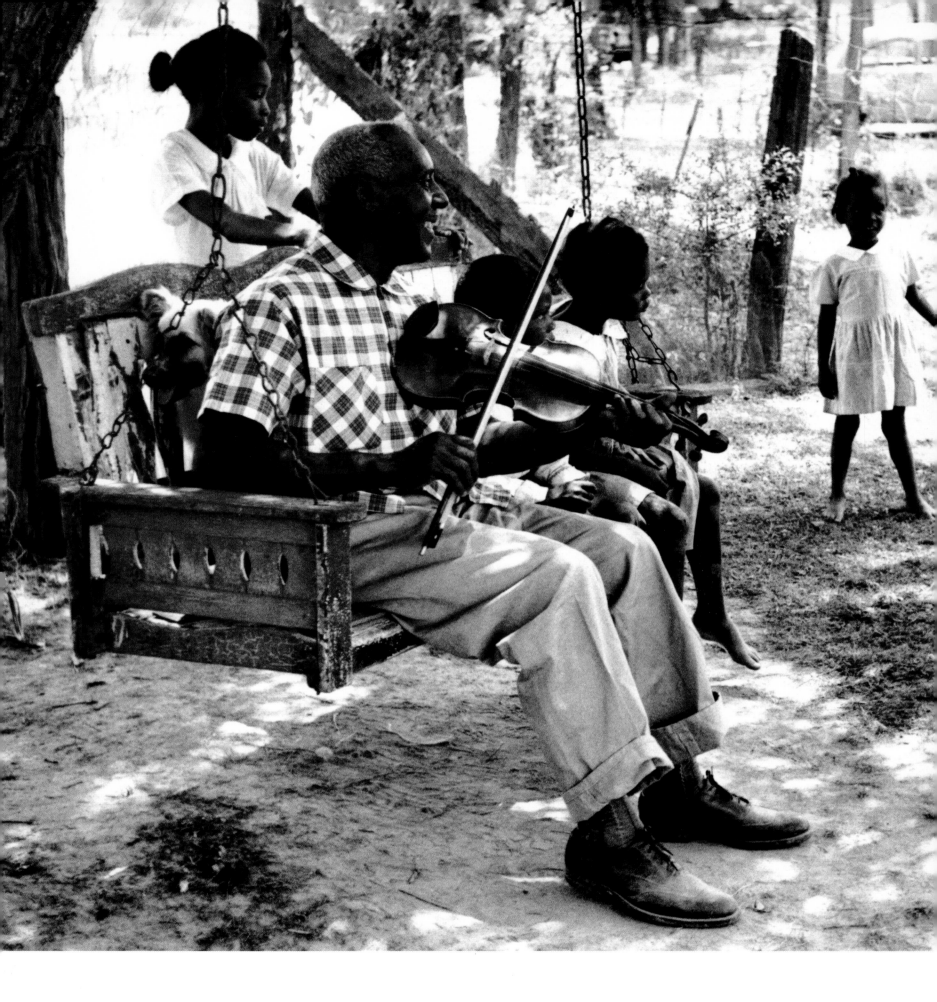

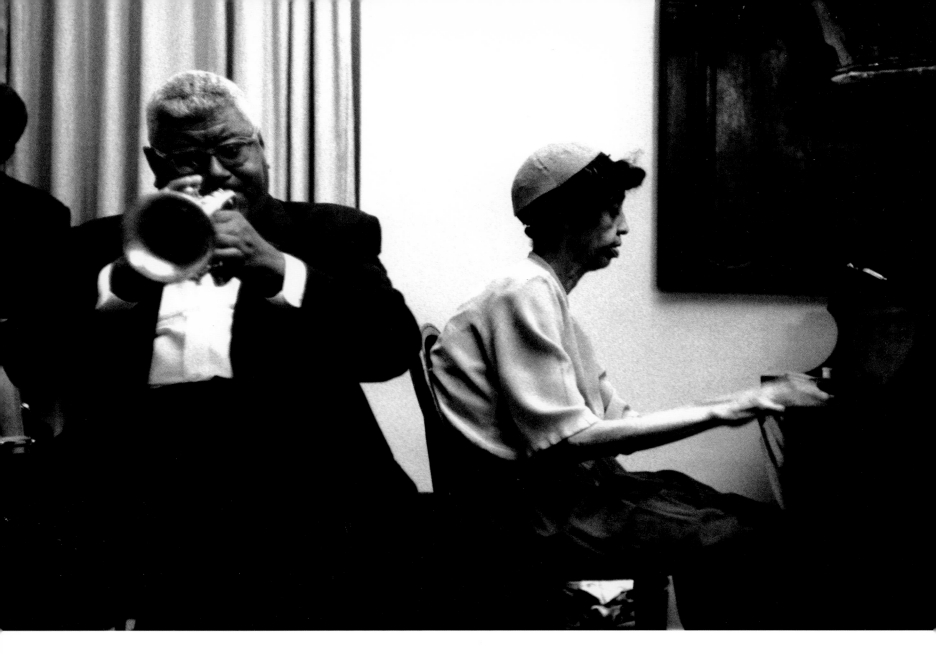

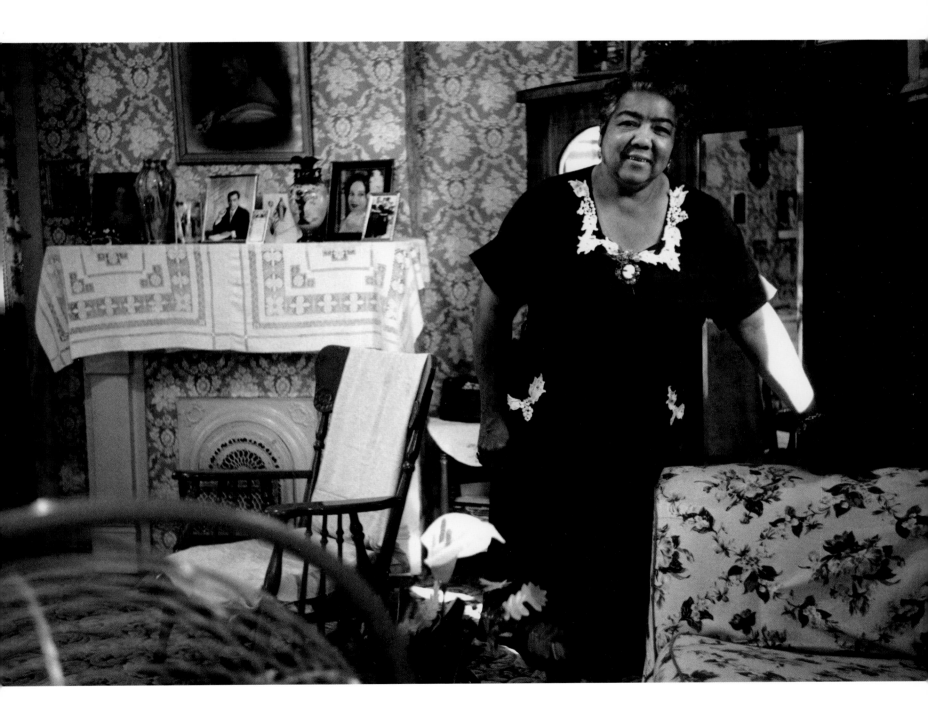

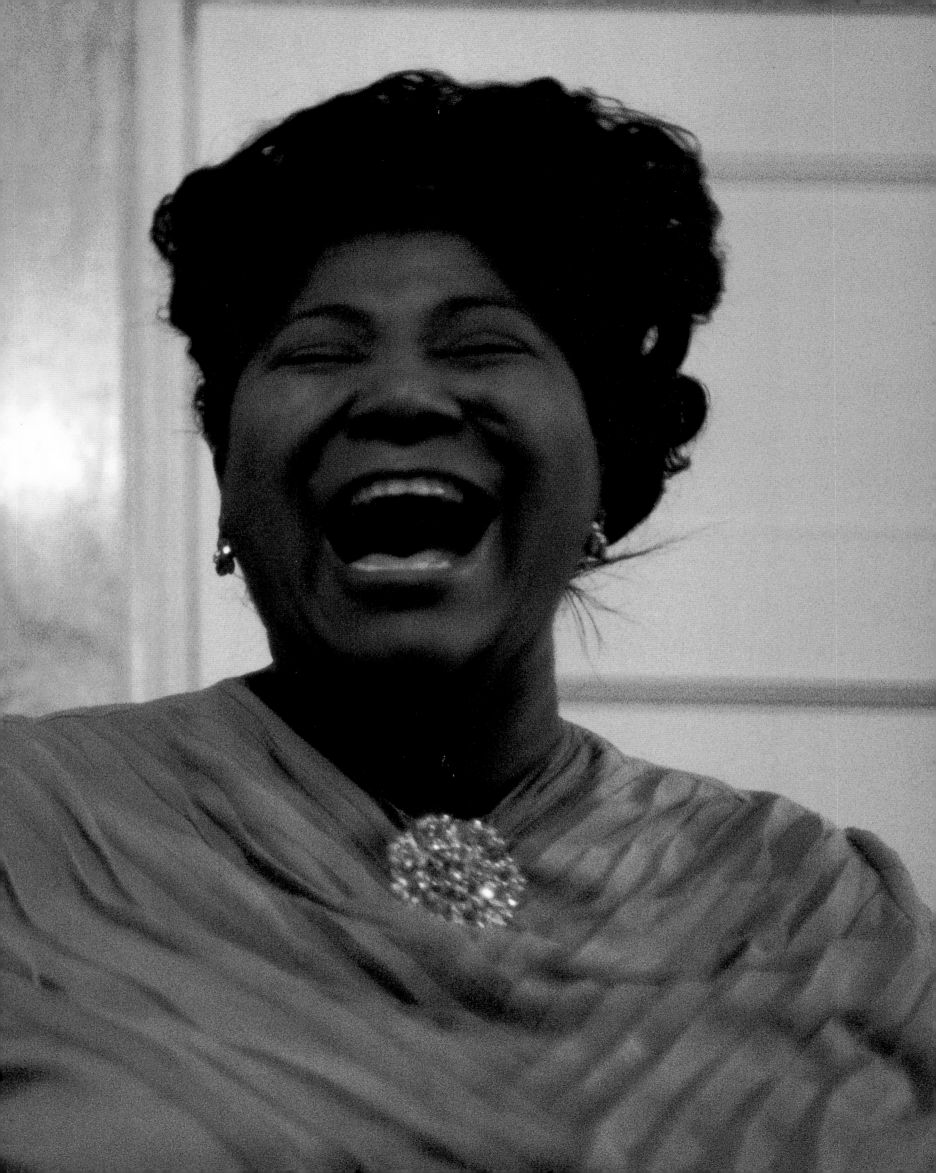

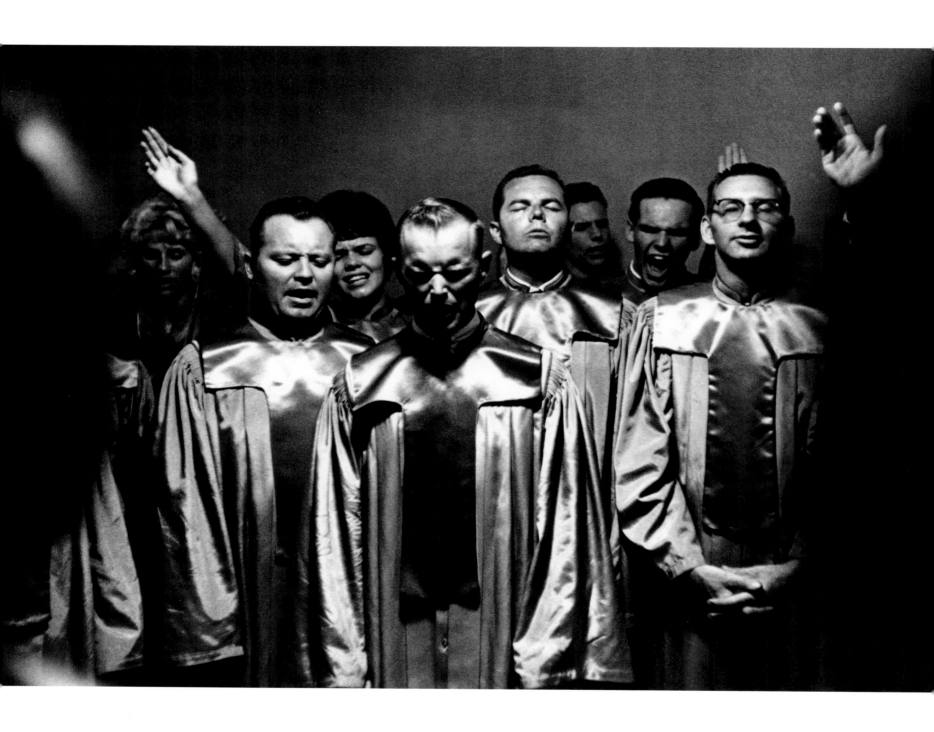

117 *Mahalia Jackson, Chicago, 1960*
The Sky Pilot's Church, Los Angeles, 1959 **118**
The choir reacts to Ethel Waters singing **119**

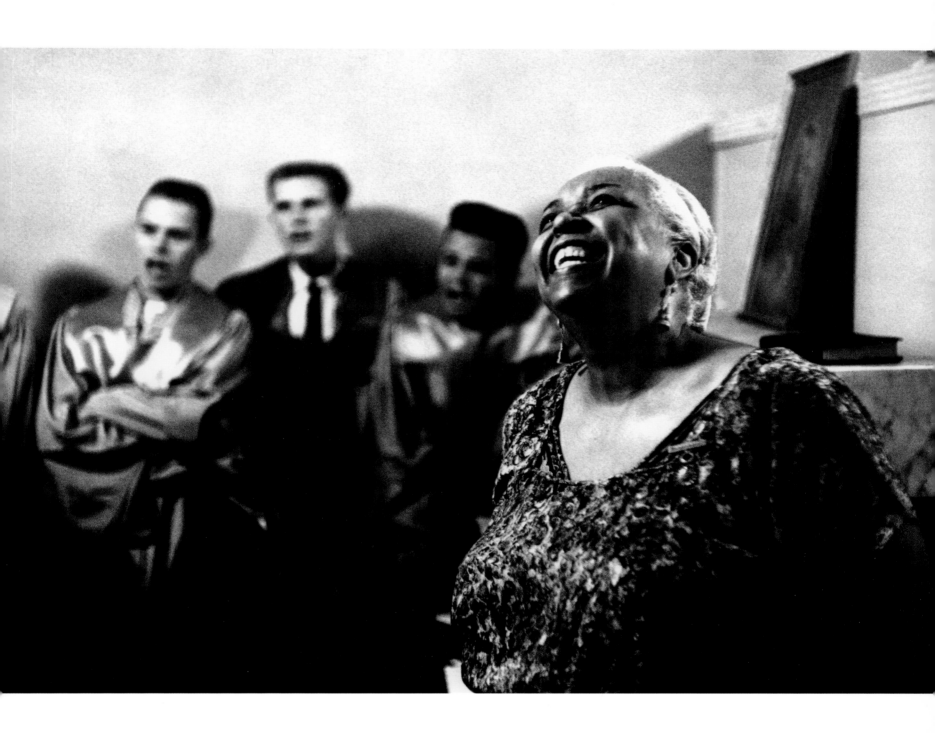

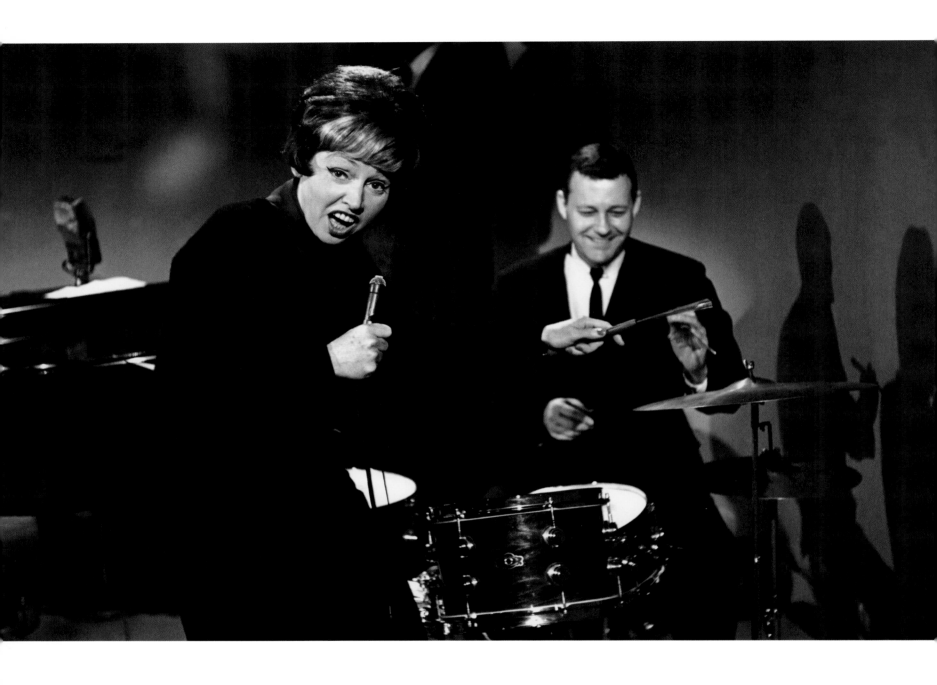

122

123

Anita O'Day, Charlie Pool (drummer), Hollywood, 1957 **124**

125 *Zoot Sims (tenor sax), Bill Holman,*

Buddy DeFranco, "Stars of Jazz" television show, Hollywood, 1956 126 *Stu Williamson (trombone), Hollywood, 1954*

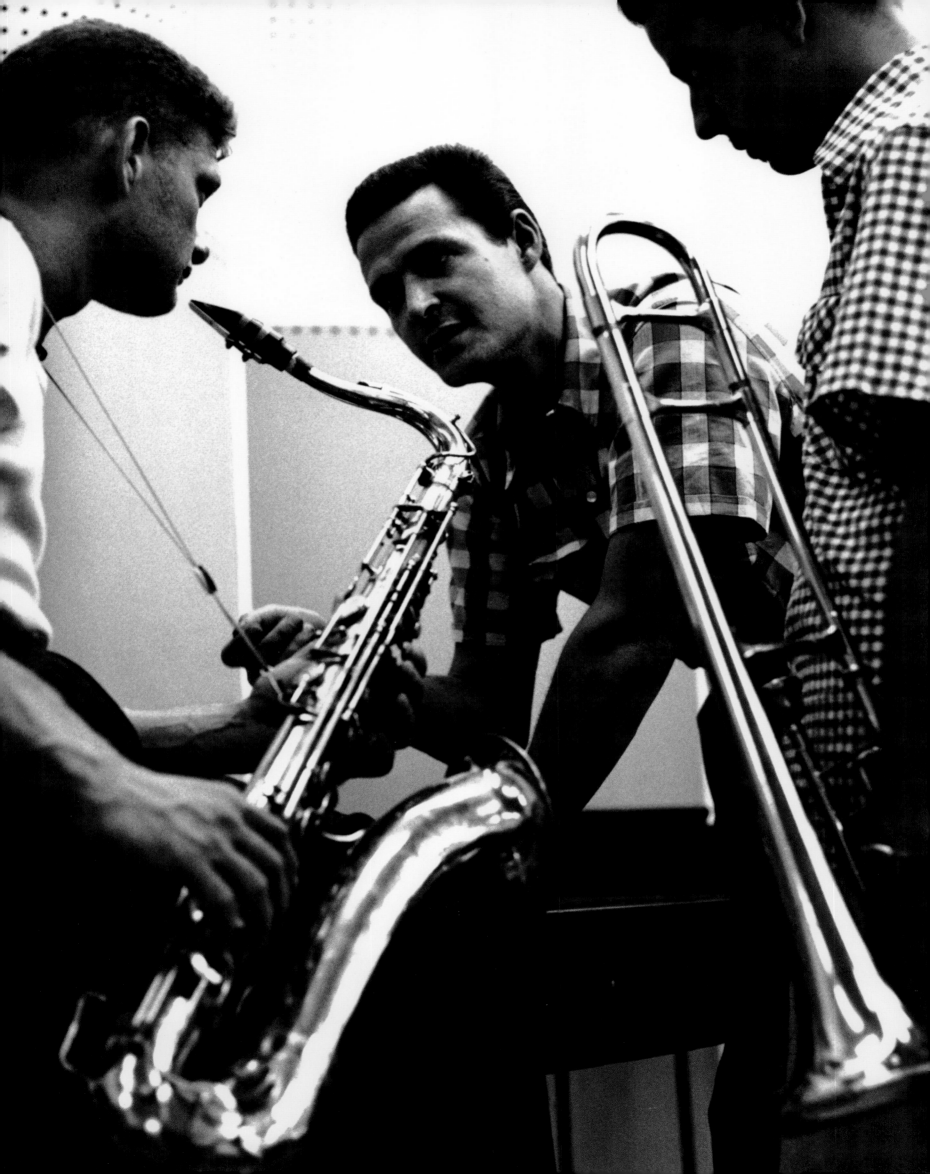

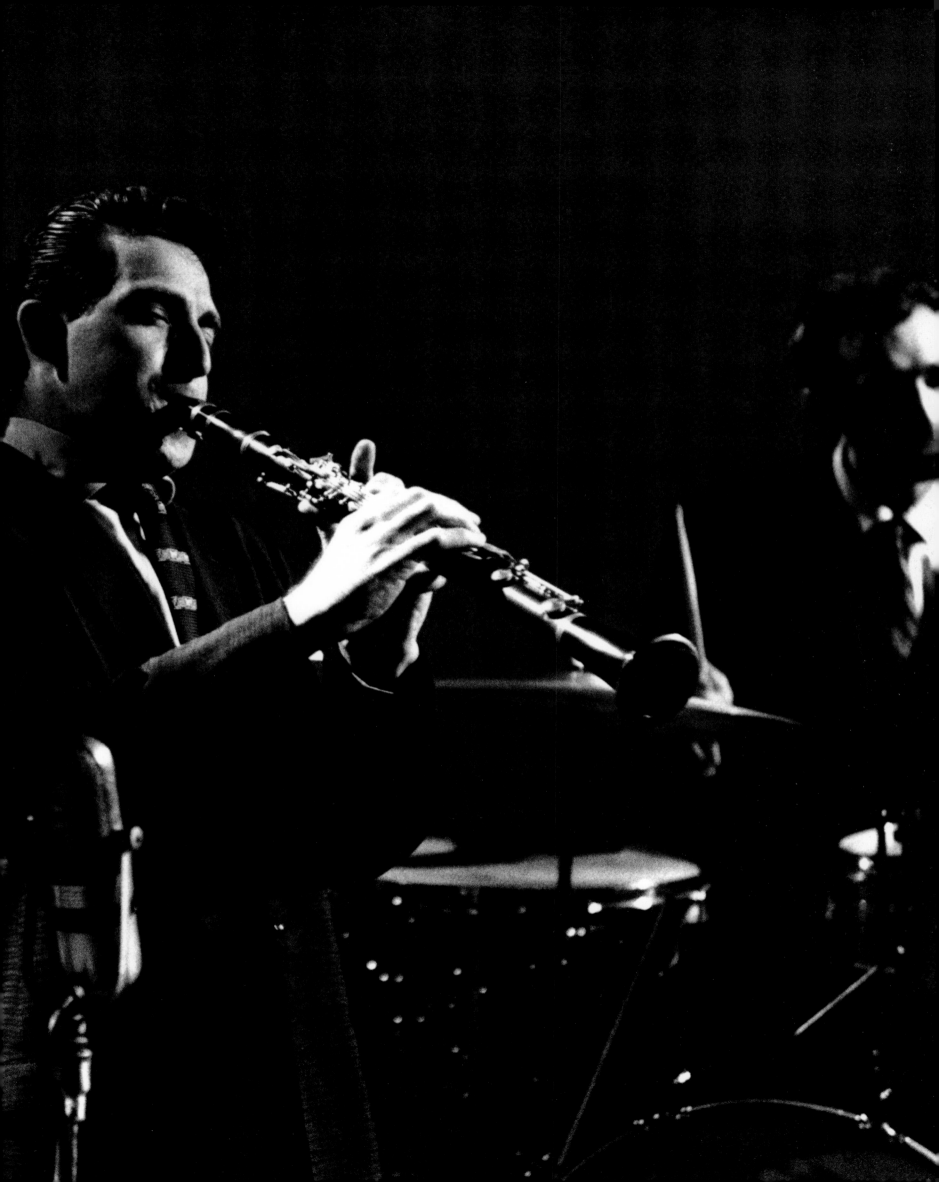

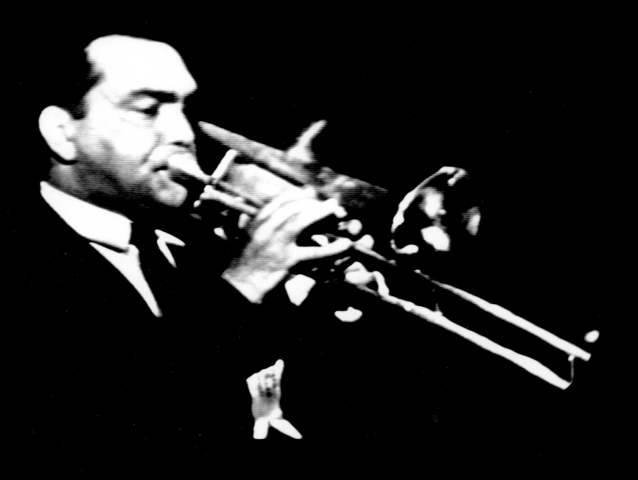

Bob Enevoldsen, "Vivian", Buddy DeFranco, Kenny Drew,
Jazz on television, 1953

Jack Teagarden, Stan Getz, Buddy DeFranco,
Gene Norman (announcer), Kenny Drew , Paula Kelly, Jazz on television, 1953

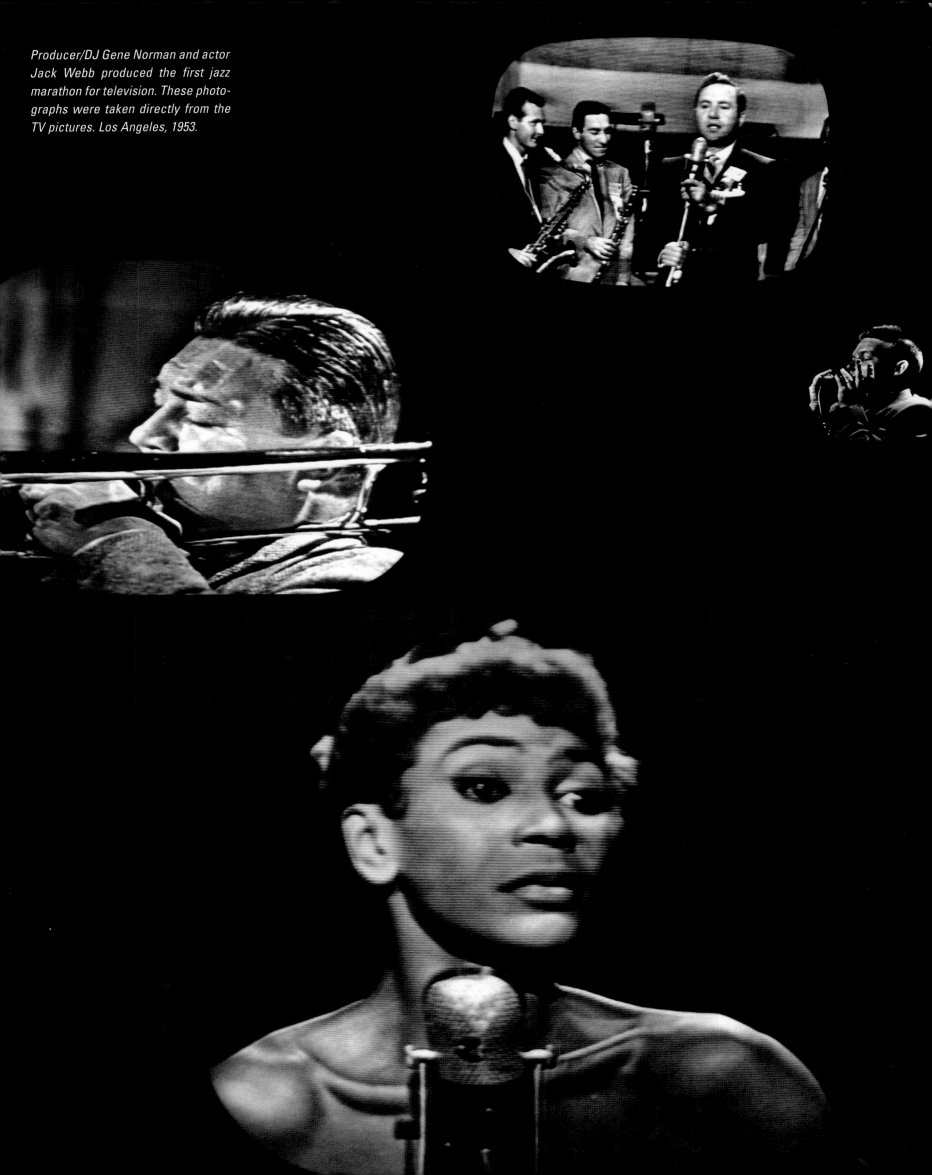

Producer/DJ Gene Norman and actor Jack Webb produced the first jazz marathon for television. These photographs were taken directly from the TV pictures. Los Angeles, 1953.

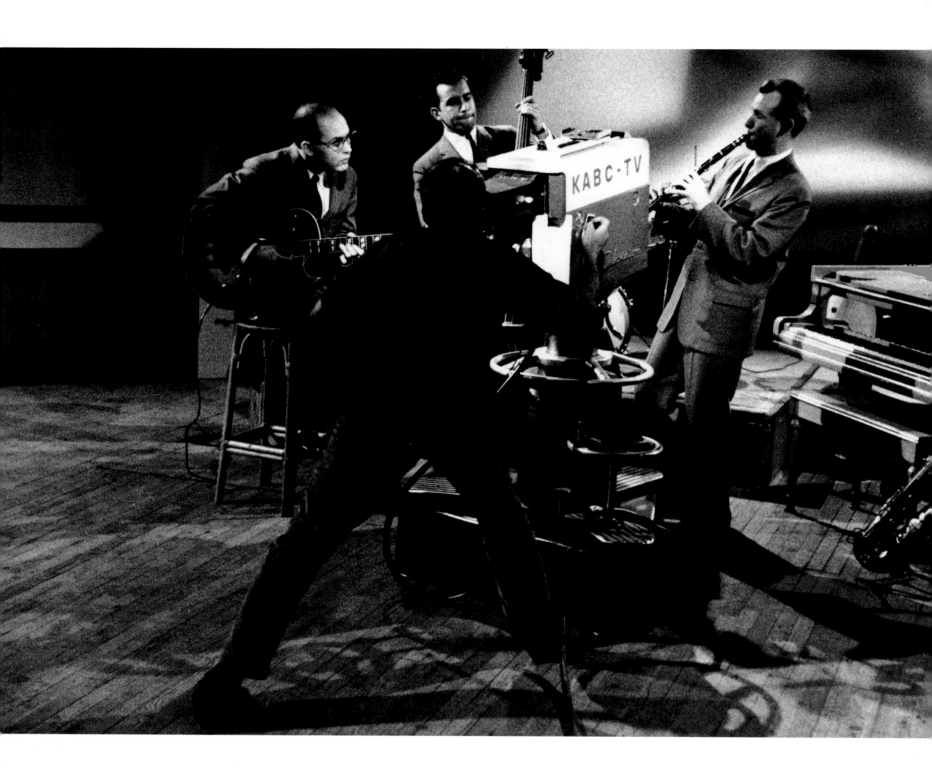

The Jimmy Giuffre Trio: Jim Hall (guitar), Ralph Peña (bass),
Jimmy Giuffre (clarinet), Hollywood, 1957 **131** *Billie Holiday, Hollywood, 1957*

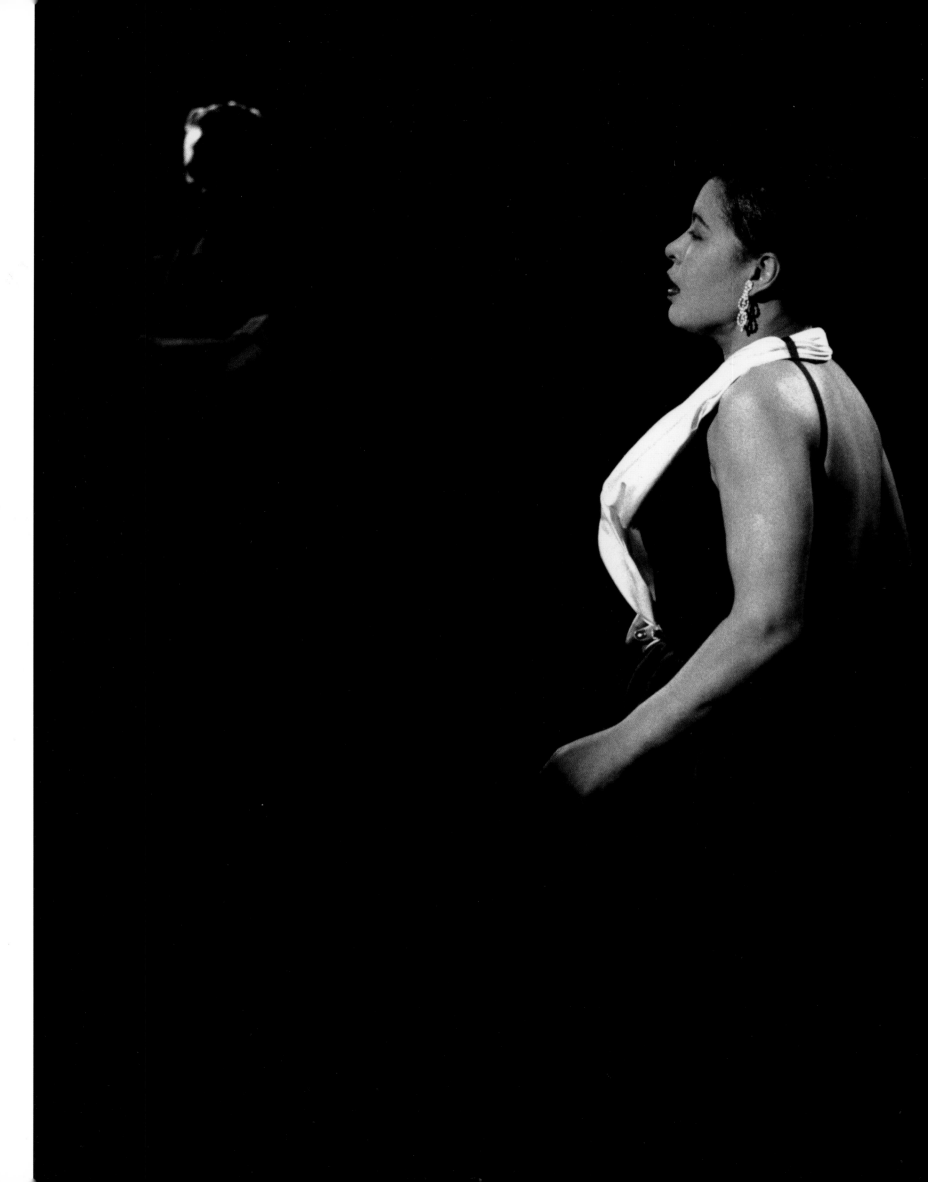

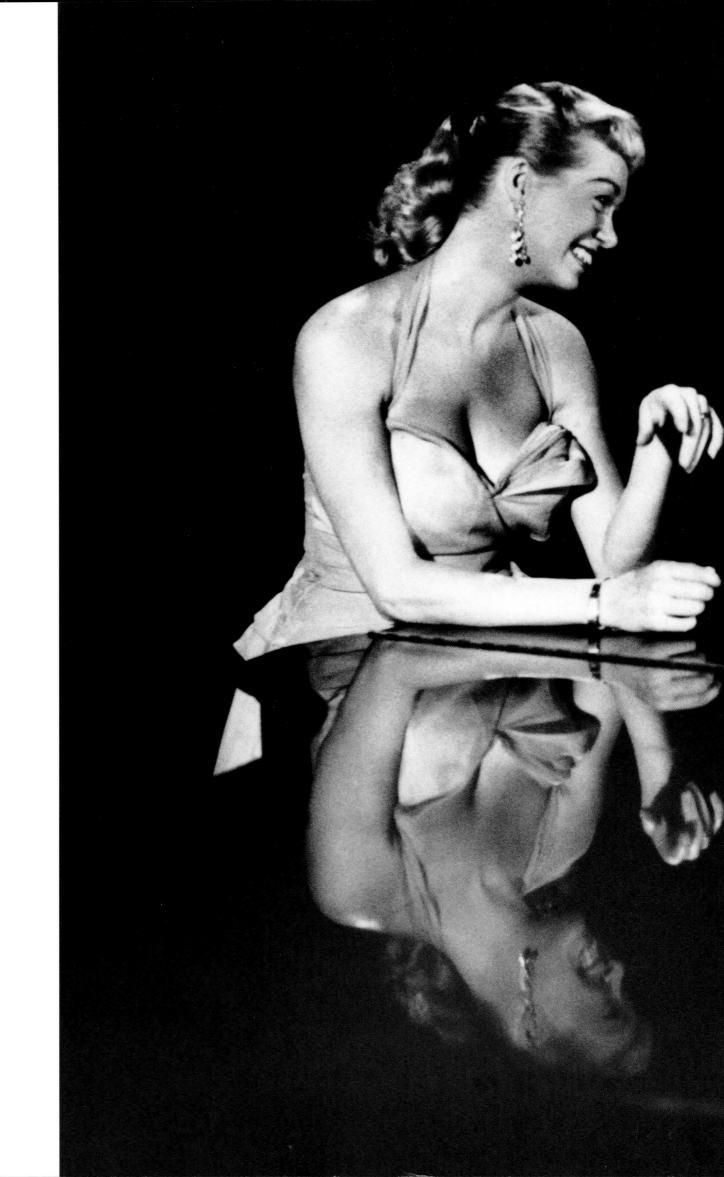

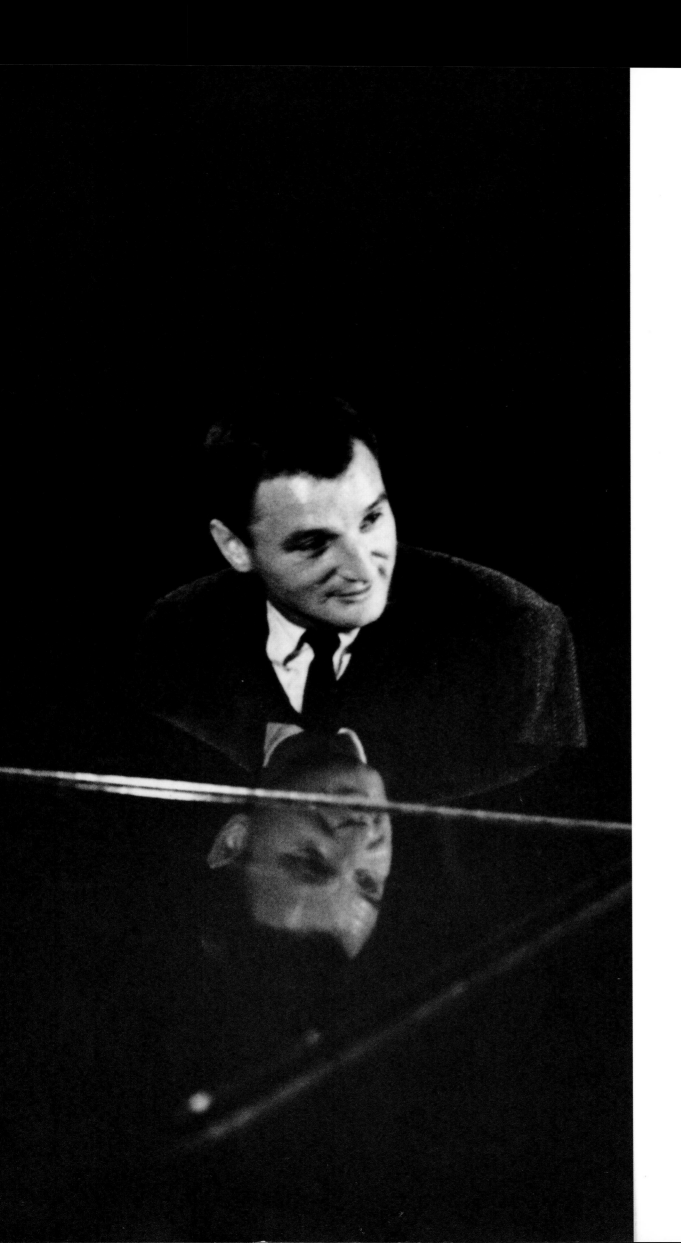

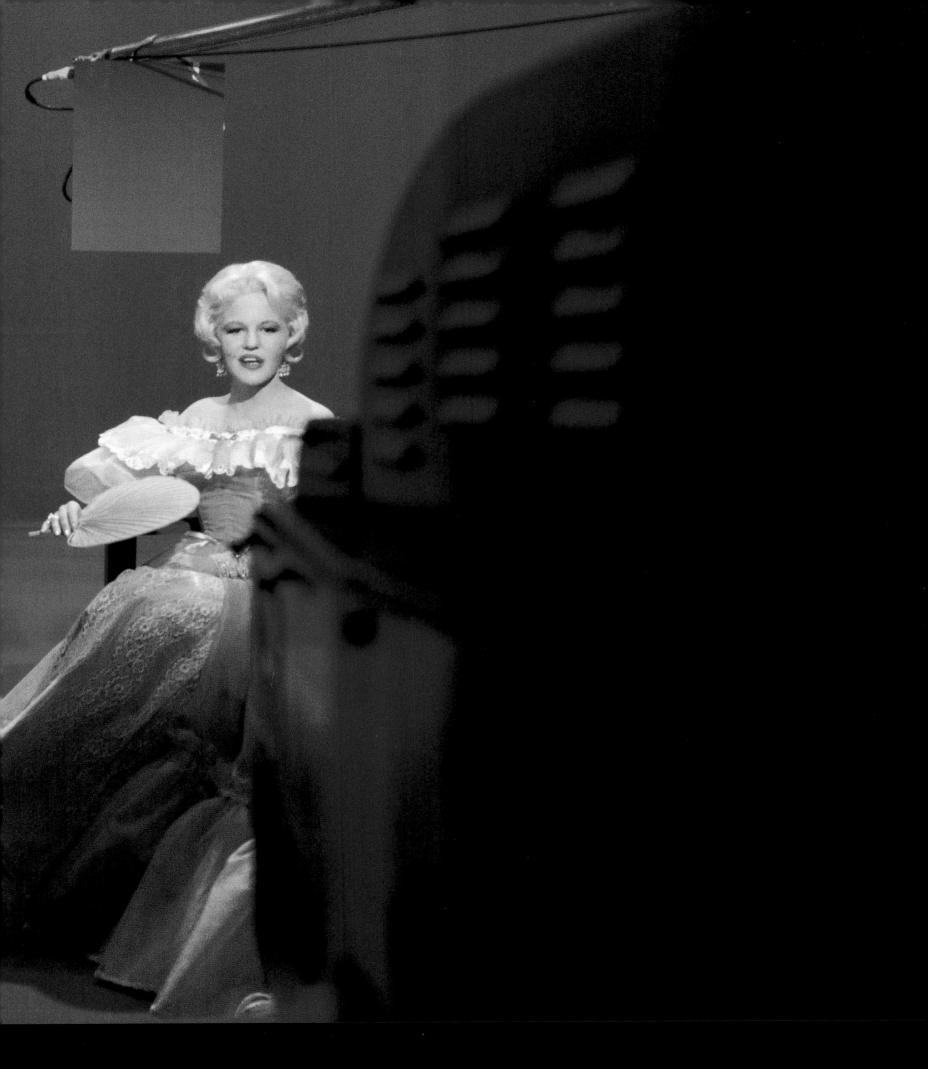

Peggy Lee, NBC Studios, Burbank, 1957

On a warm summer day in 1955, I went to Redondo Beach where Chet was living, to shoot some pictures for a possible record cover. I really had no idea of just what or how I was going to shoot, but when I arrived, a young woman named Halima greeted me at the door. She looked so fresh and pretty in her summer dress that I had to include her in the pictures. I took Chet and Halima next door to an unoccupied house that was in the process of being remodeled. I had them sit in a bare window seat, with soft back light streaming through the window. I asked Chet to whisper to Halima, and the mood was set.

134
135
136
137 *Halima and Chet Baker, Redondo Beach, California, 1955*
Chet's chops, North Hollywood, 1954 138

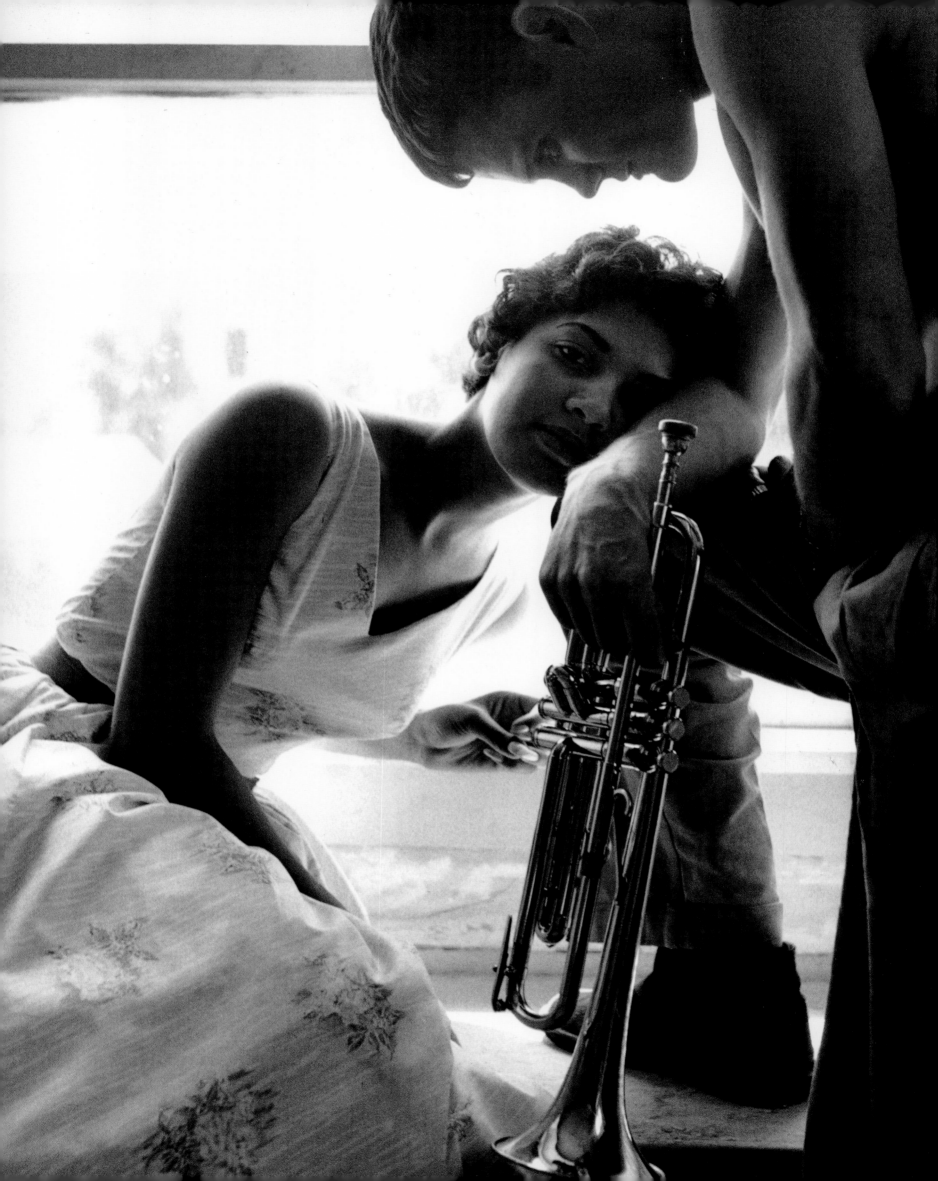

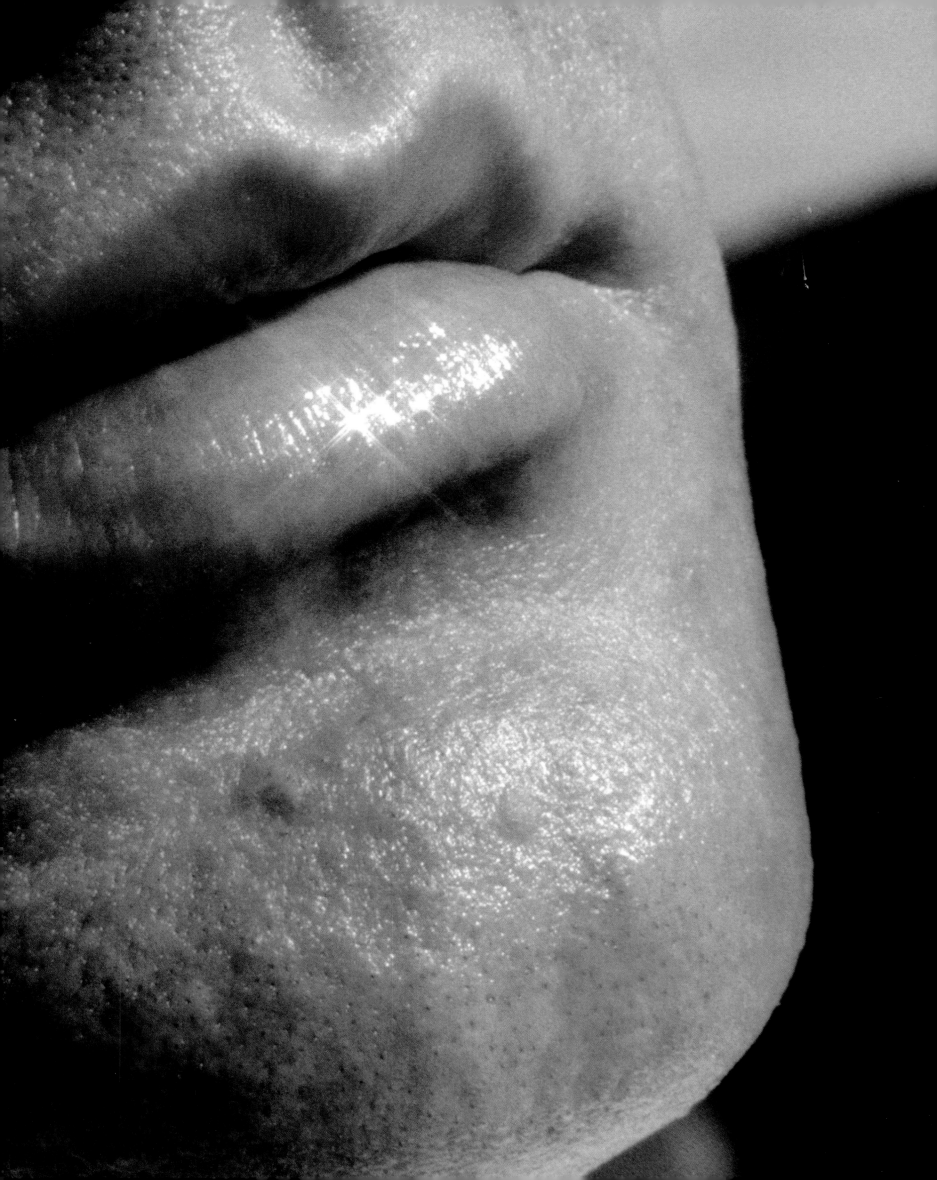

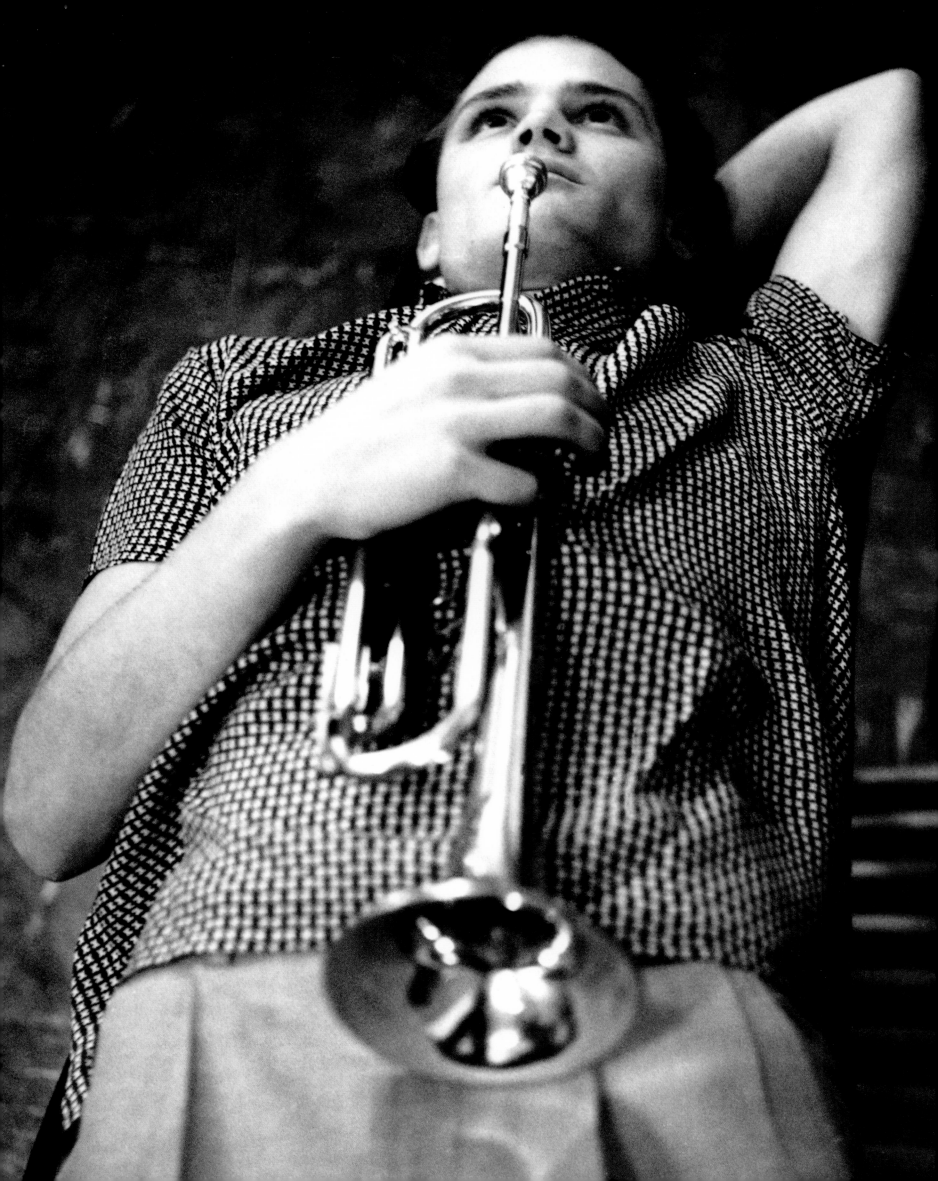

Chet Baker relaxes and listens to a play-back
in the recording studio, Hollywood, 1954

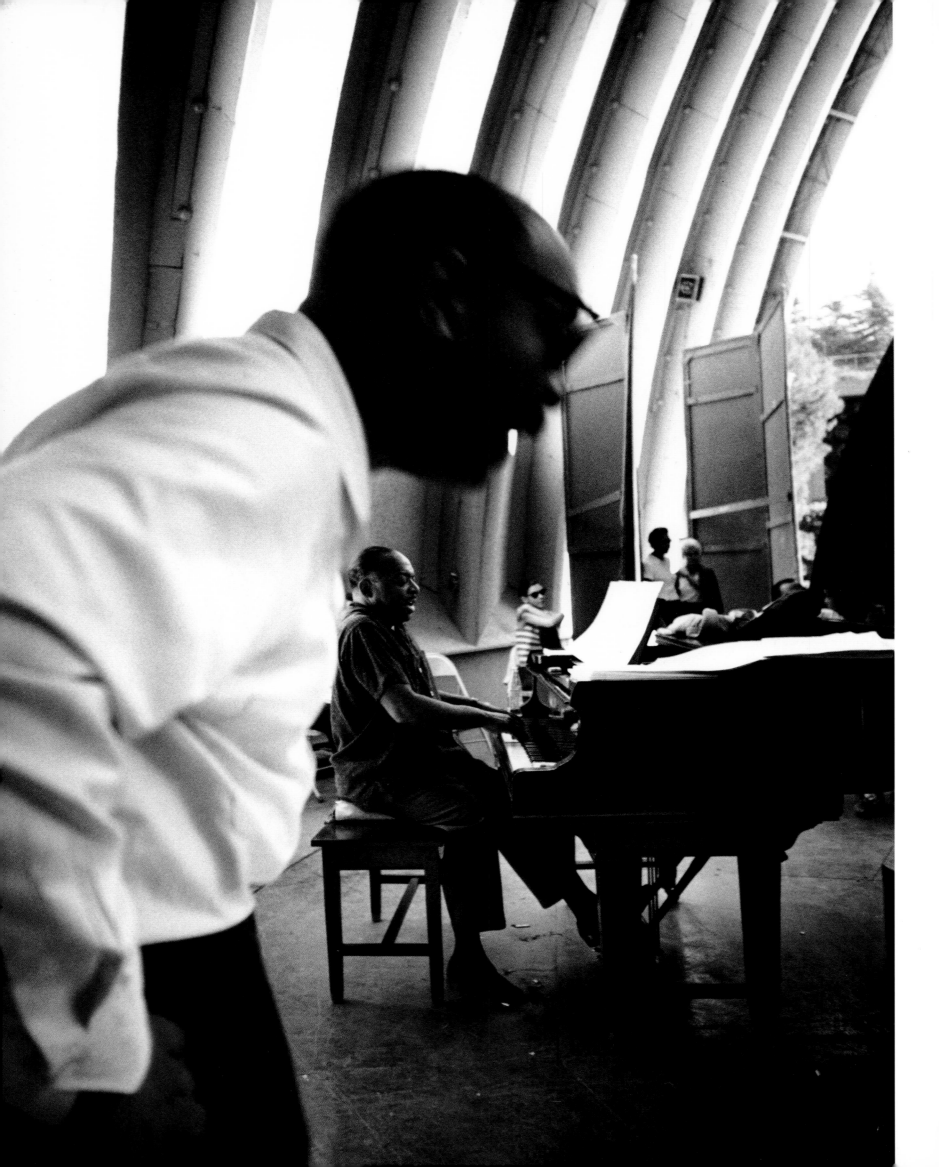

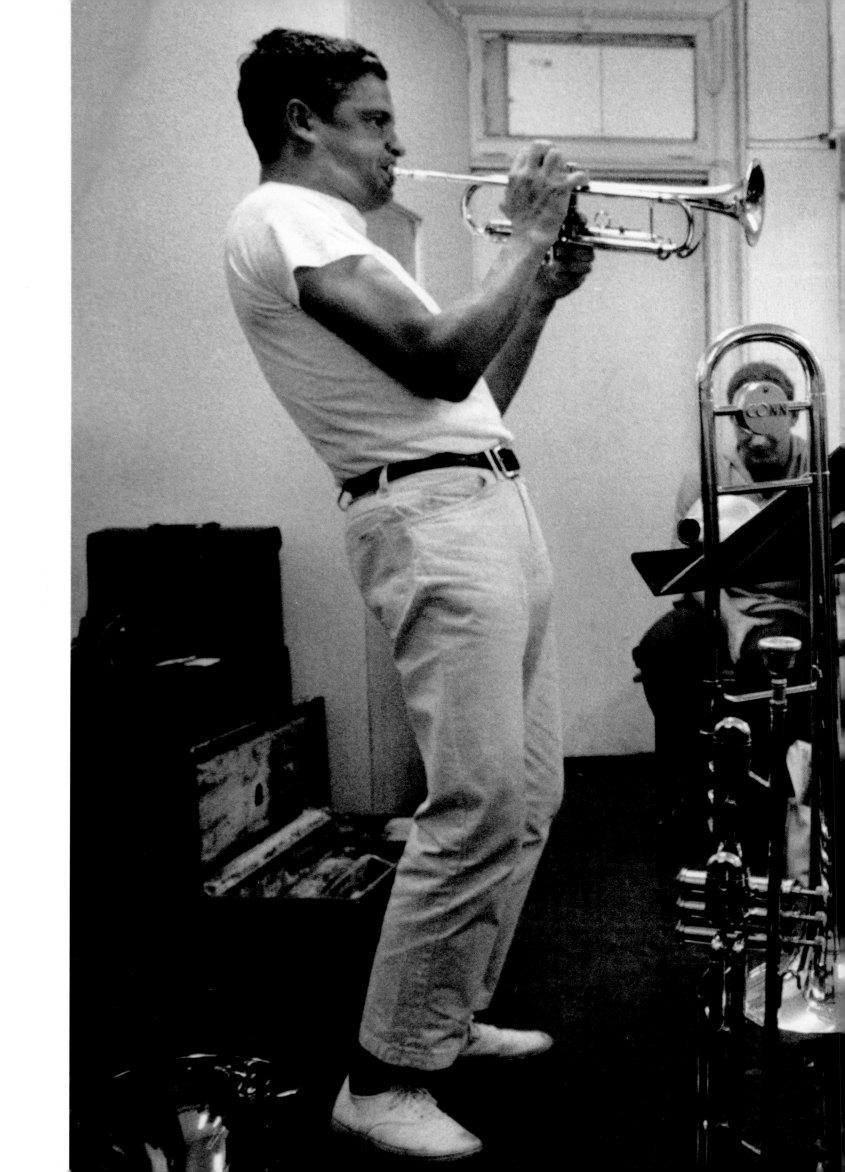

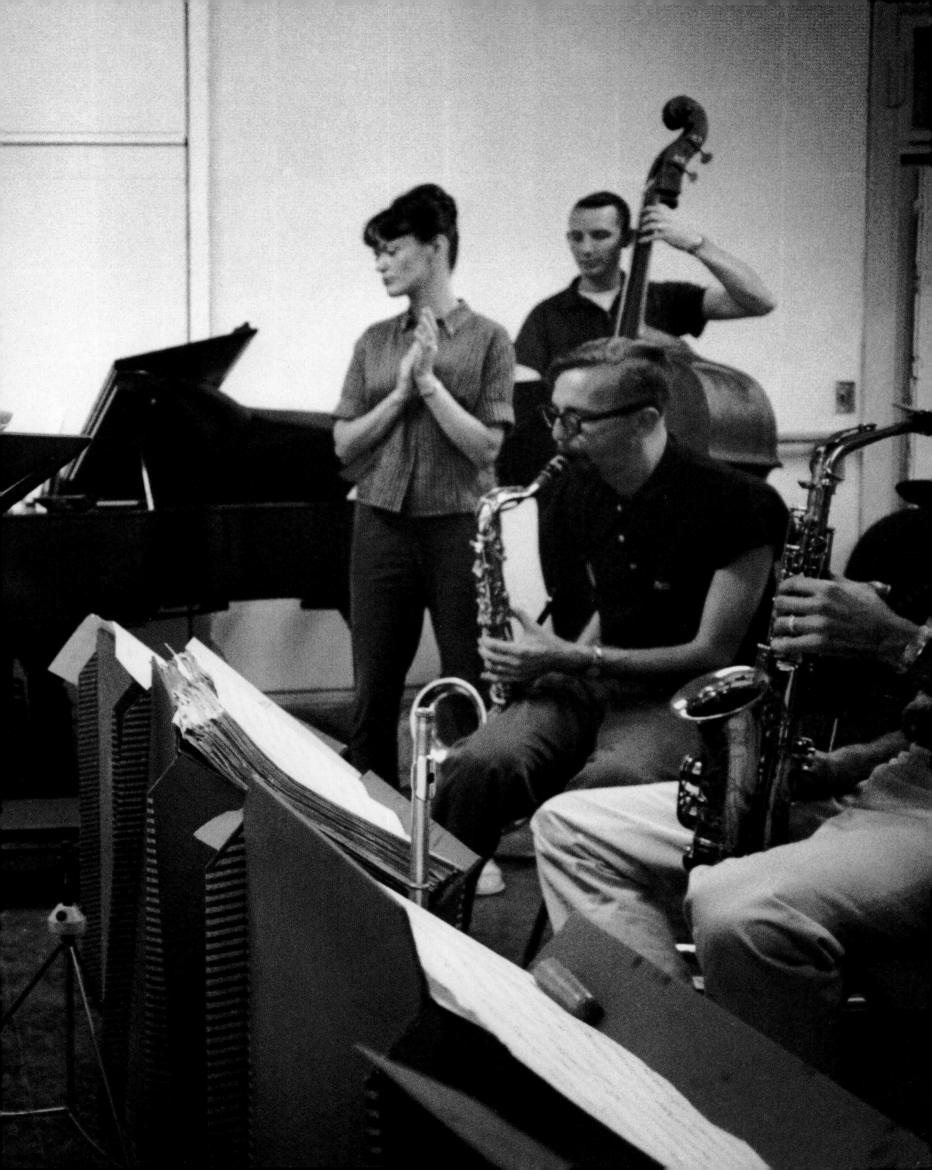

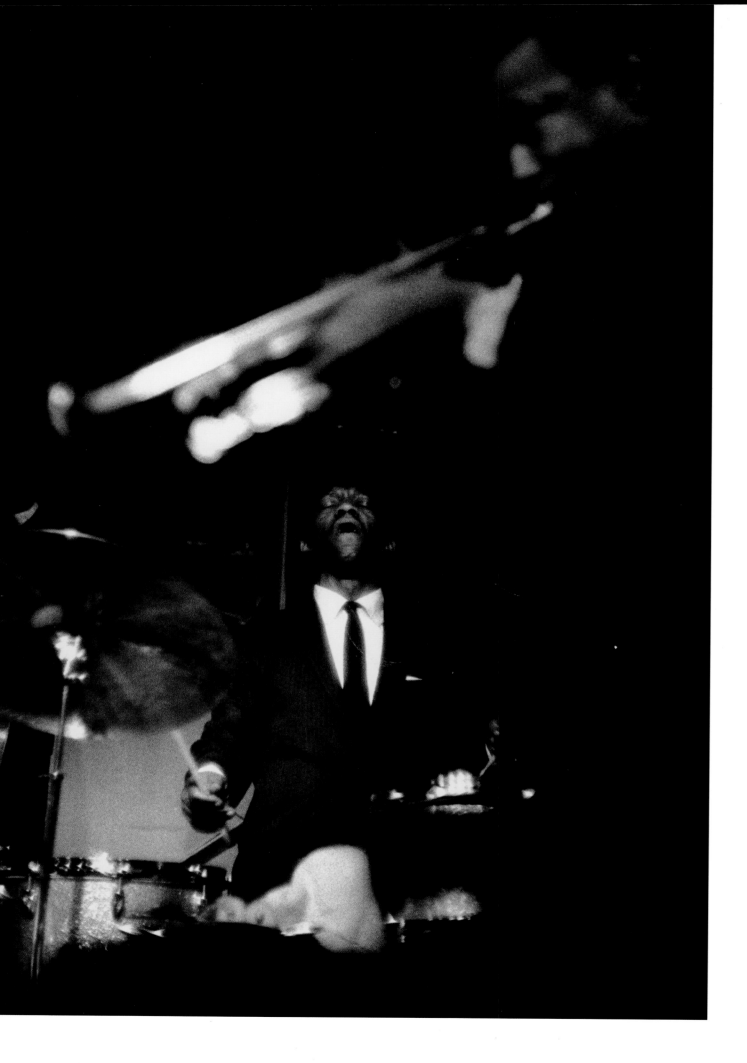

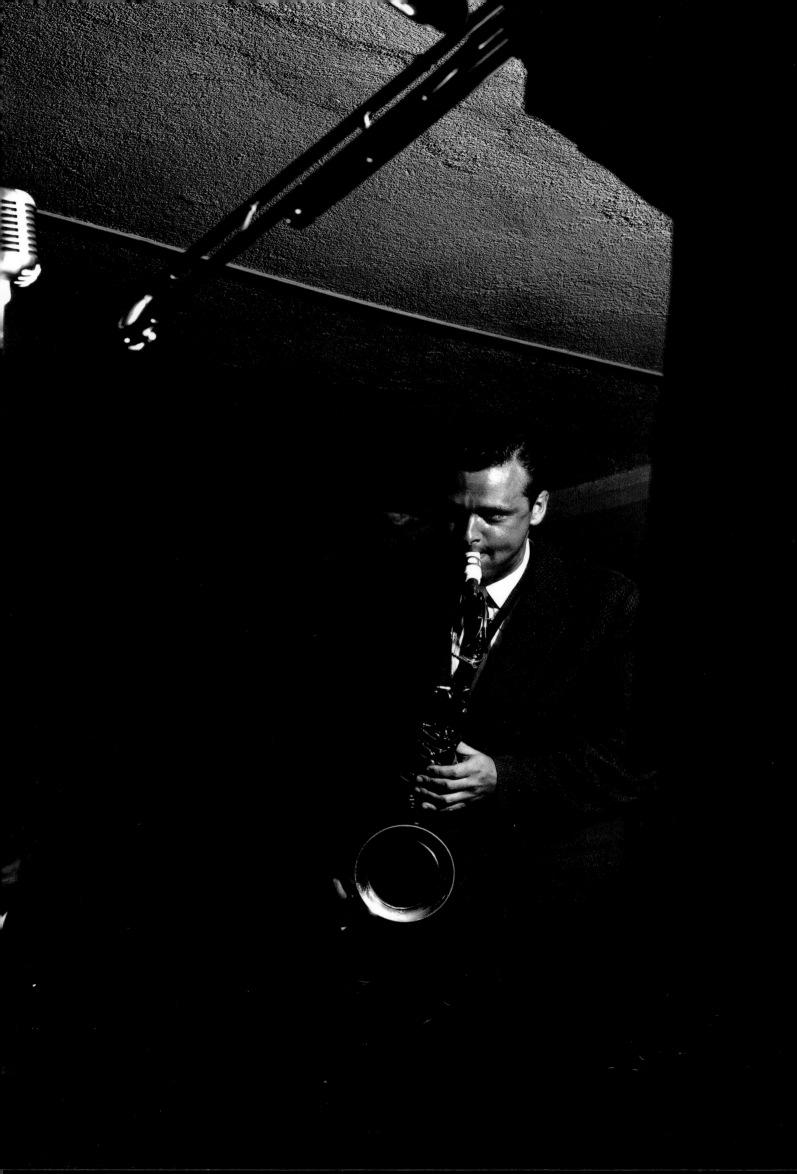

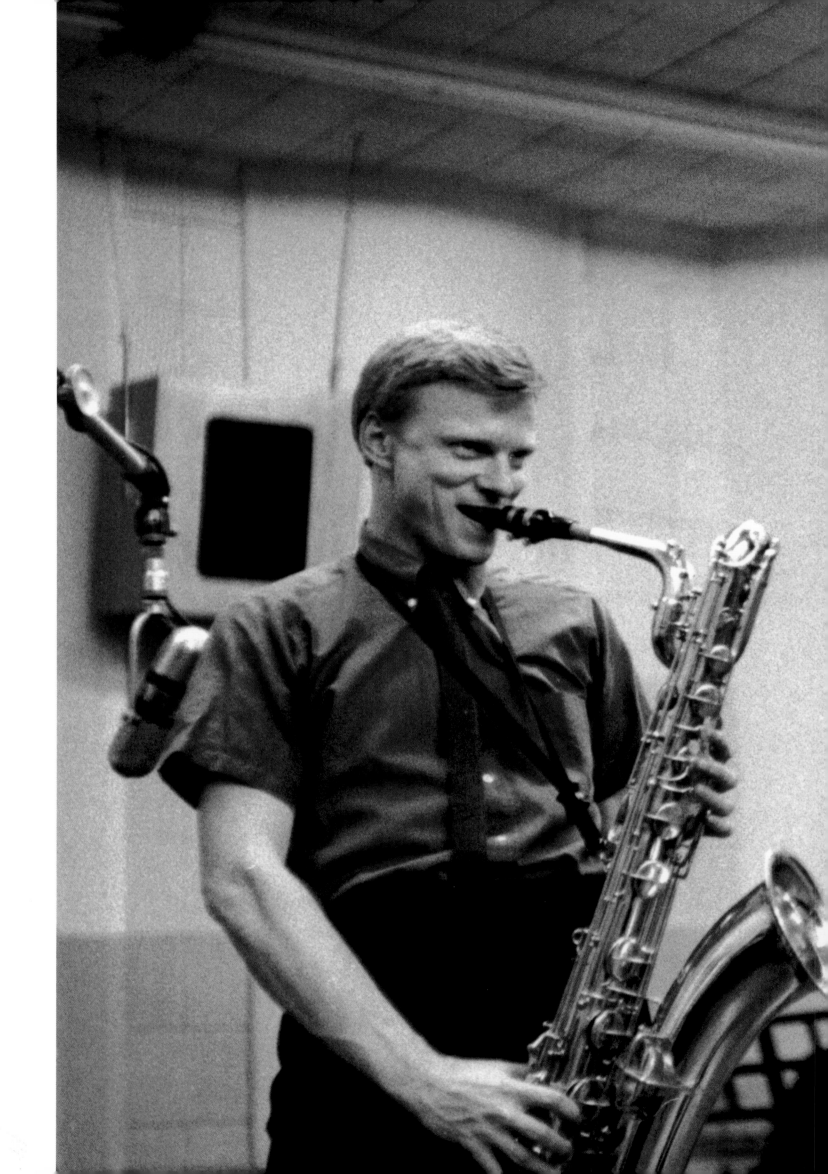

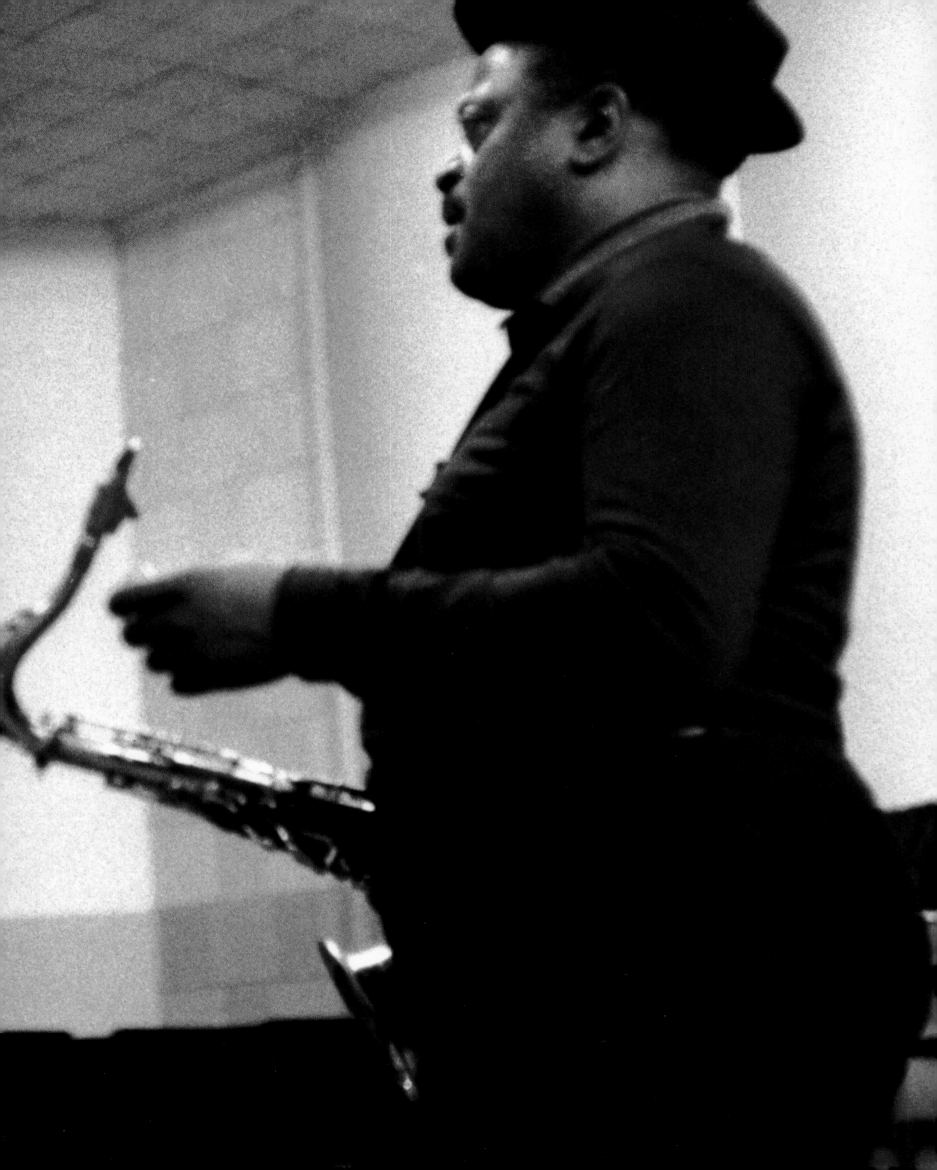

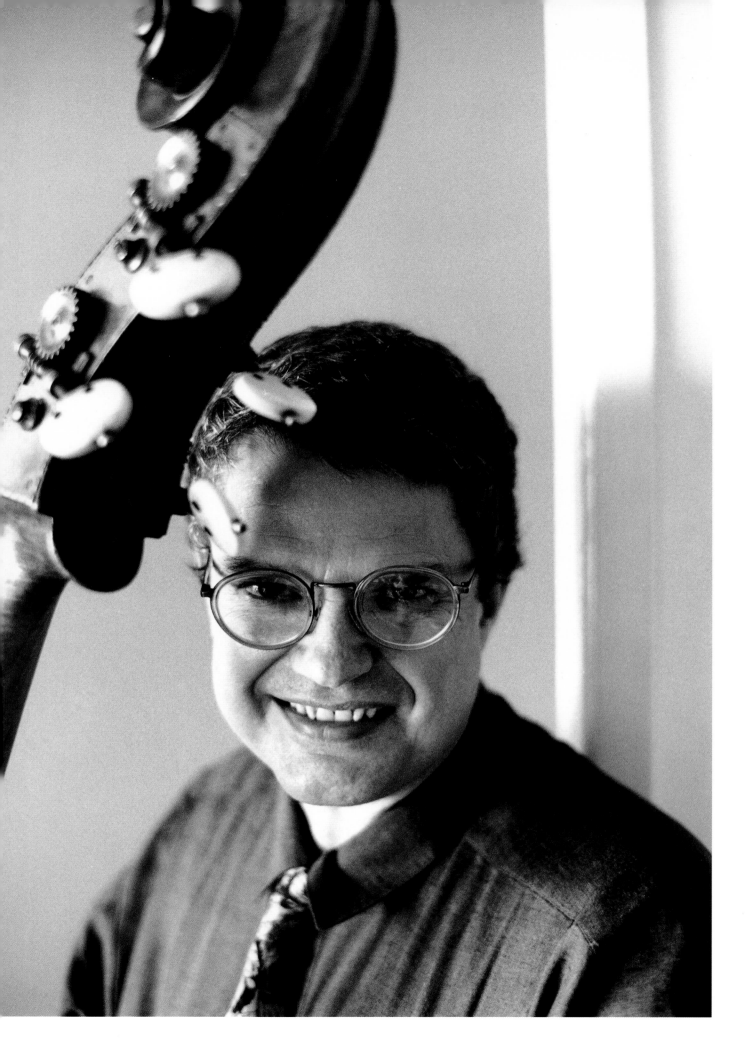

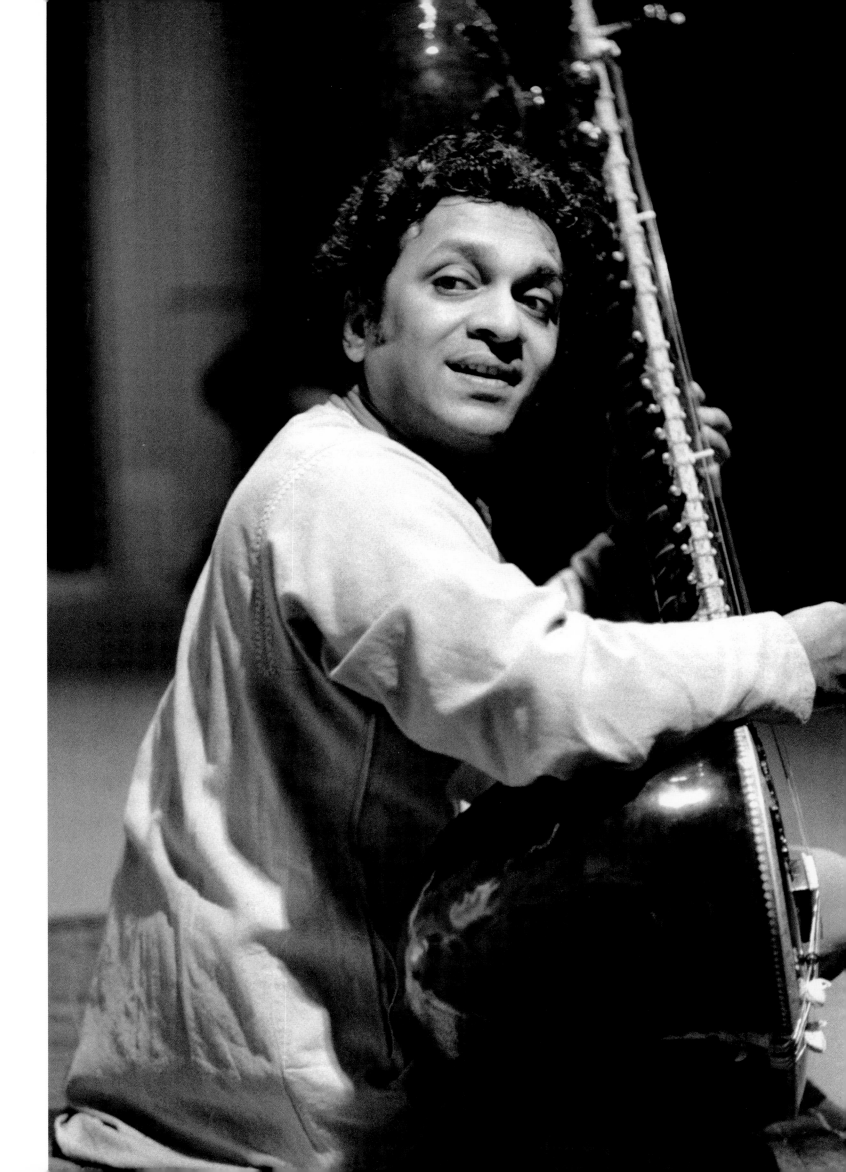

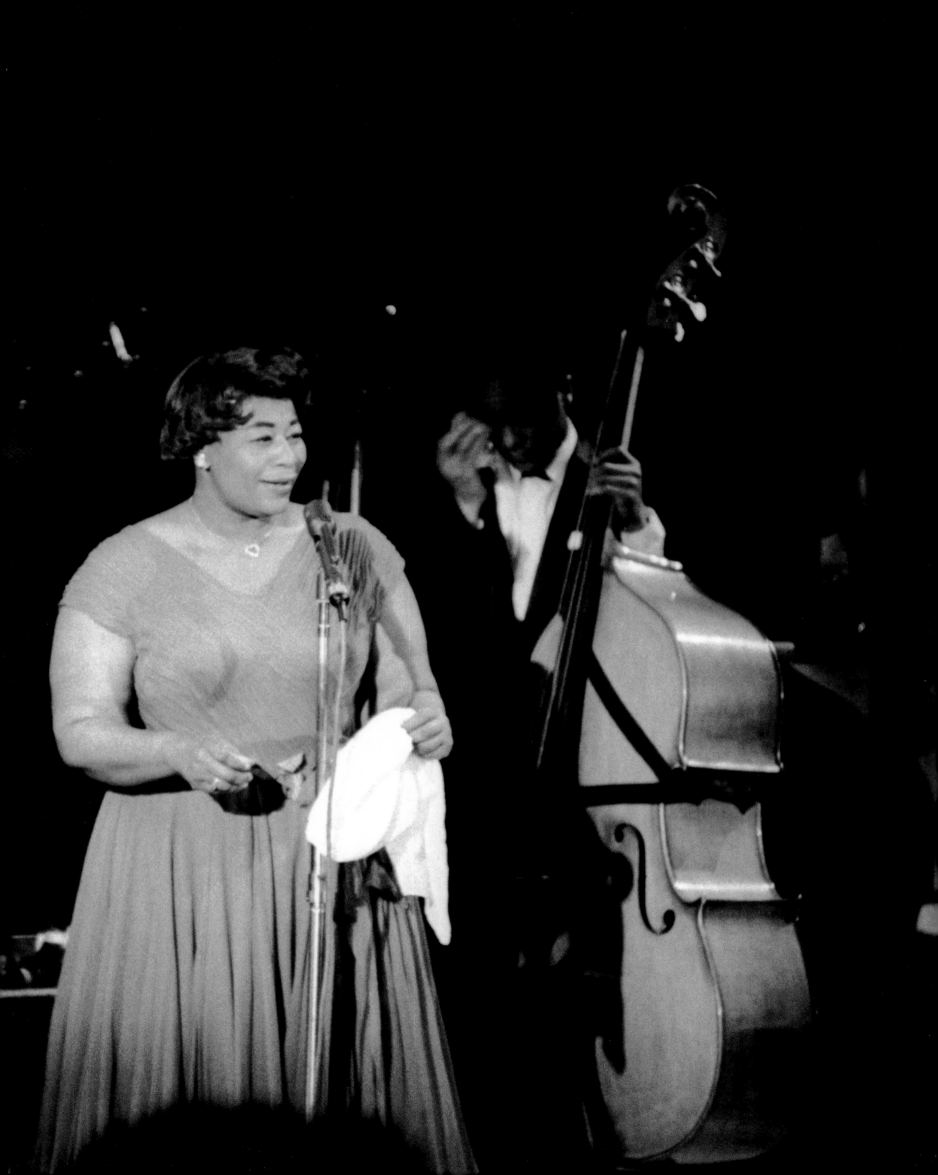

I had heard that "Bird" (Charlie Parker) was going to be in town. If I had a jazz idol, he would certainly be the one. So I had to meet him and photograph him. One Saturday night, I borrowed my father's car, packed up my borrowed 4 x 5" Speed Graphic camera, and took off for the Tiffany Club down on Eighth Street near downtown Los Angeles. On the bandstand with Bird was Harry Babasin on bass; Lawrence Marable, drums; Donn Trenner, piano; and a very pale, yet handsome Chet Baker who looked to me like an angelic-faced boxer. Bird, of course, played brilliantly, and Chet sounded totally new and fresh. I shot pictures and got to know the musicians.

After the club closed, Chet took off with a pretty blond girl, and Bird asked me if we could have some breakfast. All of the restaurants in that area were closed at 3:30 in the morning. In my youthful enthusiasm to make Bird happy, I suggested that we (including a few other fans) go to my family's house in a suburb of Pasadena. After all, I reasoned, my folks were out of town for the weekend. We cooked breakfast for Bird. Then he sat in a big lounge chair looking like Buddha with all of us, his young fans, at his feet. He regaled us with stories about his experiences and gossip about other performers. At one point I asked him why he happened to choose a young unknown player like Chet Baker to play with him when he could pick and choose from the many great musicians in Los Angeles at the time. Bird replied, "Pure and simple, man, he plays pure and simple. A little like Bix. He blows sweet and honest. Know what I mean?" After hearing Bird make that evaluation of Chet Baker, we all listened more carefully to this new, young player with the pretty prize-fighter's face.

My famous house guest stayed the rest of the weekend swimming and eating. He had an enormous appetite. During one hilarious moment, I photographed Bird standing at the end of the diving board above the swimming pool. He was stark naked, covered only by his alto saxophone on which he was playing a very funny rendition of *Moon Over Miami*. Unfortunately, that negative was lost in a flooding of my studio a few years later. On Monday afternoon my parents returned home. I greeted my mother excitedly and told her that the greatest jazz musician in the world had been my house guest that weekend. My mother smiled and replied, "That's nice, dear. Did you give him something to eat?"

153
Charlie "Bird" Parker, La Crescenta, 1951

155 *Charlie "Bird" Parker, La Crescenta, 1951*

157

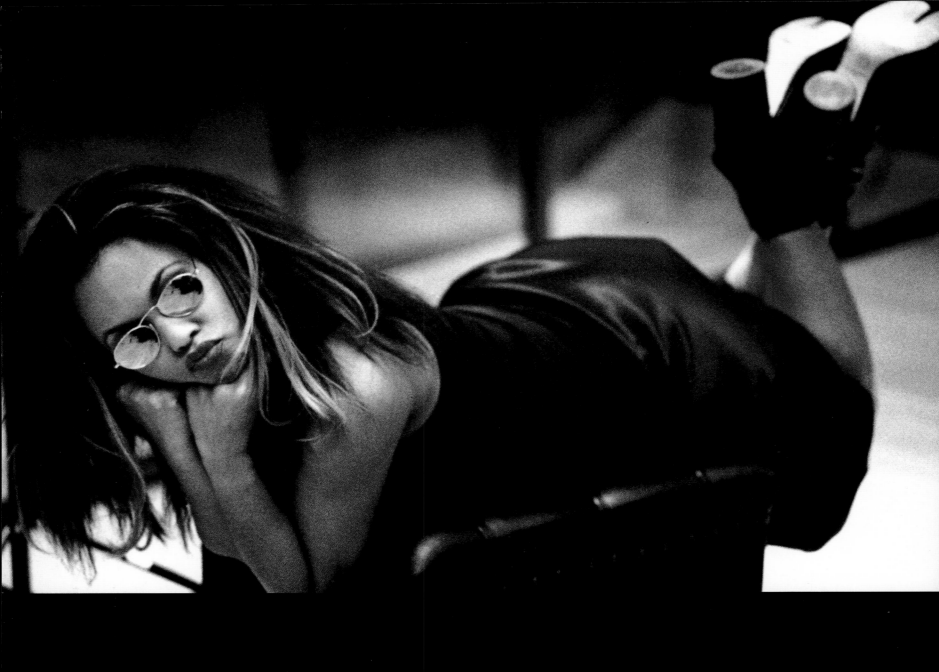

N'Dea Davenport, London, 1993 156

Diana Ross, New York City, 1993

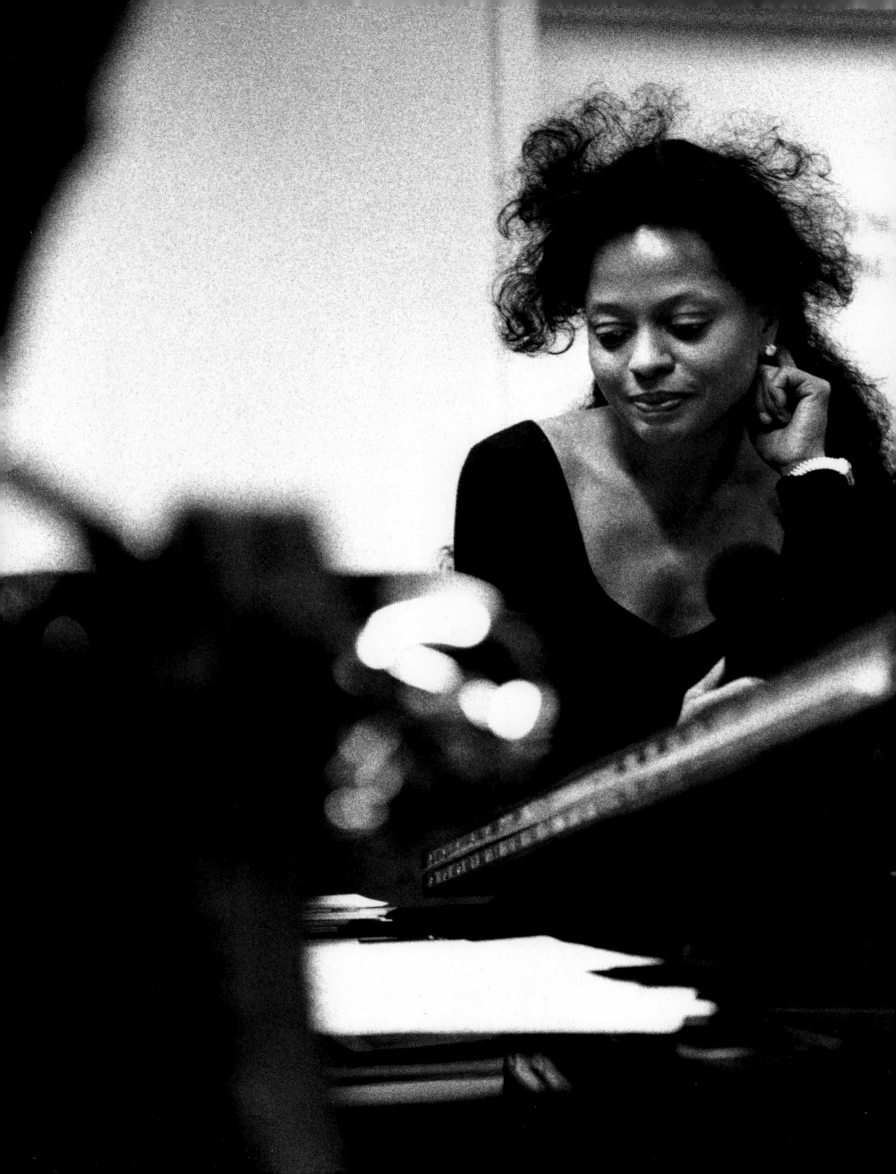

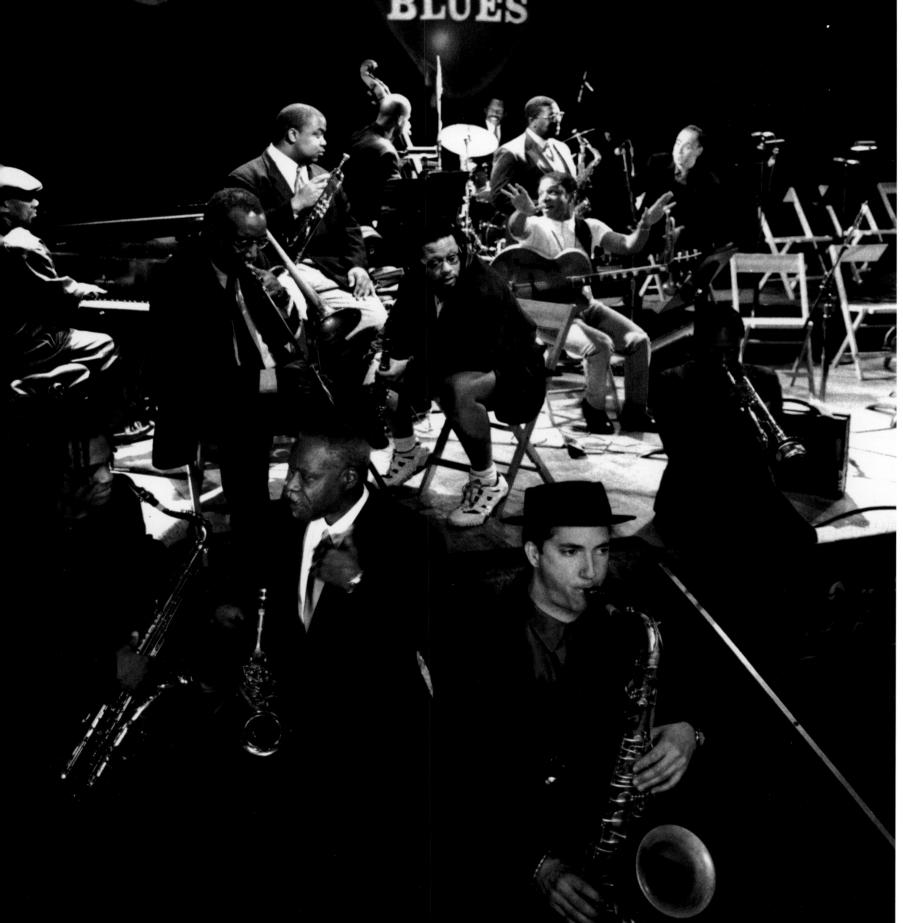

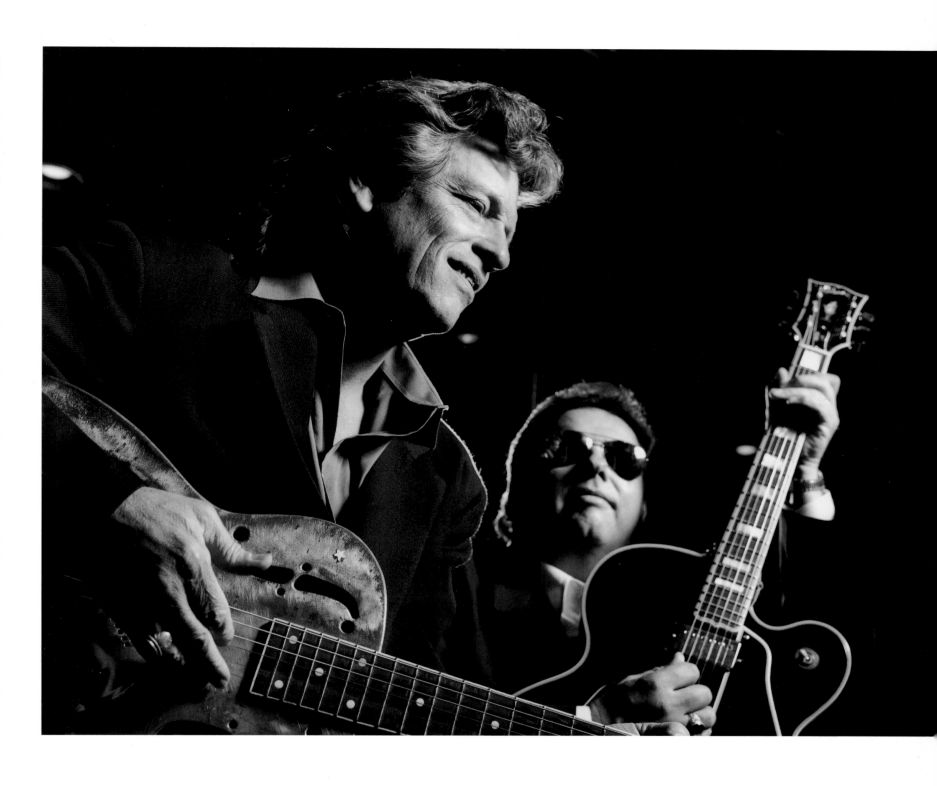

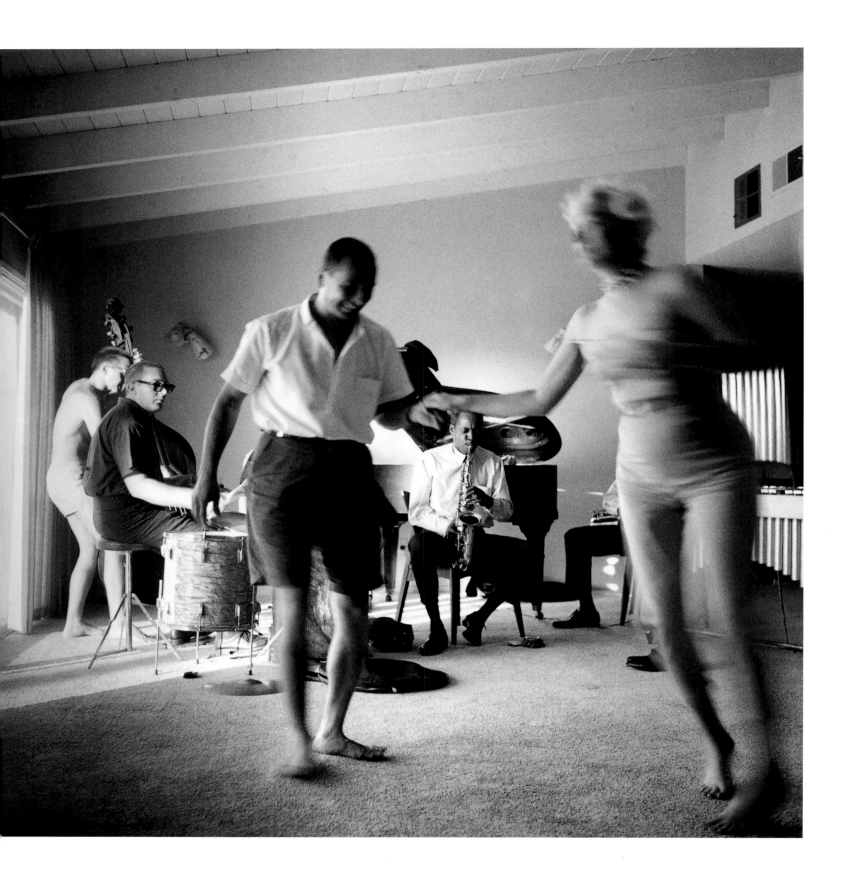

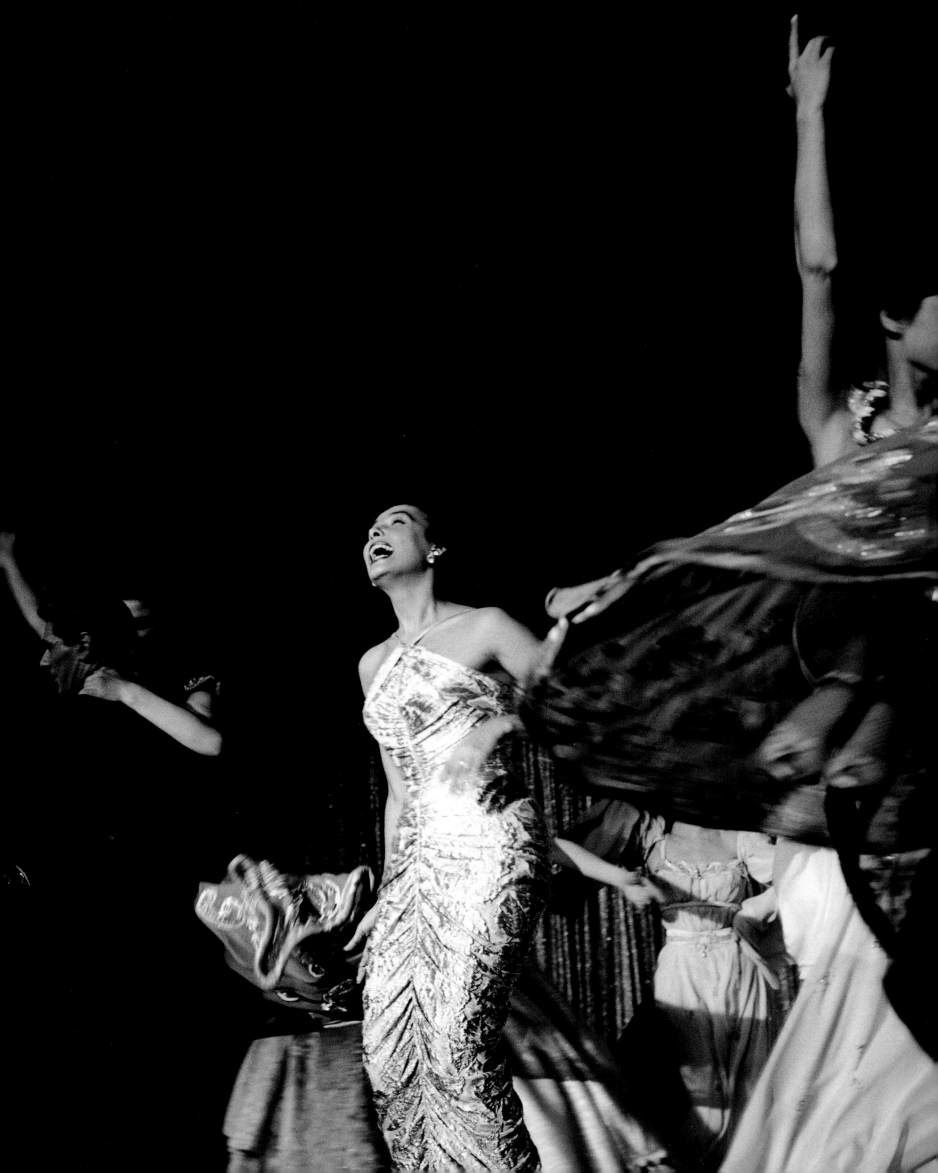

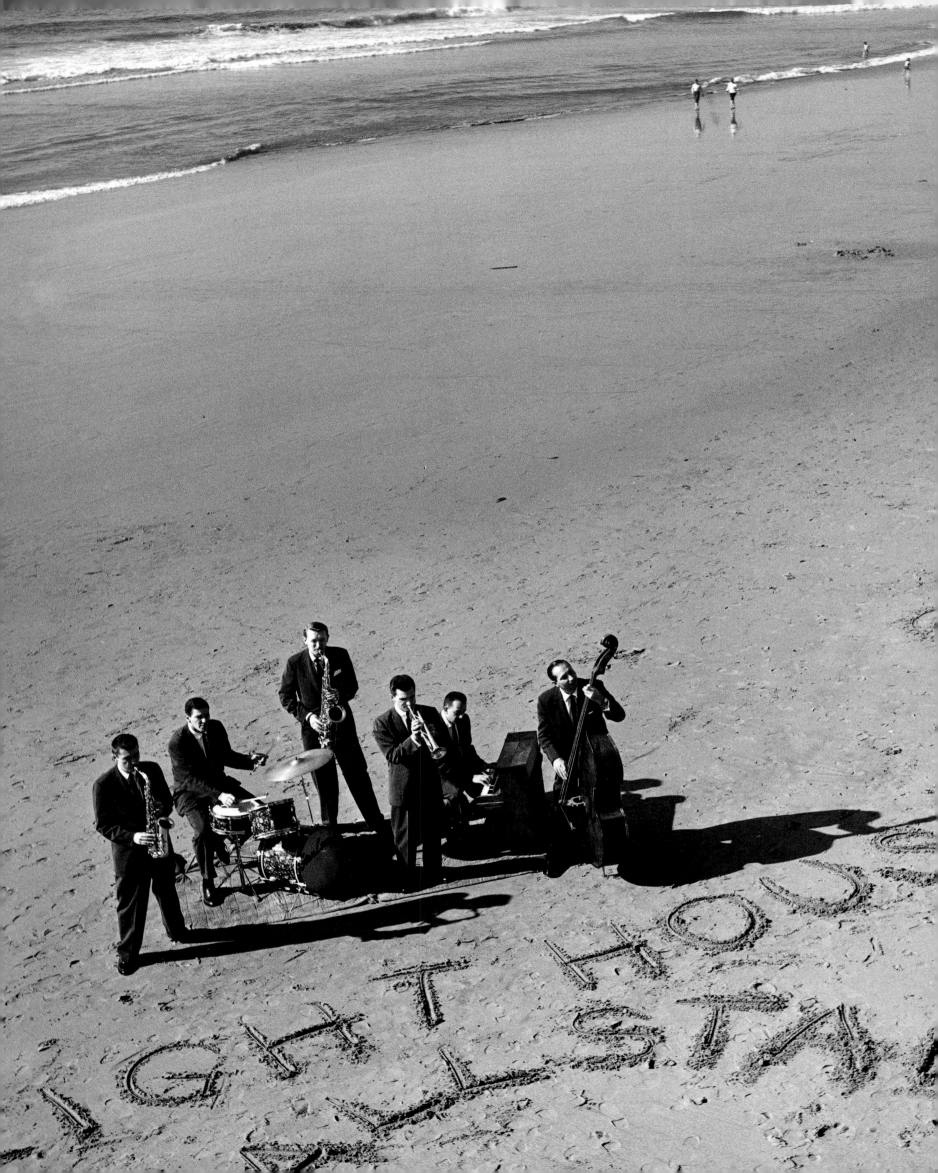

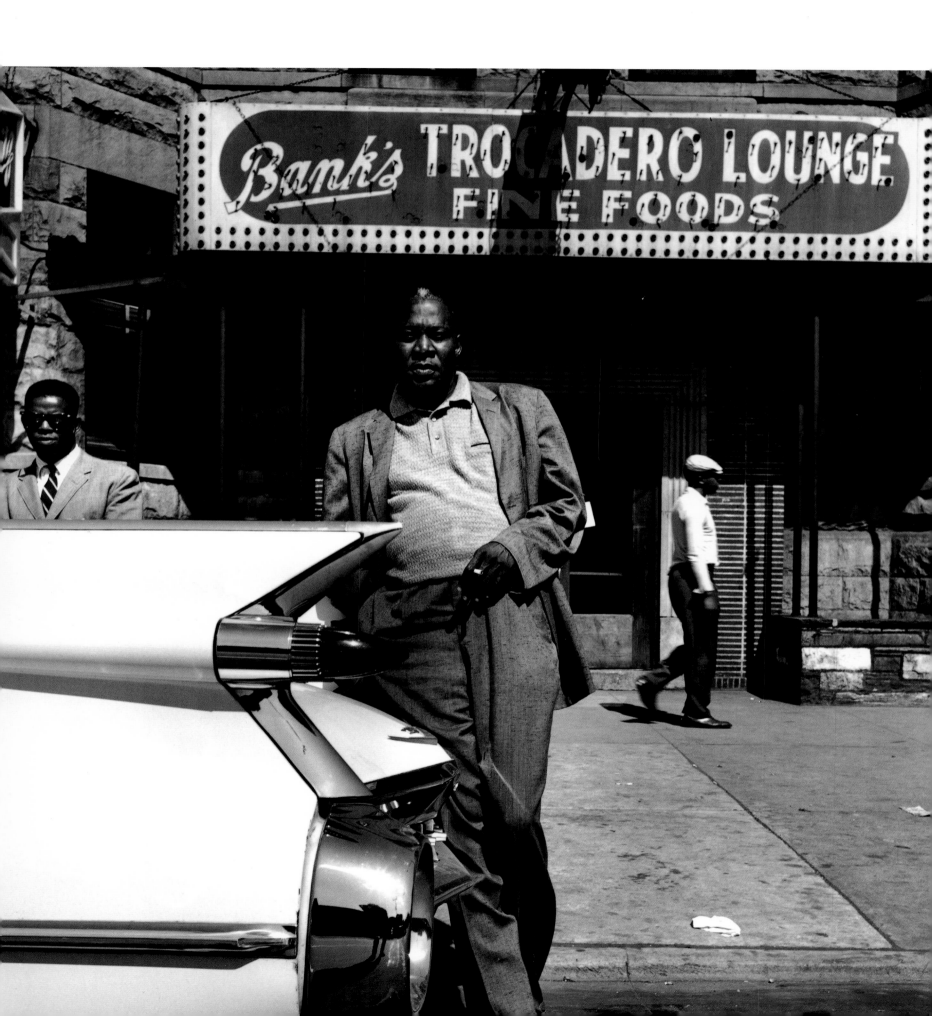

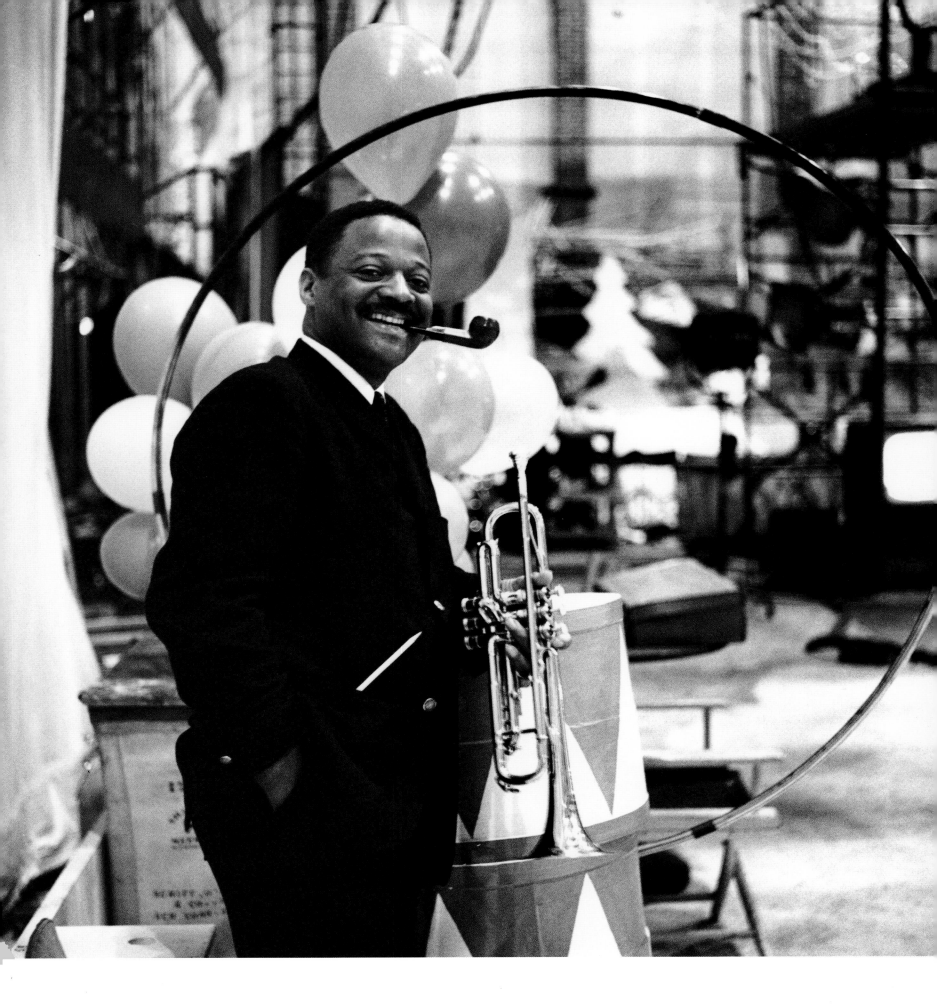

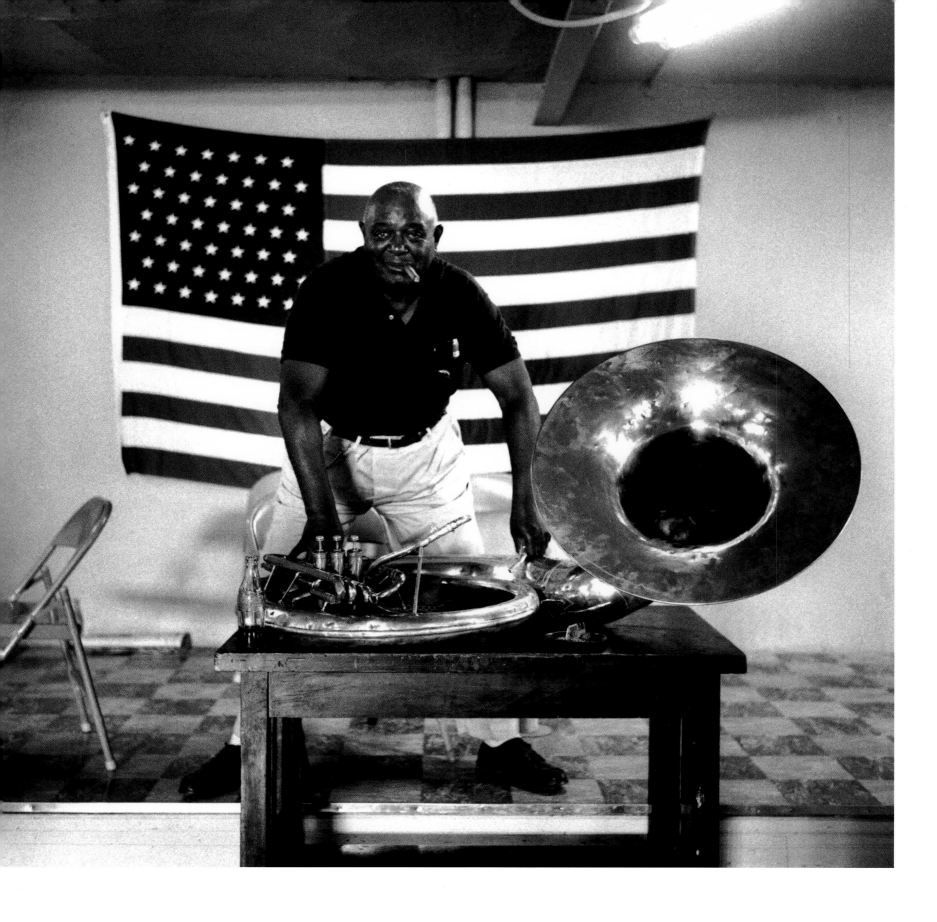

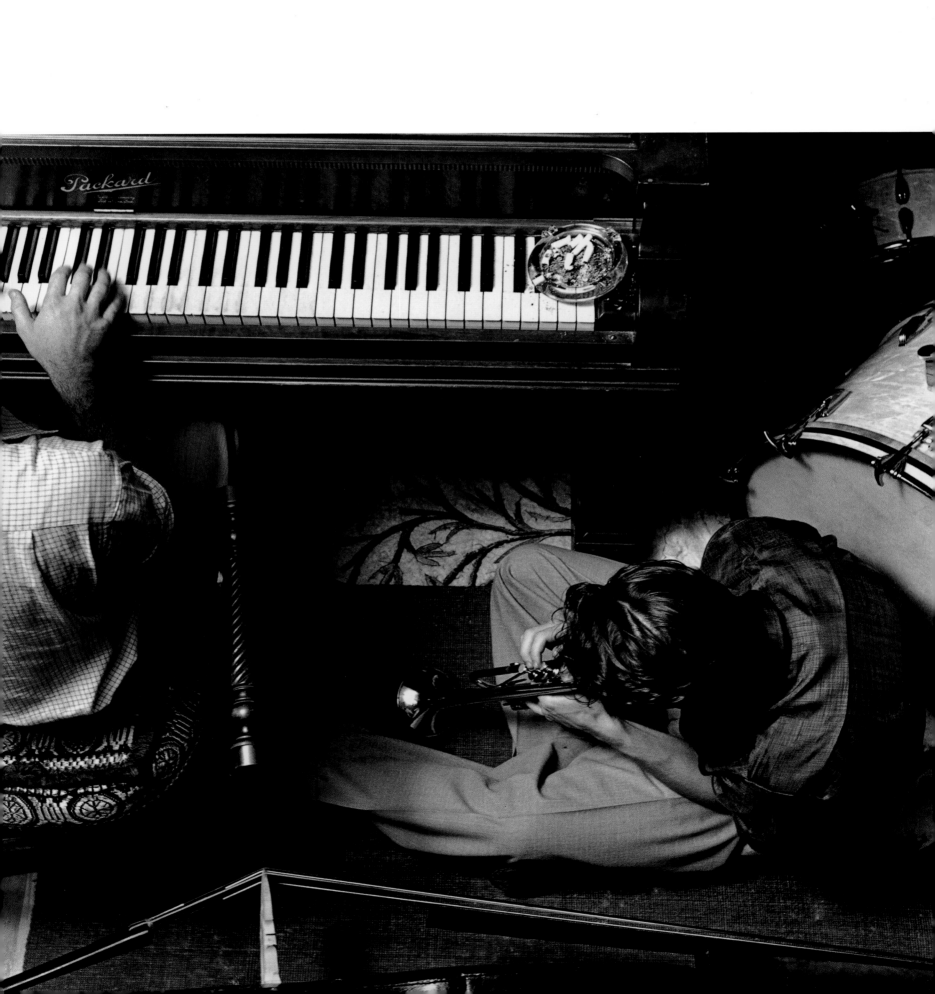

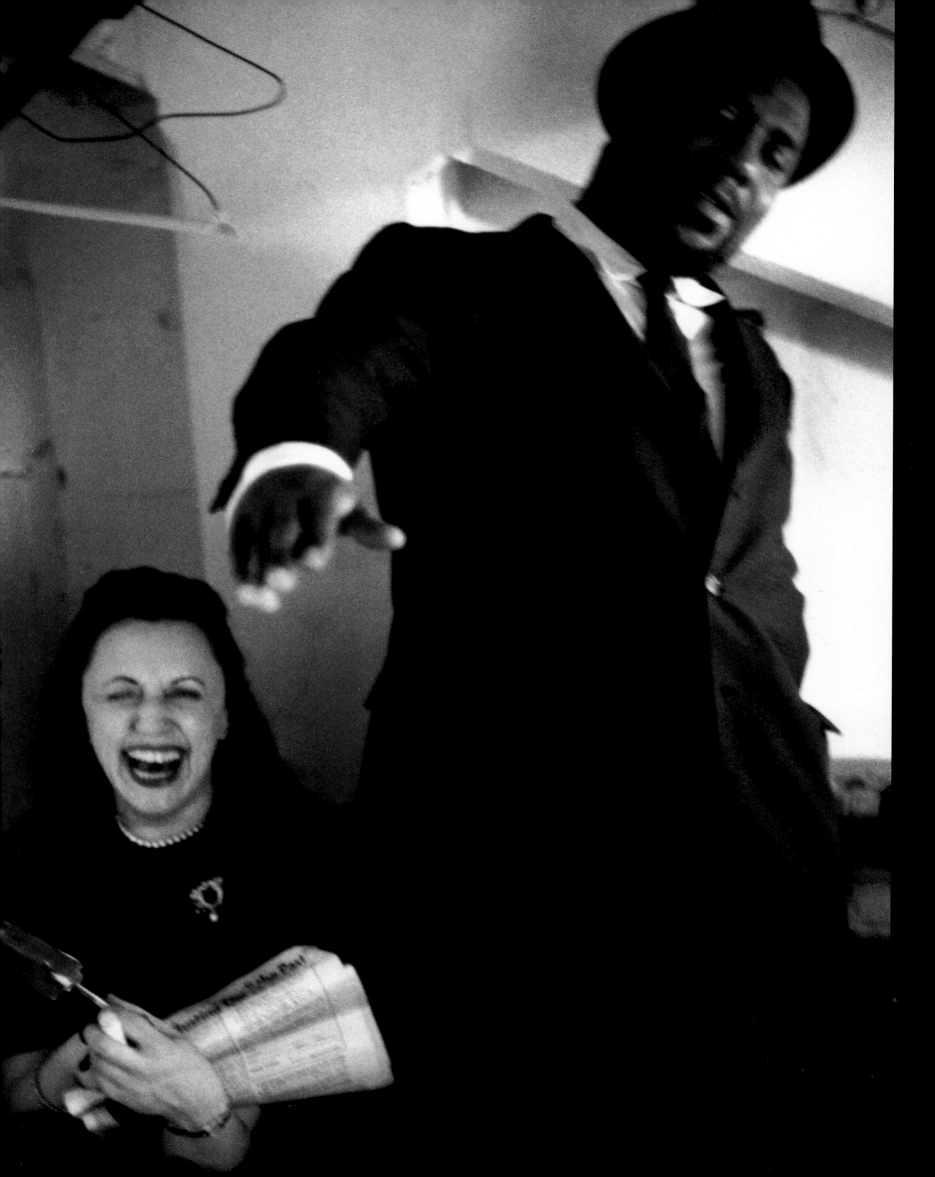

Orrin Keepnews of Riverside Records hired me to photograph Thelonious Monk in San Francisco for the cover of his new, upcoming album which was to be recorded in that city. Orrin said, "Maybe you can get a shot of Monk on one of those cute little cable cars or on anything with a San Francisco flavor." He went on to warn me that sometimes Monk was not very cooperative with photographers and their ideas.

At the designated hour, my bride, Peggy, and I picked Monk up at his hotel punctually. All was well, so far. I sensed that Monk was a bit grumpy. After all 3 o'clock in the afternoon was early for any jazz musician. So, rather than go directly to shoot pictures, I suggested that we go have some food. Monk liked that idea. We took him to a colorful outdoor cafe in the North Beach area where we began with Champagne cocktails. At one point, Monk turned to me and asked where were we going to shoot the pictures. I told him the cable car idea whereupon he frowned, shook his head and said, "Oh, man. I got no eyes for that cable car stuff, period." I ordered another round of drinks. During some point in our conversation, I said to Monk, "Did you know that a rather good spoonerism can be made of your name? Thelonious Monk can be Melodious Thunk!" That broke him up.

Many Champagne cocktails later and a little food, Monk turned to Peggy and me and toasted us and said, "That cable car idea sounds pretty funny; let's do it!" We shot that picture and had a lot of fun doing it. It turned out to be a rather good cover.

Later we passed by an open door to what turned out to be an empty music hall with a grand piano in the middle of the room. Monk sat down at the piano and played for almost an hour. So, Peggy and I were treated to a private performance by the great Monk.

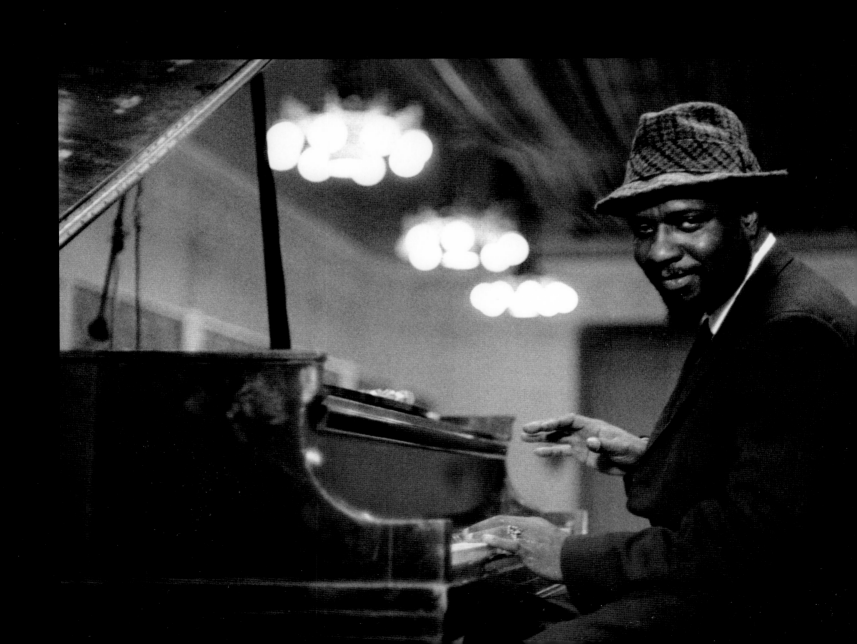

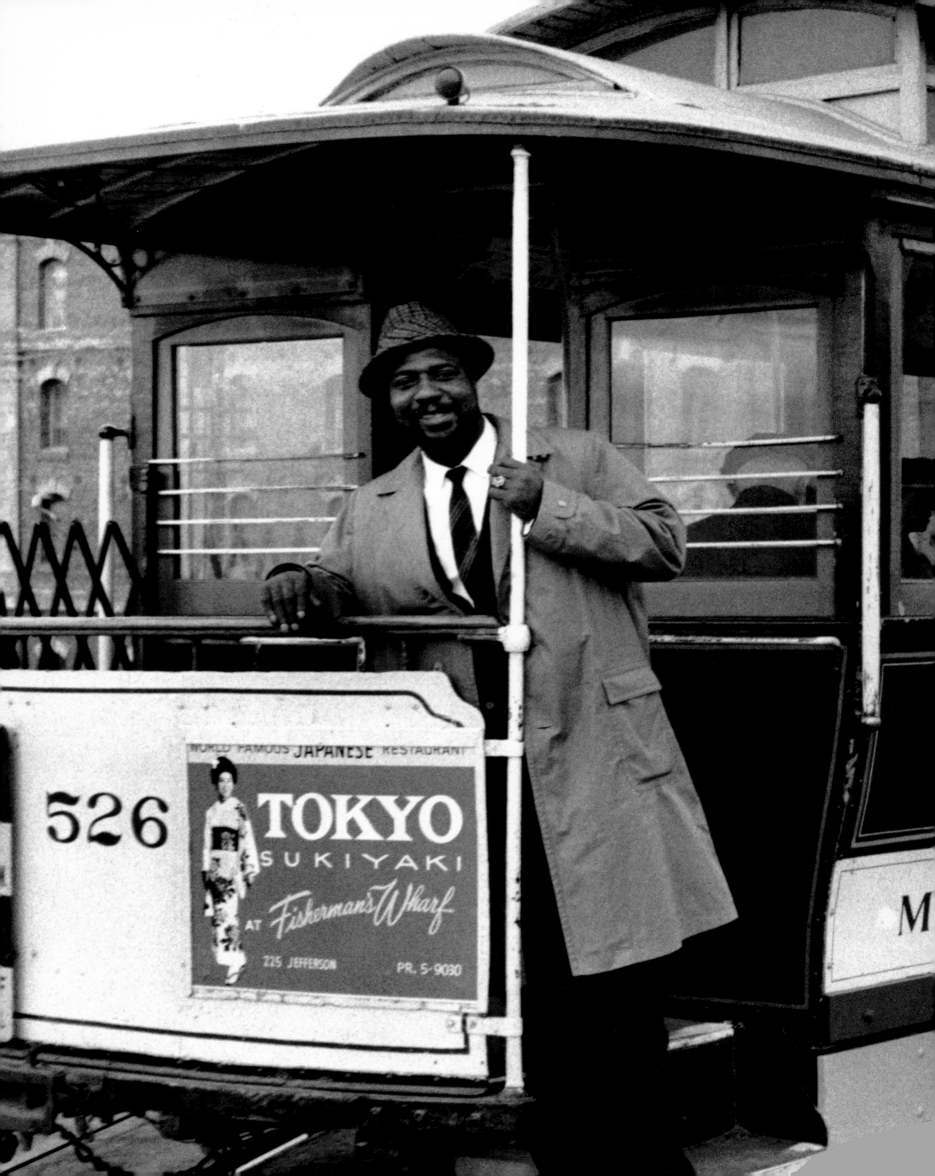

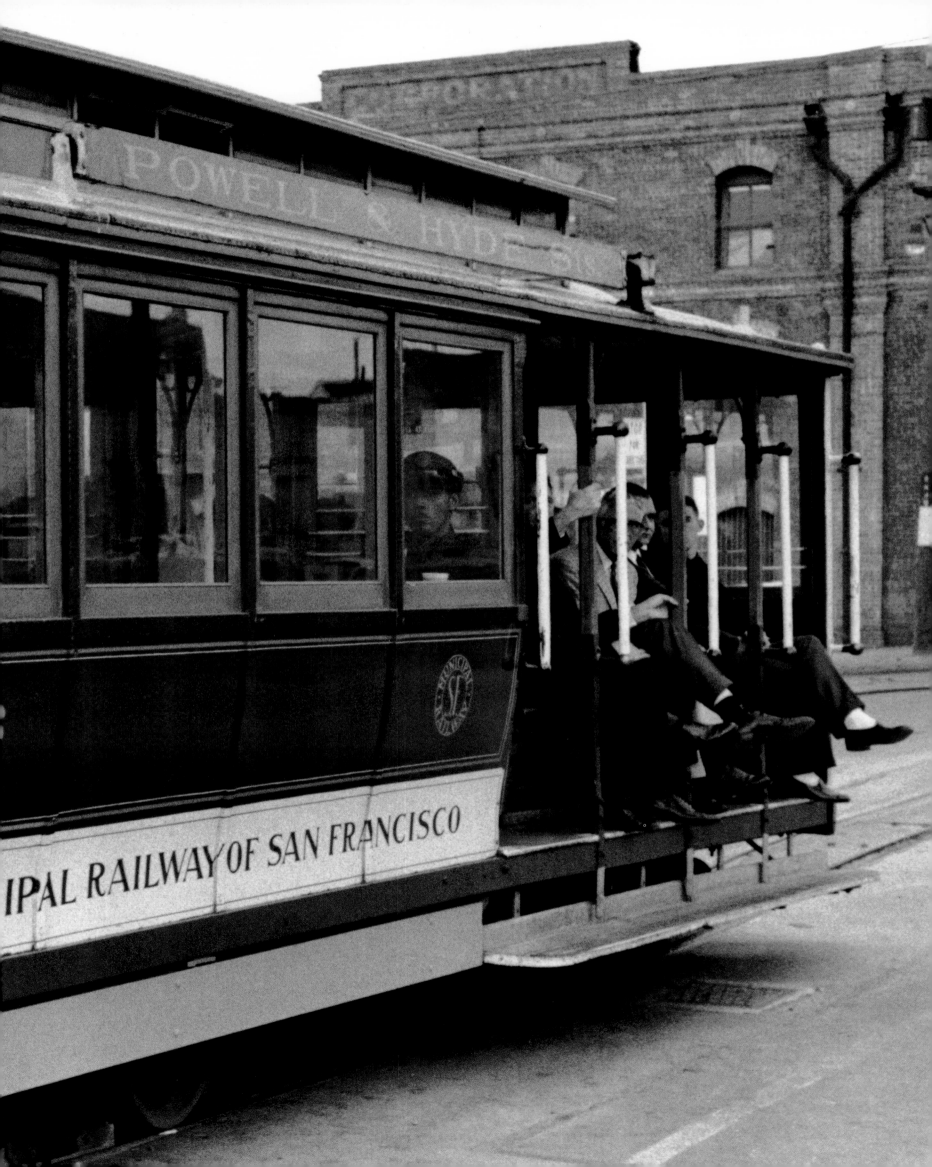

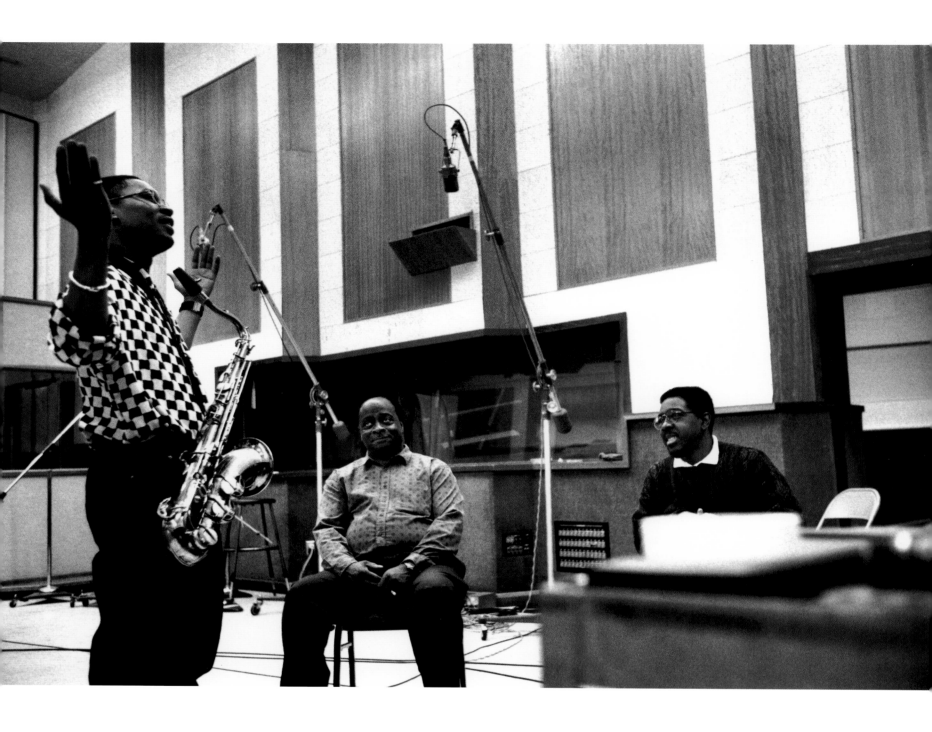

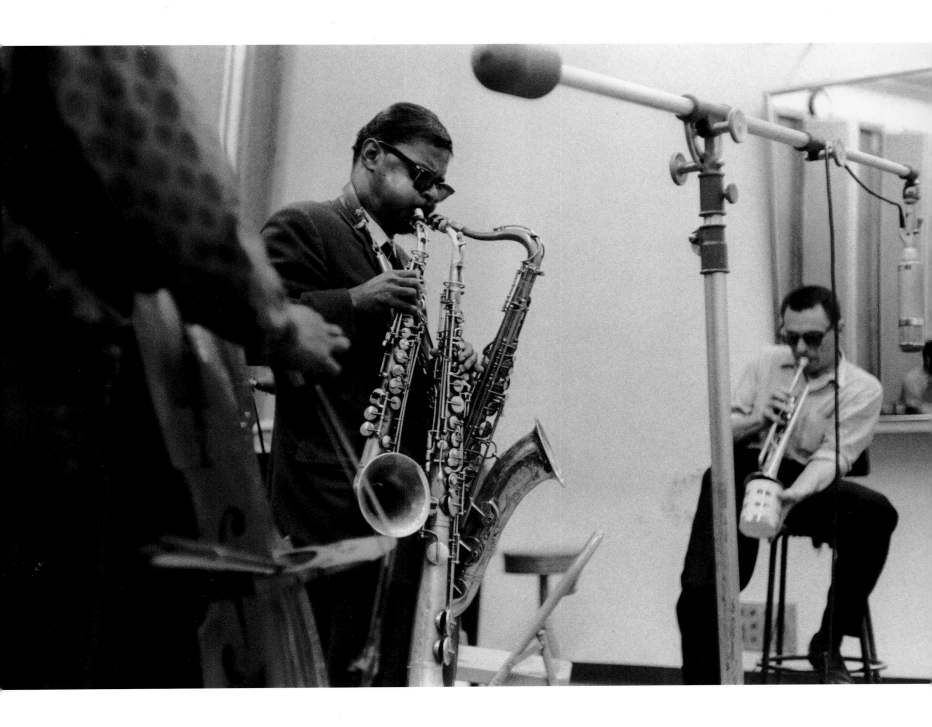

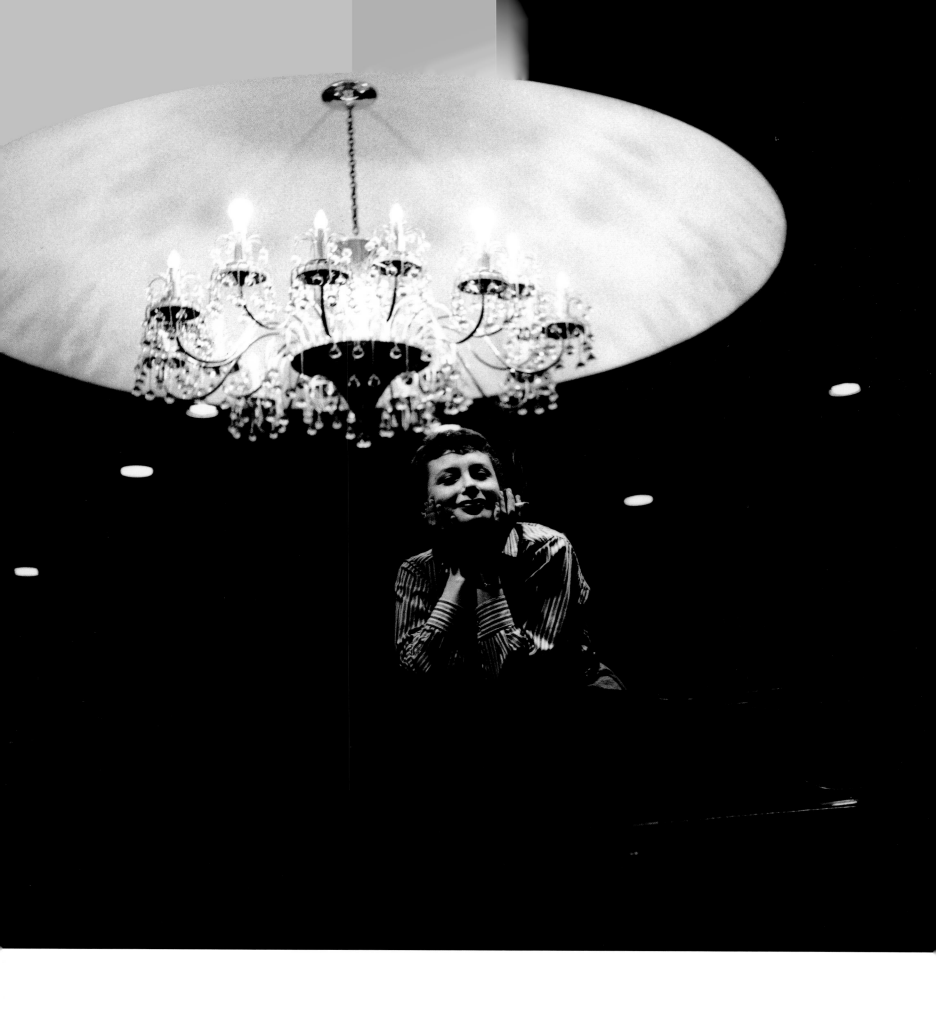

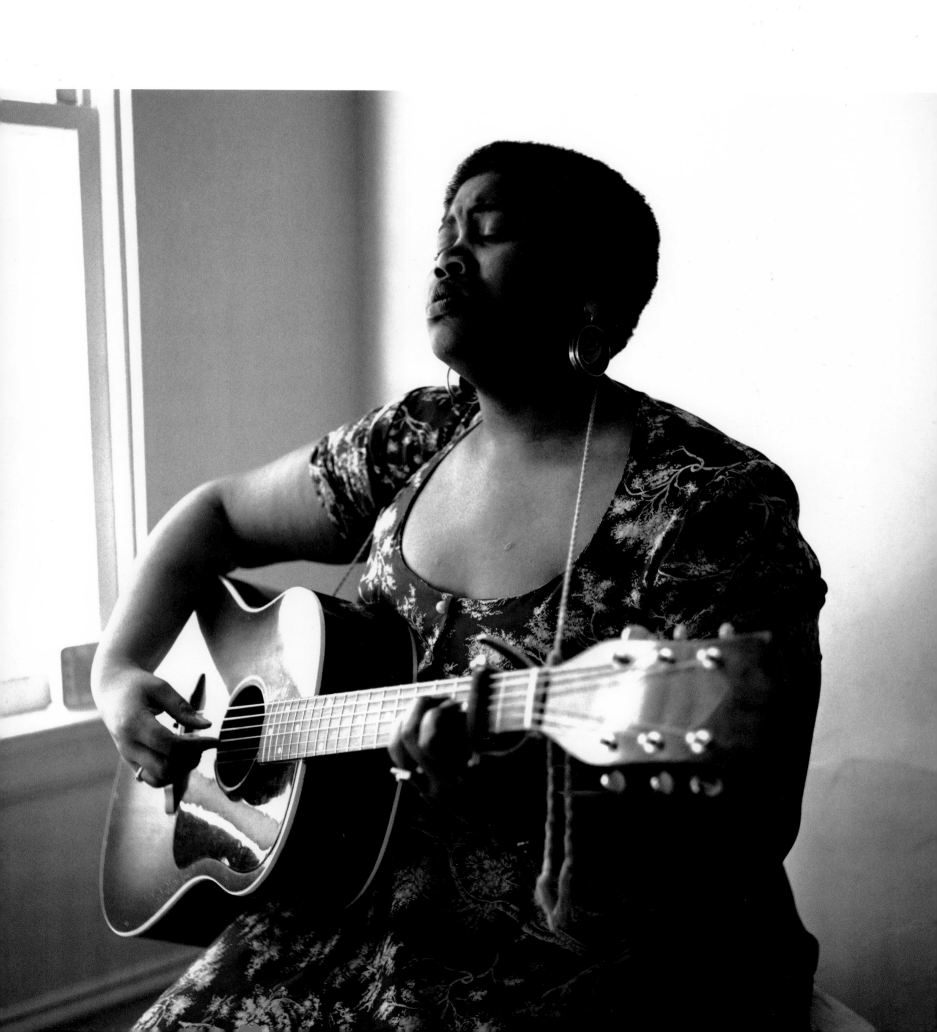

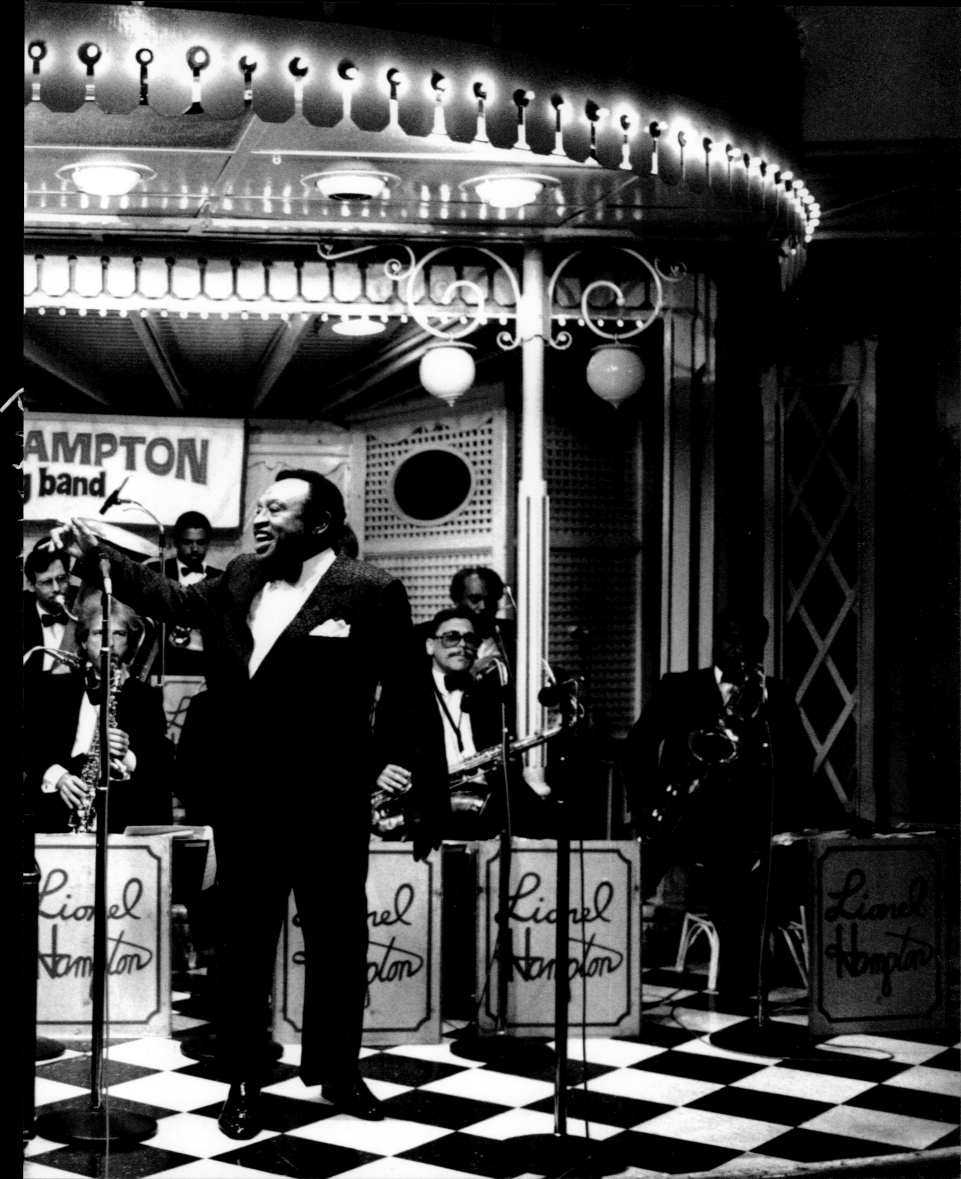

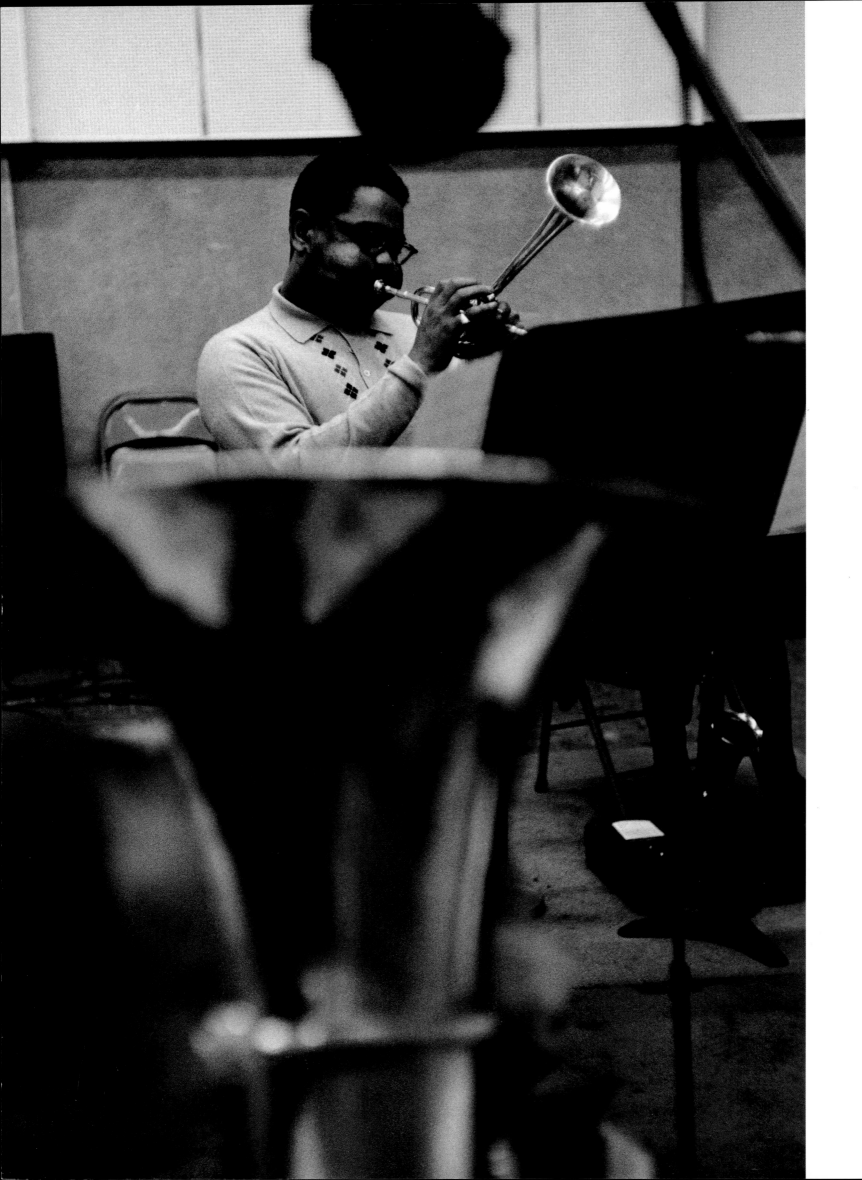

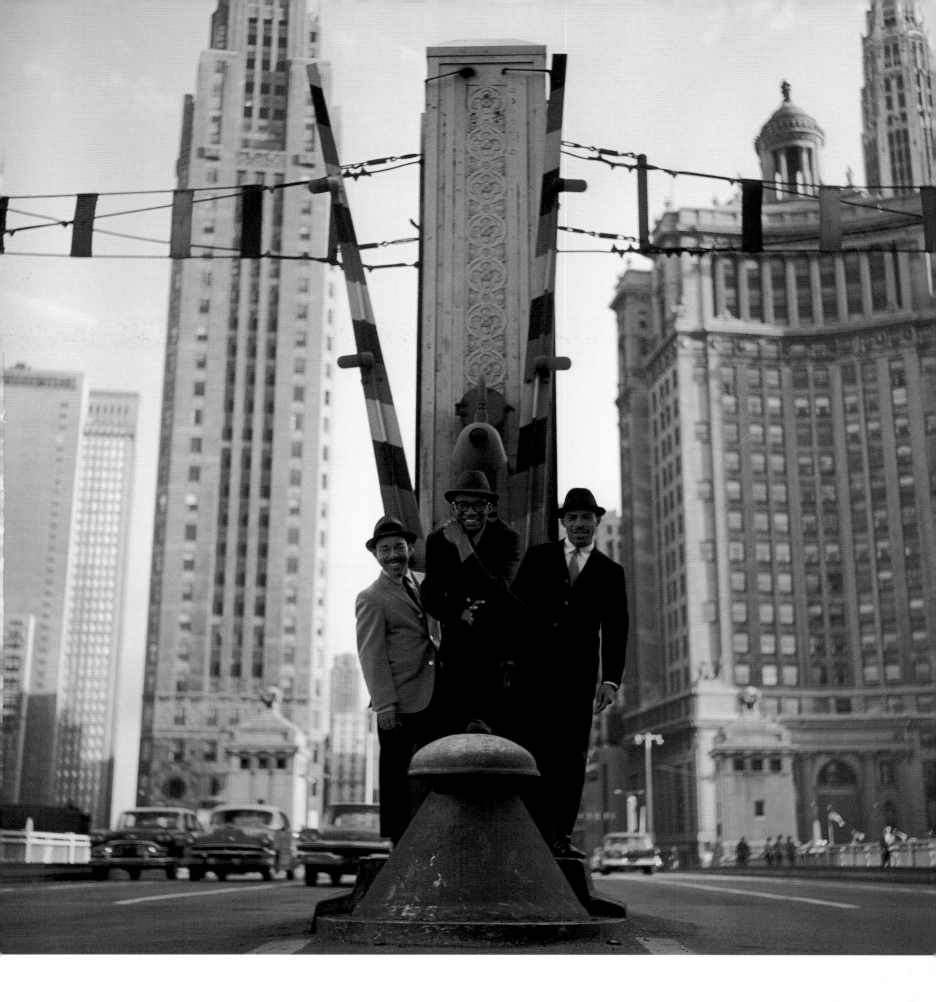

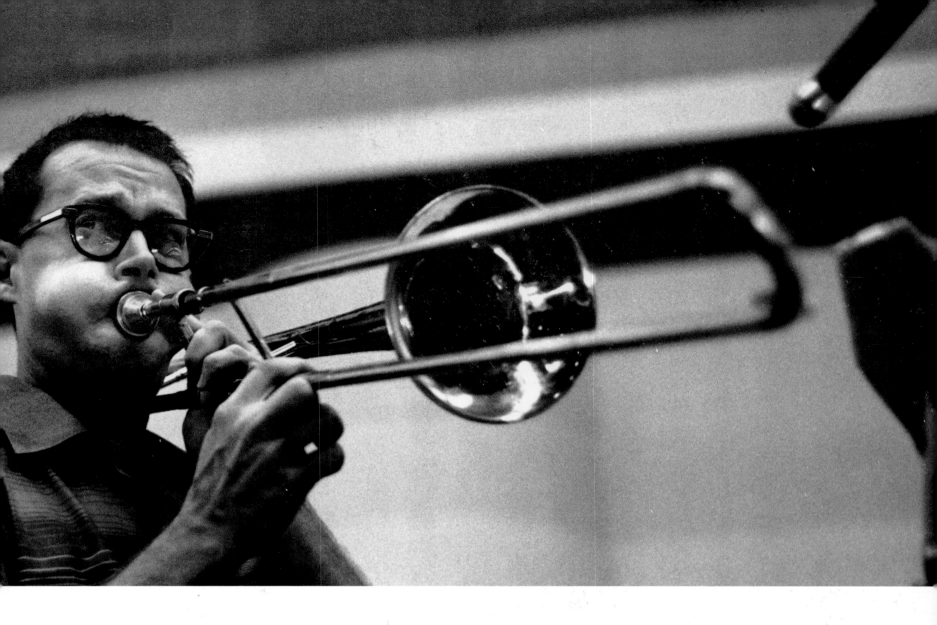

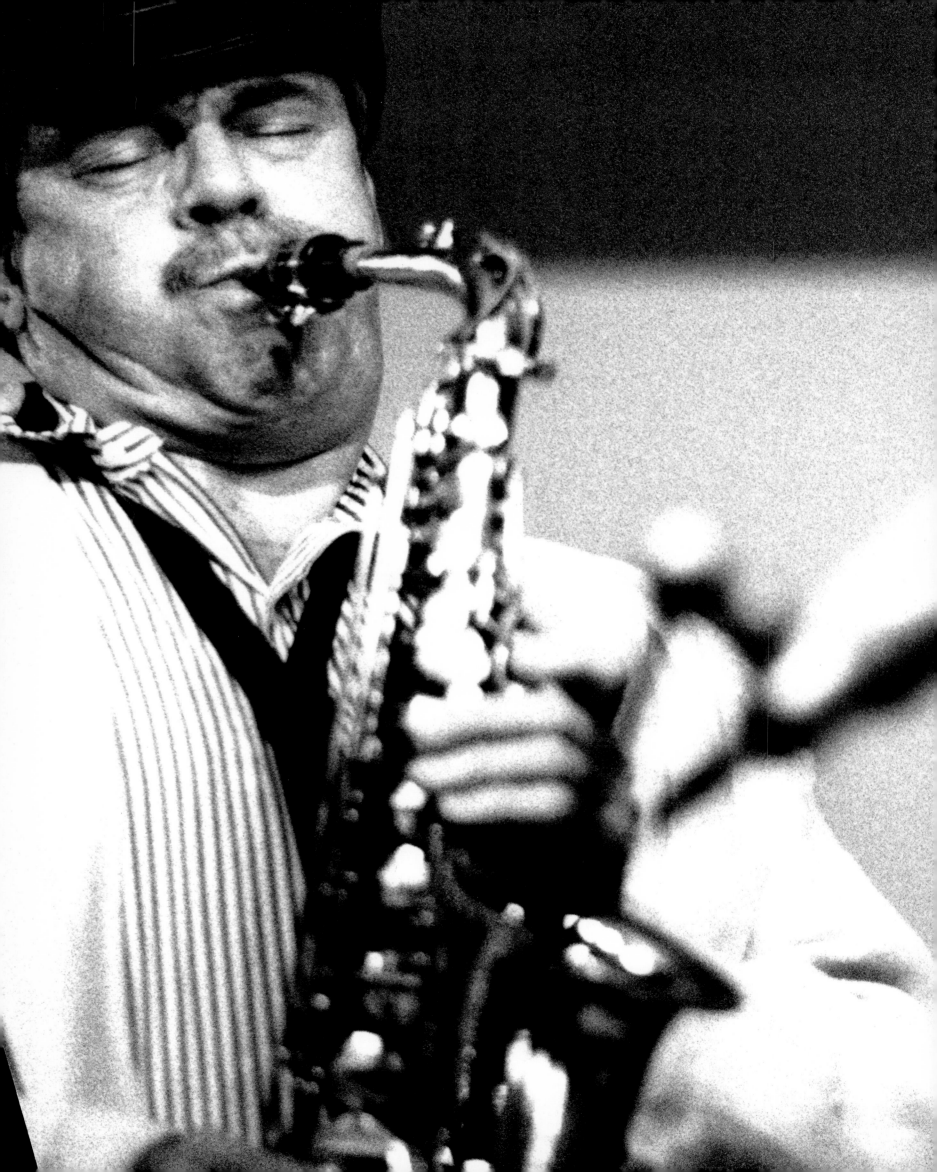

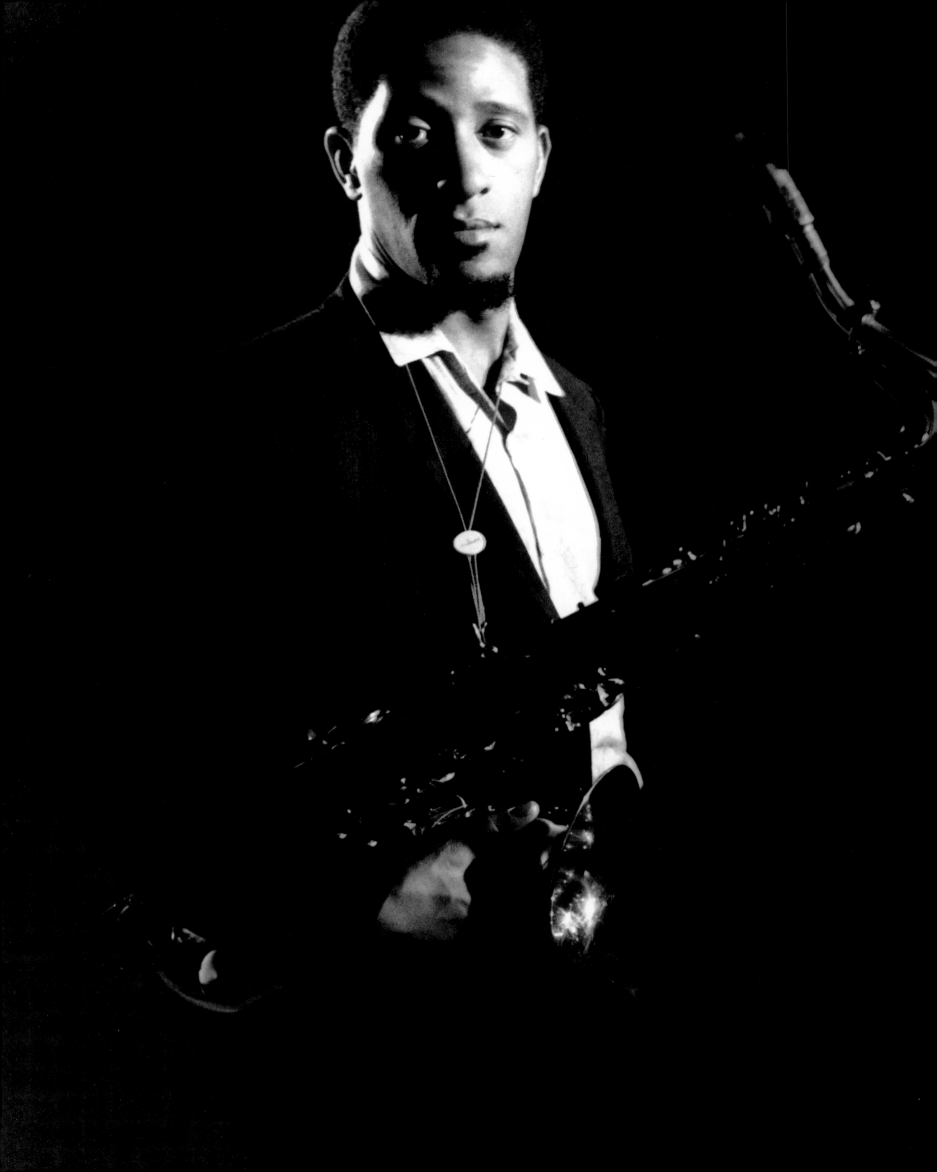

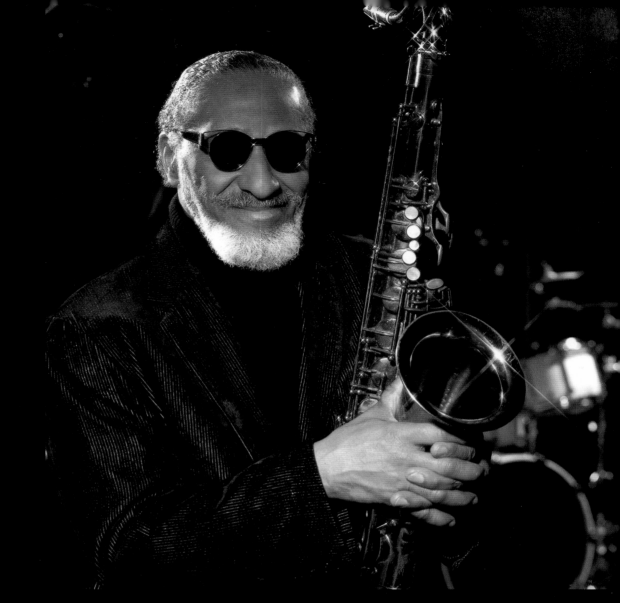

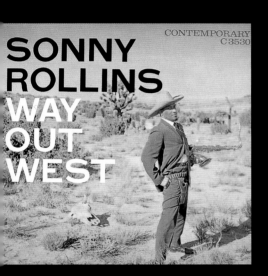

When the west coast of the United States was enjoying a jazz renaissance in the 1950s, Sonny Rollins made his first trip to Los Angeles. He was warmly welcomed, and Les Koenig wanted to be the first to record him on his Contemporary Records label. I'm not sure whether it was I, Sonny or Les who thought up the idea of photographing him dressed in cowboy attire, but I took Sonny to Western Costumers in Hollywood and had him fitted with a ten-gallon cowboy hat, gathered up a belt, holster and six-shooter and headed out to the Mojave Desert to photograph his record cover. Sonny and I had great fun, and the album cover became famous.

When Sonny returned to New York, his fellow jazz players put him down and chided him about the "outrageous" cover picture. I heard from various sources that he was not happy with my using that picture on the cover of his album.

Forty years later, the Rico reed musical instrument people hired me to photograph Sonny for an important national advertisement showing Sonny using their reeds. When Sonny and I met to photograph this ad, Sonny was gracious and "forgiving" towards me for that 1957 "outrageous" *Sonny Rollins, Way out West* cover picture.

The first time I laid eyes on Miles Davis was in the summer of 1949. It was during my first visit to the "Apple" (New York City) as an adult. My friend, musician Allen Eager, was showing me around the city, and one night we were walking through the theater district. As we turned the corner of Broadway and 44th Street, I spotted Miles walking towards us. He was dressed in a black Brooks Brothers suit, white shirt and a thin black, knit tie. He was flanked on either side by two of the most gorgeous fashion models I had ever seen. On his left arm was Dorian Leigh, and on his right arm was the very blond Sunny Harnett. Both girls were also dressed in black. I thought that they were the choicest people I had ever seen. They were laughing as they almost danced down 44th Street taking up the entire sidewalk. Allen and Miles greeted one another and introductions were made. Allen said, "Miles, this is my friend from out west – California – his name is Clax." Miles shook my hand and in his uniquely raspy voice said loudly, "CLAX! Sounds like a household cleanser!"

Years later, in 1965 to be exact, I met Dorian Leigh again. She ran a successful fashion model agency and represented my wife, Peggy Moffitt, for fashion work around Europe. Dorian said that she remembered our meeting with Miles, and that Miles always referred to me as that "Cowboy from Hollywood" with that funny name "Clax".

In 1957 Miles and I met again. Columbia Records had assigned me to photograph him for his next LP release, *Miles Ahead*. He showed up at my studio in Hollywood dressed in a dark brown suede jacket, a bright silk scarf and gray Glen plaid trousers, with suede shoes to match his jacket. He looked like he had just stepped out from the fashion pages of a slick men's magazine. We had a wonderful time working together. He enjoyed being photographed, and the resulting photographs were well received by the record company. It was to be on the cover of his first collaboration with Gil Evans since the *Birth of the Cool* dates in 1949. But when the record was released, the cover photo was of a pretty girl wearing a straw hat and seated on a sail boat. I was very disappointed. I supposed that the record producers thought that the image of a pretty girl on the cover would sell more records. But now I believe that *Miles Ahead* was so great as a piece of music that it would be a success with almost any image on the cover.

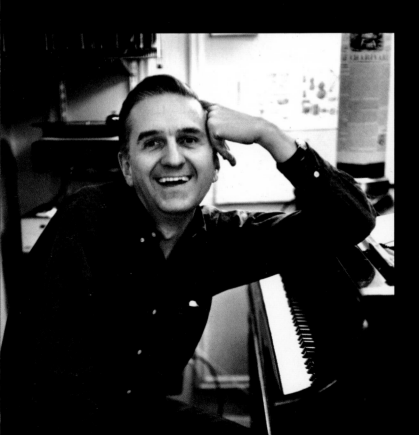

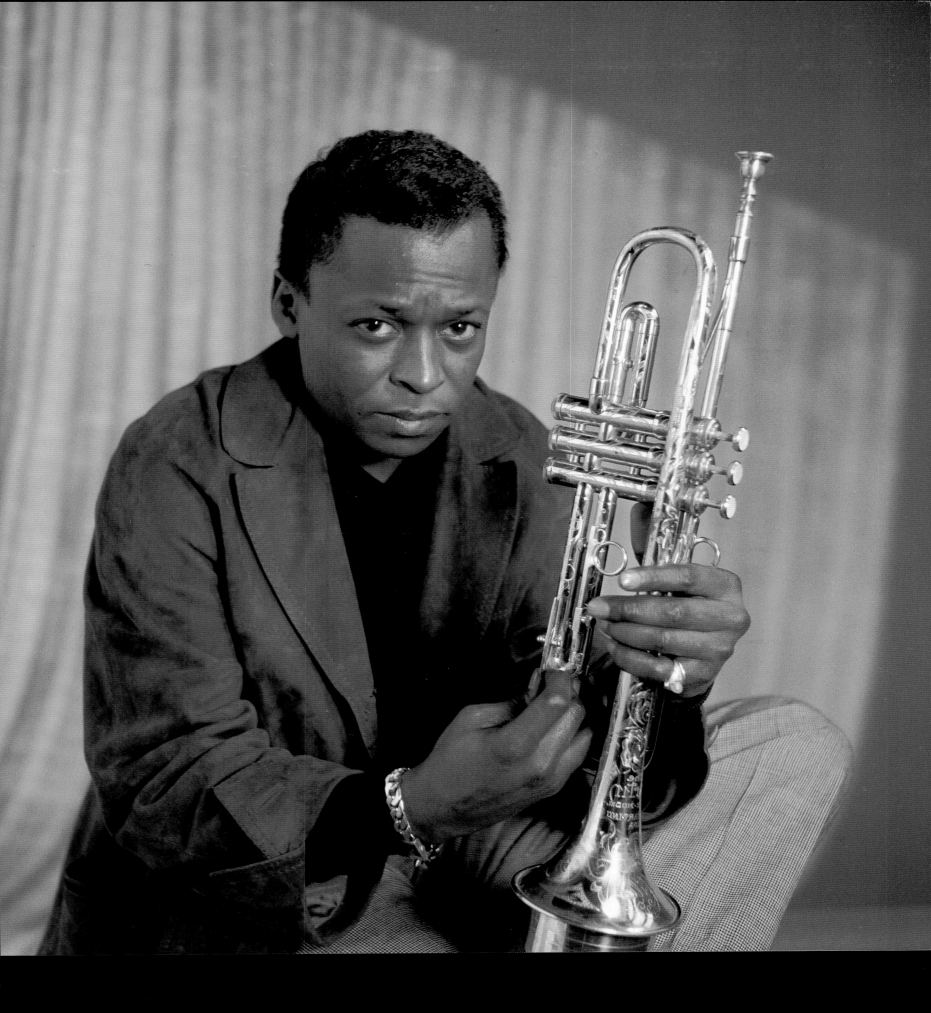

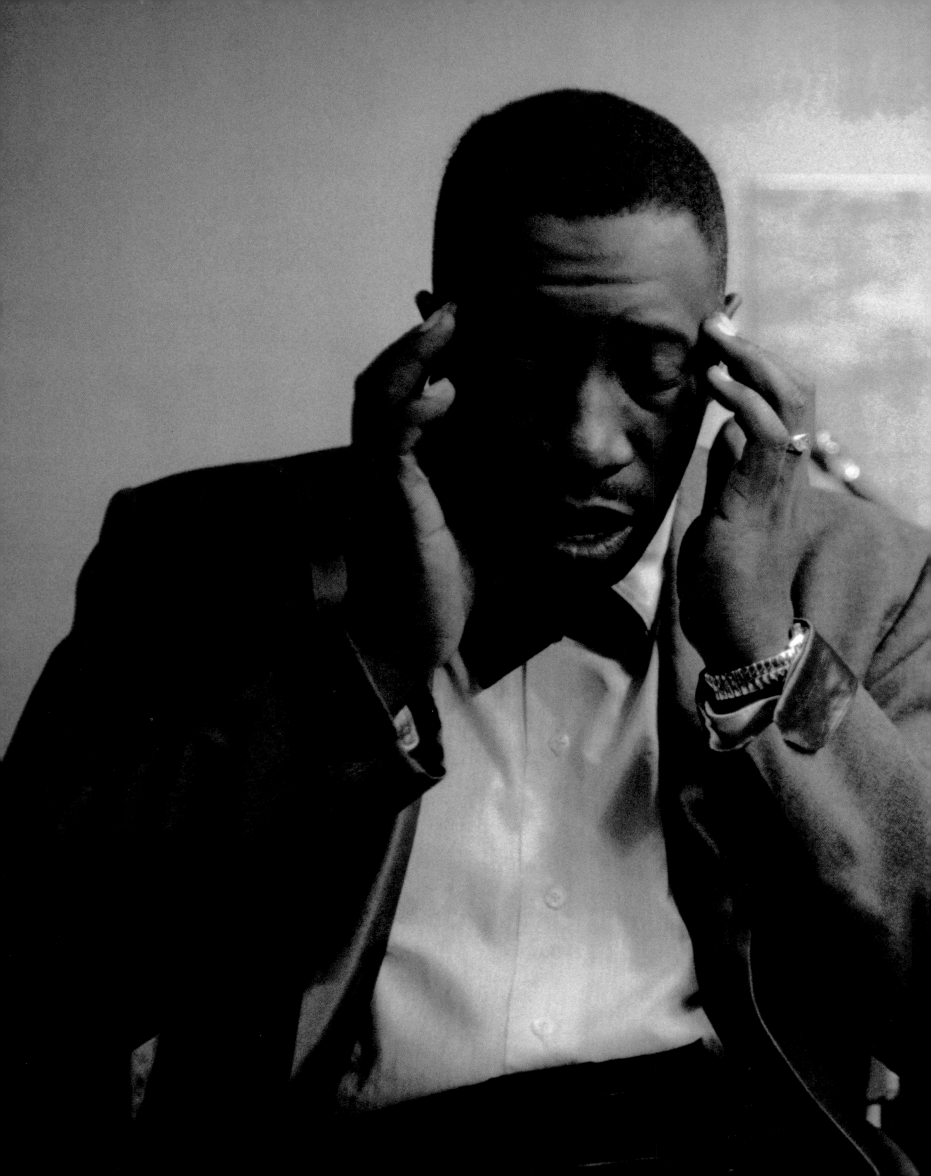

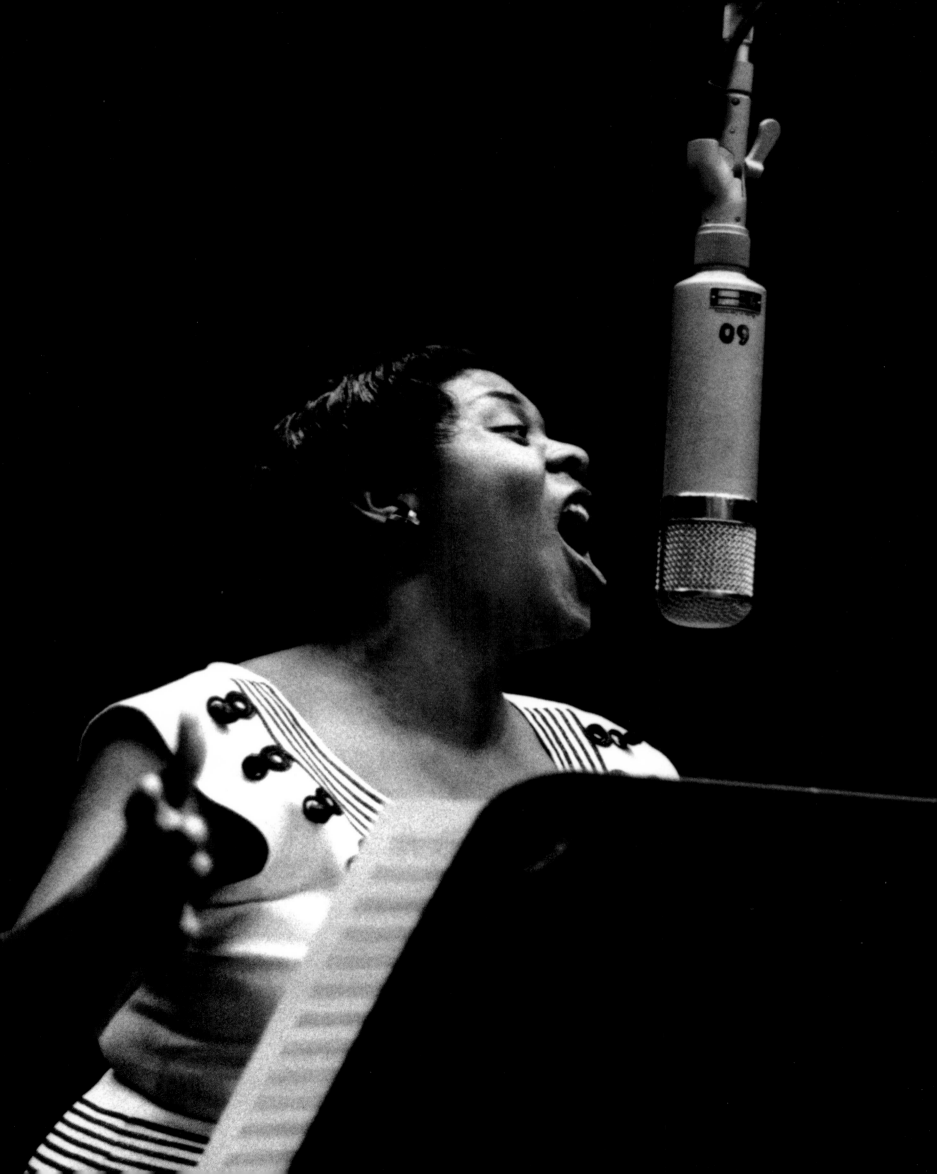

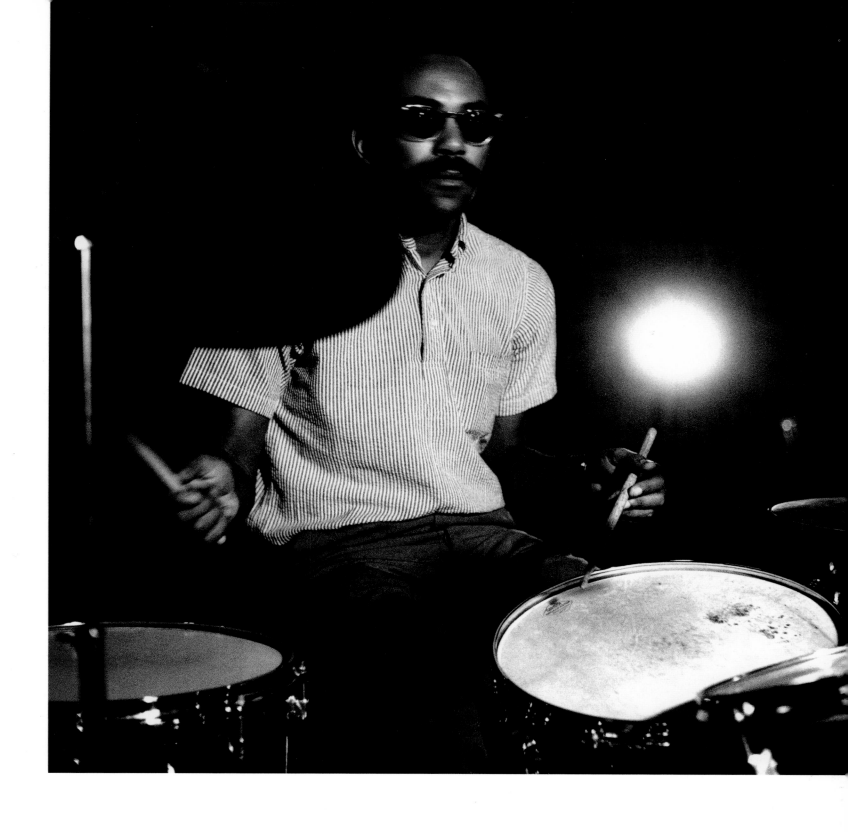

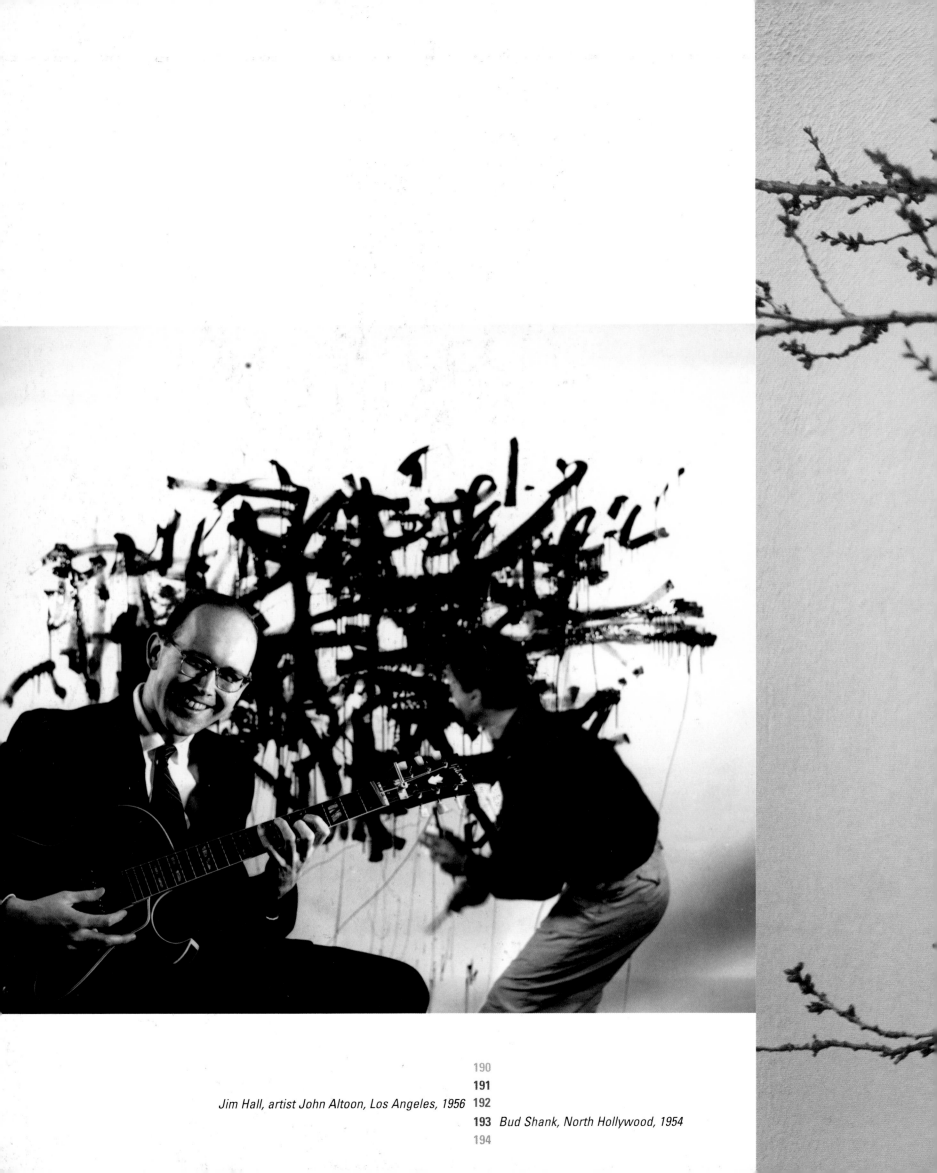

Jim Hall, artist John Altoon, Los Angeles, 1956

193 Bud Shank, North Hollywood, 1954

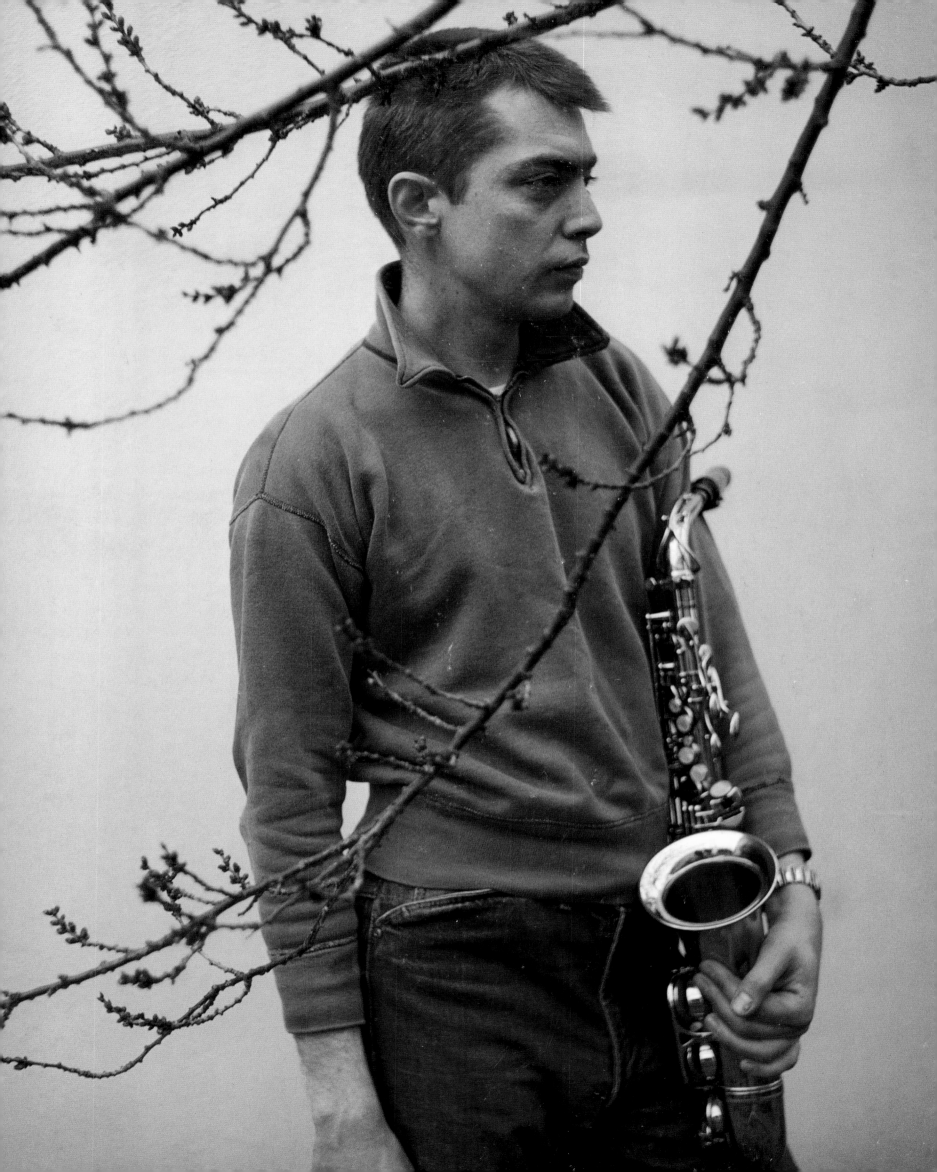

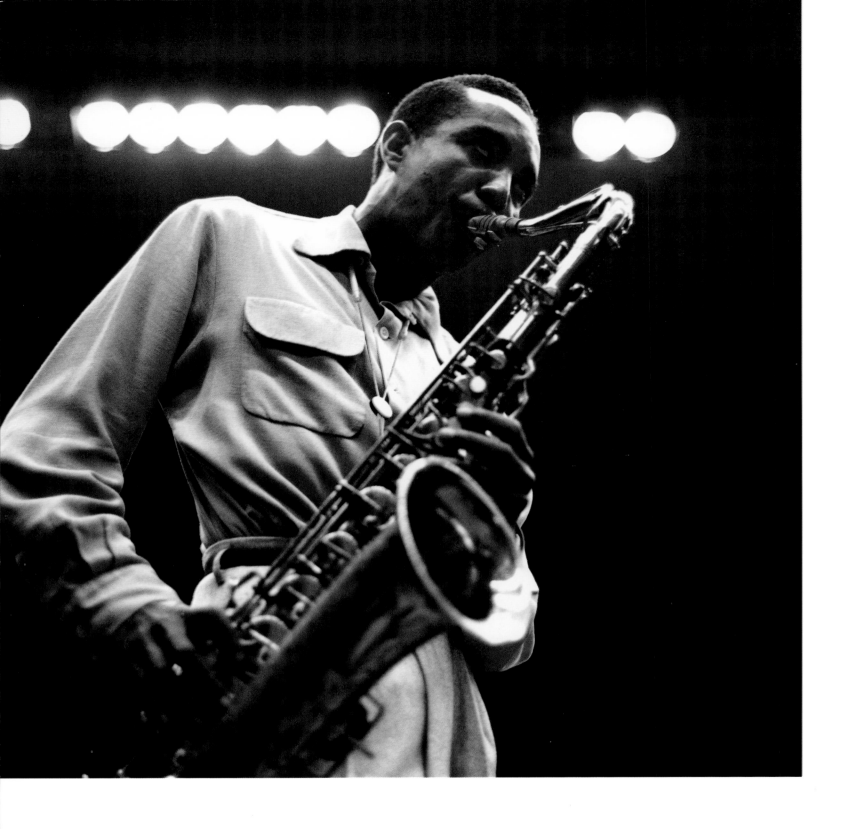

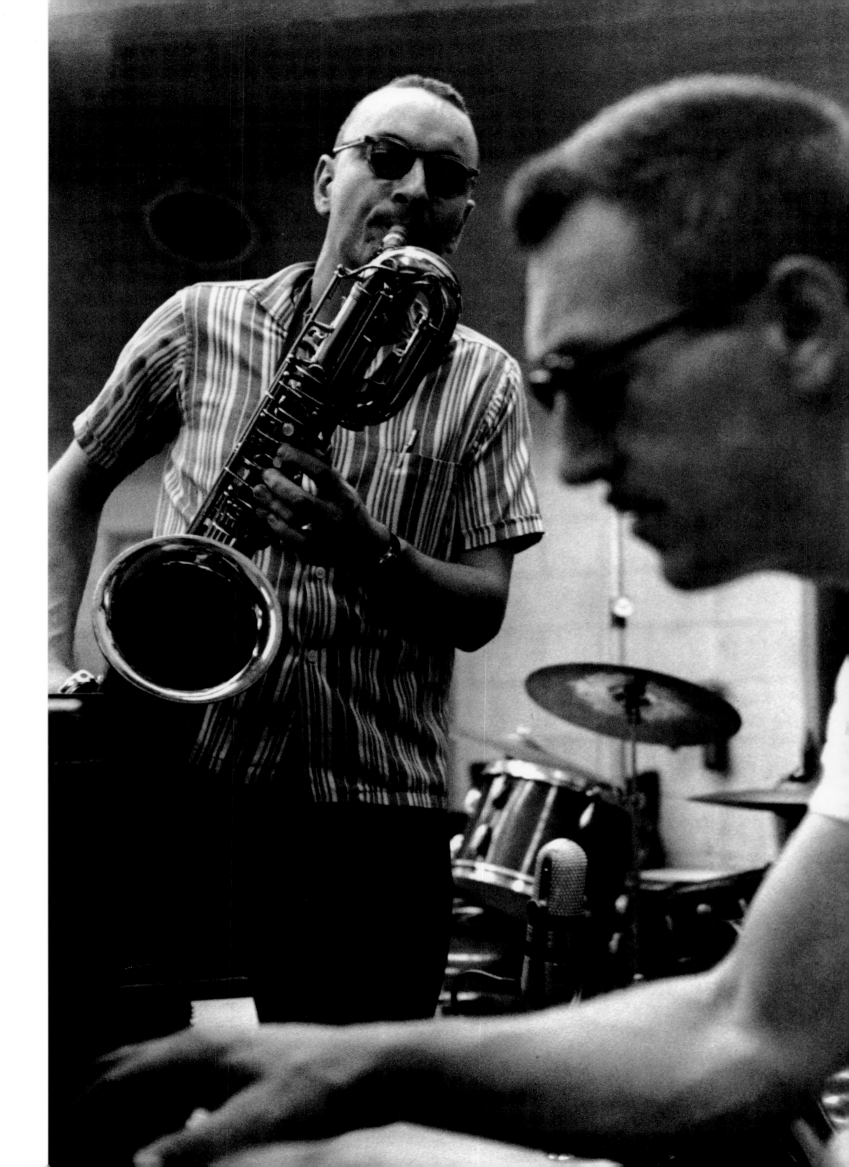

CANNONBALL ON THE BEACH

In the early 1950s I began earning a reputation for photographing jazz musicians in unusual places or against unusual backgrounds. I did this intentionally, because I wanted to get away from the stereotypically jazz musician images – sweaty venues in New York and in Chicago. In California, we had sunshine, beaches, convertibles, hilltops, great weather, and everybody was on a health kick. Even the junkies ate health food. With this in mind, I photographed Sonny Rollins wearing a cowboy hat in the middle of the Mojave Desert; Shorty Rogers high up in his son's tree house; the Ramsey Lewis Trio in the center of Michigan Avenue in Chicago with the traffic whizzing by; Ray Brown, Barney Kessel with Shelly Manne, on the *The Poll Winners Ride Again* cover, are riding on the horses of a merry-go-round; Chet Baker and His Crew on a sail boat in Santa Monica Bay; and on and on.

So, when Cannonball Adderley saw my cover of the Lighthouse All Stars on the sand of Hermosa Beach, he also wanted to be photographed on the beach for his album *The Cannonball Adderley Quintet at the Lighthouse*. However, Cannonball thought that it would be more appropriate to be dressed in "beach-attire", specifically in swimsuits. I thought about this idea and decided against it. First of all, the members of the band might not look attractive in swimsuits. But more importantly, the idea was to have them dressed in suits and ties standing on a sandy beach to bring out the incongruity of the situation and, therefore, be more amusing. Cannonball agreed, but we compromised: The group wore sporty-looking clothing. But I added a big beach ball and had them stand under a large, Japanese paper umbrella so they would look cool.

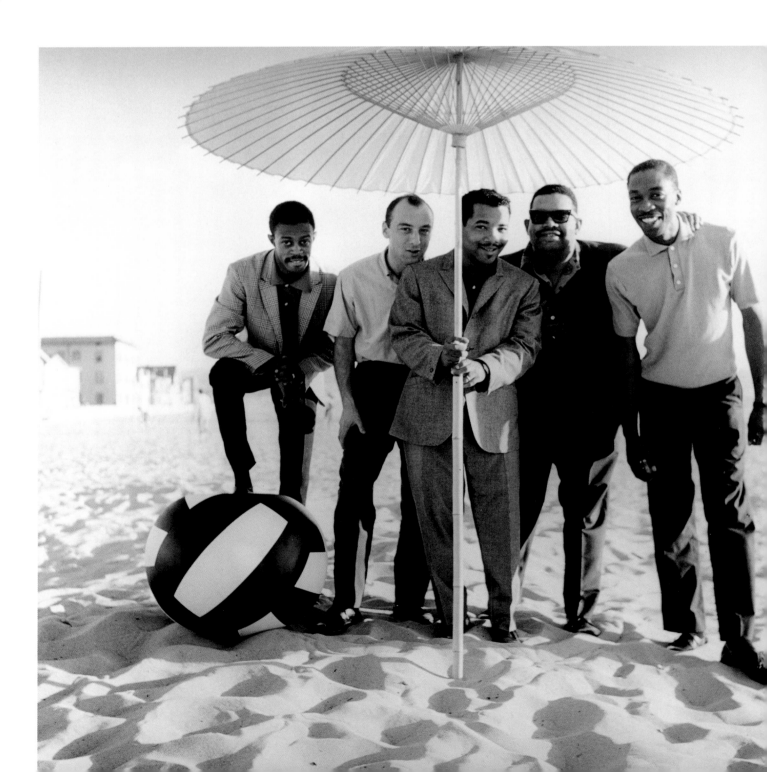

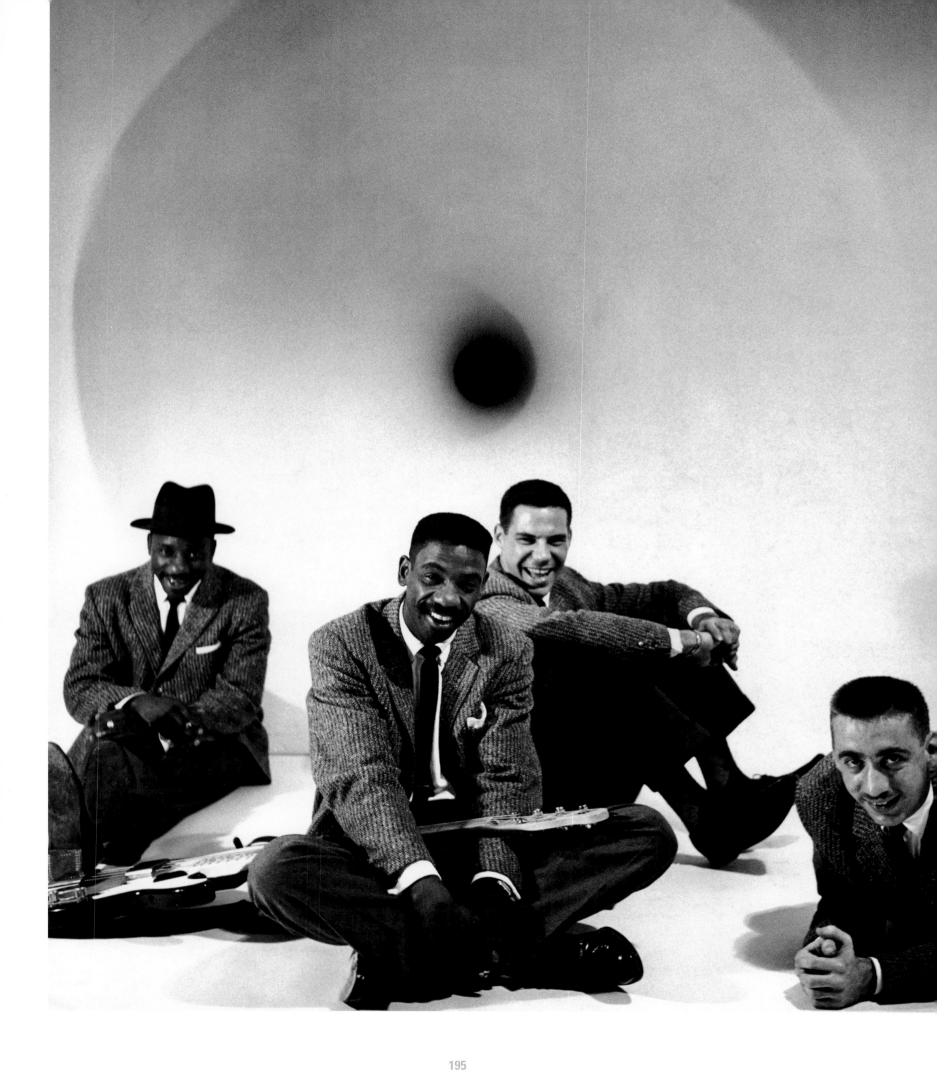

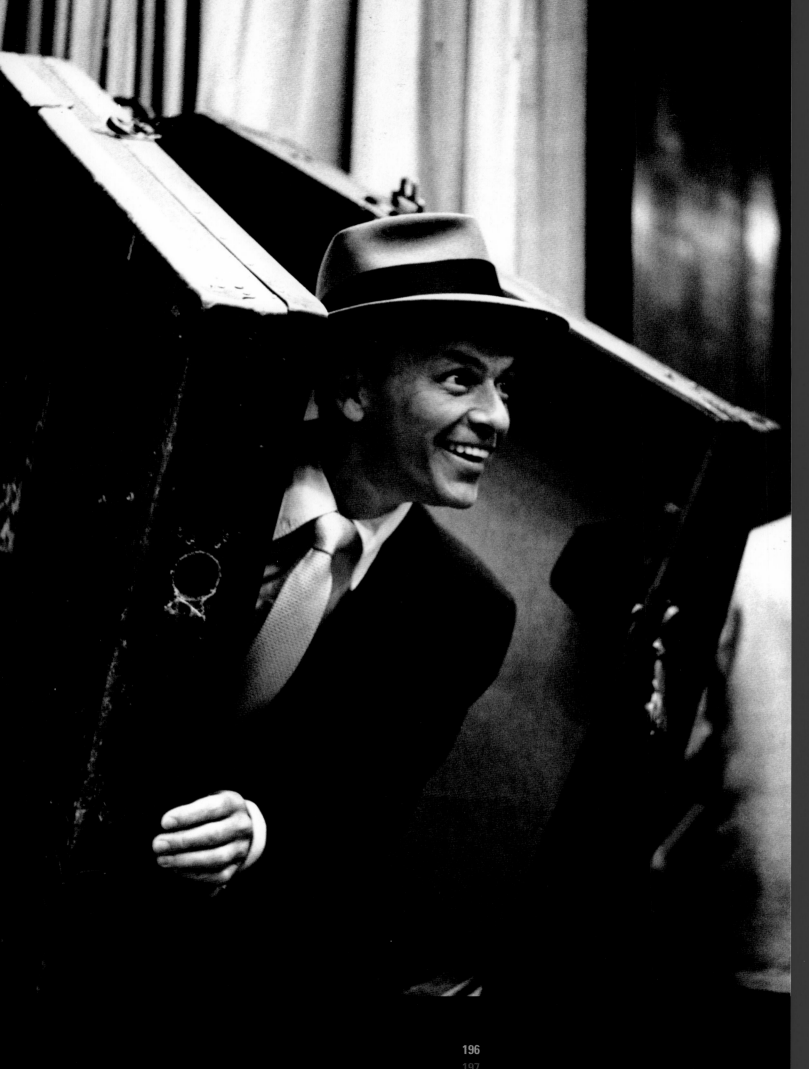

Frank Sinatra, Hollywood, 1955

Bing Crosby, Bob Scobey, Hollywood, 1957

There are those people who would question whether these great musical artists are jazz artists or not. My feeling is that they all influenced jazz with their sound, phrasing and certainly their unique personalities. And all of them surrounded themselves with great jazz talent.

Bing Crosby is or was the closest to jazz of all and had a major influence on jazz singers. In his early days in the 1920s, he sang with the Rhythm Boys, a very swinging jazz vocal group. Bing always said that he was influenced by Bix Beiderbecke and Joe Venuti. He recorded with the Ellington Orchestra and worked with Louis Armstrong many times.

When I spent time photographing Bing with Bob Scobey, I asked him about those days as a Rhythm Boy. He not only told me some wonderful stories, but he scat sang whole passages from songs that he had recorded in the 1920s and 30s. He sang up close only a few inches from my ear. It was a fantastic experience. It was like wearing headphones turned up to full volume and tuned in to a whole other swinging era of music.

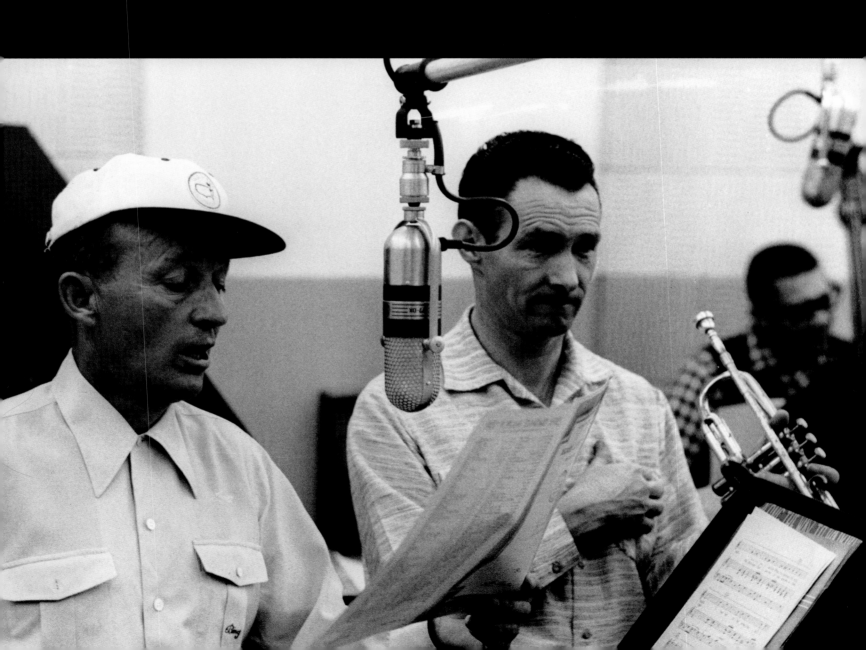

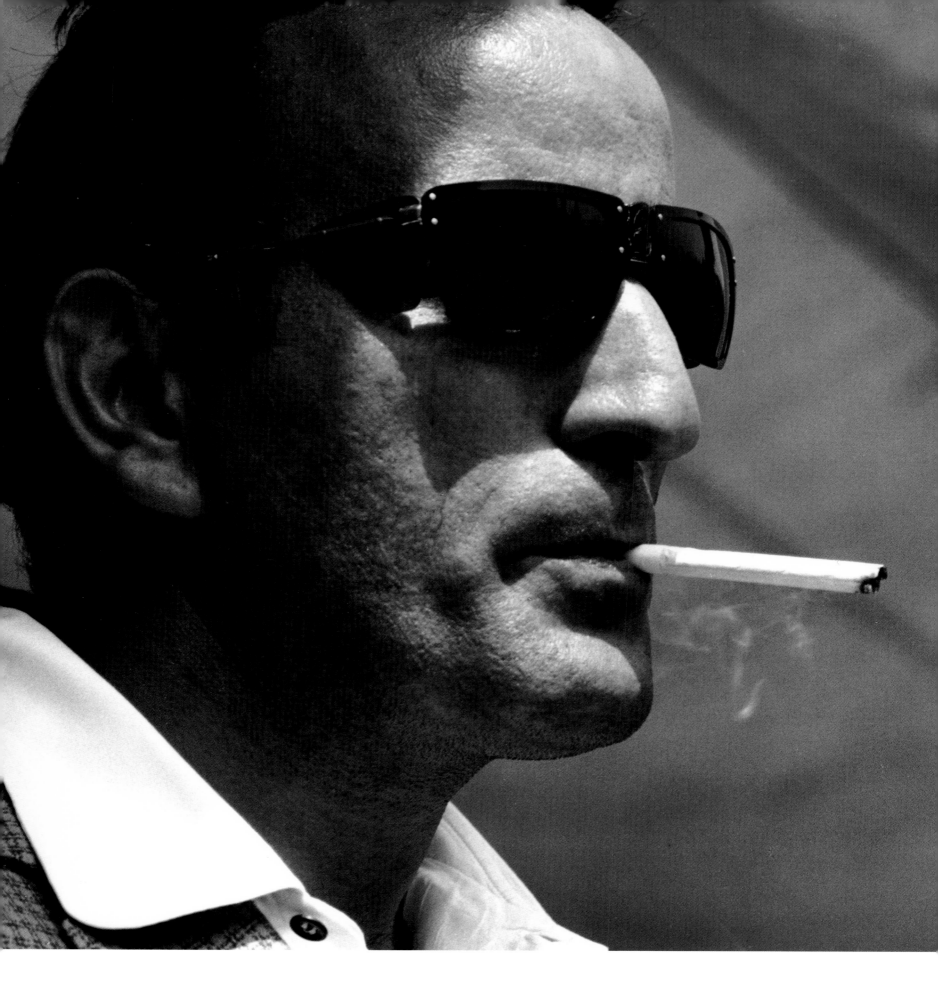

Tony Bennett, Hollywood, 1958

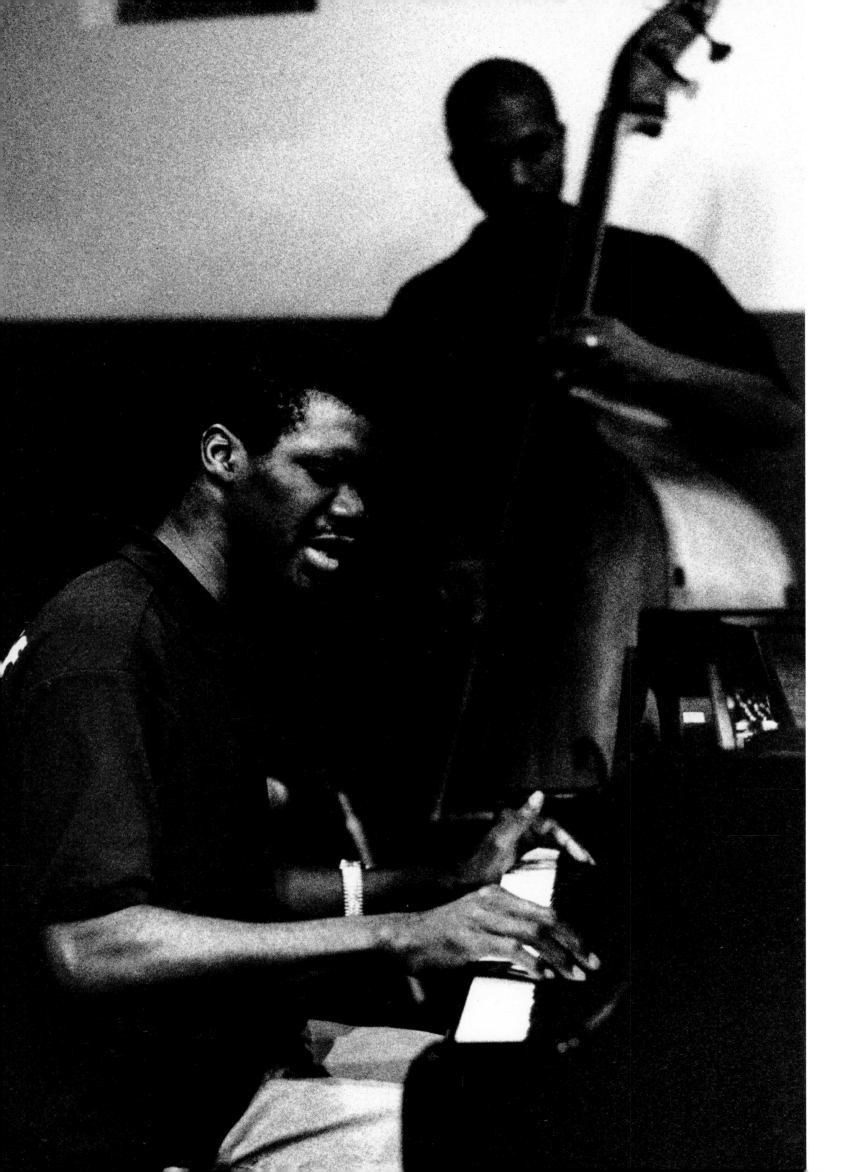

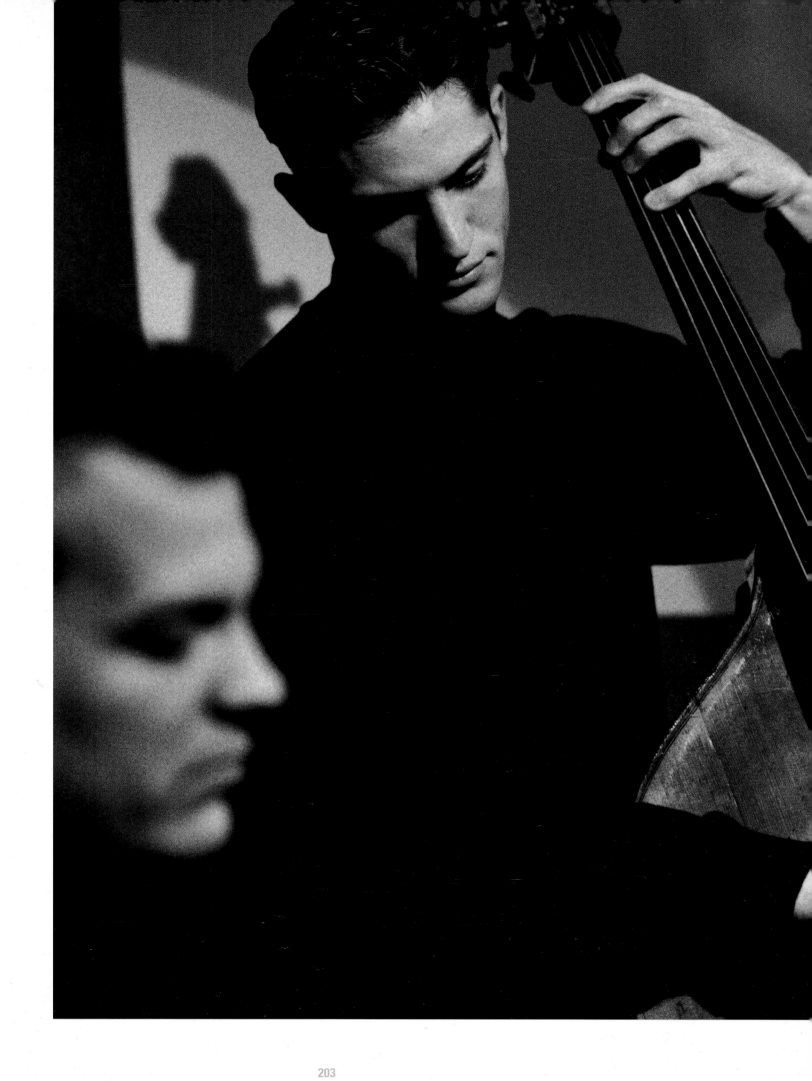

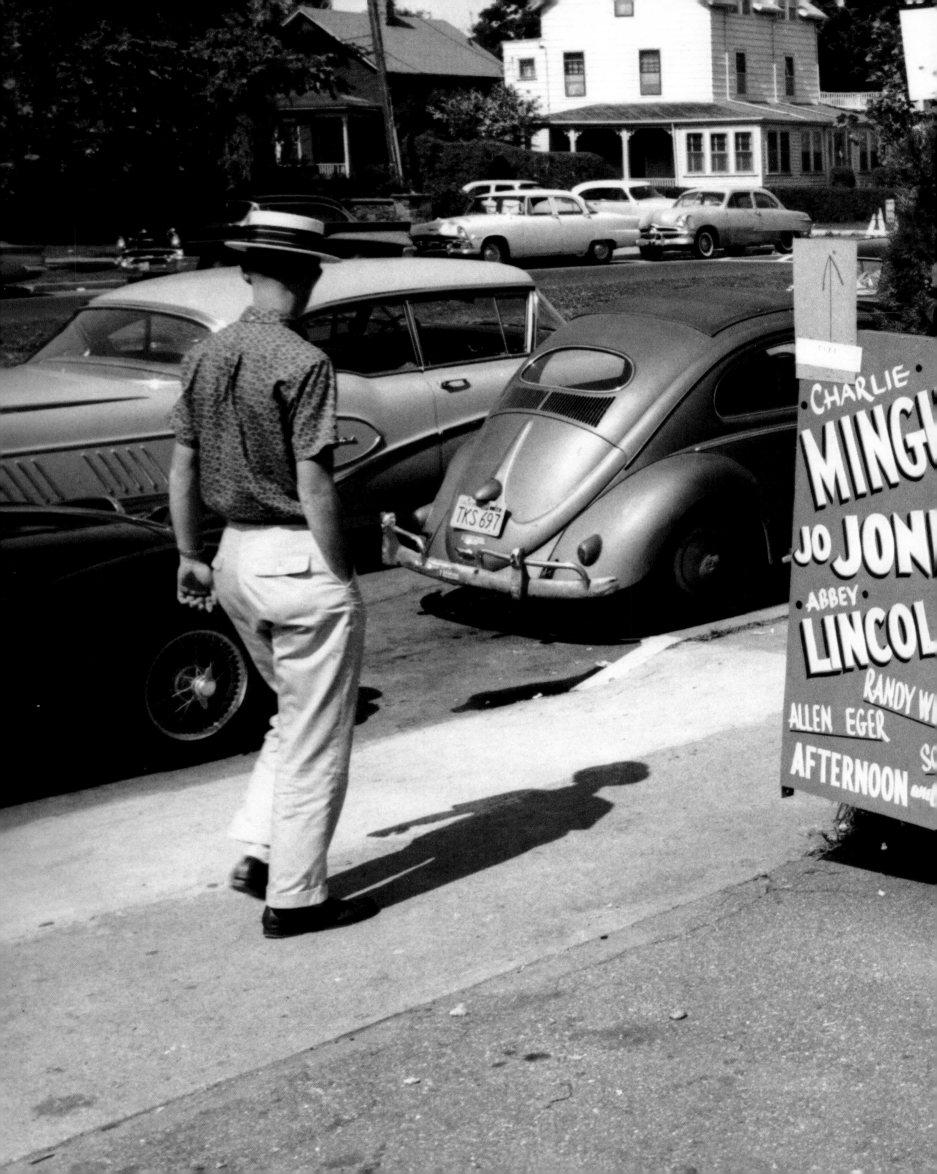

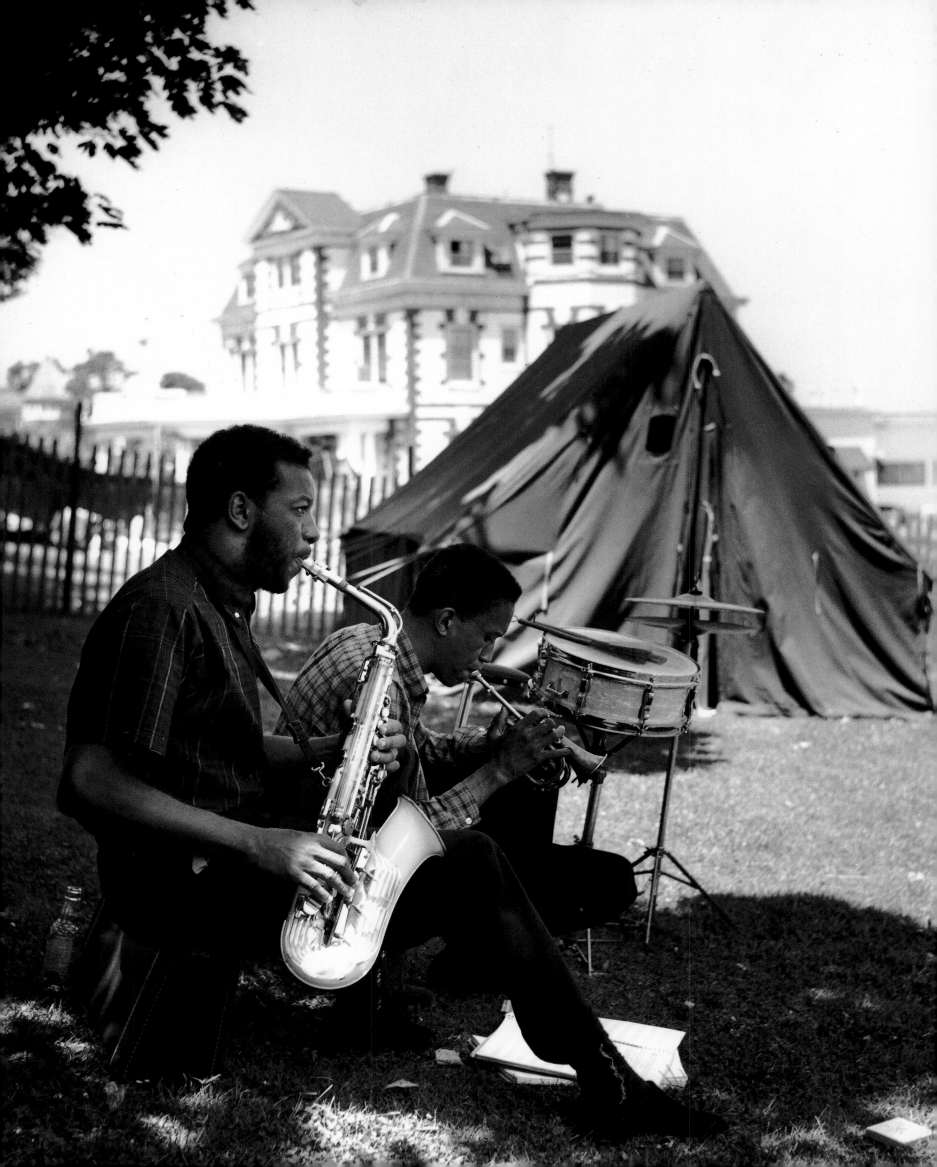

George Wein's Newport Jazz Festival in the summer of 1960 had an enourmous roaster of jazz talents. But many important jazz personalities had been omitted from this main event. So, Charlie Mingus took matters in hand and formed a smaller event next door to the big festival and called it "The Newport Rebels". The rebels included many new and talended performers as well as some of the important older ones.

It was a beautiful setting high on a bluff overlooking Rhode Island Sound and the music was terrific. It was a wonderful way to stage a jazz competition. Amongst the musicians were Thelonious Monk, Max Roach, Ornette Coleman, Abbey Lincoln, Allen Eager, Sonny Rollins, Gigi Gryce and Roy Eldridge.

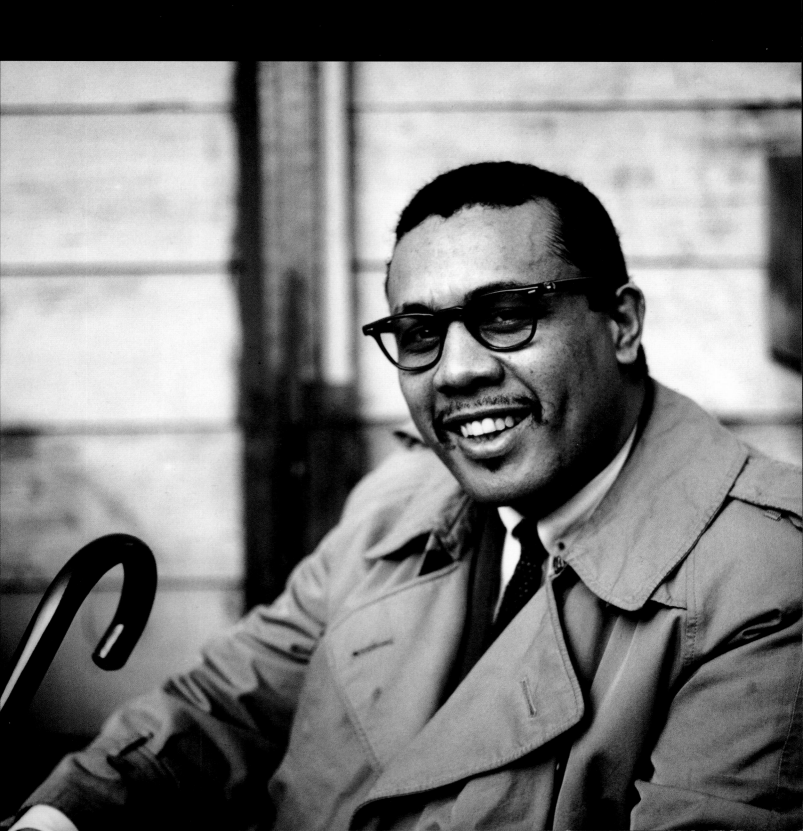

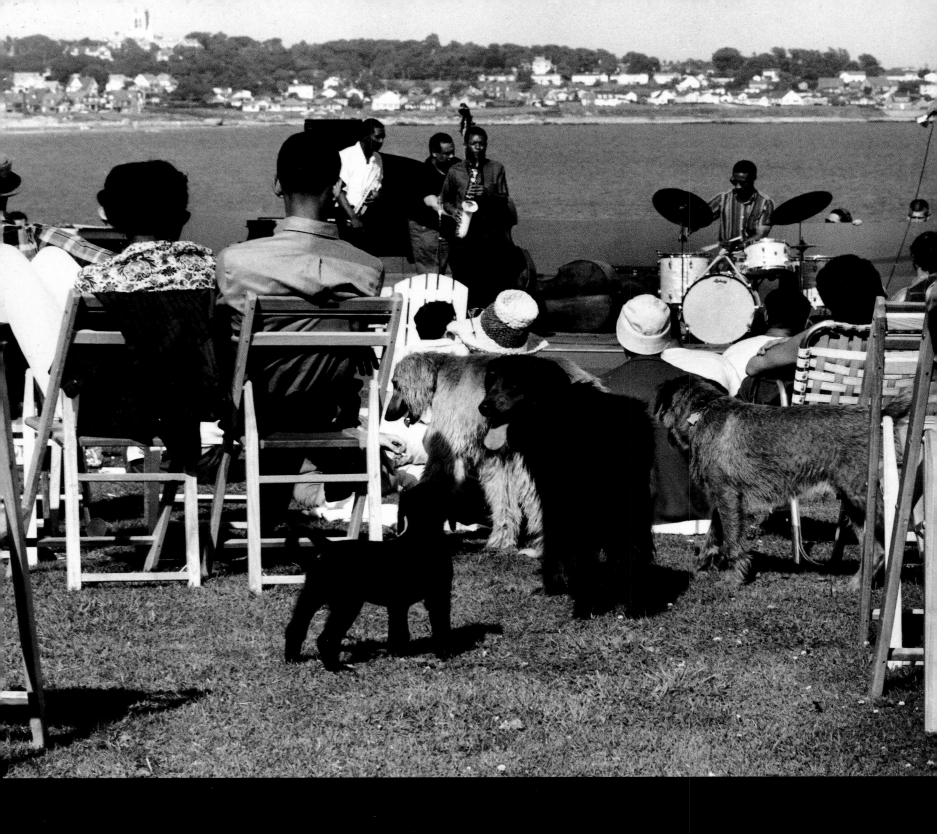

Ornette Coleman (saxophone), Don Cherry (trumpet) 208

Charles Mingus, leader of The Newport Rebels, Newport, 1960

The Newport Rebels performing at Cliff Walk Manor, Newport, 1960 210

Ornette Coleman, Hollywood, 1959

John Williams, Max Bennett (bass), Howard Roberts (guitar), Hollywood, 1956 212

ORNETTE COLEMAN, 1959

I had an assignment to photograph Ornette Coleman for his first record cover. When he arrived at my small studio in Hollywood, I heard a timid knock on the door. There standing before me was Ornette with his shiny, scrubbed face, neatly dressed and very shy. He had just come in from Texas and immediately stated that he had never been (formerly) photographed before now.

In front of the camera his shyness persisted, almost approaching a state of fright. I tried to relax and comfort him, but it was very difficult. My wife, Peggy, offered him refreshments and a warm welcome. Then suddenly I realized that he didn't have his instrument in hand. So, I asked him to get his alto sax from its case. Out came this yellow-colored, plastic horn! I had never seen one like that before and began to laugh. My rather rude amusement must have been infectious, because Ornette began laughing too. We collapsed in each other's arms laughing, and the "ice was broken". He relaxed enough to be photographed, and the result became his LP cover for Atlantic Records, *The Shape of Jazz to Come*.

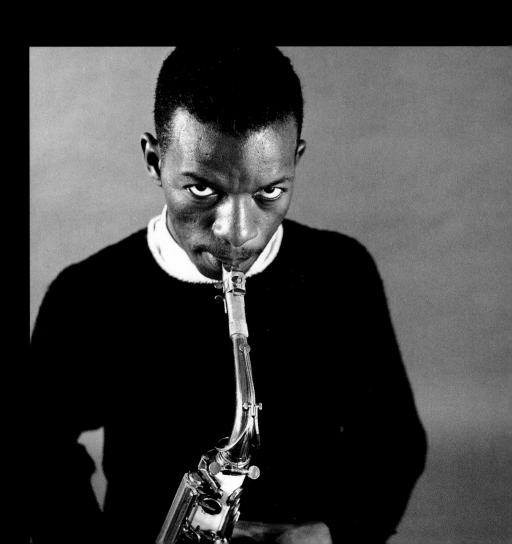

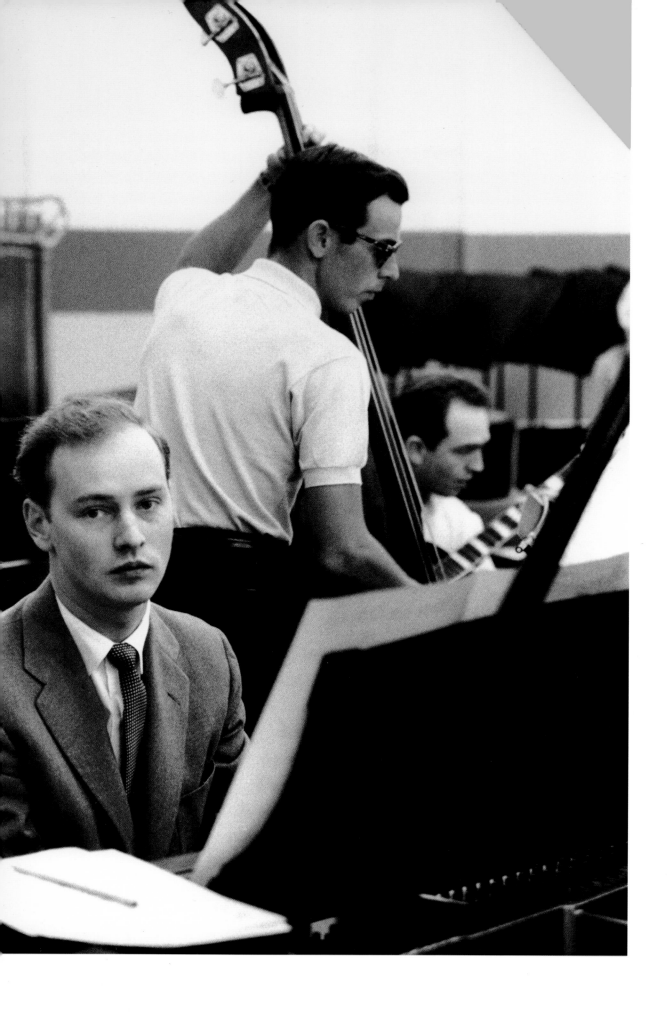

JOHN WILLIAMS

This poetic-looking young man seated at the piano is John Williams. He went on to compose music for the soundtrack of the film *Star Wars* and many of Steven Spielberg's films, including *Raiders of the Lost Ark* while holding down the job of Conductor of the Boston Pops Orchestra.

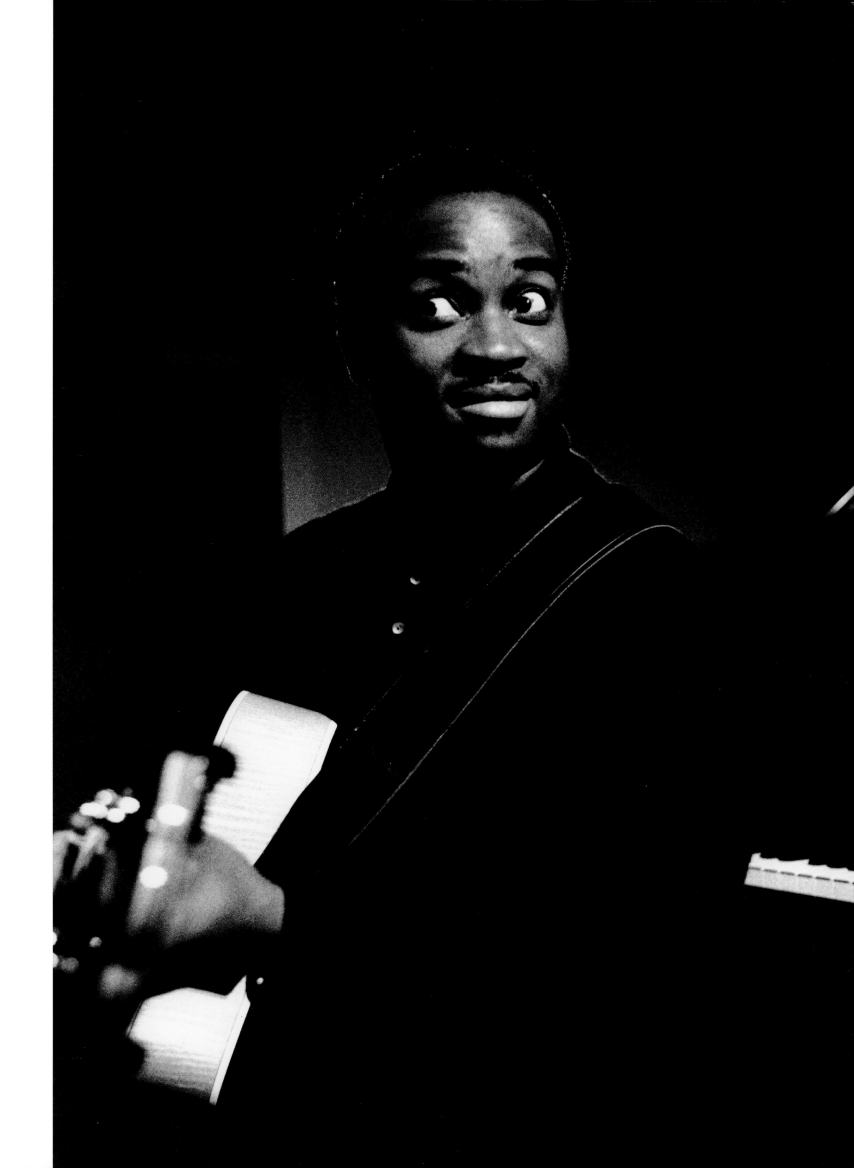

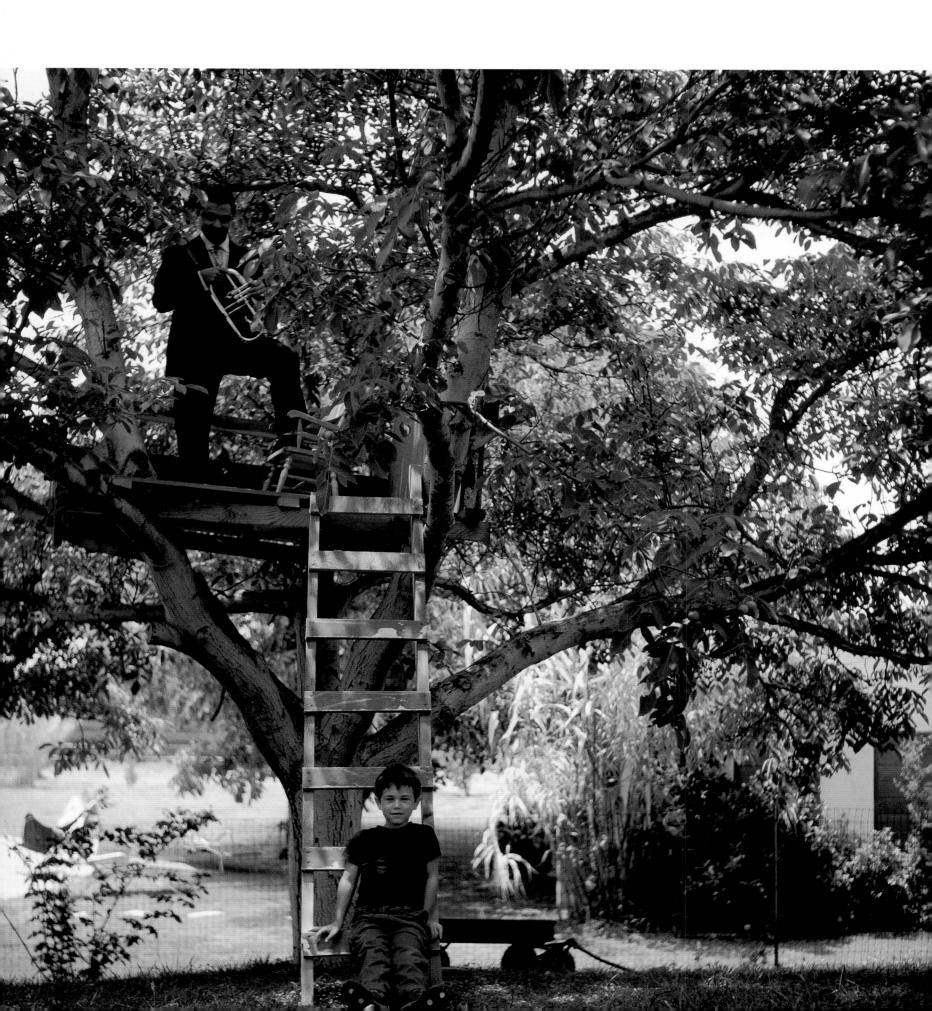

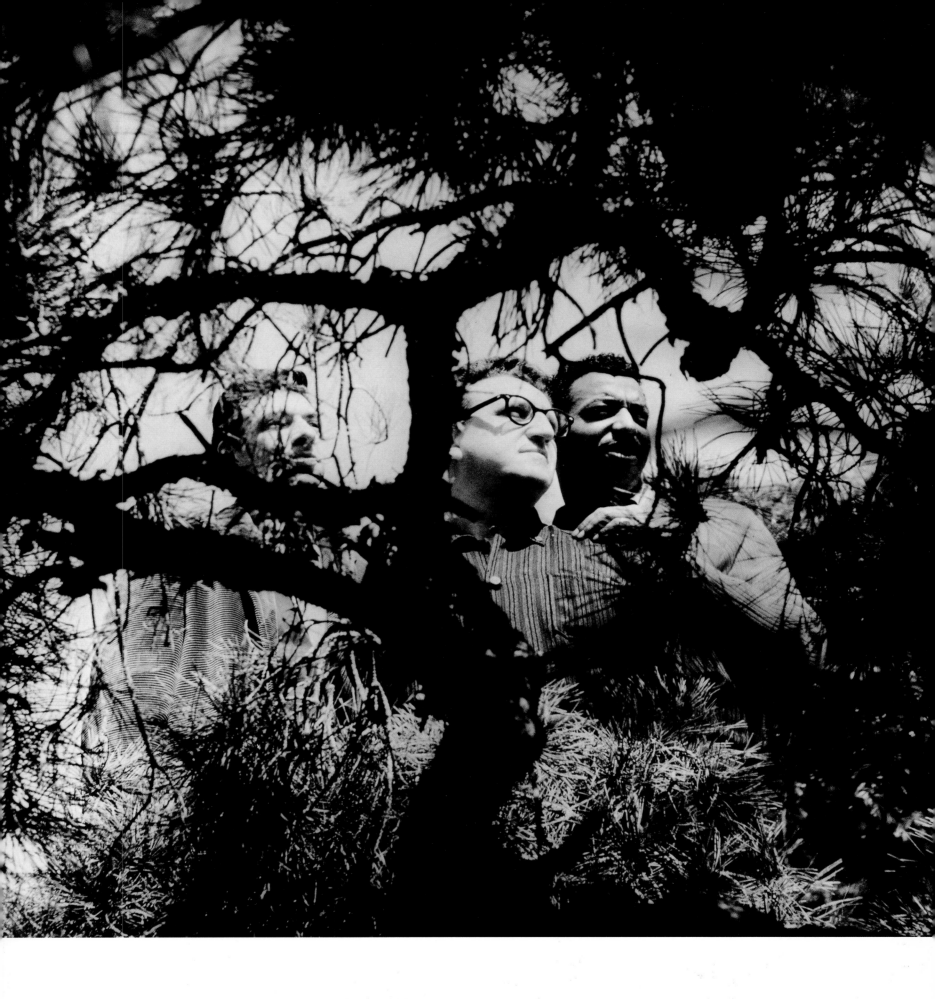

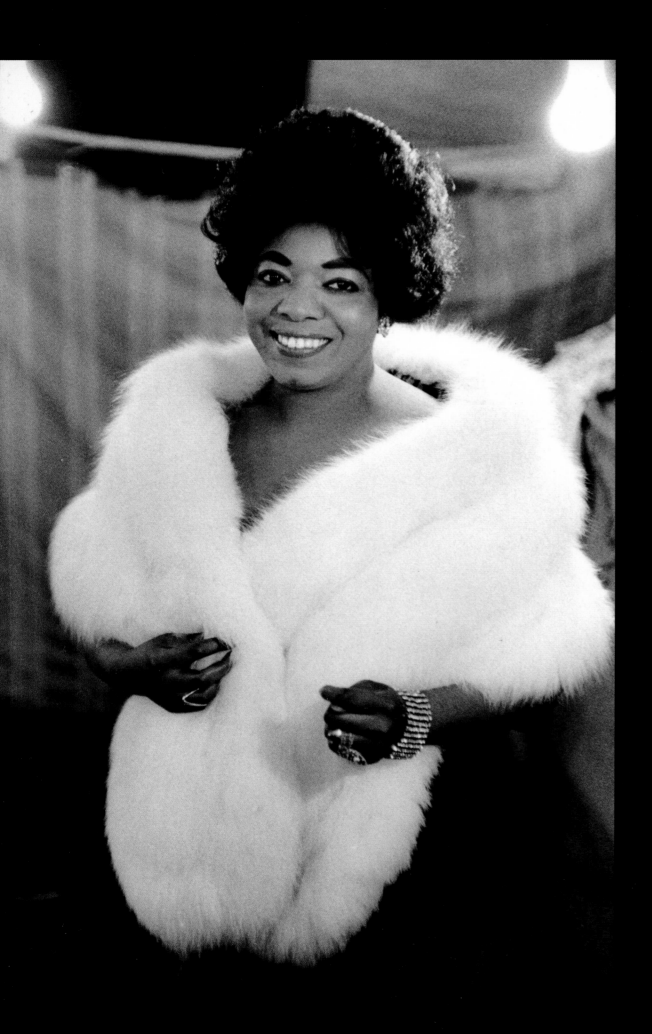

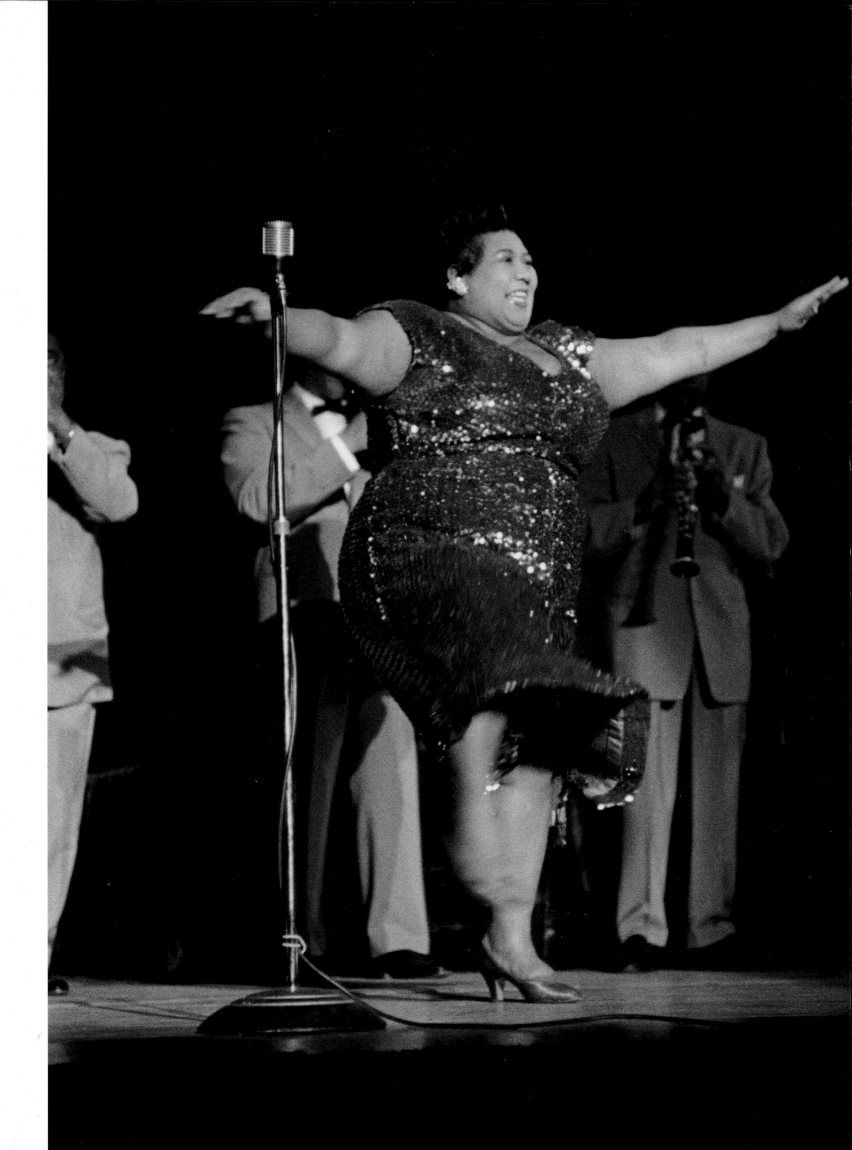

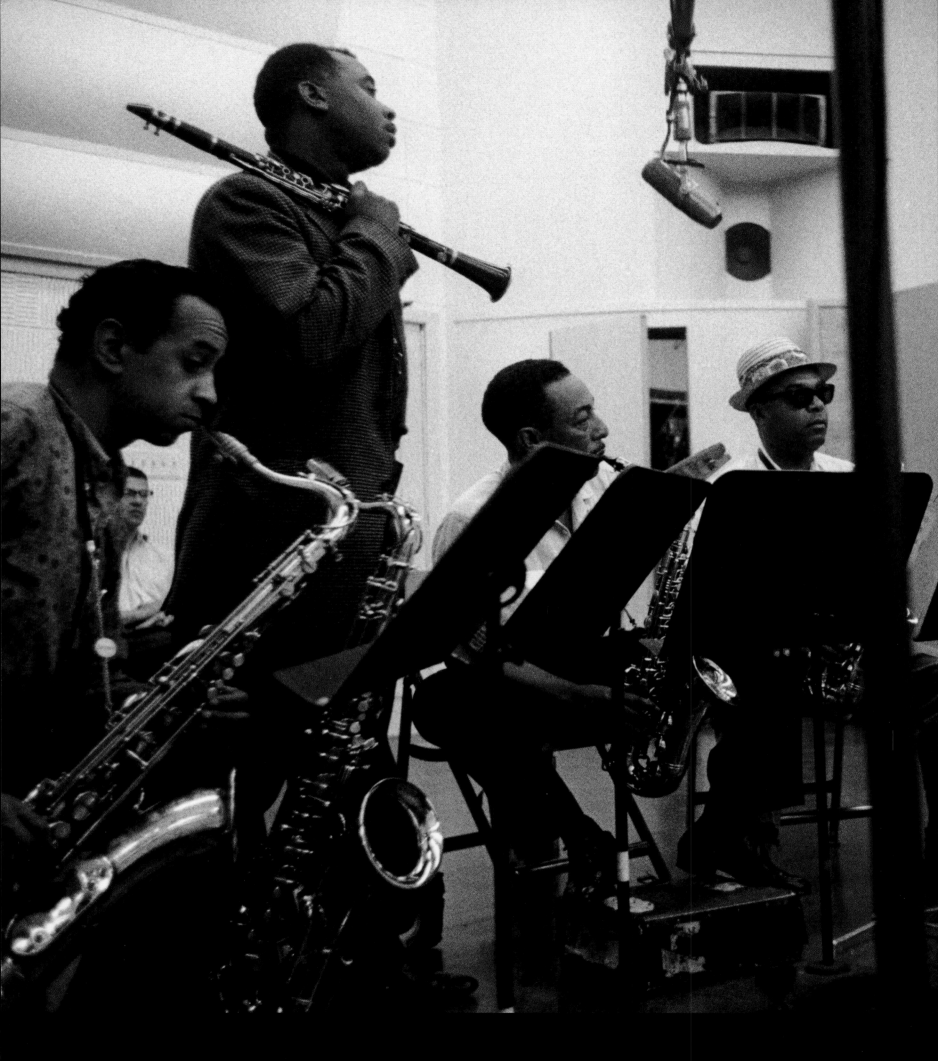

Duke Ellington (on the right) with the sax sections of his orchestra: Paul Gonsalves,
Jimmy Hamilton, Johnny Hodges, Russell Procope, Harry Carney, Las Vegas, 1957

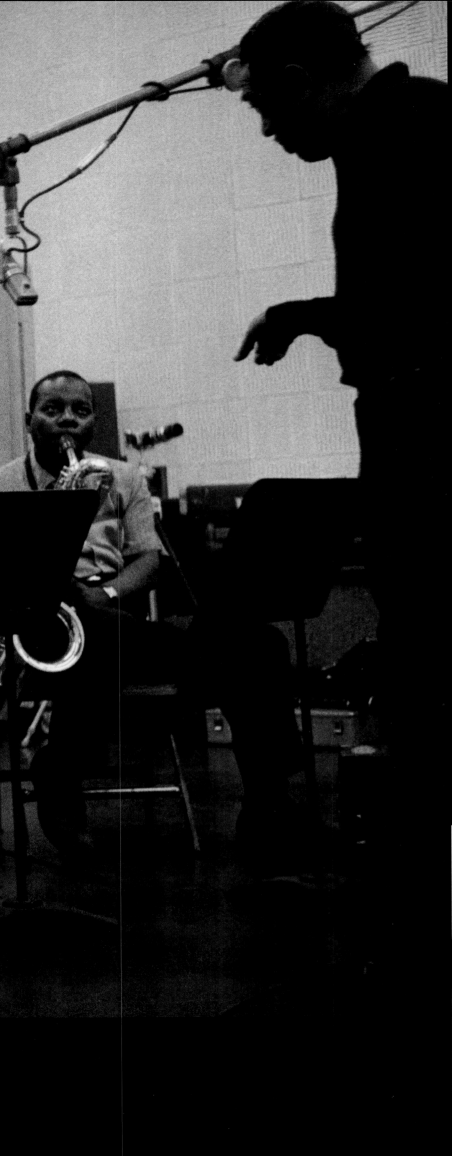

DUKE ELLINGTON, BACKSTAGE

The first time that I saw the Duke Ellington Orchestra on stage was in downtown Los Angeles at the Orpheum Theater. I was 16 years old. The band sounded awesome, what with Johnny Hodges, Harry Carney, Lawrence Brown, Sonny Greer and Al Hibbler just a few feet away from my front row seat.

When the curtain came down and the movie was about to begin, I grasped the opportunity to go backstage to meet the great Duke. I had no trouble getting in to meet him. I was ushered into his dressing room where he was changing out of his lavender-beige colored suit, pink silk shirt and purple necktie into an enormous golden robe. He was gracious to me and very generous with his time. What a treat!

As the years went by, I would always go backstage after the show to see Duke no matter what city we both happened to be in. And I would frequently take a girlfriend with me. Duke would always remember me and greeted us warmly. Then he would turn and bow to the young lady with me and deliver one of his famous complimentary phrases: "You're so pretty, you ought to be arrested!", or, "You are absolutely kissy pink!", or, "The gods outdid themselves when they created you, my dear."

That was Duke.

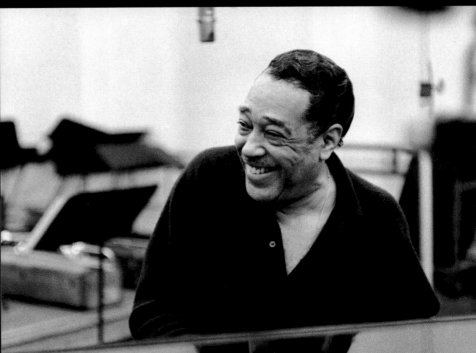

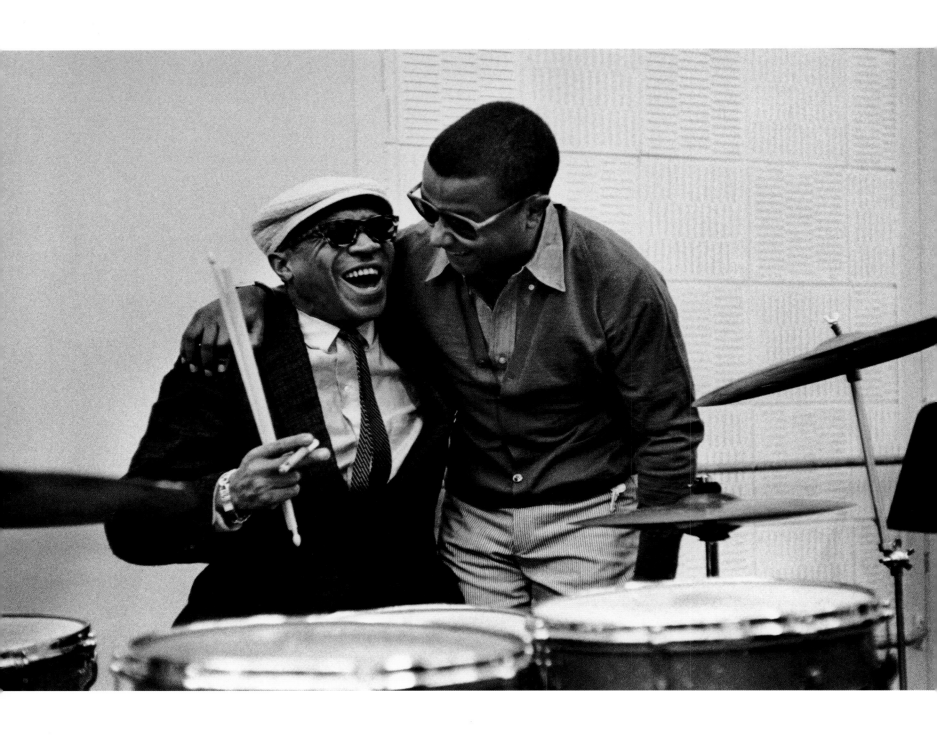

Billy Strayhorn with drummer Sam Woodyard, Hollywood, 1959 **220**

221 *Cy Touff (flugel horn), Richie Kamuca (tenor sax), Hollywood, 1956*

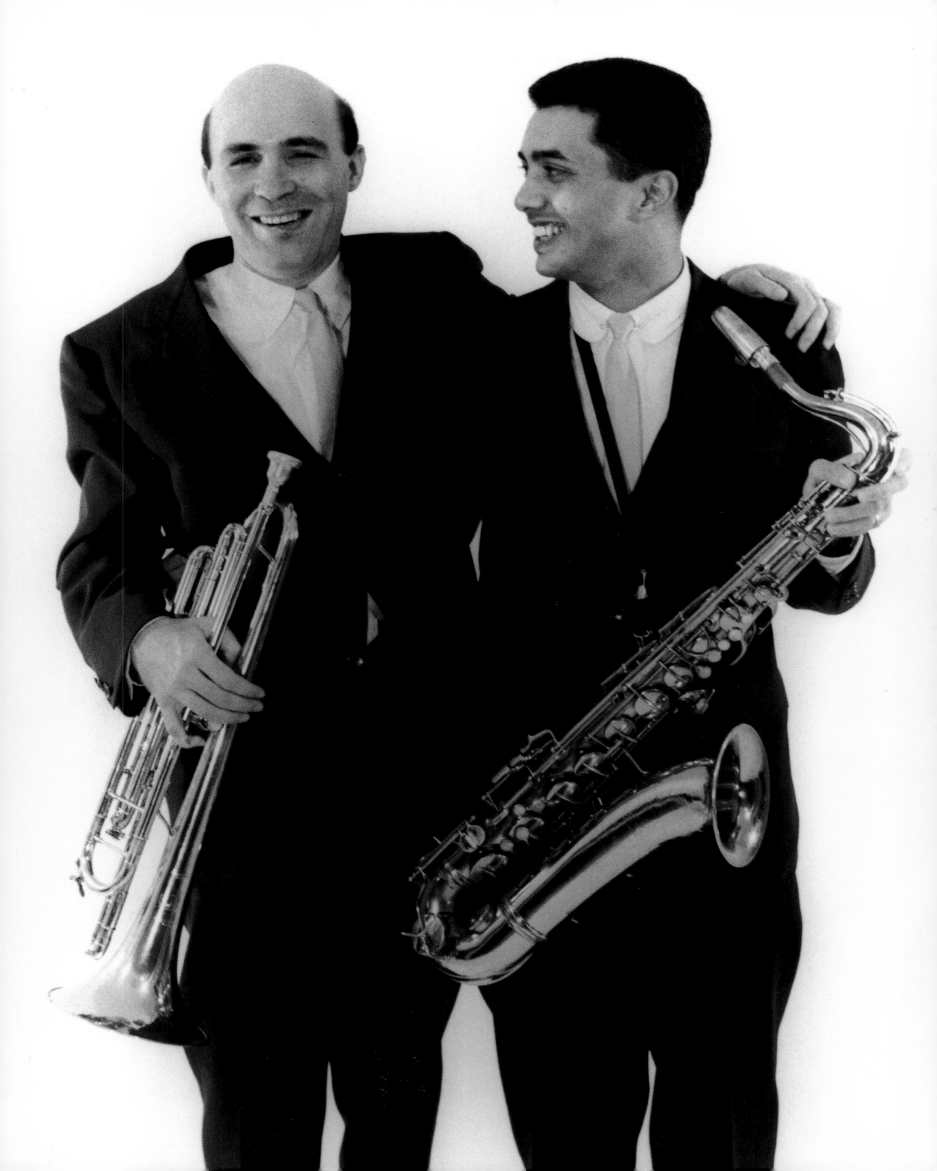

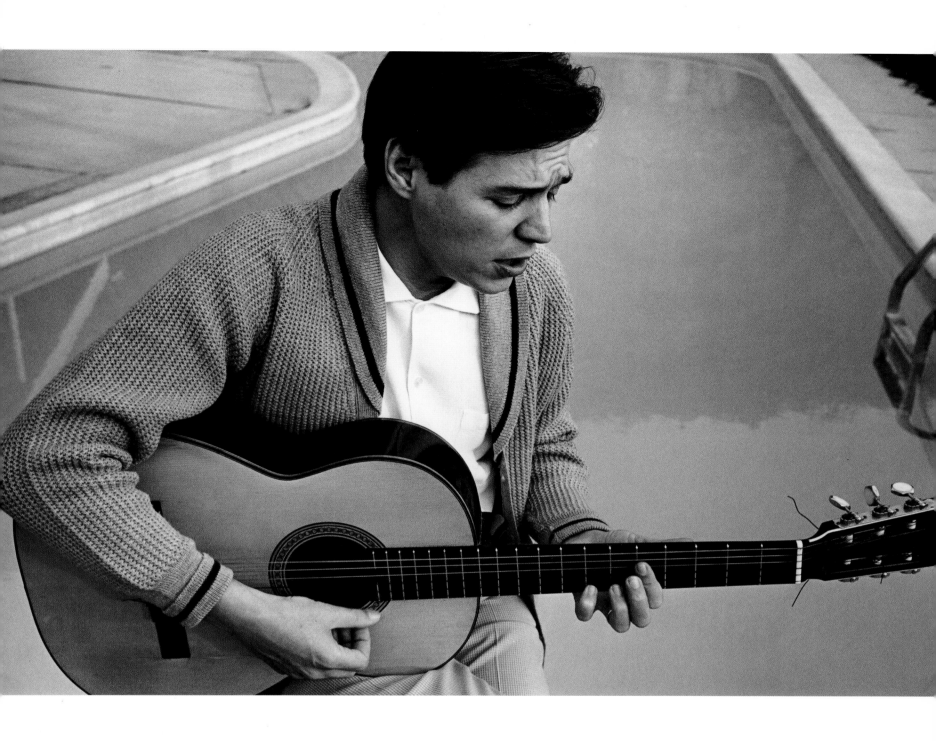

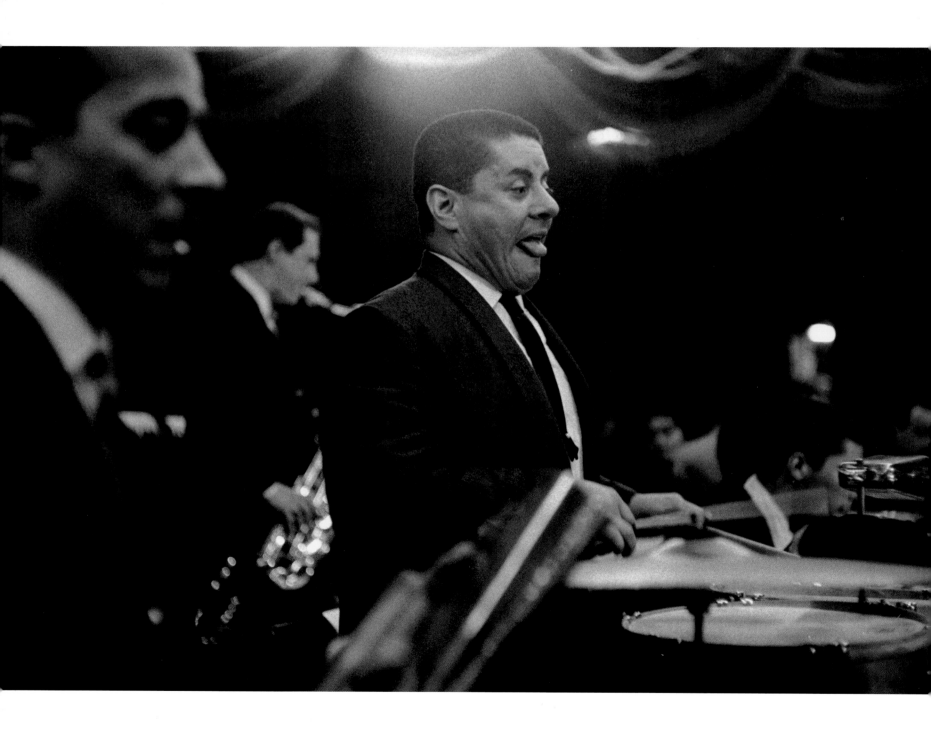

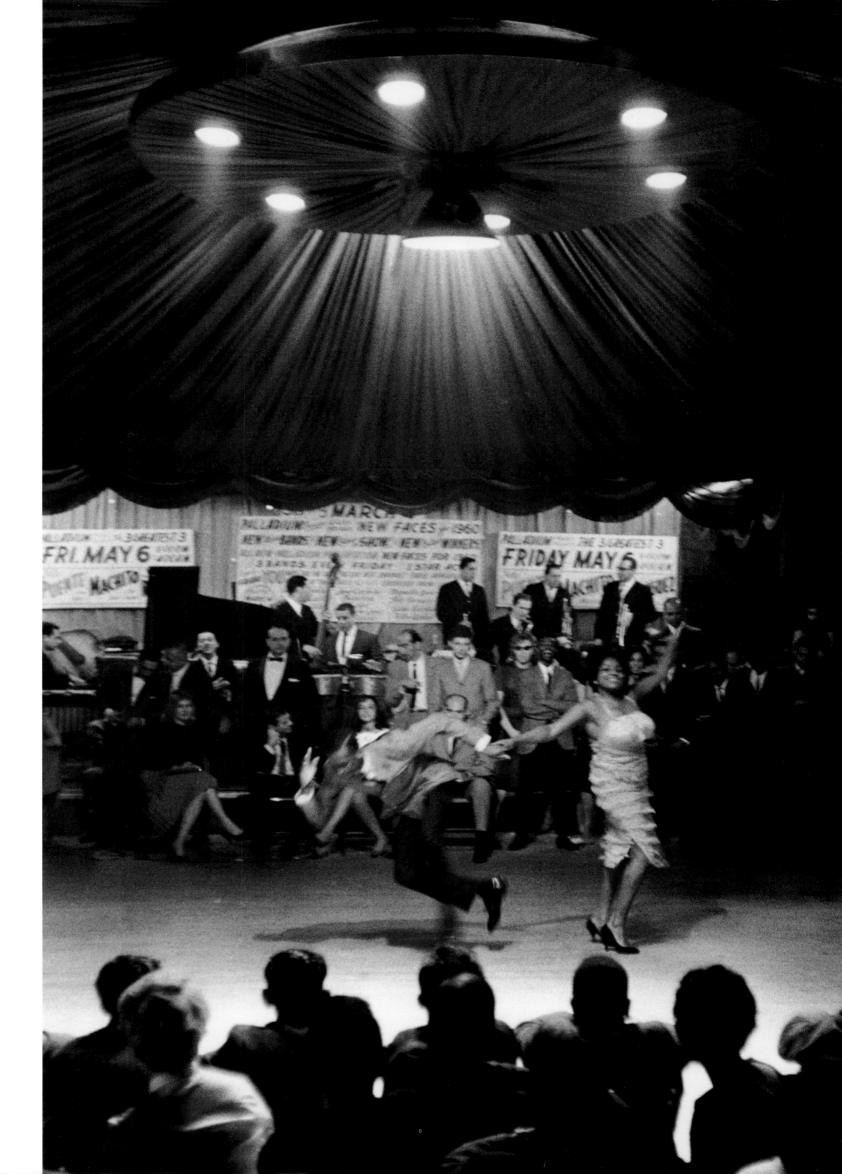

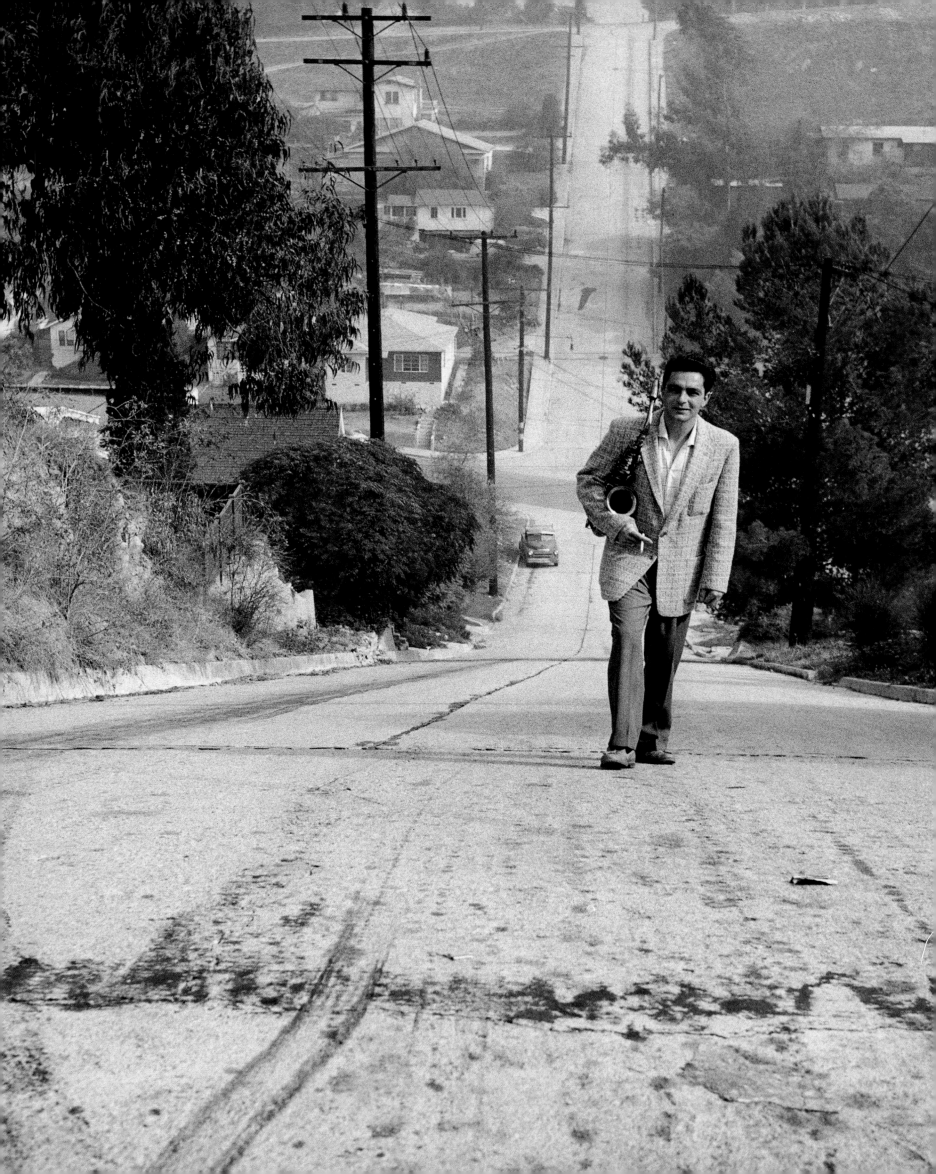

Art Pepper was in agony when I went to his home high atop one of the steepest hills in Los Angeles. It was on Fargo Street, an area where many of the Keystone Cop movies were filmed in the early 1920s. Art had just been released from prison, and I had gone there to photograph him for the cover of his new LP to be titled, *The Return of Art Pepper*. As we were deciding about his wardrobe for the picture, Art complained that he was ill. He lamented that his connection had not arrived as promised with his "medicine". But he decided to do the pictures anyway.

He actually enjoyed being photographed in spite of his misery, and he looked quite handsome. Towards the end of our photo session, I decided to have him walk up this steep hill as I photographed him. To me it symbolized his uphill struggle to survive.

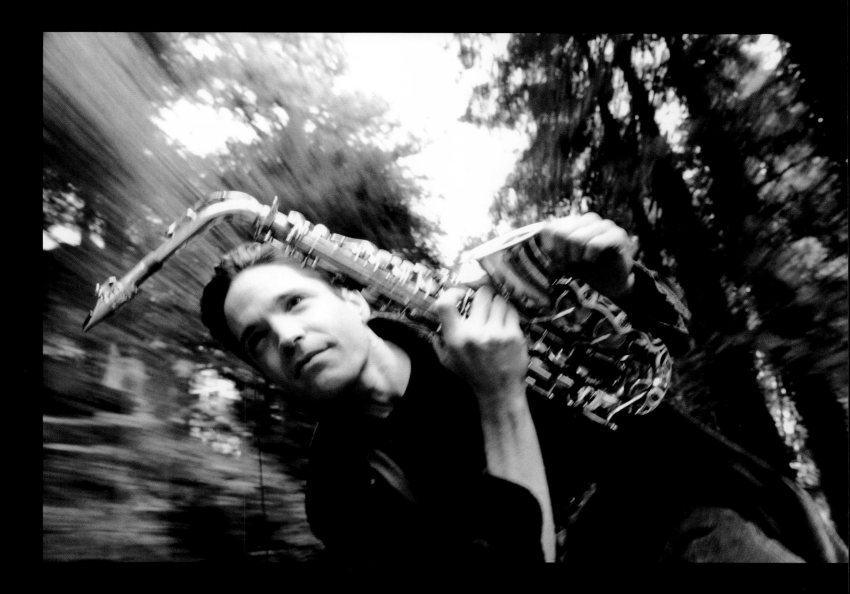

225
Art Pepper, Los Angeles, 1956 226
227 *Dave Koz, Mill Valley, 1997*
Doc Cheatham, Harlem, 1992 228
229

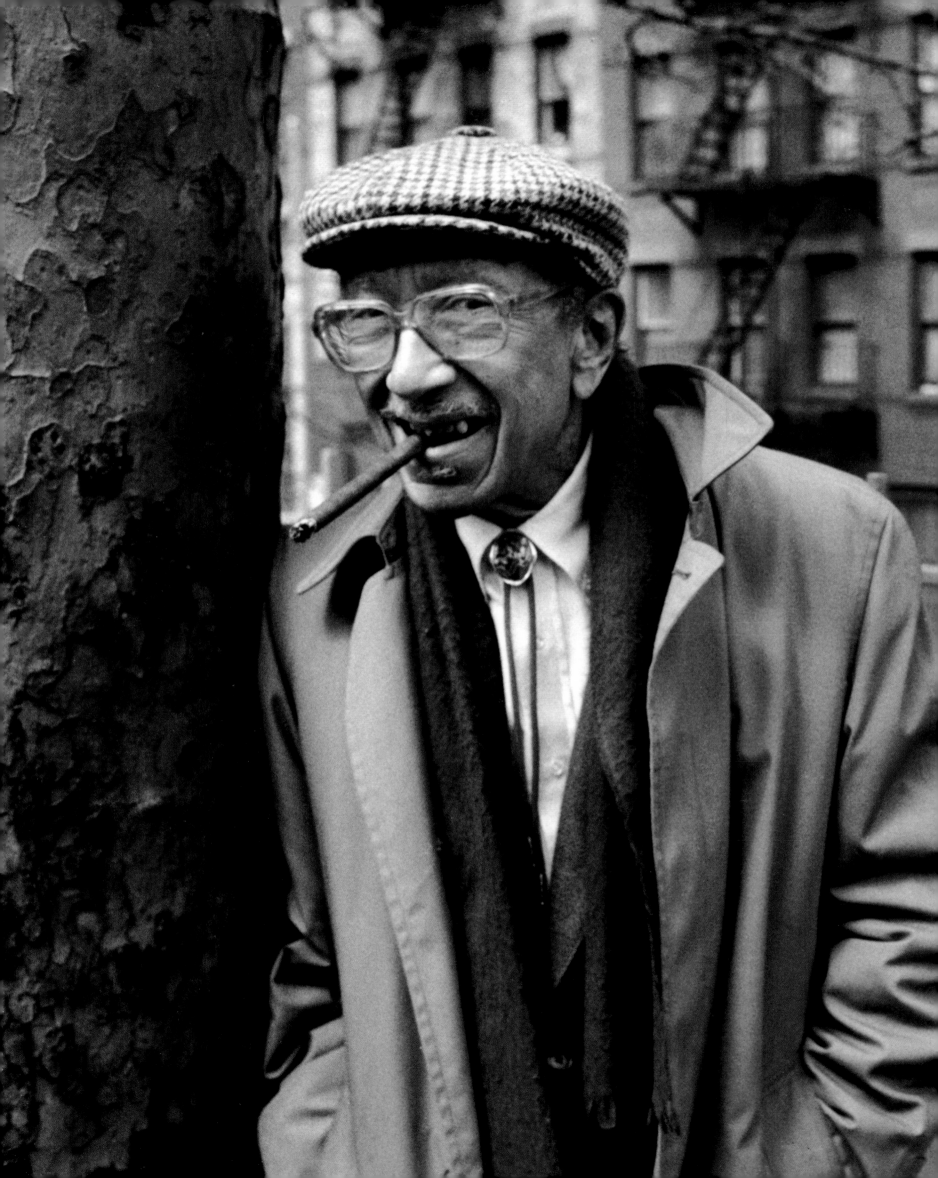

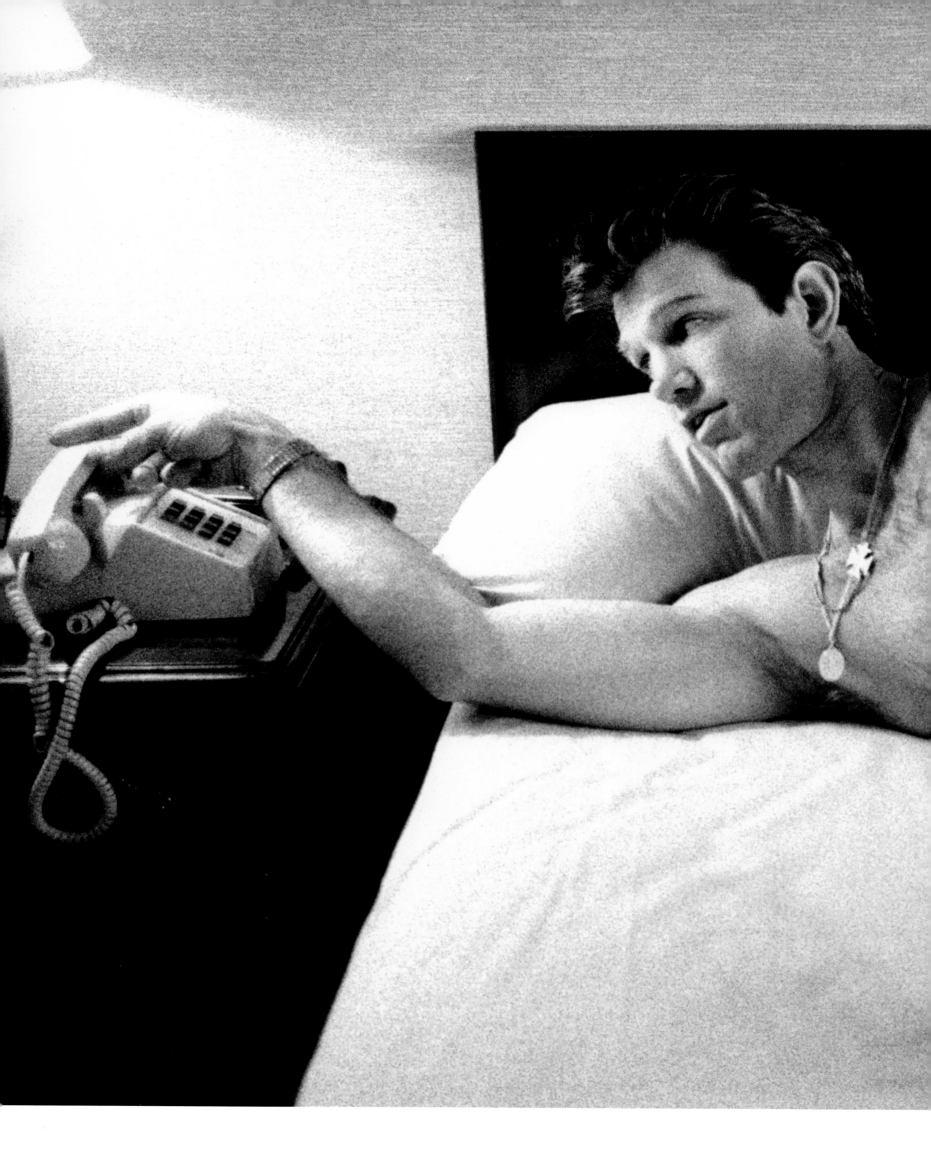

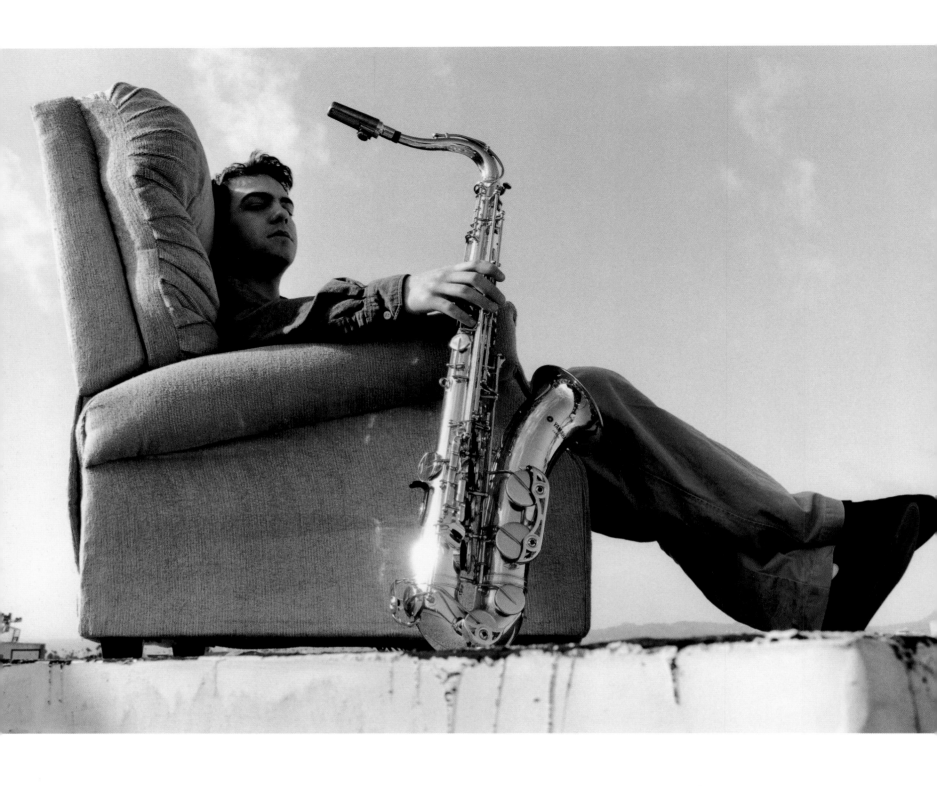

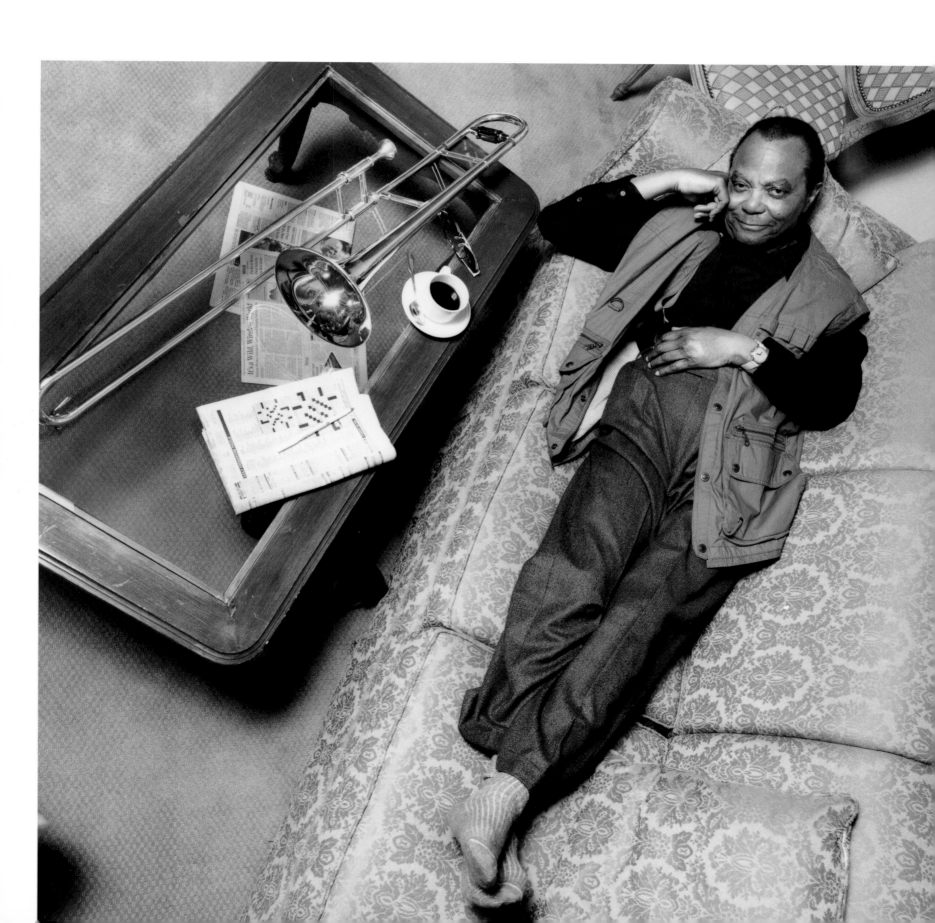

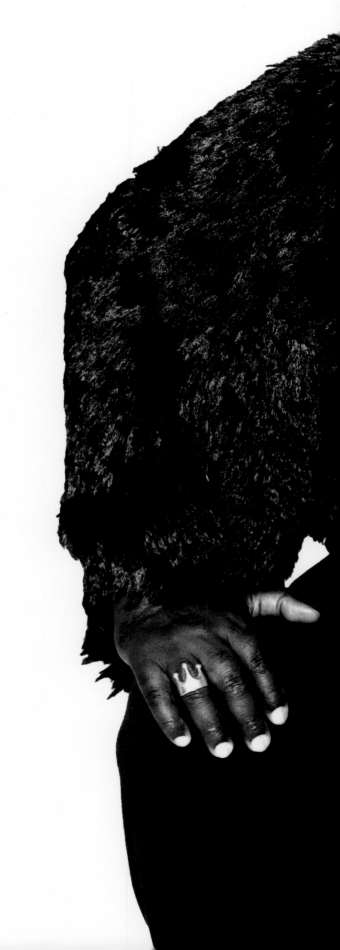

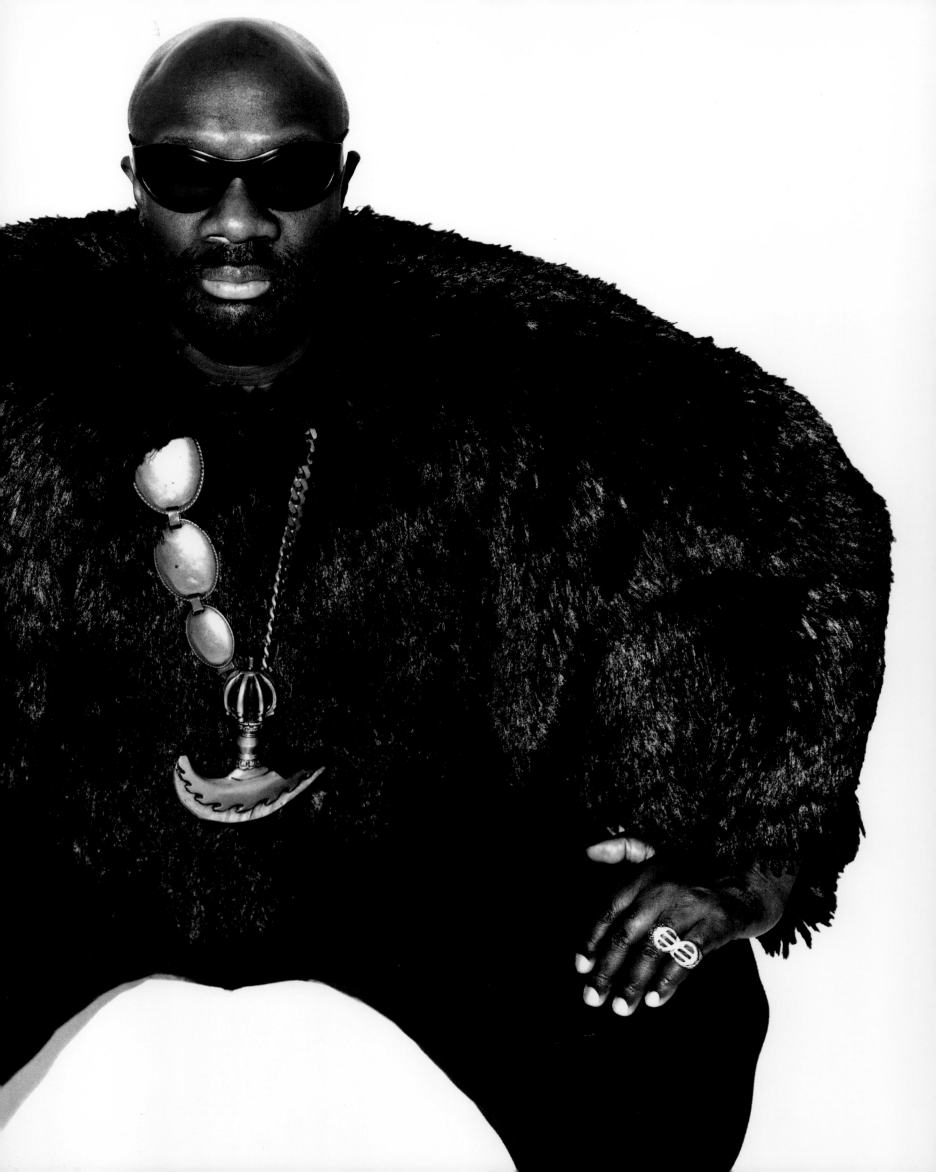

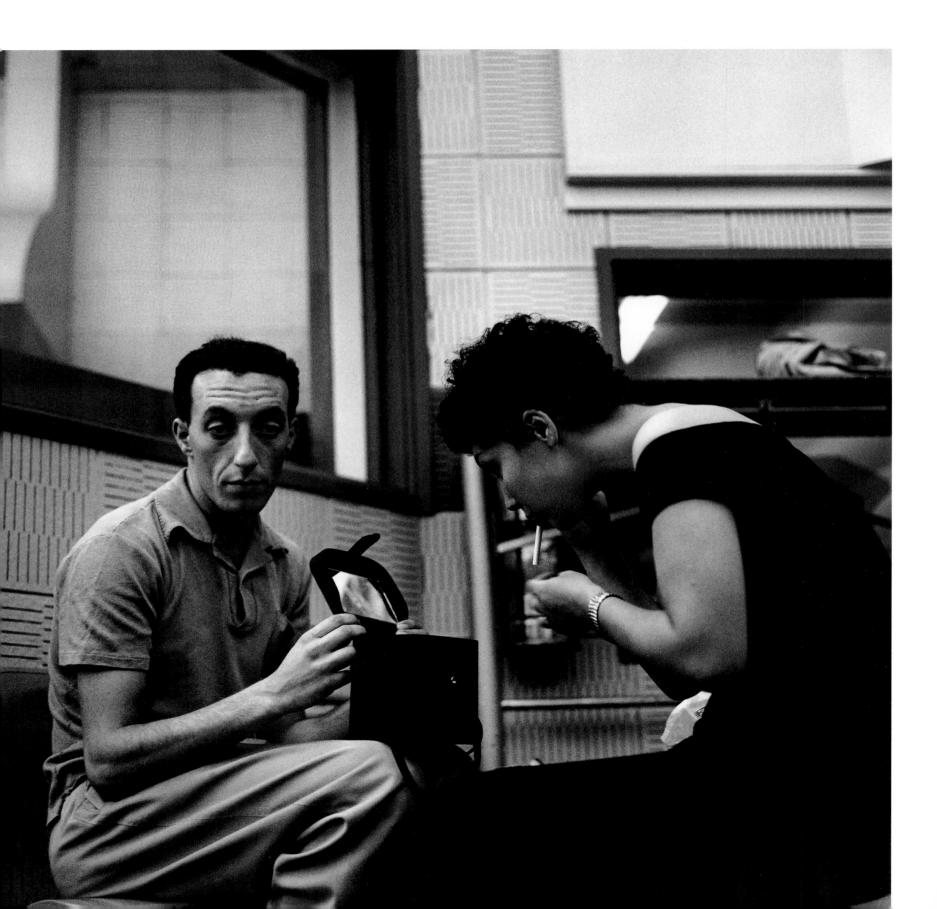

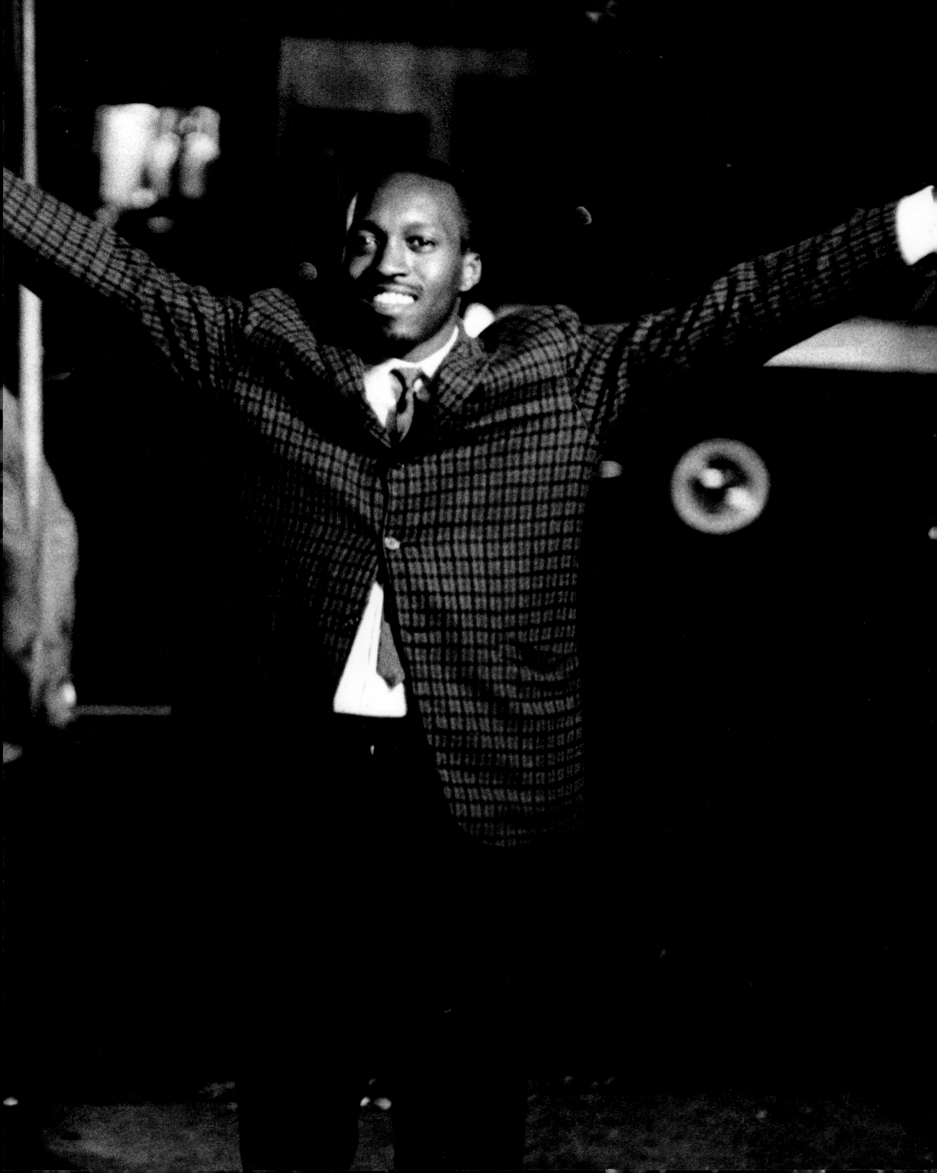

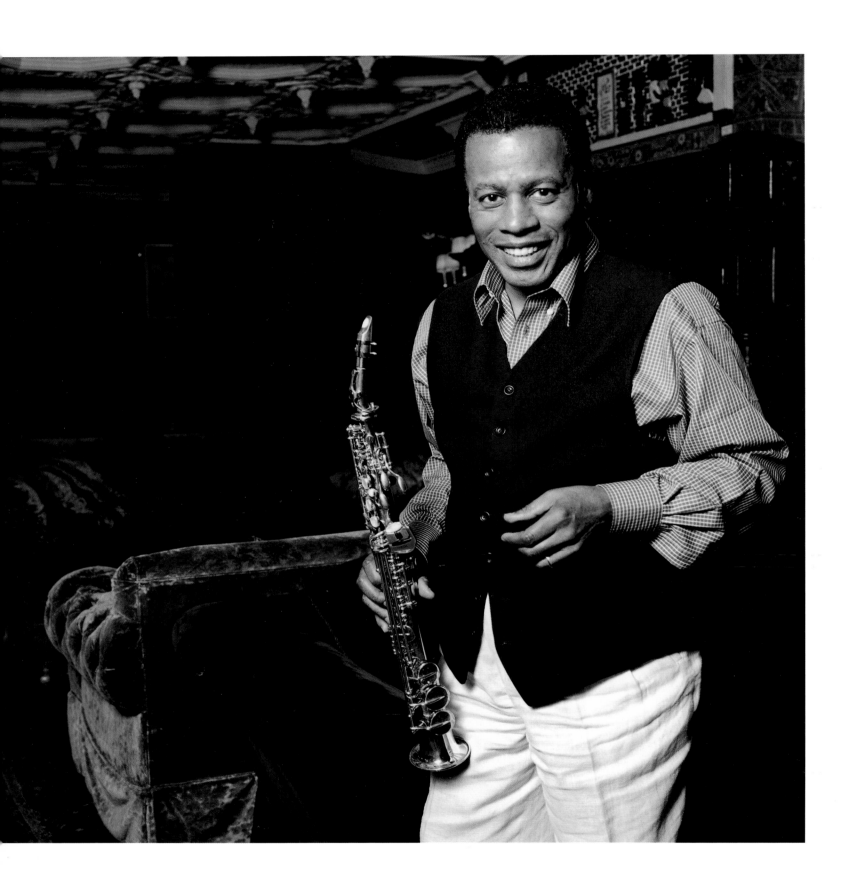

Wayne Shorter, West Hollywood, 1996 **240**

241 *Herbie Hancock, Hollywood, 1996*

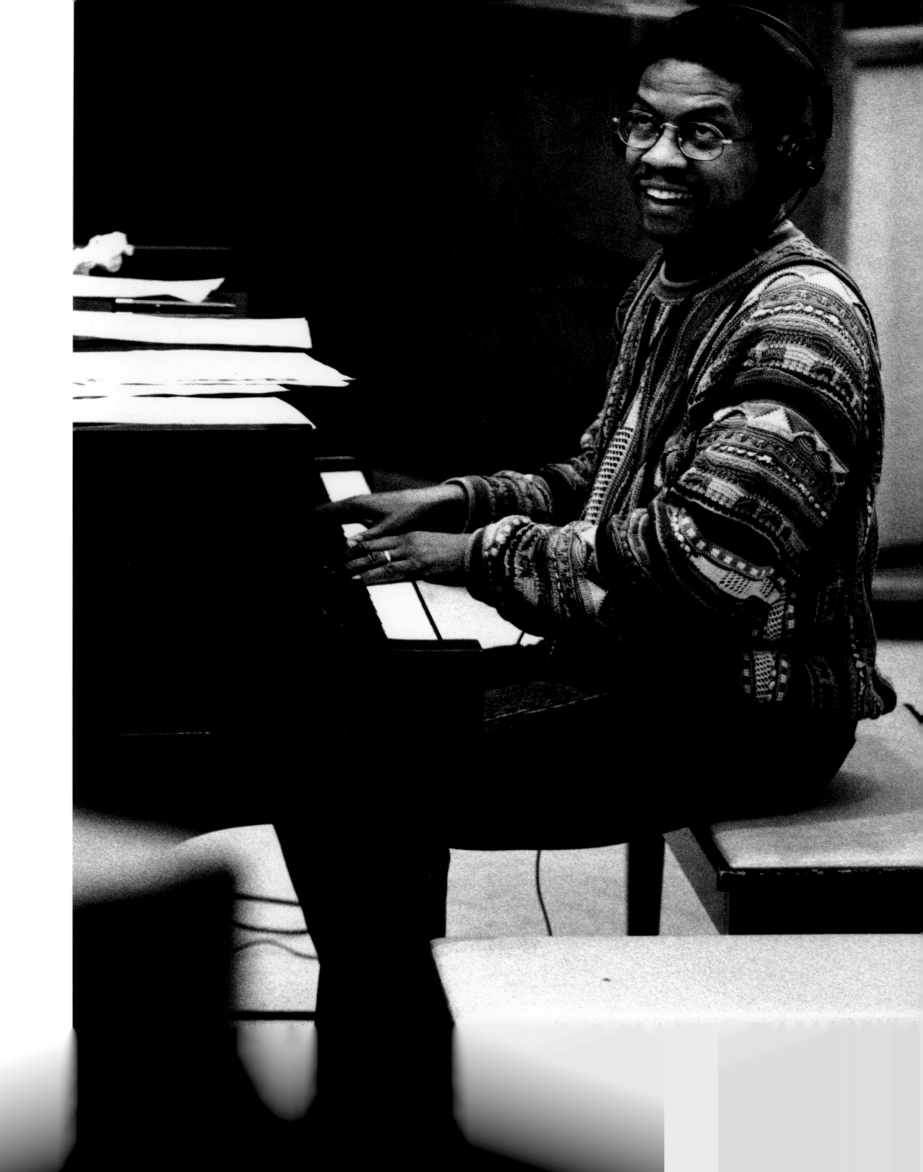

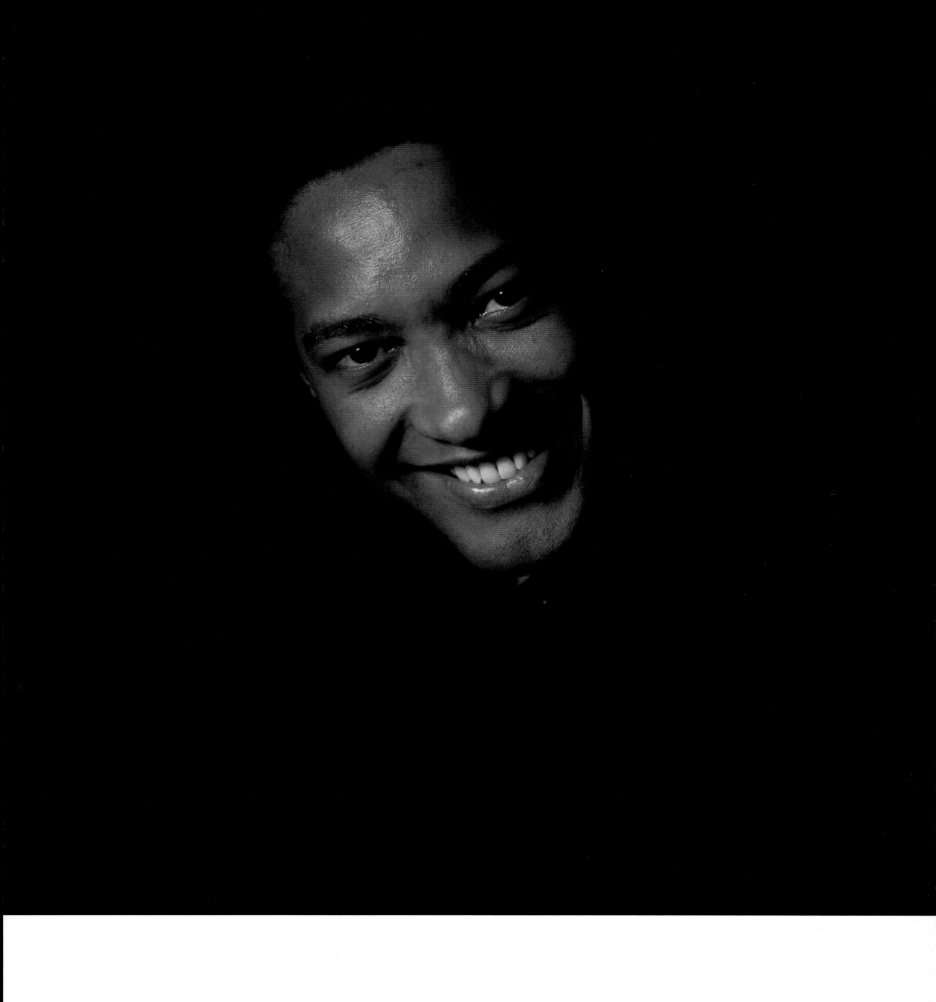

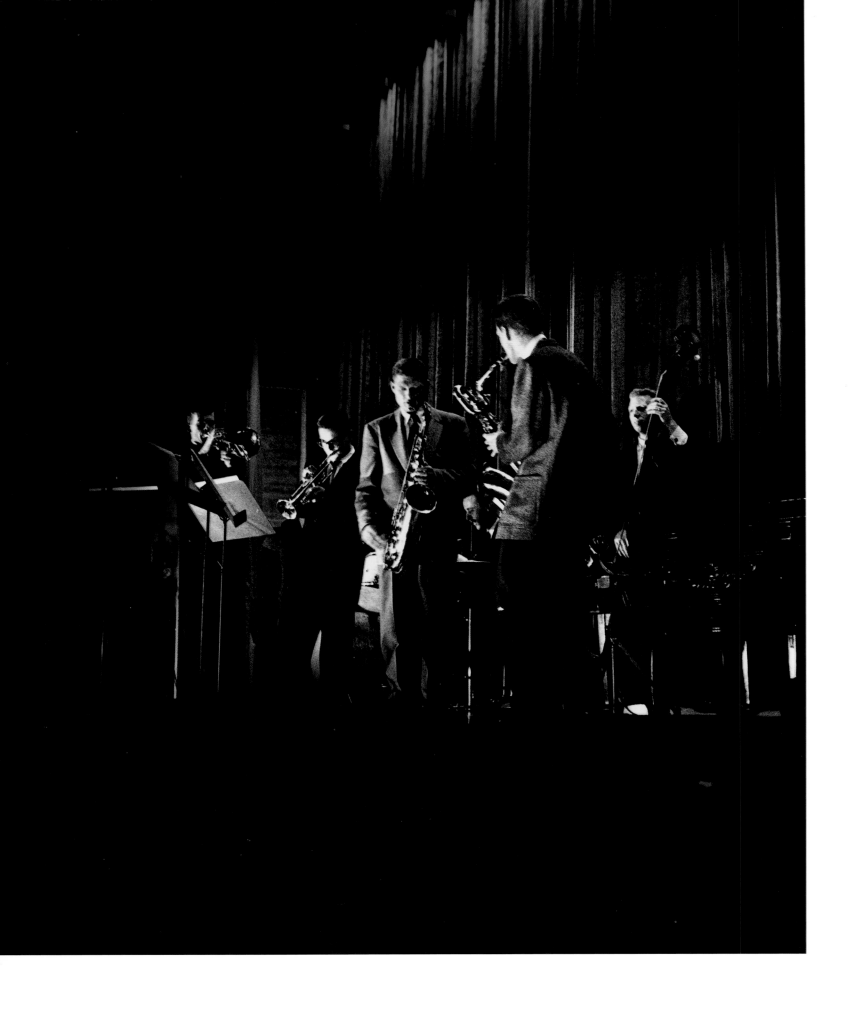

Gerry Mulligan Quintet:
Bob Brookmeyer (trombone), Zoot Sims (tenor sax), Jon Eardley (trumpet), Gerry Mulligan, Concert, San Diego, California, 1955
Red Mitchell (bass), and Larry Bunker (drums), San Diego, California, 1955

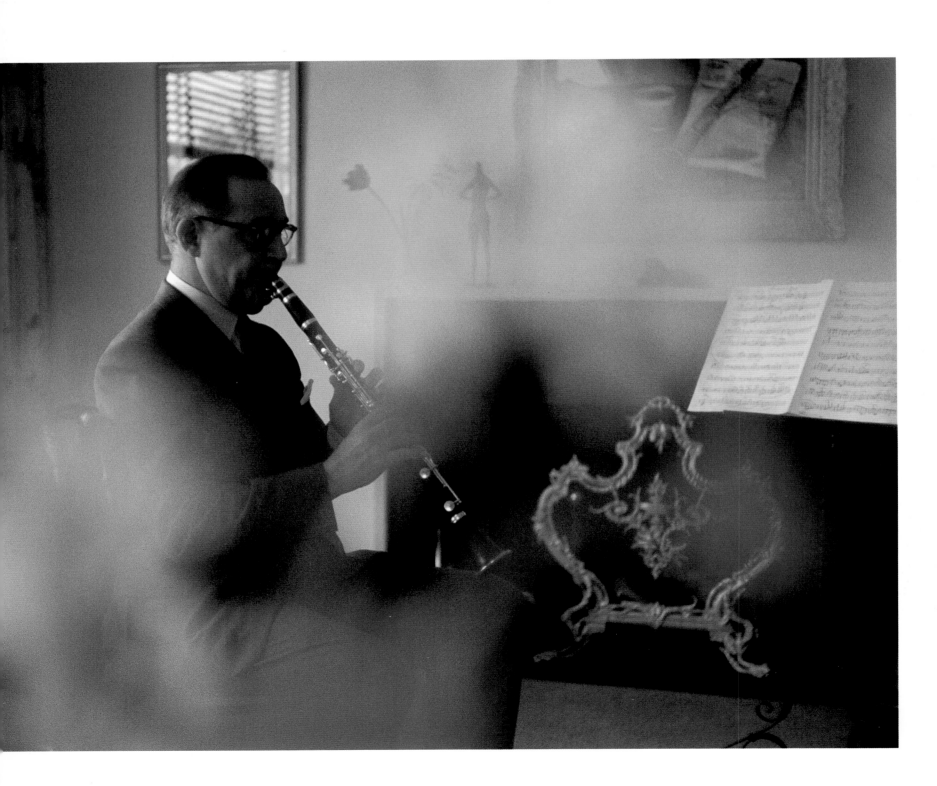

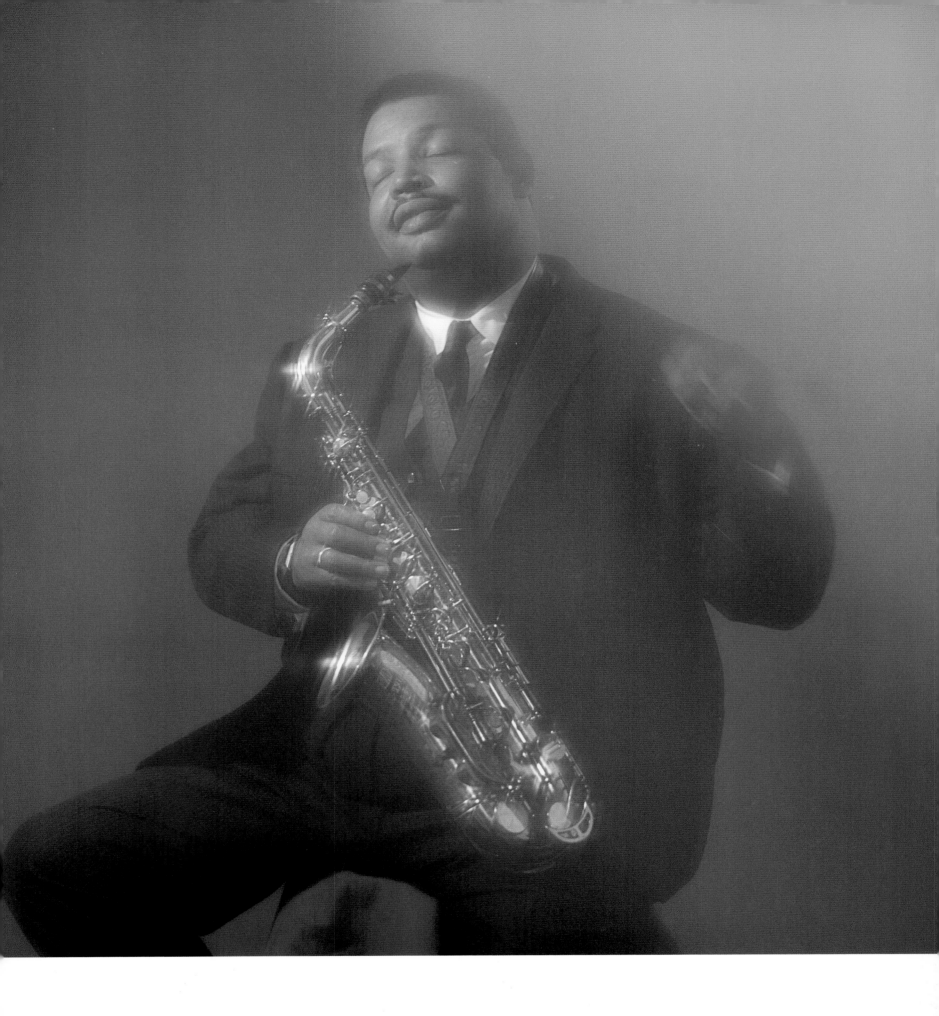

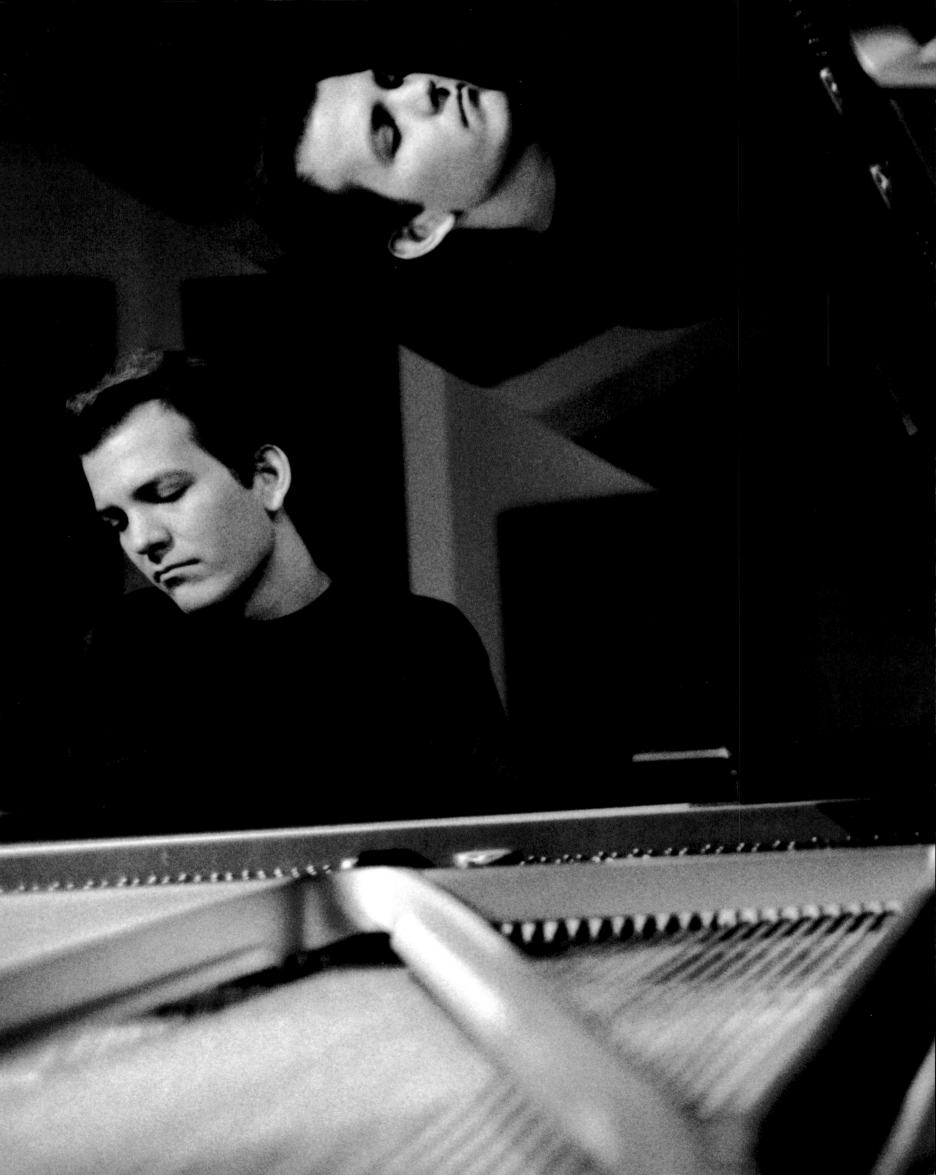

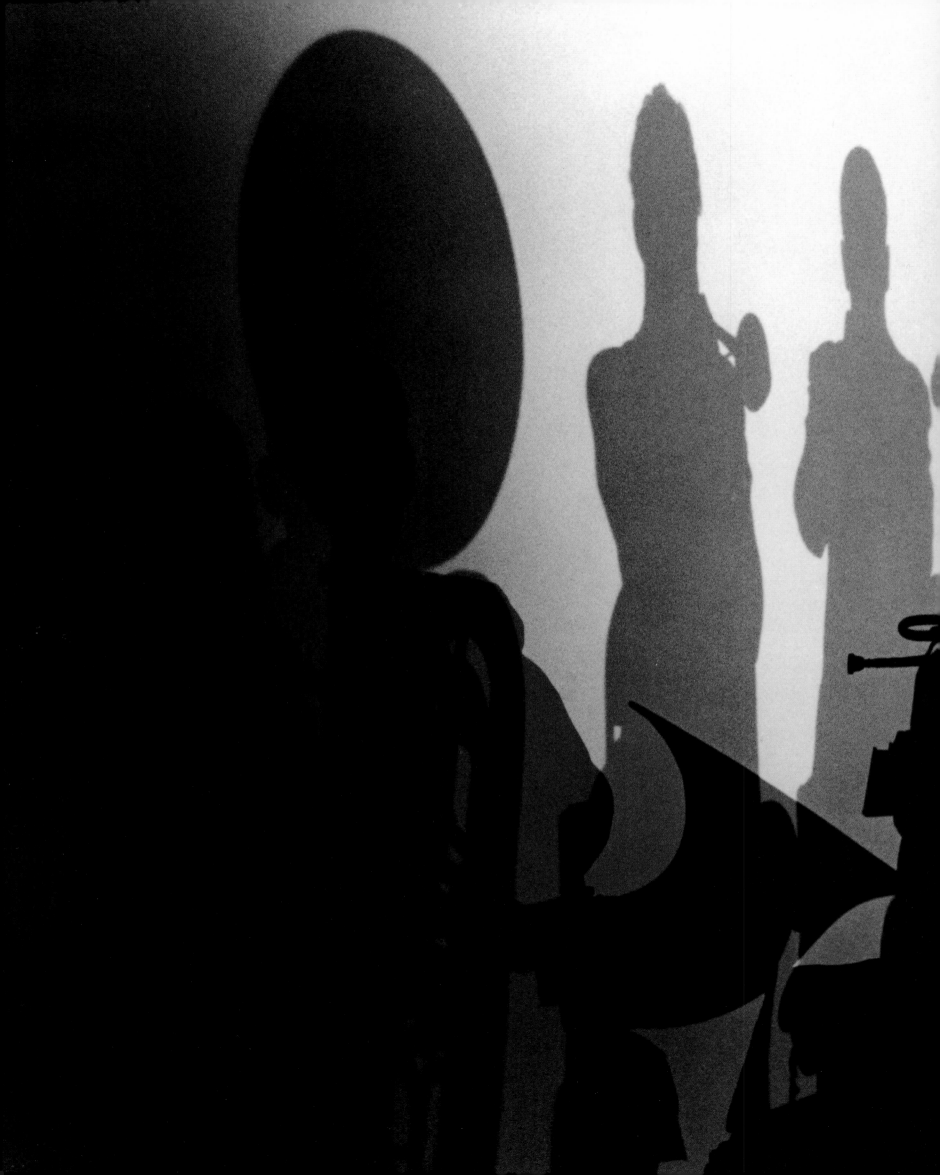

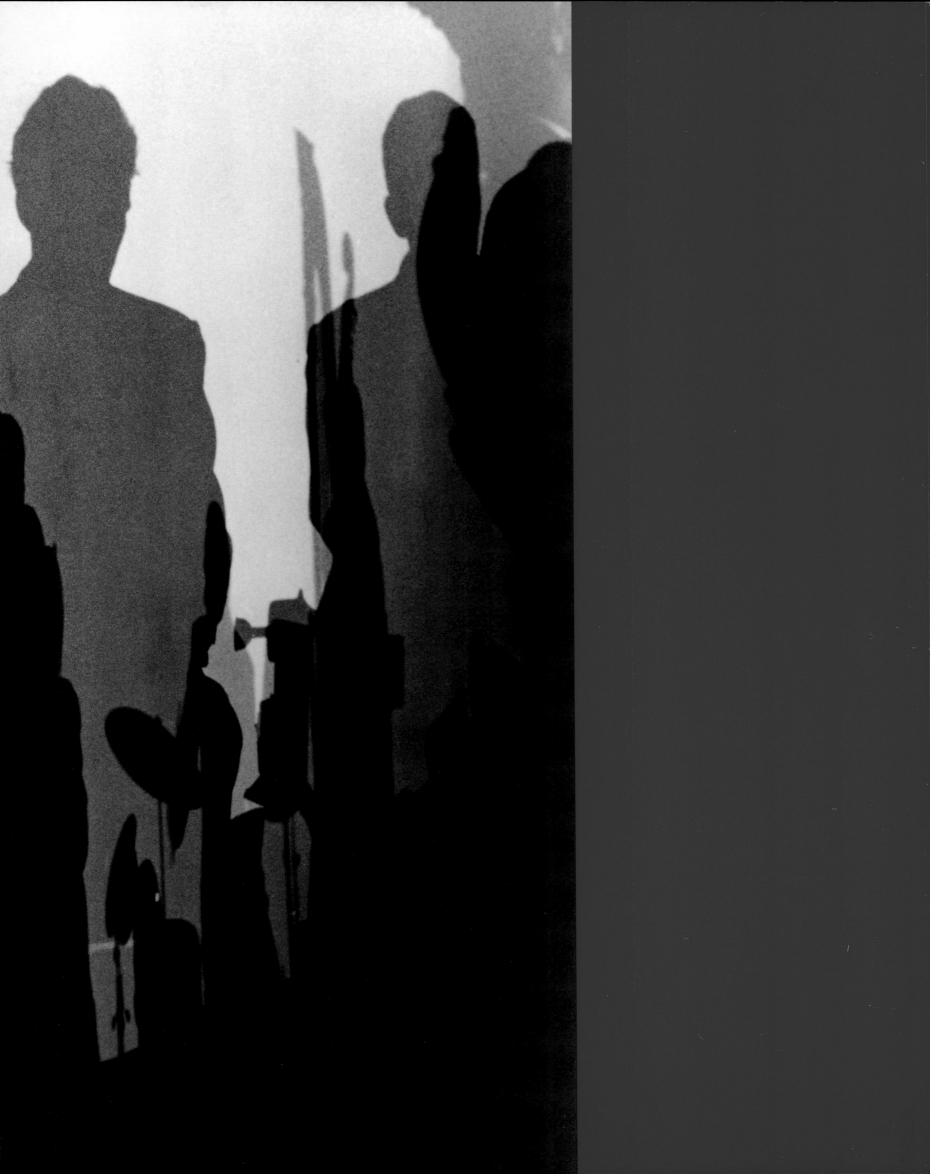

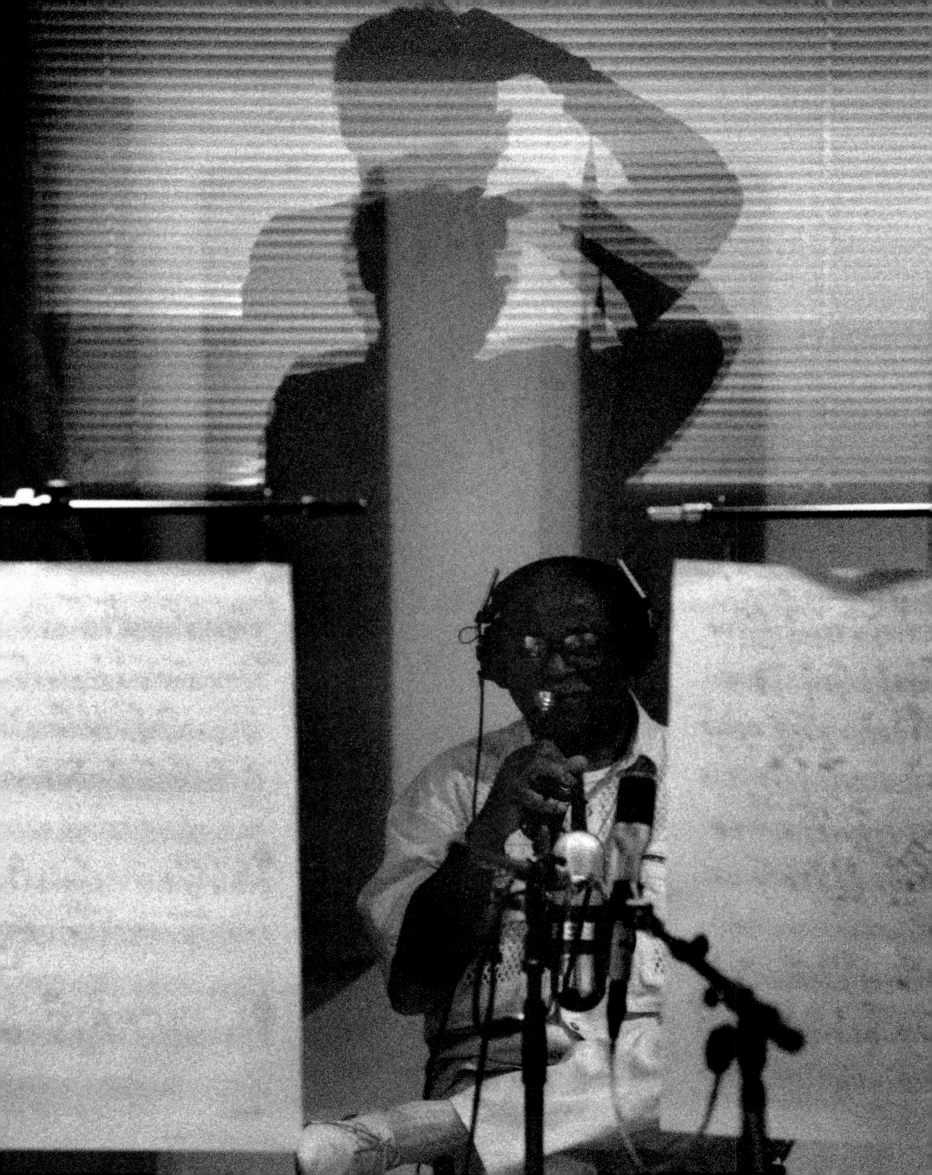

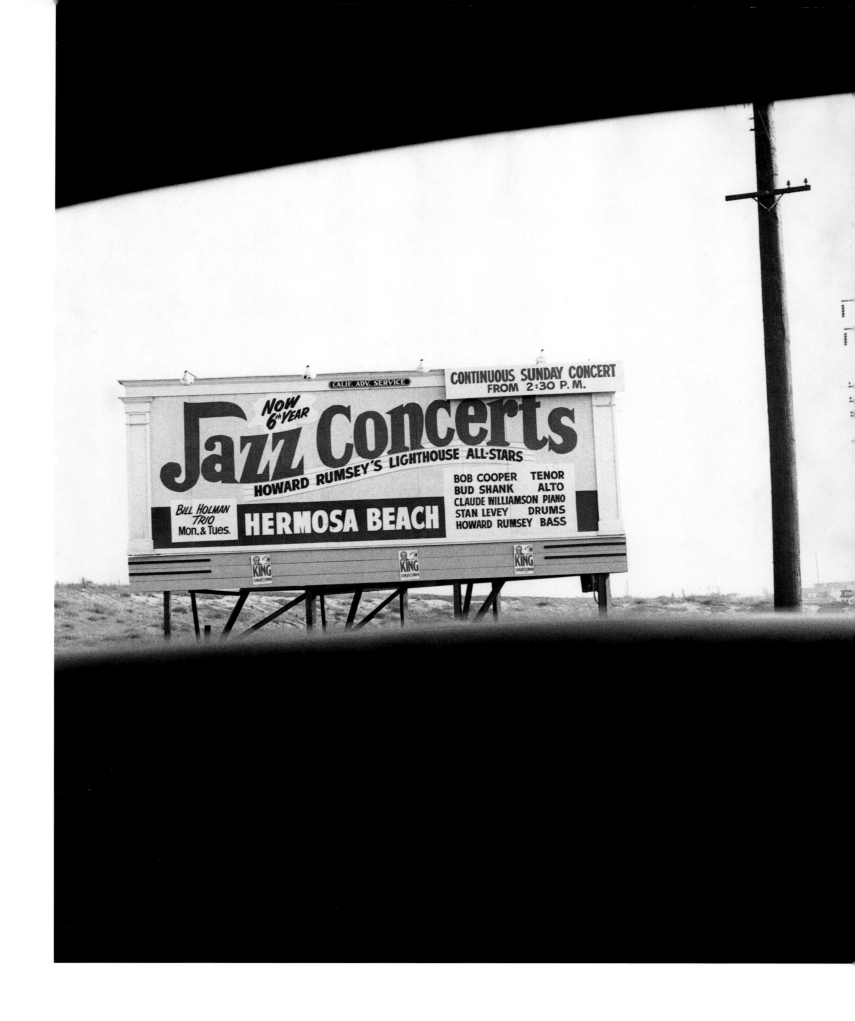

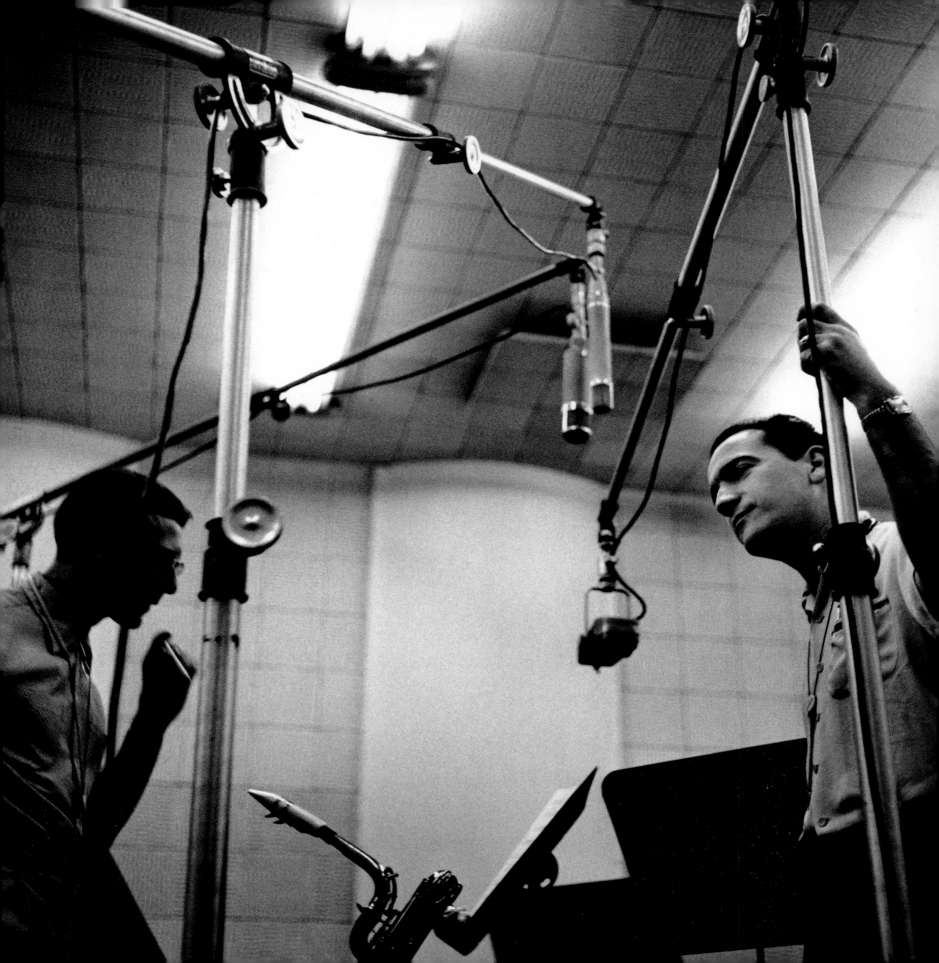

WILLIAM CLAXTON

Jazz
seen

VORWORT VON

Don Heckman

MIT TEXTEN VON

William Claxton

Jazz und Fotografie. Auf den ersten Blick zwei völlig verschiedene, geradezu gegensätzliche Künste. Die eine zum Hören, die andere zum Schauen. Doch hinter diesen Unterschieden und Gegensätzen verbergen sich bei genauer Betrachtung überraschende Gemeinsamkeiten. Und nirgends kommen diese Gemeinsamkeiten besser zum Ausdruck, nirgends wird die Verbindung zwischen den beiden Künsten greifbarer als in den außergewöhnlichen Fotografien von William Claxton.

Bereits seit dem Ende der 50er Jahre ist Claxton der begehrteste Fotograf für Aufnahmen von Jazzmusikern. Und das aus gutem Grund: Die Jazzmusiker mit dem ihnen anscheinend ureigenen Talent, unberührt von Oberflächlichkeiten die Dinge auf den Punkt zu bringen, erkannten in Claxton schon früh einen der ihren.

Jazz ist wohl eine der rätselhaftesten aller musikalischen Stilrichtungen. Auf den ersten Blick erscheint der Jazz trügerisch einfach: Die musikalischen Grundelemente Melodie, Harmonik und Rhythmus werden durch spontane Improvisation verändert und mit dem treibenden Feeling, das die Musiker als ›Swing‹ bezeichnen, aufgeladen.

Aber im Grunde birgt die Jazzmusik viele Geheimnisse in ihrer musikalischen Grundsubstanz, ihrem Stimmungsgehalt und in der Art, wie die verschiedenen musikalischen Elemente zusammentreffen. Sehen wir es einmal so: Ein Jazzmusiker muß in erster Linie über enorme technische Fähigkeiten verfügen, über eine Geschicklichkeit, wie sie auch in der klassischen Musik gefordert ist. Der Spieler muß in der Lage sein, virtuoseste Passagen in halsbrecherischen High-Speed-Tempi auszuführen, um dann plötzlich in eine ruhigere Gangart zurückzuschalten und langsamere Passagen mit großer emotionaler Dichte zu spielen.

Technische Virtuosität allein reicht jedoch nicht aus. Ein Jazzmusiker muß imstande sein, aus dem Stegreif bei der Umsetzung spontaner musikalischer Ideen diese Virtuosität einzubringen, und zwar innerhalb des strukturellen Rahmens der Musik, d. h. zum Beispiel in der Verbindung von Standard-Liedformen mit Blues und freiem Spiel. In einem Song wie dem klassischen *Cherokee* oder John Coltranes *Giant Steps* ist der Jazzmusiker gezwungen, in Bruchteilen von Sekunden auf unglaublich komplexe harmonische Anforderungen zu reagieren.

Wie gelingt ihm das? Hierin liegt das Rätsel, die unbeantwortete und vielleicht nie zu beantwortende Frage. Wie verbindet der Jazzmusiker so vermeintlich gegensätzliche Elemente wie die technische Versiertheit einerseits und die völlig subjektive, zutiefst persönliche, spontane und originelle künstlerische Improvisation andererseits? Und wie bringt er diese zum Verschmelzen?

255
Bob Gordon, Jack Montrose, Hollywood, 1954 256
257 *Gary Frommer, Hollywood, 1955*
258
259

Ist es nicht ebenso erstaunlich wie faszinierend, daß die Kunst der Fotografie dasselbe Rätsel und dieselben Fragen aufgibt? Genau wie der Jazzmusiker arbeitet der Fotograf mit einem Instrument, das manchmal unhandlich oder auch schwierig zu bedienen ist.

»Was dem Jazzmusiker sein Instrument«, so Claxton, »ist dem Fotografen seine Kamera. Ein Werkzeug nämlich, auf das man am liebsten verzichten möchte, das man jedoch braucht, um die Gedanken, oder was immer man ausdrücken will, zu transportieren.«

Und der Fotograf muß, wieder genau wie der Jazzmusiker, im Bruchteil einer Sekunde reagieren und dabei sämtliche technischen Daten seiner Kunst – Belichtungszeit, Schärfe, Beleuchtung, Blende – in seine spontane Entscheidung einbeziehen. In diesem Augenblick verfolgt er nahezu dasselbe Ziel wie der Jazzmusiker: Talent und Virtuosität dazu einzusetzen, einen Moment in der Zeit einzufangen, einen kurzen, nicht wiederholbaren Augenblick der tiefen Einsicht in eine emotionale Wirklichkeit.

»Hier treffen sich Jazz und Fotografie«, erklärt Claxton. »Sie ähneln einander in Spontaneität und Improvisation. Genau in dem Moment, in dem man etwas hört oder sieht, wird es durch die Aufnahme für immer festgehalten.«

Bereits als langer, schlaksiger College-Student im kalifornischen Pasadena der späten 40er und frühen 50er Jahre war William Claxton von der Kamera fasziniert. Mit einer halbprofessionellen Sängerin als Mutter und einem Bruder, der Boogie-Woogie-Klavier spielte, war es nur verständlich, daß sich auch Claxton zur Musik hingezogen fühlte. Bereits mit sieben Jahren legte er ein Sammelalbum an, das er Duke Ellington, Count Basie, Cab Calloway, Lena Horne sowie Fred Astaire und Ginger Rogers widmete. Als Teenager hörte er die Musik so legendärer Stars wie Fats Waller und Art Tatum.

»Damals träumte ich davon«, erinnert sich Claxton, »einen Nachtclub wie aus einem Film mit Fred Astaire und Ginger Rogers zu besitzen. Einen Club, in dem alles schwarzweiß ist, außer den bunt zusammengewürfelten Gästen aller Hautfarben. Vermutlich waren das schon damals die ersten Anzeichen einer Faszination, die mich auch später als Erwachsener nicht loslassen sollte.«

Claxton studierte Psychologie und Kunst an der University of California in Los Angeles (U.C.L.A.). Angezogen vom unwiderstehlichen Zauber der Musik, besuchte er damals jeden Jazz-Club, zu dem er sich mit viel Überredungskunst Zutritt verschaffen konnte. Anfangs arbeitete er mit einer unhandlichen Speed-Graphic-Kamera, aber selbst mit diesem sehr direkten, geradezu entlarvenden Instrument gelang es ihm, einige der atemberaubenden Bilder in diesem Buch einzufangen.

Durch ein frühes Treffen mit der Saxophonlegende Charlie »Bird« Parker wurde Claxtons Verbindung zum Jazz noch gefestigt. Gern erinnert er sich an jene Begebenheit, die sich zutrug, als er fast noch ein Teenager war.

»Ich weiß nicht, woher ich den Mut dazu nahm«, erzählt Claxton. »Aber auf einem seiner Konzerte fragte ich ihn, ob er nicht Lust hätte, nach der Show in meine Wohnung in Pasadena zu kommen, um ein wenig zu entspannen. Und zu meinem größten Erstaunen sagte er ›okay‹. Vermutlich war ich einer der wenigen, wenn nicht der einzige weiße Junge, den Charlie Parker jemals zu Hause besuchte.«

In den Semesterferien machte Claxton zusammen mit einer Freundin, die als Fotomodell arbeitete, einen Ausflug nach New York, wo er Richard Avedon kennenlernte. Avedon war von Claxtons jugendlichem Enthusiasmus so beeindruckt, daß er ihm spontan eine seiner alten Rolleiflex-Kameras schenkte. Das unerwartete Geschenk verstärkte Claxtons bereits entfachtes Interesse an der Fotografie und am Jazz noch weiter, und der Grundstein für seine Karriere war gelegt.

»Ich liebe diese Musik«, gesteht er. »Das war von Anfang an so. Gleichzeitig war ich aber auch stets davon fasziniert, wie sie entsteht und wie das aussieht. Die Körpersprache und die Bewegungen der Musiker, während sie spielen, die Art, wie das Licht ihre Gesichter erhellt.«

So wie Degas das reale Leben des Balletts hinter den Kulissen malte – Aufwärmübungen der Tänzerinnen –, sucht Claxton das Herz des Jazz, indem er Musiker in ungezwungenen, gelösten Momenten fotografiert.

»Das eigentlich Faszinierende«, schwärmt er, »ist ihr Gesichtsausdruck, wenn sie nicht spielen, in anderen Lebenssituationen, wenn sie üben, proben, rauchen, herumstehen und reden, sogar wenn sie essen oder Drogen nehmen. Ich höre ihnen sozusagen mit meinen Augen zu.«

1952 arbeitete Claxton gemeinsam mit dem Produzenten Richard Bock für das neu gegründete Label Pacific Jazz Records und wurde Art-director und Fotograf der Plattenfirma, die im aufkommenden West Coast Jazz eine wichtige Rolle spielen sollte. Claxtons innovative Full-Cover-Fotos von Jazzmusikern brachten den offenen, lockeren Lifestyle der Szene zum Ausdruck und waren für die Jazz-Bewegung der amerikanischen Westküste fast ebenso wichtig wie die Musik selbst. Claxton holte von Natur aus fotogene Künstler wie Chet Baker und Art Pepper aus der traditionell düsteren, schummrigen Szenerie der Jazz-Clubs heraus und fotografierte sie draußen in der Sonne Kaliforniens. Damit fing er den Look und das Feeling einer einzigartigen Jazzdekade meisterhaft ein und trug maßgeblich dazu bei, diesen Stil zu etablieren.

»Fotoaufnahmen für 12 x 12-Plattencover, das Format der alten Vinylalben«, so Claxton, »machten sehr viel mehr Spaß als die Shoots im 5 x 5-Format für CDs. In den 50er Jahren, in jenen Tagen, als die LP ganz groß war, waren Fotoaufnahmen für ein Plattencover eine relativ simple und erfreuliche Angelegenheit. Das einzige, worüber man sich Gedanken machen mußte, waren der Titel oder das Thema des Albums. Man besprach lediglich die Garderobe des Musikers, dann traf man sich mit ihm und machte die Aufnahmen – entweder in der warmen kalifornischen Sonne oder im Studio.«

256
257
258
259 *Jimmy Giuffre Trio: Jim Hall (guitar), Ralph Peña (bass), Jimmy Giuffre (saxophon*
260 *Hollywood, 1957*

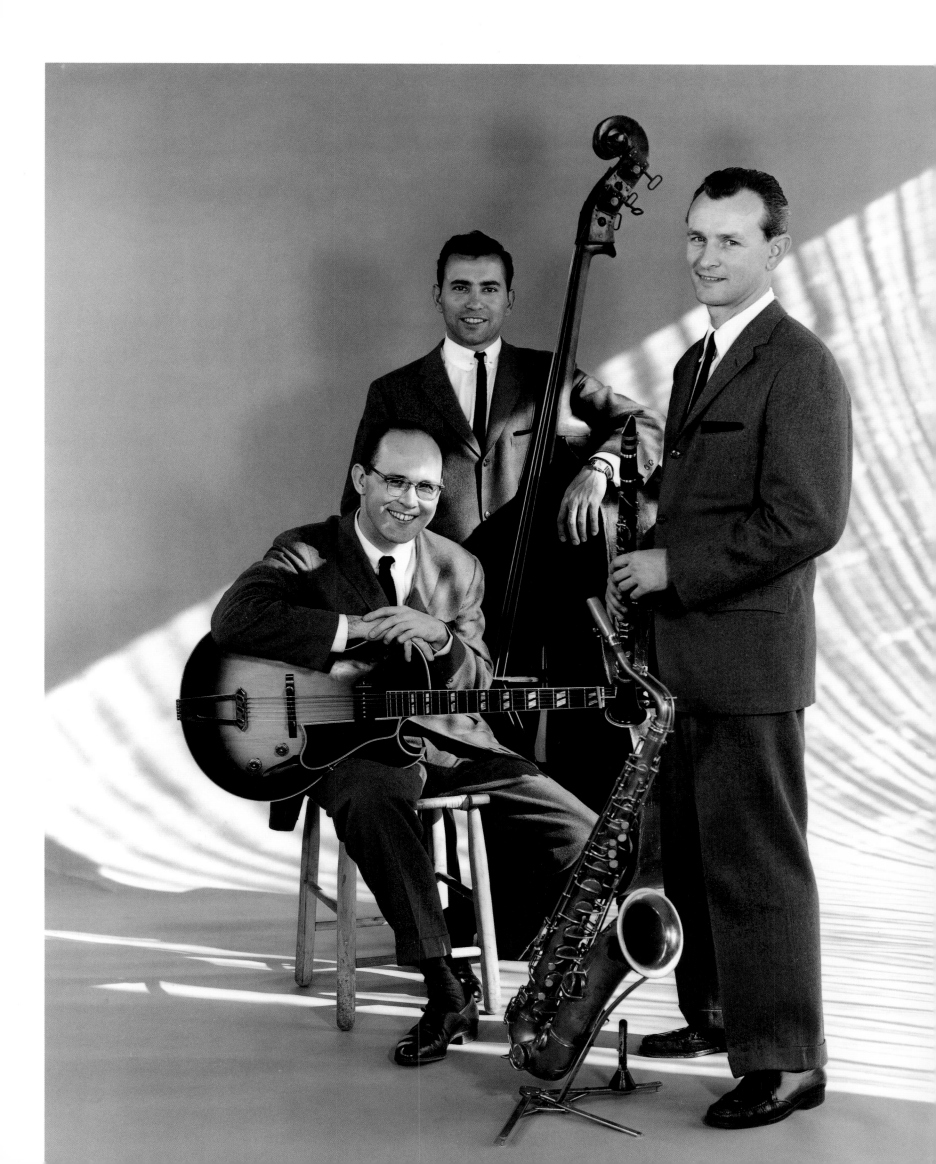

»Heute jedoch ist das völlig anders als damals, als ich die Coverfotos für Pacific Jazz machte«, fährt er fort. »Wenn man heute einen großen Star fotografiert, hat man erst mal endlose Gespräche und Treffen mit Creativ- und Art-directors, Künstler- und Managementanwälten sowie Vertretern der Plattenfirma. Dann kommen die Anproben mit Kostümbildnern, Stylisten und Visagisten. Erst wenn das alles vorbei ist, kann man sich endlich mit dem Musiker zusammensetzen und hat ein paar Stunden Zeit für die Aufnahmen. Was früher ganz einfach war, ist heute eine überaus komplizierte Geschichte.«

Obwohl er buchstäblich alle Plattencover für Pacific Jazz fotografierte, fand Claxton stets noch genügend Zeit für andere Arbeiten. Nahezu jede große Plattenfirma der 50er Jahre – Capitol, Columbia, Fantasy, Decca, RCA Victor usw. – verwendete Claxtons Bilder, und es ist zweifellos der Qualität seiner Aufnahmen zu verdanken, daß das Jazzalbum-Cover zum werbewirksamen Verkaufsinstrument wurde.

»Claxton«, schrieb der verstorbene Jazzkritiker Leonard Feather, »sieht mehr als das augenfällige Bild, das seine Modelle darstellen. Im Zusammenspiel mit der Kulisse, in der er sie präsentiert, wurden sie häufig zur Metapher für den Zeitgeist, für eine ganze Ära der Musikgeschichte.«

Feather hatte recht. Gewiß hatte Claxton das Glück, zu einer Zeit seine künstlerische Reife zu erlangen, als der Jazz eine wahre Innovationswelle erlebte. Doch ist es allein seinem Talent und seinem Gespür für die Energien des Jazz der 50er und 60er Jahre zu verdanken, daß seine Bildchroniken so erfolgreich geworden sind. Claxton verstand die Musik und war sowohl für die individuelle Persönlichkeit der einzelnen Spieler als auch für das Wesen ihrer musikalischen Suche empfänglich. Nur so konnte es ihm gelingen, die Kraft ihrer Musik mit der ›Tiefenschärfe‹ seiner Bilder zu vereinen.

Über kurz oder lang war es jedoch nicht nur der Jazz, der in den Genuß von Claxtons fotografischem Scharfblick kam. So widmete er in den 60er Jahren einen Teil seiner kreativen Energie der Modefotografie. Seine Arbeiten erschienen schon bald in fast allen namhaften Zeitschriften, von *Time* und *Newsweek* bis hin zu *Vogue*, *Harper's Bazaar*, *Paris Match* und Dutzenden anderen.

Claxtons Aufnahmen von seiner Ehefrau, der Schauspielerin Peggy Moffitt, im gewagten Oben-ohne-Badeanzug des Modeschöpfers Rudi Gernreich sorgten in den 60er Jahren für Furore. *The Rudi Gernreich Book* (Rizzoli, 1991; neue Ausgabe Benedikt Taschen Verlag, 1999), eine Bildergeschichte mit den Kreationen des Avantgarde-Designers, entstand als Gemeinschaftsprojekt des Fotografen William Claxton und des Mannequins Peggy Moffitt und umspannt beinahe zwei Jahrzehnte ihrer Arbeit mit Gernreich. 1967 schufen Claxton und Moffitt *Basic Black*, einen Modefilm über Gernreich, der heute als der »Urahn« des Modevideos gilt und der seinerzeit die aufkommende multimediale Modebranche stark beeinflußt hat.

Claxtons erfülltes Fotografenleben ging bald über die Grenzen des Jazz hinaus. Er ist Mitbegründer der National Academy of Recording Arts and Sciences (NARAS), führt Regie bei Fernsehshows und Werbespots und hat zahlreiche Arbeiten für die Unterhaltungsbranche übernommen, darunter Fotoaufnahmen für aktuelle Spielfilme wie Spike Lees *Mo' Better Blues*. Seine Fotos zieren die auffälligen Werbeanzeigen der Gap-Läden und erscheinen regelmäßig in Wochenzeitschriften wie *Interview Magazine* und im *GQ Magazine*.

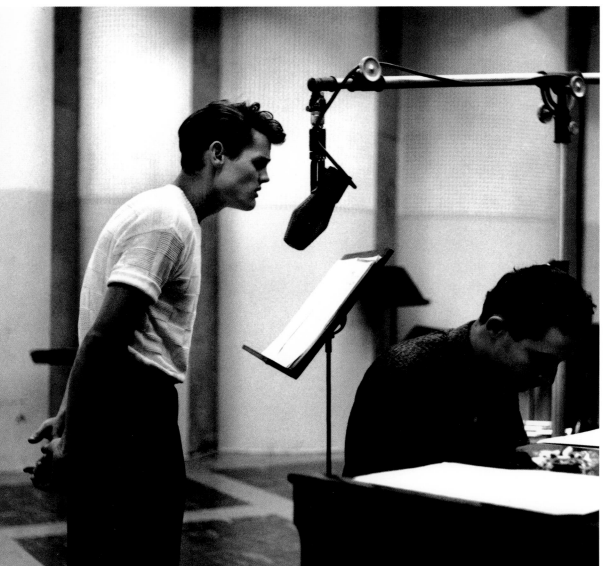

»Einmal pro Jahr«, so Claxton, »stelle ich für das englische *GQ* eine Gruppe von Jazzmusikern meiner Wahl für eine Fashion Story zusammen, Musiker jeden Alters und jeder Herkunft, und fotografiere sie in der aktuellen Herrenmode.«

Claxtons Fotografien werden in renommierten Galerien in aller Welt ausgestellt, in New York, London, Paris, Zürich, Berlin, Tokio, San Francisco und Los Angeles. Limitierte Editionen seiner Bilder sind inzwischen begehrte Sammlerstücke.

Obwohl Claxton als einer der angesehensten Topfotografen in der Welt des Entertainment gilt, schlägt sein Herz nach wie vor für den Jazz und verwandte Musik. Den besten Beweis für diese lebenslange Liebe liefert diese phantastische Fotokollektion, die einen Überblick gibt über das reiche, vielseitige Schaffen eines Fotografenlebens, das dem Jazz gewidmet ist.

Zweifellos wird jeder in der prachtvollen und gut durchdachten Sammlung von Fotos in diesem Band eine Aufnahme finden, die ihn besonders anspricht,

und es wird einige Ikonen geben, die mit Sicherheit auf dem Wunschzettel jedes Betrachters auftauchen. Man sehe sich beispielsweise den nachdenklichen John Coltrane (S. 16/17) an, während er sich im Museum of Modern Art in New York mit dem Abstrakten Expressionismus auseinandersetzt. Sein Gesichtsausdruck läßt die Entschiedenheit erkennen, mit der er die Kunstwerke zu verstehen sucht. In ihrer Fokussiertheit und Motivation erinnert diese Entschiedenheit exakt an die Energie, die Coltranes Improvisationen unentwegt antreibt.

Man achte auch darauf, wie Claxton für Nat »King« Cole (S. 72) eine geradezu perfekte Position ausgewählt hat. Im maßgeschneiderten Smoking steht er – eine Zigarette in der Hand – vor einem ornamentalen Eisengitter und lächelt geheimnisvoll, ähnlich wie die Mona Lisa – angesichts seines großen Erfolges mit dem Blockbuster-Song desselben Titels durchaus angemessen.

Ähnlich genau erfaßt, aber in einem ganz anderen Stil erscheint Maynard Ferguson (S. 144/145) während einer Probe mit seiner Big Band. Seine Backen sind aufgeblasen, seine Knie gebeugt, während er auf der zielsicheren Suche nach einer seiner patentierten Noten in höchster Tonlage ist. Claxtons Foto von Joe Williams (S. 188/189) läßt die Zeit für einen Moment stillstehen, während sich der Veteran des Blues- und Jazzgesangs mit

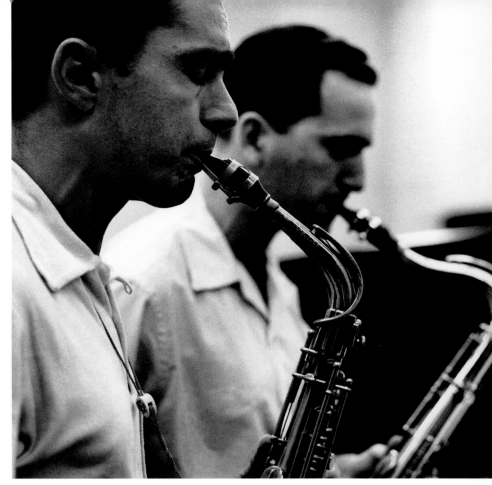

geschlossenen Augen und den Fingern an den Schläfen in seinen persönlichen Sound einzustimmen scheint, bevor er auf die Bühne geht. Das Foto des jugendlich aussehenden Ornette Coleman (S. 211), der überlegen die Griffe auf seinem weißen Altsaxophon aus Plastik beherrscht, ist ein weiteres Beispiel für Claxtons Talent, den rechten Moment und das rechte Maß an Begeisterung für sein Gegenüber zu finden. Konzentriert man sich auf Colemans leuchtende Augen, die mit Intensität direkt auf das Objektiv der Kamera gerichtet sind, wird deutlich, wie Claxton unmittelbar eine Verbindung zu Colemans eindringlicher Vision von Improvisation und Freiheit herstellt.

Im Kontrast dazu steht eine Reihe von Duke-Ellington-Aufnahmen (S. 218, 219), in denen die eher kühle Seite des Musikers zutage tritt, der ein kontrollierendes Verhalten als Komponist bzw. Bandleader an den Tag legt und gleichzeitig im Umgang mit dem Orchester seinen Charme spielen läßt. Die teils ernsten, teils humorvollen Aufnahmen, die Duke Ellington und seinen Assistenten in komplizierter Interaktion zeigen, entstanden meist als Schnappschüsse.

Ähnlich einnehmend sind auf eine eigene, äußerst originelle Weise die Fotos des Popsängers und Rapstars Isaac Hayes (S. 234/235), der den Rahmen von Claxtons Foto buchstäblich dominiert. Mit dicker Pelzjacke bekleidet und mächtigen, von seiner Brust herabhängenden Schmuckstücken erscheint Isaac Hayes auf dem Foto in der gleichen dunklen, maskulinen Ausstrahlung, die viele seiner Plattenhits in den frühen 70er Jahren prägte.

Die vorliegende Fotokollektion zeigt außerdem einige der interessantesten »Musikerpaare«, manche auf einem Foto, andere auf gegenübergestellten Aufnahmen.

Man beachte die wunderschönen Aufnahmen von Louis Armstrong und dem Schauspieler Danny Kaye (S. 40, 41), die das Zusammentreffen und sich wieder Lösen der Meister des feinen Humors hervorragend zum Ausdruck bringen. Indem Claxton die Bewegung und das Zusammenspiel des begnadeten Paares ins Zentrum seiner Fotos stellt, unterstreicht er den leicht spleenigen Touch, der so typisch für Louis Armstrong und Danny Kaye ist.

Ein paar Seiten weiter ist Diana Krall (S. 64) – noch nicht der bekannte Jazz-Star, der sie bald werden sollte – aufgrund ihrer blonden Haare ein Zentrum des Lichtes, wobei ihr enthusiastisches Lächeln von einem sanften Lachen und einer koketten Pose Sylvia Syms' (S. 65) flankiert wird.

Und welcher musikalische Witz wird gerade zwischen Gerry Mulligan und Ben Webster (S. 148/149) gerissen, als der korpulente Webster den Rhythmus anschlägt und der stets schlanke und ranke Mulligan mit einem spitzbübischen Lächeln während des Spielens darauf reagiert? Was auch immer die Motivation gewesen sein mag, Claxton war zugegen, um das Wesentliche dieses Ereignisses festzuhalten.

Die Reihe der Musikerpaare wird fortgeführt: Schnappschüsse von Diana Ross (S. 157), die sich zu konzentrieren scheint, und N' Dea Davenport (S. 156) mit Schmollmund. Nachdenkliche Aufnahmen der beiden äußerst verschiedenen Sängerinnen Barbara Carroll und Odetta (S. 174, 175), die sich jedoch äußerlich hinsichtlich ihres Ausdrucks und ihrer Stimmung so sehr ähneln, daß die Unterschiede ihrer musikalischen Ausrichtung vernachlässigt werden können. Ein Blick auf Sonny Rollins damals und heute (S. 184, 185) hebt die Unterschiede zwischen seinem jugendlichen Esprit und seiner gebieterischen Reife hervor. Entsprechend wird eine typische atmosphärische Aufnahme von Miles Davis (S. 187; eines von Hunderten von Claxton aufgenommenen Fotos) einer unge-

Chet Baker, Russ Freeman, Hollywood, 1954 **260**

261 *Art Pepper, Jack Montrose, Hollywood, 1954*

262

wöhnlich heiteren Aufnahme des lächelnden Gil Evans (S. 186) gegenübergestellt, der nicht nur Miles Davis beliebtester Arrangeur war, sondern auch sein bester Freund. Und nur Claxton konnte die Idee haben, den spitzbübischen Frank Sinatra (S. 198) posieren zu lassen, als dieser aus dem Kasten einer Engelsharfe lugt, und dann diese Aufnahme neben einen Schnappschuß von Bing Crosby (S. 199) zu stellen, der gerade in seinem Aufnahmestudio Wunder geschehen läßt.

Drei weitere »Paare«, die jeweils auf ihre eigene Art und Weise originell sind, müssen noch erwähnt werden. Die Sängerin Cassandra Wilson und der Pianist Jacky Terrasson (S. 202) sind ein höchst kompatibles musikalisches Team. Sie wurden Jackie Cain und Roy Kral (S. 202/203) zur Seite gestellt, die sowohl musikalisch als auch privat seit langem ein Paar sind. Und wenn Claxton Wayne Shorter (S. 240) und Herbie Hancock (S. 241) mit einem Lächeln auf den Lippen auf einer Seite zeigt und beide sich offensichtlich gut amüsieren, skizziert der Fotograf eine lebenslange persönliche und musikalische Freundschaft, die bis heute zwischen den beiden Veteranen der Jazzmusik Bestand hat.

Neben der erstaunlichen Bandbreite von Fotografien einzelner Persönlichkeiten und faszinierender musikalischer »Pärchen« gibt es einige Fotoreihen, die ihr eigenes Profil haben und für sich allein stehen.

So dokumentiert Claxton das New Orleans der 60er Jahre (S. 98–108). Wie es oft den besten Fotografen, etwa Cartier-Bresson, gelingt, zur rechten Zeit am rechten Ort zu sein, so war auch Claxton passend zur Stelle. Das Jahr 1960 stellte den Übergang zu einer neuen Ära dar. Es war das Jahr der Wahl von John F. Kennedy zum Präsidenten der Vereinigten Staaten, ein Jahr, in dem die Bürgerrechtsbewegung in Schwung kam.

Claxtons phantastische Aufnahmen einer lokalen, nicht sehr bekannten Band aus New Orleans, die auf ihrem Weg von einer Beerdigung nach Hause musiziert, halten einen friedlichen Moment fest, wobei sie noch die Traditionen der Vergangenheit anklingen lassen. Sie entspringen einer Zeit, in der sich eine komplexe, unsichere und oftmals brutale Zukunft, welche die 60er nach sich ziehen sollten, bereits am Horizont abzeichnete.

Eine andere Reihe von Fotos (S. 126–135) hat den entsprechend körnigen Look der »Television-Cinescopes«. Aufgrund der Distanz schaffenden Effekte in den Aufnahmen scheinen diese den kurzen Zeitraum zu dokumentieren, als der Jazz noch auf dem Fernsehbildschirm willkommen war und eine Fernsehnacht tatsächlich faszinierende Momente bieten konnte, wie sie in den Aufnahmen von Billie Holiday (S. 131), Peggy Lee (S. 134/135), June Christy (S. 132/133), Buddy DeFranco (S. 128) oder auch Jimmy Giuffre (S. 130) erfaßt sind.

Ähnlich faszinierend sind die Aufnahmen von Chet Baker (S. 137, 138/139, 140) und zwar insbesondere das Bild, das seine vollen, sinnlichen Lippen zeigt und damit das erotische Element akzentuiert, das eine Parallele zu seinem Spiel auf der Trompete darstellt. Man achte auch auf die raffinierten Fotos auf den Seiten 245 bis 254. Sie repräsentieren einen Querschnitt aus Claxtons eher seltenen Exkursionen in die Welt der Foto-Effekte. Besonders deutlich wird dies im Porträt des nachdenklich wirkenden Brad Mehldau (S. 248/249), dessen Bild auf der spiegelnden Innenseite des Flügels eingefangen wird.

Gerade weil Fotografie und Jazz untrennbar mit der amerikanischen Geschichte verbunden sind – von Matthew Bradys Civil-War-Fotos zur Musik von Duke Ellington und parallel dazu von den sozialen und historischen Einflüssen des *Life Magazine* zur Swing-Musik und der 52. Straße –, ist Claxtons Werk mehr als eine Sammlung reizvoller Bilder. Seine Fotos gewähren einen Einblick in das Wesen Amerikas, vergleichbar mit den außergewöhnlichen Arbeiten von Walker Evans und Robert Frank. Durch die Energie und den inhärenten Individualismus, den die Gesichter ausstrahlen, die Bewegungen und die Intensität der Jazzmusiker und den allgegenwärtigen Gemeinschaftssinn illustrieren Claxtons mitreißende Momentaufnahmen des Lebens in New Orleans das Beste, was Amerika zu bieten hat.

Individualismus, Gemeinschaftssinn, Phantasie, Spontaneität und kreative Schaffensfreude sind Elemente, die in dem oft überheblichen Selbstbild der USA als alleinig verbleibende Supermacht meist unbeachtet bleiben, die jedoch einen wesentlichen Bestandteil des realen Amerika bilden. Claxton besaß die Weitsicht, diese Elemente mit seiner Kamera einzufangen, und hat so Amerika von seiner besten Seite für die Nachwelt unvergeßlich gemacht.

PAUL DESMOND [p. 23]

Auf die Frage: »Mit welchem Jazzmusiker möchten Sie am liebsten auf einer einsamen Insel stranden?«, würde ich spontan antworten: mit »Bird«, dem Jazz-Genie unserer Zeit. Doch wenn ich dann an Charlie Parkers Drogenprobleme und persönliche Schwierigkeiten denke, würde meine Wahl wohl auf Paul Desmond fallen. Paul war einer der humorvollsten, fröhlichsten und herzlichsten Musiker, denen ich je begegnet bin, ein origineller und charmanter Satiriker voller Wortwitz. Falls wir auf der einsamen Insel doch mal aufhören sollten zu lachen, könnte Paul auf seinem Altsaxophon spielen – so wunderbar lyrisch und einfühlsam swingend.

An einem warmen, verregneten Abend in Washington D. C. schlichen Paul und ich einmal von einem Jazzfestival davon, um uns in der schlimmsten Gegend von Baltimore eine Striptease-Show anzusehen. Dafür verzichteten wir sogar auf Dizzy Gillespie, Gerry Mulligan und Thelonious Monk. Doch als sich die letzte Stripperin im Programm bis zum String-Tanga ausgezogen hatte, nahm sie zu unserem größten Erstaunen eine Klarinette zur Hand. Während sie vor uns und vier anderen Männern im Regenmantel die Hüften schwang, spielte sie Artie Shaws Erkennungsmelodie *Nightmare*. Vor dem Jazz gibt es wohl kein Entrinnen.

THE FIVE PENNIES [p. 40]

Das Foto entstand während einer Probe für den Soundtrack des Films *The Five Pennies*. Die Musical-Biographie erzählt die Geschichte des Kornettisten Red Nichols und seiner »Five Pennies«. Danny Kaye spielt Red Nichols, der Danny die Fingerfertigkeit auf dem Kornett beibrachte und die Musik für den Soundtrack spielte. Während der Aufnahmen amüsieren sich Louis Armstrong und Danny Kaye gemeinsam auf der Bühne.

DILLON O'BRIAN [p. 45]

Die Welt Dillons. Dillon O'Brian ist in Baltimore aufgewachsen. BMG/RCA beauftragte mich, dorthin zu fahren und Aufnahmen von ihm für das neue Plattencover zu machen. Dillon und ich gingen zusammen aus. Als wir durch die Straßen der Stadt liefen, erinnerte sich Dillon an frühere Zeiten und erzählte mir, welchen Einfluß die Stadt und insbesondere die Kirche auf sein Leben und seine Musik ausgeübt haben. Nach einem vergnüglichen und feucht-fröhlichen langen Mittagessen gingen wir in die Kirche, die Dillon während seiner Kindheit zum Gottesdienst besucht hatte. Zu Füßen der mächtigen neogotischen Kirche streckte er sich im Gras aus.

RAY CHARLES, HOLLYWOOD, 1962 [p. 68]

Dieses Foto entstand in den United Studios in Hollywood während einer Plattenaufnahme für Atlantic Records.
Zwei Ereignisse blieben mir besonders gut in Erinnerung:
Einmal wurde in den frühen Morgenstunden eine Kaffeepause eingelegt, damit sich die riesige Band und die Raylettes ausruhen konnten. Plötzlich bemerkte ich, daß nur noch zwei Menschen in dem stillen, leeren Studio zurückgeblieben waren: Ray Charles und ich. Der blinde Musiker ergriff meinen Arm und bat mich, ihn zur Harfe zu führen. Ray ließ die Hände über das Instrument gleiten und sagte: »Ich habe nie zuvor eine Harfe aus der Nähe *gesehen*.« Dann *betrachtete* er die Pauke, die Waldhörner und all die anderen Instrumente. Es war ein sehr eindringliches Erlebnis.
Die andere Episode war eher geselliger Natur: Am Abend kam plötzlich Frank Sinatra herein, Arm in Arm mit Marilyn Monroe. Er trug eine schwarze Krawatte, sie war in einen weißen Pelz gehüllt und mit Juwelen behängt. Sie wollten dem »Genius of Soul« nur mal »Hallo« sagen. Eine schlechte Nachricht: Die Leibwächter von Sinatra erlaubten mir keine Aufnahmen.

ROOSEVELT CHARLES [p. 94]

1959 beauftragte mich ein großer deutscher Verlag, mit dem Musikhistoriker und Schriftsteller Joachim-Ernst (Joe) Berendt quer durch die USA zu reisen, um die verschiedensten Arten amerikanischer Musik zu dokumentieren: Blues, Folk, Gospel und natürlich Jazz. Wir besuchten Kirchen, Schulen, Theater, Nachtclubs, abgelegene Waldhütten und Gefängnisse und machten Tonband- und Fotoaufnahmen von den unterschiedlichen Musikern.
Im Staatsgefängnis von Angola, Louisiana, empfing uns der Direktor mit seinen Mitarbeitern. Man bot uns an, entweder die Abteilung der »Weißen« oder die der »Farbigen« zu besuchen. Die Mitarbeiter des Direktors berichteten, sie hätten »nie irgendwelche Musik auf dem Hof der Weißen gehört«, also entschieden wir uns für das Areal der »Farbigen«. Einen Begleitschutz könne man uns aber nicht stellen, da der Direktor »keinen seiner Wärter erübrigen« könne.

Als Joe und ich auf den Gefängnishof traten, wurden wir sofort von den schwarzen Häftlingen umringt. Wir erklärten unser Anliegen, und sofort bot sich einer der unternehmungslustigeren Insassen als unser Guide an und verkündete, er kenne alle »großen Begabungen im Hof«. Er hieß »Hoagman« und spielte selbst Gitarre.

Wir begegneten den verschiedensten musizierenden Häftlingen, doch einer der beeindruckendsten und originellsten war Roosevelt Charles, ein überführter Mörder. Er sang ohne Begleitung in einem wunderbar bluesigen Stil und komponierte Songs über sein Leben im Gefängnis. Einer der packendsten Songs erzählte davon, wie er während der Feldarbeit zweimal an einem Tag vom Blitz getroffen wurde:

»Der gütige Gott sprach zu mir. Er sagte: / ›Charles, du bist ein besonderer Mann.‹ / Und er traf mich einmal und traf mich ein zweites Mal / mit seiner mächtigen goldenen Hand. / Der gütige Gott sprach zu mir. Er sagte: / ›Charles, du bist ein besonderer Mann.‹ / Seine Feuerhand traf mich kalt, / doch ich brannte im Innern vom goldenen Glanz. / Der gütige Gott sprach zu mir. Er sagte: / ›Charles, du bist ein besonderer Mann.‹ / Ich weiß, ich bin jetzt ein besserer Mensch, / denn ich lebe noch und bin doch verletzt von Seiner Hand. / Amen.«

NEW ORLEANS, MARCHING BANDS, 1960 [p. 96, 97]

Im Rahmen unserer Rundreise durch die USA für unser Buch *Jazzlife* verbrachten Joachim-Ernst Berendt und ich etwa zwei Wochen in New Orleans. Unser wohl beeindruckendstes und ungewöhnlichstes Erlebnis war der Zug der großartigen Marching Bands durch die Straßen dieser Stadt. Es ist Tradition, daß diese Blaskapellen auf der Begräbnisfeier spielen, wenn eines ihrer Logen- oder Bandmitglieder verstorben ist. Eine würdevolle, komplette Marschkapelle gibt dem Verstorbenen das letzte Geleit. Auf dem Weg zum Friedhof spielt sie eine Trauerhymne, auf dem Rückweg fröhliche Jazz-Nummern. Nun schließen sich der Band auch die »Second Liners« an, die zur Musik tanzen, singen und als stolze Parade aufmarschieren. Die »Second Liners« sind jene zähen Jungs, die kein Instrument spielen können, aber unbedingt an diesem Treiben teilhaben wollen.

Es ist für Außenstehende schwierig, die Termine der Begräbnisse, die zugleich eine Feier des Lebens sind, in Erfahrung zu bringen. Doch unser Freund Richard Allen, der an der Tulane University Jazz-Geschichte lehrt, ist eine unerschöpfliche Informationsquelle, was diese Bands und ihre Mitglieder betrifft. Dank seiner Hinweise konnten wir drei dieser Begräbnismärsche miterleben, auf denen drei der damals berühmtesten Brass Bands spielten: die Tuxedo, die Eureka und die George Williams Brass Band.

HALIMA UND CHET BAKER, REDONDO BEACH, KALIFORNIEN, 1955 [p. 136]

An einem heißen Tag im Sommer 1955 fuhr ich zu Chet nach Redondo Beach, um einige Aufnahmen für ein Plattencover zu machen. Ich hatte noch keine konkreten Vorstellungen, doch als ich bei Chets Haus ankam, öffnete mir eine junge Frau namens Halima. Sie sah so frech und hübsch aus in ihrem Sommerkleid, daß ich sie einfach mit ins Bild bringen mußte. Ich ging mit Chet und Halima zum Nachbarhaus, das gerade renoviert wurde und leerstand. An einer schmucklosen Fensternische plazierte ich die beiden, und sanft strömte das Licht von draußen herein. Ich bat Chet, Halima etwas zuzuflüstern: Schon war die richtige Stimmung geschaffen.

BIRD, 1951 [p. 155]

Ich hatte gehört, daß »Bird« (Charlie Parker) in die Stadt kommen sollte. Wenn es *ein* Idol im Jazz für mich gab, dann war er es. Ich mußte ihn einfach sehen und fotografieren. Am Samstag abend lieh ich mir das Auto meines Vaters, nahm meine ebenfalls geborgte Kamera, eine 4 x 5 Speed Graphic, und fuhr zum Tiffany Club in der 8. Straße, Downtown Los Angeles. Mit Bird auf der Bühne spielten Harry Babasin am Baß, Lawrence Marable am Schlagzeug, Donn Trenner Klavier, und – sehr blaß, aber attraktiv – Chet Baker, der wie ein Boxer aussah, aber ein »Engelsgesicht« hatte. Bird spielte selbstverständlich glänzend, und Chets Sound klang völlig neuartig und frisch. Ich fotografierte und machte mich anschließend mit den Musikern bekannt.

Als der Club seine Türen schloß, zog Chet mit einer hübschen Blondine davon, und Bird fragte mich, ob wir gemeinsam frühstücken würden. Doch um halb vier in der Nacht waren alle Restaurants in der Gegend geschlossen. Ich wollte Bird eine Freude machen und schlug in meiner jugendlichen Begeisterung vor, wir könnten gemeinsam mit ein paar weiteren Fans zu mir nach Hause gehen (wir wohnten in einem Vorort von Pasadena). Zum Glück waren meine Eltern über das Wochenende verreist.

Wir bereiteten Bird ein Frühstück. Später saß er in einem großen Sessel und thronte wie Buddha – mit uns, den jungen Fans, zu seinen Füßen. Er erzählte uns von seinen Erlebnissen und gab den neuesten Klatsch über andere Künstler zum besten. Ich fragte ihn, weshalb er einen jungen unbekannten Musiker wie Chet Baker in seine Band hole, obwohl ihm in Los Angeles doch so viele große Musiker zur Ver-

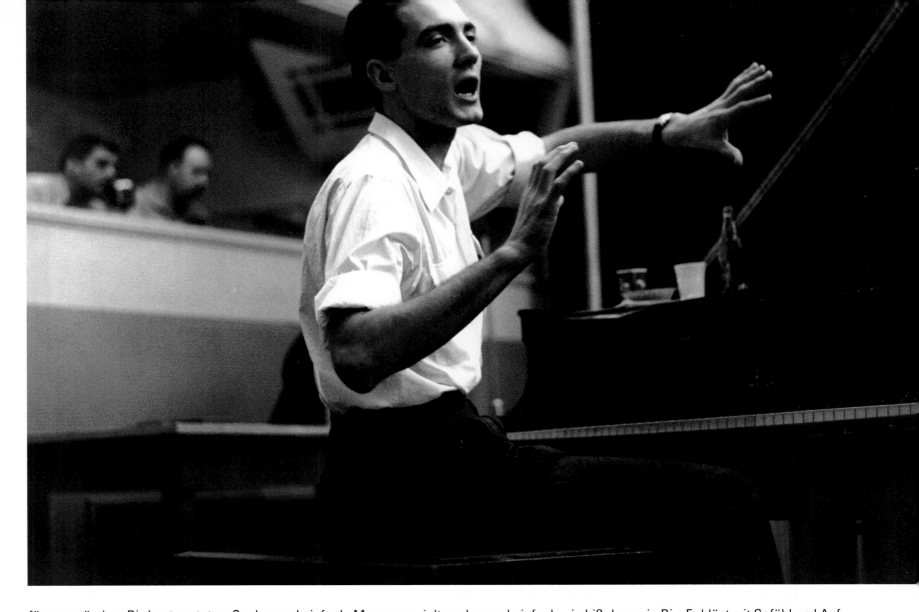

fügung stünden. Bird antwortete: »Sauber und einfach, Mann, er spielt sauber und einfach, ein bißchen wie Bix. Er bläst mit Gefühl und Aufrichtigkeit. Verstehst du?« Wir begannen Chet Baker, diesem neuen, jungen Bläser mit dem hübschen Gesicht, aufmerksamer zuzuhören. Mein berühmter Gast verbrachte das restliche Wochenende mit Schwimmen und Essen. Er hatte einen außerordentlichen Appetit. Ich fotografierte Bird, als er in ausgelassener Stimmung auf dem Sprungbrett des Swimmingpools stand. Er war splitternackt, nur sein Altsaxophon bedeckte seine Blöße, und er spielte eine überaus komische Version von *Moon Over Miami*. Leider ging das Negativ ein paar Jahre später bei einer Überschwemmung in meinem Studio verloren. Am Montag nachmittag kamen meine Eltern nach Hause. Ich begrüßte meine Mutter ganz aufgeregt und erzählte ihr, daß der größte Jazzmusiker der Welt an diesem Wochenende bei uns zu Gast gewesen sei. Meine Mutter lächelte und entgegnete: »Wie schön, mein Schatz. Hast du ihm auch etwas zu essen angeboten?«

THELONIOUS MONK, SAN FRANCISCO, 1961 [p. 170]

Orrin Keepnews, der Produzent von Riverside Records, engagierte mich, um in San Francisco Thelonious Monk für das Cover seiner neuen Platte zu fotografieren. Orrin meinte: »Vielleicht kannst du Monk auf einem dieser niedlichen Cable Cars fotografieren oder mit irgendwas anderem, das für San Francisco typisch ist.« Dann warnte er mich noch, daß Monk für Fotografen und ihre Vorschläge nicht immer aufgeschlossen sei. Zur verabredeten Stunde holten meine Frau Peggy und ich Monk in seinem Hotel ab. So weit, so gut. Ich spürte sofort, daß Monk ein bißchen gereizt war; schließlich ist drei Uhr nachmittags für einen Jazzmusiker noch früh am Tag. So schlug ich vor, erst einmal essen zu gehen. Monk stimmte zu. Wir fuhren zu einer beliebten Caféterrasse am North Beach und tranken Champagner-Cocktails. Schließlich fragte mich Monk, wo wir fotografieren würden. Ich erzählte ihm von der Idee mit den Cable Cars, worauf sich seine Miene verfinsterte und er kopfschüttelnd meinte: »O Mann, ich hab keine Lust auf dieses Cable-Car-Zeugs. Basta.« Ich bestellte noch eine Runde Drinks und sagte: »Wußtest du schon, daß man aus deinem Namen einen guten Schüttelreim machen kann? Thelonious Monk, das ergibt Melodious Thunk.« Das brach das Eis.

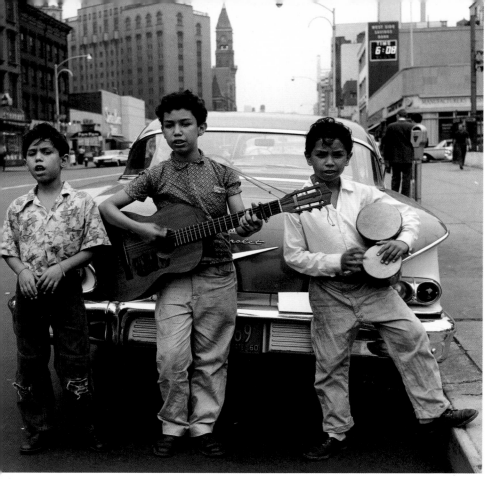

Nach vielen weiteren Champagner-Cocktails und nur einem kleinen Imbiß toastete Monk uns zu und meinte: »Diese Cable-Car-Idee klingt gut. Worauf warten wir noch?«

Wir machten das Foto und hatten dabei viel Spaß. Es wurde ein ziemlich gutes Plattencover. Später kamen wir an einer offenstehenden Tür vorbei: Sie führte zu einem leeren Musiksaal, in dem ein Flügel stand. Monk setzte sich ans Klavier und spielte fast eine Stunde lang. So kamen Peggy und ich in den Genuß einer Privatvorstellung des großen Monk.

SONNY ROLLINS, 1957 UND 1997 [p. 185]

Als man in den 50er Jahren an der Westküste der USA den Jazz wiederentdeckte, reiste Sonny Rollins zum ersten Mal nach Los Angeles. Man bereitete ihm einen herzlichen Empfang, und Les Koenig von Contemporary Records wollte der erste sein, der eine Aufnahme mit Sonny machte.

Ich bin mir nicht sicher, wer von uns – Sonny, Les oder ich – den Einfall hatte, ihn in Cowboy-Kluft zu fotografieren; jedenfalls ging ich mit Sonny zu Western Costumers in Hollywood und stattete ihn mit Zehn-Gallonen-Hut, Patronengurt, Pistolentasche und einem sechsschüssigen Revolver aus. Dann fuhren wir in die Mojave-Wüste, um das Plattencover aufzunehmen, und wir hatten bei der Session sehr viel Spaß.

Als Sonny nach New York zurückging, kritisierten seine Jazz-Kollegen das »abscheuliche« Coverfoto. Von verschiedenen Seiten wurde mir zugetragen, Sonny wäre nicht glücklich darüber, daß ich diese Aufnahme für das Albumcover verwendet hatte, doch das Cover wurde sehr bekannt.

Vierzig Jahre später beauftragte mich die Firma Rico, Sonny für eine wichtige landesweite Anzeigenkampagne zu fotografieren. Als Sonny und ich uns für das Foto trafen, behandelte er mich gnädig und verzieh mir das »abscheuliche« Bild von 1957, das seine Platte *Sonny Rollins, Way Out West* ziert.

MILES DAVIS [p. 186]

Im Sommer 1949 begegnete ich in New York zum ersten Mal Miles Davis. Ich war seit meiner Jugend nicht mehr im »Big Apple« gewesen, und ein Freund, der Musiker Allen Eager, zeigte mir die Stadt. Als wir eines Abends durch den Theaterbezirk spazierten und an der Kreuzung Broadway und 44. Straße um die Ecke bogen, erspähte ich Miles, der uns entgegenkam. Er trug einen schwarzen Anzug von Brooks Brothers, ein weißes Hemd und eine dünne, schwarze Wollkrawatte.

Zwei der glanzvollsten Mannequins, die ich je gesehen hatte, begleiteten ihn: zu seiner Linken Dorian Leigh, rechts die superblonde Sunny Harnett. Beide Mädchen waren ebenfalls schwarz gekleidet, und ich glaubte, nie zuvor schickere Menschen getroffen zu haben. Lachend und beinahe tanzend kamen sie die 44. Straße herunter und nahmen dabei die ganze Breite des Gehsteigs ein.

Allen und Miles begrüßten sich, man stellte einander vor. »Miles, das ist mein Freund aus dem fernen Westen, aus Kalifornien; er heißt Clax.« Miles schüttelte mir die Hand und sagte mit seiner einzigartigen kratzenden Stimme: »CLAX! Klingt wie ein Haushaltsreiniger!«

Jahre später – um genau zu sein: 1965 – traf ich Dorian Leigh wieder. Sie leitete eine erfolgreiche Modeagentur und vermittelte meiner Frau, Peggy Moffitt, in ganz Europa Aufträge als Model. Dorian erinnerte sich an unsere Begegnung mit Miles und daran, daß Miles von mir immer nur als dem »Cowboy aus Hollywood mit dem komischen Namen Clax« gesprochen hätte.

1957 traf ich Miles wieder. Columbia Records hatte mich beauftragt, ihn für seine nächste LP *Miles Ahead* zu fotografieren. Als er in mein Studio in Hollywood kam, trug er eine dunkelbraune Wildlederjacke, einen hellen Seidenschal, karierte graue Hosen und Wildlederschuhe, passend zur Jacke. Er sah aus, als wäre er gerade den Modeseiten eines vornehmen Herrenmagazins entstiegen. Er ließ sich gerne fotografieren, und die Fotos kamen auch bei der Plattenfirma gut an. Die Platte war Miles' erste Zusammenarbeit mit Gil Evans seit den Auf-

Street musicians, New York City, 1960

George "Creole Blues" Guesnon, New Orleans, 1960

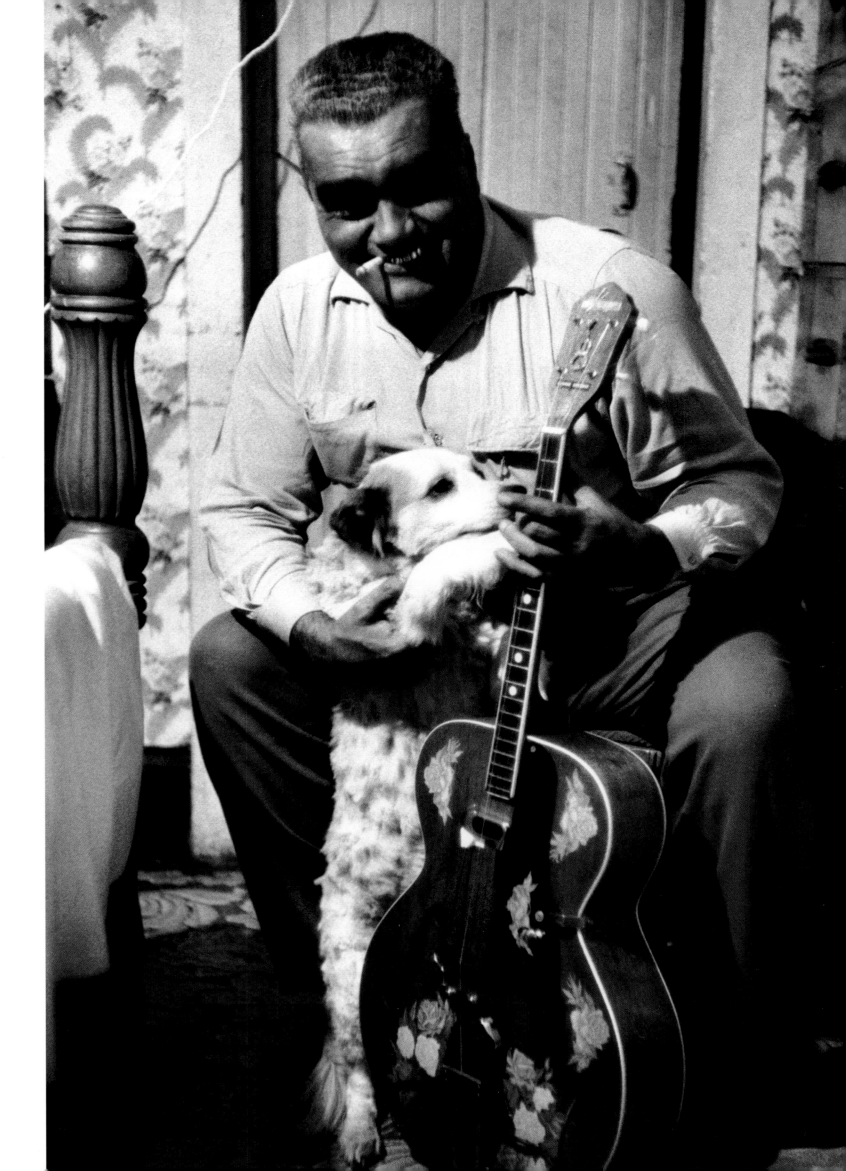

nahmen von *Birth of the Cool* im Jahr 1949. Aber als die Platte erschien, zeigte das Coverfoto ein hübsches Mädchen mit Strohhut auf einem Segelboot. Ich war sehr enttäuscht. Wahrscheinlich glaubten die Produzenten, das Bild eines hübschen Mädchens auf dem Cover würde die Verkaufszahlen der Platte in die Höhe treiben. Heute denke ich, *Miles Ahead* ist ein so großartiges Stück Musik, daß die Platte mit so ziemlich jedem Cover erfolgreich gewesen wäre.

CANNONBALL AM STRAND [p. 196]

In den frühen 50er Jahren wurde ich dafür bekannt, daß ich Jazzmusiker an ungewöhnlichen Orten und vor ungewöhnlichem Hintergrund fotografierte. Ich tat das gezielt, weil ich von den stereotypen Jazz-Bildern wegkommen wollte – den verschwitzten Musikergesichtern aus New York und Chicago.

Bei uns in Kalifornien gab es Sonnenschein, Strände, Kabrioletts, Hügelkuppen, tolles Wetter, und jeder tat etwas für seine Gesundheit. Sogar die Drogensüchtigen achteten auf gesunde Ernährung. Daher fotografierte ich Sonny Rollins mit einem Cowboyhut mitten in der Mojave-Wüste; Shorty Rogers hoch droben im Baumhaus seines Sohnes; das Ramsey Lewis Trio inmitten des tosenden Verkehrs der Michigan Avenue in Chicago; Ray Brown, Barney Kessel und Shelly Manne auf Karussellpferden (das Cover zu *The Poll Winners Ride Again*); Chet Baker and His Crew auf einem Segelboot in der Bucht von Santa Monica; und so weiter.

Als Cannonball Adderley das Coverfoto der Lighthouse All Stars im Sand von Hermosa Beach sah, wollte er für sein Album *The Cannonball Adderley Quintet at the Lighthouse* ebenfalls am Strand fotografiert werden.

Allerdings meinte Cannonball, es sei passender, Strandkleidung zu tragen, am besten Badehosen. Ich dachte über diesen Vorschlag nach und entschied mich dagegen. Zunächst mal mochten die Bandmitglieder in Badehosen nicht gerade attraktiv aussehen. Wichtiger noch:

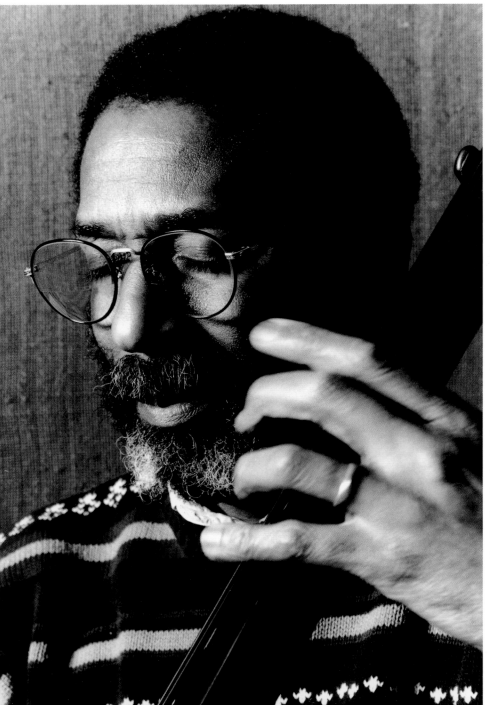

Die Idee war ja gerade, sie auf einem Sandstrand in Anzug und Krawatte zu zeigen, um so einen verblüffenden Effekt zu erzielen. Cannonball akzeptierte das, aber wir schlossen einen Kompromiß: Die Band trug sportliche Kleidung. Ich legte einen großen Strandball dazu und plazierte die Band unter einem breiten japanischen Papierschirm, um sie »cool« rüberzubringen.

SINATRA, CROSBY, TONY BENNETT, LENA HORNE UND DER JAZZ [p. 199]

Es gibt Menschen, die diese großen Künstler gar nicht zu den Jazzmusikern zählen würden.

Doch meiner Meinung nach prägten sie alle den Jazz durch ihren Sound, ihre Phrasierung und natürlich durch ihre Persönlichkeit nachhaltig. Und alle haben sie große Jazzmusiker um sich versammelt.

Dem Jazz am nächsten war Bing Crosby, der viele Jazzsänger beeinflußt hat. In seiner Frühzeit in den 20er Jahren sang er mit den Rhythm Boys, einer Jazz-Gesangsgruppe, die viel Swing hatte. Bing sagte oft, daß er von Bix Beiderbecke und Joe Venuti beeinflußt sei. Er machte Aufnahmen mit dem Ellington-Orchester und hat oft mit Louis Armstrong gearbeitet.

Als ich ihn mit Bob Scobey fotografierte, fragte ich Bing Crosby nach seiner Zeit mit den Rhythm Boys. Er erzählte nicht nur einige wunderbare Anekdoten, sondern scattete ganze Passagen aus den Songs, die er in den 20er und 30er Jahren aufgenommen hatte. Er sang dicht an meinem Ohr, nur ein paar Zentimeter entfernt. Es war phantastisch – als trüge man Kopfhörer, die bei voller Lautstärke eine ganz andere Ära swingender Musik empfangen.

THE NEWPORT REBELS [p. 209]

Auf Georg Wein's Newport Jazzfestival im Sommer 1960 trat eine Reihe hervorragender Jazztalente auf. Viele bedeutende Persönlichkeiten der Jazz-Szene wurden jedoch zu diesem wichtigen Ereignis nicht eingeladen. Folglich ergriff Charlie Mingus die Initiative und organisierte ein kleineres Festival nebenan und nannte es »The Newport Rebels«. Die »Rebels« repräsentierten viele talentierte unbekannte sowie auch ältere bekannte Musiker. Das Festival fand an einem wunderschönen Ort statt, von dem aus man, auf einem Felsvorsprung stehend, auf den Rhode Island Sound blicken konnte, und die Musik war phantastisch. Es war der ideale Ort zur Austragung eines Jazz-Musikwettbewerbs. Unter den Musikern waren Persönlichkeiten wie Thelonious Monk, Max Roach, Ornette Coleman, Abbey Lincoln, Allen Eager, Sonny Rollins, Gigi Gryce und Roy Eldridge.

ORNETTE, 1959 [p. 211]

Ich sollte Ornette Coleman für sein erstes Plattencover fotografieren. Als er zu meinem kleinen Studio in Hollywood kam, hörte ich ein zaghaftes Klopfen an der Tür: Vor mir stand Ornette mit strahlend frischem Gesicht, gut gekleidet und sehr schüchtern. Er war eben erst aus Texas eingetroffen und verriet mir sogleich, daß er noch nie zuvor fotografiert worden sei.

Vor der Kamera steigerte sich seine Schüchternheit fast zur Panik. Ich unternahm alles, um eine entspannte Atmosphäre zu schaffen. Meine Frau Peggy begrüßte Ornette herzlich und bot ihm Erfrischungen an. Plötzlich wurde mir bewußt, daß er sein Instrument nicht in der Hand hielt. Ich bat Ornette, sein Altsaxophon aus dem Koffer zu nehmen, und hervor kam dieses gelbe Plastikhorn! Ich hatte so etwas noch nie gesehen und begann zu lachen. Mein Heiterkeitsausbruch war ansteckend. Lachend fielen wir einander in die Arme – das Eis war gebrochen. Nun konnte ich ihn fotografieren, und eine der Aufnahmen kam schließlich auf das Cover der Atlantic-Platte *The Shape of Jazz to Come*.

JOHN WILLIAMS [p. 212]

Neben dem Klavier sitzend, gleicht der junge John Williams einem Poeten. Gerade ist der Musiker dabei, den Soundtrack für den Film *Star Wars* sowie für andere Steven-Spielberg-Filme zu komponieren, wie z. B. *Raiders of the Lost Ark,* und unterbricht dafür seine Arbeit als Dirigent des Boston Pops Orchestra.

DUKE ELLINGTON, BACKSTAGE [p. 218]

Zum ersten Mal sah ich das Duke-Ellington-Orchester als Sechzehnjähriger live im Orpheum Theater, Downtown Los Angeles. Ehrfürchtig lauschte ich, denn Johnny Hodges, Harry Carney, Lawrence Brown, Sonny Greer und Al Hibbler spielten unmittelbar vor meinem Platz in der ersten Reihe. Als der Vorhang fiel und der anschließende Film anfangen sollte, ging ich hinter die Bühne, um den großen Duke zu treffen. Man ließ mich ohne Schwierigkeiten durch. Ich wurde in die Garderobe geführt, wo der Duke gerade seinen violett-grauen Anzug, das pinkfarbene Hemd und die dunkelrote Krawatte gegen eine gewaltige goldene Abendrobe tauschte. Er war freundlich und widmete mir viel Zeit. Was für eine Ehre!

Im Lauf der Jahre ging ich immer wieder nach den Auftritten hinter die Bühne, um den Duke zu sehen – in welcher Stadt es auch gerade war. Oft nahm ich meine jeweilige Freundin mit. Duke erinnerte sich jedesmal an mich und begrüßte uns herzlich. Dann wandte er sich für gewöhnlich an meine Begleiterin, verbeugte sich und brachte eines seiner berühmten Komplimente an: »Sie sind so schön, man sollte Sie einsperren«, oder »Sie sind ja total zum Anbeißen«, oder »Die Götter haben sich selbst übertroffen, als sie Sie schufen, meine Liebe.« So war Duke.

267

Ron Carter, New York City, 1996 **268**

269 *Joe Lovano, Irvine, California, 1997*

270

271

ART PEPPER, 1956 [p. 227]

Art Pepper war in schlechter Verfassung, als ich ihn in seinem Haus hoch oben auf einem der steilsten Hügel von Los Angeles besuchte. Es lag in der Fargo Street, in einer Gegend, in der in den frühen 20er Jahren viele der Keystone-Cop-Filme gedreht worden waren. Art war gerade aus dem Gefängnis entlassen worden, und ich wollte ihn für das Cover seiner neuen LP *The Return of Art Pepper* fotografieren. Während wir die Kleidung für das Foto auswählten, klagte er, er sei krank. Er jammerte, daß seine »Connection« noch nicht die versprochene »Medizin« vorbeigebracht hatte. Aber er beschloß, die Fotos dennoch zu machen.

Trotz seiner Not war er ganz bei der Sache und machte eine gute Figur. Gegen Ende unserer Fotositzung fotografierte ich, wie er den steilen Hügel hinaufstieg. Das schien mir wie ein Symbol für seinen Überlebenskampf.

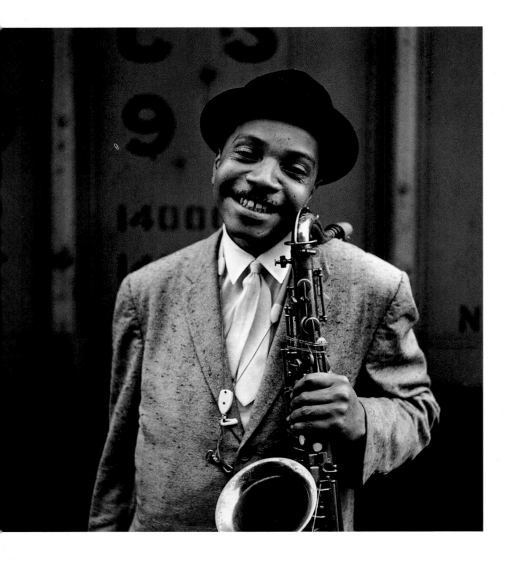

Oscar "Fats" Dennis, Kansas City, 1960 270

271 *Carmell Jones, Charles Matthews, Kansas City, 1960*

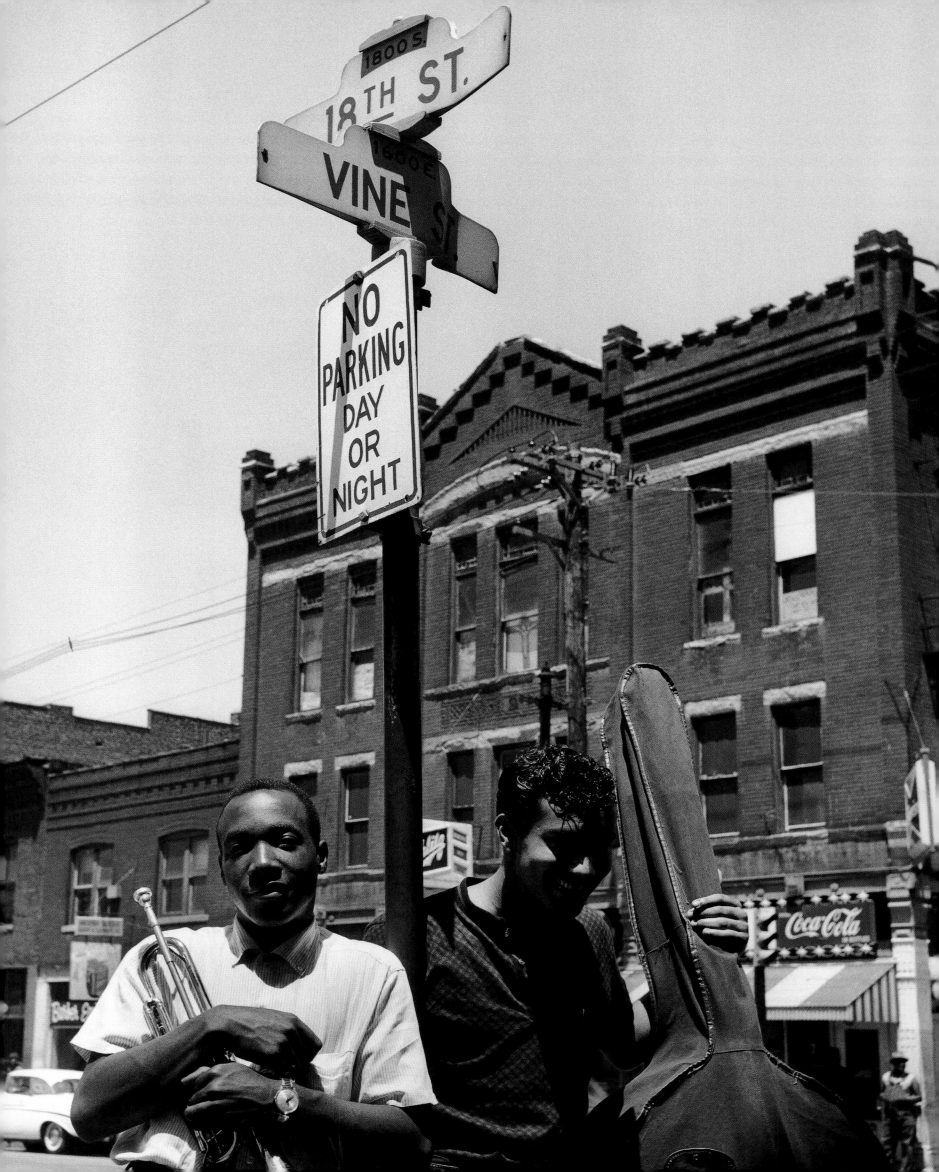

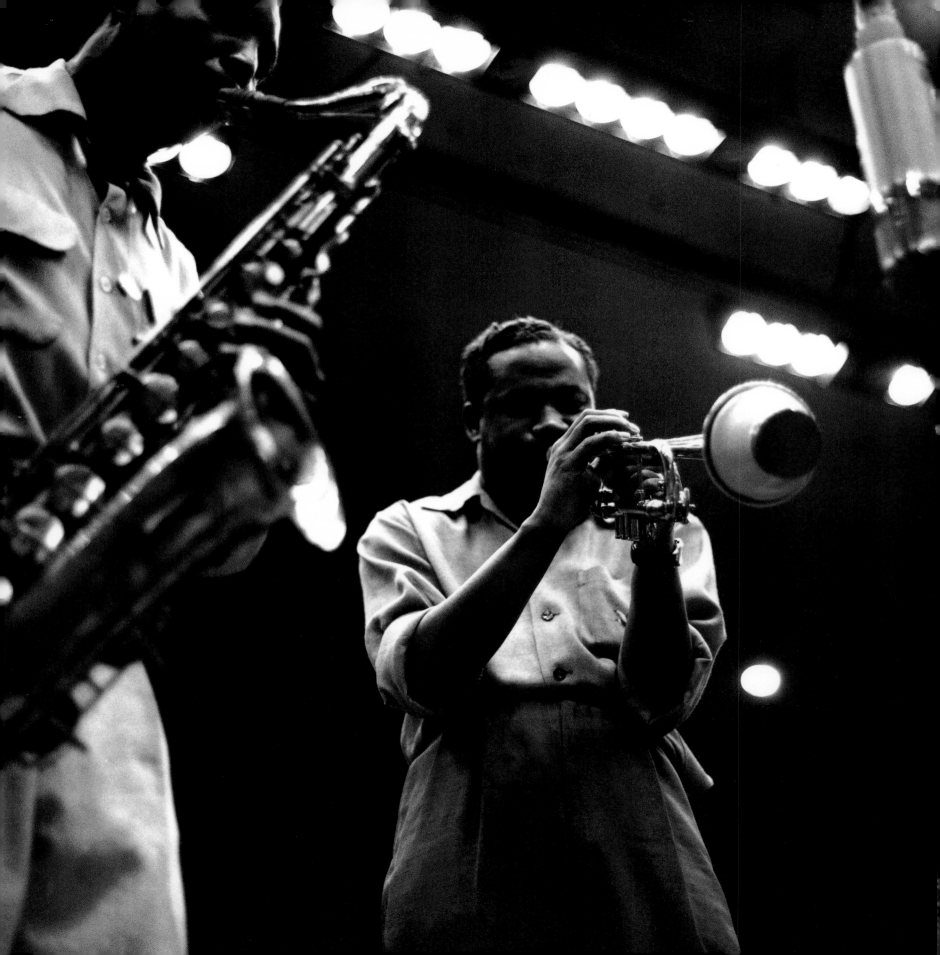

WILLIAM CLAXTON
Jazz
seen

PRÉFACE DE

Don Heckman

AVEC DES TEXTES DE

William Claxton

Le jazz et la photographie. Deux arts apparemment sans rapport, l'un sonore, l'autre visuel. Pourtant, derrière cette différence apparente se cachent des similitudes frappantes qui ne sont jamais aussi bien mises en valeur que dans les extraordinaires photos de William Claxton.

Depuis les années 50, Claxton est le photographe de prédilection des musiciens de jazz. À juste titre. Avec leur aptitude innée à aller au cœur des choses et à ne jamais se laisser déconcerter par les apparences, les jazzmen ont tout de suite reconnu en Claxton un des leurs.

Le jazz est sans doute la plus mystérieuse des musiques. À première vue, il semble d'une simplicité trompeuse : les éléments fondamentaux de la mélodie, de l'harmonie et du rythme sont constamment remaniés de manière improvisée et spontanée, dynamisés par cette force vive que les musiciens appellent « le swing ». Pourtant, le mystère est là… dans la substance, l'esprit et la manière avec lesquels ces éléments sont associés. Le jazzman doit avant tout avoir une immense maîtrise technique, une dextérité hors pair, comparable à ce que l'on exige du plus rigoureux des musiciens classiques. Il doit être capable d'exécuter des phrasés extrêmement rapides, avec des tempos fulgurants, puis de passer brusquement à la vitesse inférieure pour jouer des passages lents, chargés d'une riche densité émotionnelle. Cependant, la virtuosité à elle seule ne suffit pas. Le jazzman doit savoir l'adapter à un traitement inventif et spontané de la musique, tout en respectant une structure précise (standard, blues, free jazz, etc.). En outre, ses réactions doivent être instantanées. Par exemple, dans un standard comme *Cherokee*, ou dans un passage de *Giant Steps* de John Coltrane, il doit répondre en quelques fractions de secondes à des contraintes harmoniques extrêmement complexes. Comment fait-il ? C'est bien là le mystère, la question à laquelle personne n'a encore répondu et qui n'a peut-être pas de réponse : comment les jazzmen parviennent-ils à associer les éléments apparemment contradictoires de la maîtrise mécanique et technique à la création forcément subjective, personnelle, spontanée et inventive d'un art hors du temps ?

Il est étrange et fascinant de constater que le même mystère vaut pour l'art de la photographie. Le photographe, comme le musicien de jazz, travaille avec un instrument souvent encombrant, exigeant et difficile à maîtriser.

« Pour le photographe, explique Claxton, l'appareil photo est comme le saxo du jazzman. C'est l'outil qu'on aimerait pouvoir oublier, mais dont on ne peut se passer pour transmettre nos pensées et tout ce que l'on cherche à exprimer. »

271
Clifford Brown, Hollywood, 1954 **272**

273 *Marty Paich, Chet Baker,*
274 *Jack Montrose, Zoot Sims,*
275 *Hollywood, 1954*

Le photographe, comme le musicien de jazz, doit réagir à la fraction de seconde près, organisant instantanément toutes les données techniques de son art – ouverture, mise au point, éclairage, temps d'exposition … Son but est alors presque identique à celui du jazzman : mettre tout son talent et sa virtuosité au service d'un instant fugitif, unique ; ouvrir une fenêtre sur une réalité intime et chargée d'émotion.

« Pour moi, c'est là que le jazz et la photographie se rejoignent, déclare Claxton. Ils répondent au même sens de l'improvisation et de la spontanéité. Tous deux interviennent au moment précis où l'on voit ou entend quelque chose, où on l'enregistre et où on le fige à jamais. »

William Claxton est hanté par l'appareil photo depuis les années 40, quand il était encore un grand étudiant dégingandé à Pasadena, en Californie. Sa mère était une chanteuse semi-professionnelle et son frère un pianiste de boogie-woogie. Il était donc inévitable qu'il se sentît attiré par la musique. À l'âge de sept ans, il assembla un cahier de coupures de presse consacrées à Duke Ellington, Count Basie, Cab Calloway, Lena Horne, Fred Astaire et Ginger Rogers. Adolescent, il assista à des concerts des jazzmen légendaires Fats Waller et Art Tatum.

« À l'époque, se souvient-il, je rêvais de devenir le propriétaire d'un night-club qui ressemblerait au plateau d'un film de Fred Astaire et de Ginger Rogers, où tout aurait été noir et blanc sauf les gens, qui auraient été de toutes les couleurs. Je portais déjà en moi tous les signes de ce que je serais une fois adulte. »

Claxton étudia la psychologie et l'histoire de l'art à l'Université de Californie à Los Angeles. Toutefois, irrésistiblement attiré par le jazz, il passait tout son temps dans les clubs de jazz où il parvenait à s'introduire à force de persuasion, de bluff et de cajoleries. Il commença à travailler avec un gros appareil Speed Graphic. Même avec cet instrument particulièrement difficile à maîtriser, il parvint à prendre quelques-uns des clichés envoûtants présentés dans cet album. Sa rencontre avec le saxophoniste légendaire Charlie « Bird » Parker cimenta encore ses liens avec le jazz. Il se souvient de ce jour, alors qu'il était tout jeune homme, avec émotion : « Je ne sais pas où j'ai trouvé le courage de l'aborder mais, après l'avoir entendu jouer, je lui ai demandé s'il ne voulait pas venir se détendre chez moi à Pasadena après le concert. J'en ai eu le souffle coupé quand il m'a répondu : O. K. – Je suis sans doute un des rares, sinon le seul, gamin blanc, à avoir jamais ramené Charlie Parker à la maison ! »

À l'occasion de vacances scolaires, Claxton se rendit à New York avec sa petite amie d'alors, un mannequin, et y rencontra Richard Avedon. Impressionné par l'enthousiasme juvénile de Claxton, Avedon lui offrit spontanément un de ses vieux appareils Rolleiflex. Ce présent inattendu encouragea encore l'intérêt croissant du jeune homme pour la photographie et le jazz. Sa carrière ne tarda pas à prendre forme. « J'ai toujours aimé le jazz , déclare-t-il. Mais j'ai également toujours été passionné par la manière dont il est produit, par sa forme, par le langage corporel et la gestuelle des musiciens lorsqu'ils jouent, par la manière dont la lumière façonne leur visage. » Comme Degas, qui peignait la vie des danseuses dans les coulisses ou pendant leurs échauffements, Claxton cherche à capturer l'essence du jazz en photographiant les musiciens à leur insu, pendant leurs moments de détente. « Ce que je trouve de plus fascinant, explique-t-il, c'est ce dont ils ont l'air quand ils ne sont pas sur scène, à d'autres moments de leur existence, quand ils font des exercices, répètent, fument, bavardent entre eux ou se shootent. Disons que j'écoute avec mes yeux. »

En 1952, il travailla avec le producteur Richard Bock à la création de Pacific Jazz Records, devenant le directeur artistique et le photographe de cette maison appelée à jouer un rôle clef dans l'émergence du jazz West Coast. Les photos et les pochettes de disques innovatrices de Claxton, présentant un monde ouvert et aéré, devinrent un aspect aussi important du mouvement du jazz West Coast que la musique elle-même. En sortant des musiciens aussi photogéniques que Chet Baker et Art Pepper de l'atmosphère traditionnellement sombre et enfumée des clubs de jazz, en les plaçant dans le décor plus doux et serein de la nature californienne, Claxton a parfaitement saisi, et sans doute même aidé à établir, l'image et l'ambiance d'une décennie unique dans l'histoire du jazz. « Réaliser des photos pour des pochettes de disques de 30 x 30 cm, l'ancien format des albums en vinyle, était un plaisir absolu. Cela n'avait rien à voir avec mon travail pour des pochettes de CD, qui font 13 x 13 cm. Dans le bon vieux temps, à savoir dans les années 50, quand

le LP était à la mode, faire une pochette était une expérience relativement simple et jouissive. Ma seule préoccupation était de penser au thème de l'album et à la place qu'occuperait son titre. On discutait de la garde-robe du musicien, on le rencontrait puis on prenait la photo, sous le soleil de Californie ou dans un studio. Aujourd'hui, ce n'est plus comme au temps de Pacific Jazz. Avant de photographier une star, il faut des réunions à n'en plus finir avec le directeur artistique, le directeur créatif, les avocats de l'artiste et de la maison de disques. Ensuite, il y a des essayages, des réunions avec les maquilleurs, les coiffeurs, les stylistes… Ce n'est qu'après qu'on peut s'asseoir tranquillement avec l'artiste et boucler une séance de photos en quelques heures. C'est une manière très compliquée de faire les choses, alors qu'autrefois, tout était si simple… »

Non content de réaliser toutes les pochettes de Pacific Jazz, Claxton accumula d'autres commandes. Pratiquement toutes les grandes maisons de disques des années 50 on fait appel à lui : Capitol, Columbia, Fantasy, Decca, RCA Victor… On peut avancer sans trop se risquer qu'il a joué un rôle déterminant dans l'évolution de la pochette de disque en un puissant argument de vente. Le critique Leonard Feather, aujourd'hui disparu, a dit de lui : « Claxton ne se contente pas de l'image évidente projetée par les sujets qu'il photographie. Outre le fait de les présenter dans un décor parlant, il les élève au rang de métaphores de l'esprit et du temps, d'incarnations d'une phase donnée dans le développement de la musique. »

Feather voyait juste. Claxton eut la chance de parvenir à sa maturité créative à une époque où le jazz était en pleine innovation. Mais c'est son talent inné, sa sensibilité face aux courants d'énergie qui animaient le jazz dans les années 50 et 60, qui donnent une telle force à ses chroniques visuelles. Parce qu'il comprenait le jazz et qu'il était réceptif tant à la personnalité des musiciens qu'à l'essence de leur quête musicale, il a su allier la puissance de leur musique à la profondeur de sa vision.

Toutefois, Claxton ne tarda pas à promener son regard scrutateur sur d'autres univers que celui du jazz. Dans les années 60, il consacra une bonne partie de son énergie créative à la mode. Ses photos commencèrent à paraître dans les plus grands magazines, de *Time* à *Newsweek* en passant par *Vogue*, *Harper's Bazaar*, *Paris Match* et tant d'autres. Vers la même époque, les portraits qu'il réalisa de sa femme Peggy Moffitt, actrice et mannequin, dans les maillots de bain provocants du styliste Rudi Gernreich, firent sensation. Le *Rudi Gernreich Book* (Rizzoli, 1991, réédité par Benedikt Taschen Verlag en 1999), histoire en images des créations avant-gardistes du couturier, fut le fruit de deux décennies de collaboration entre Claxton, Moffitt et Gernreich. En 1967, Claxton et Moffitt réalisèrent *Basic Black*, un film sur Gernreich Aujourd'hui qualifié de « père de la vidéo de mode », ce film exerça une influence considérable sur l'industrie multimédia de la mode, alors naissante.

La carrière prolifique de Claxton s'est étendue au-delà du jazz. Il a réalisé des émissions de télévision et des films publicitaires, a été l'un des fondateurs de NARAS (National Academy of Recording Arts and Sciences) et a entrepris bien d'autres projets dans le monde du spectacle, dont la réalisation de toutes les images promotionnelles du film de Spike Lee *Mo' Better Blues*. Ses publicités pour les magasins de vêtements « The Gap » sont visibles partout et ses photos sont publiées régulièrement dans des revues comme *Interview* ou *G.Q.* « Chaque année, l'édition anglaise de *G. Q.* me demande de choisir un groupe de musiciens de jazz et de réaliser un reportage de mode en photographiant des types de tout âge et de toute origine ethnique, portant les dernières collections masculines. »

Claxton a été exposé dans plusieurs galeries prestigieuses, à New York, Paris, Londres, Zurich, Berlin, Tokyo, San Francisco et Los Angeles. Les tirages limités de ses photos sont devenus des pièces de collections très recherchées. Malgré sa réputation de grand photographe du monde des arts et du spectacle,

Jerry Fieldings, Las Vegas, 1956
Billy Preston, Hollywood, 1957

Claxton serait sans doute le premier à admettre que sa plus grande passion a toujours été le jazz. Cette longue histoire d'amour est tout à fait manifeste dans ce superbe album – sorte de fenêtre sur la grande diversité créative d'un photographe baignant dans un univers de jazz.

Au fil des pages de ce recueil riche et bien pensé, chacun trouvera sans doute une photo qui lui plaît plus que d'autres. Mais il y en a beaucoup qui feront l'unanimité. Prenons, par exemple, celle d'un John Coltrane méditatif (p. 16/17) découvrant l'expressionnisme abstrait dans un musée d'art moderne. Son visage reflète sa détermination à comprendre un mouvement artistique qu'il ne connaît pas, une détermination aussi concentrée et inspirée que l'énergie qu'il insuffle constamment à ses improvisations.

On remarquera aussi comment Claxton a parfaitement cadré Nat « King » Cole (p. 72) devant un ouvrage en fer forgé, élégant dans son superbe smoking, cigarette à la main, avec un sourire énigmatique de Joconde (sans doute une référence à son grand succès « Mona Lisa »).

Tout aussi concentré, mais d'une autre manière, Maynard Ferguson (p. 144/145) lors d'une répétition avec son grand orchestre, les joues gonflées, les genoux fléchis, cherchant une de ces notes aiguës qui ont fait sa renommée. Sans parler de la photo de Joe Williams en coulisses (p. 188/189). Le temps semble suspendu tandis que le vieux chanteur de blues et de jazz, les yeux fermés, pianote sur ses tempes à la recherche de la note exacte avant d'entrer en scène.

La photo d'un jeune Ornette Coleman (p. 211), les lèvres pincées, les mains crispées sur son saxo alto en plastique blanc, illustre parfaitement l'agilité de Claxton à saisir le moment juste, à trouver l'accent qu'il faut. En concentrant l'image sur les yeux luminescents du jazzman, qui fixent droit l'objectif, il nous plonge instantanément dans la vision intense et insistante qu'a Coleman de la liberté d'improvisation.

Par contraste, une série d'images de Duke Ellington (p. 218–219) nous montre le contrôle serein qu'exerce le maître sur ses musiciens, tandis qu'il leur fait travailler quelques-unes de ses pirouettes musicales. Ces photos, tantôt drôles tantôt sérieuses, offrent un aperçu de l'interaction complexe entre le compositeur-chef d'orchestre et ses talentueux instrumentistes. Tout aussi imposant et unique, le chanteur pop et précurseur du rap Isaac Hayes (p. 234/235) domine littéralement la photo. Dans son épaisse veste en fourrure, le torse orné de bijoux impressionnants, Hayes dégage la même sensualité virile et ténébreuse qui a caractérisé ses nombreux tubes du début des années 70. Ce recueil nous propose également des associations séduisantes, parfois dans une même image, parfois sous forme de deux photos côte à côte. On remarquera le merveilleux montage des deux maîtres de l'humour subtil, Louis Armstrong et Danny Kaye, pris sur le vif (p. 40, 41). En se concentrant sur le mouvement et l'interaction entre ces deux grands artistes, Claxton fait ressortir la douce espièglerie qui leur était propre. Quelques pages plus loin, dans un halo de lumière blonde, le sourire enthousiaste de la chanteuse Diana Krall (p. 64), qui n'est pas encore la grande star qu'elle deviendra bientôt, s'oppose à celui, doux et coquin, de Sylvia Syms (p. 65).

On ignore la plaisanterie musicale qu'échangent Gerry Mulligan et Ben Webster (p. 148/149), alors que le corpulent Webster marque un contretemps et que le mince Mulligan y répond sans se départir de son sourire malicieux. Quoi qu'il en soit, Claxton était là pour saisir l'essence de cet échange.

Les couples se suivent et ne se ressemblent pas – on découvrira des instantanés de Diana Ross (p. 157), concentrée, et de N'Dea Davenport, à la moue boudeuse (p. 156), mais aussi des vues songeuses de deux chanteuses aux répertoires opposés, Barbara Carroll et Odetta (p. 174, 175), qui se ressemblent assez en pensée et en allure pour dépasser leurs différences musicales. Un regard sur le Sonny Rollins de jadis et d'aujourd'hui (p. 184/185) souligne les divergences entre la vigueur de sa jeunesse et la maestria de sa maturité. Un portrait mélancolique de Miles Davis (p. 187; un parmi les centaines que Claxton a faites de lui) jouxte celui d'un Gil Evans (p. 186) étonnamment enjoué. Il faut savoir qu'Evans n'était pas seulement l'arrangeur préféré de Davis mais aussi son meilleur ami. Il n'y avait que Claxton pour penser à photographier l'espiègle Frank Sinatra (p. 198) devant le boîtier d'une harpe (l'instrument des anges !), puis à contrer cette image avec celle d'un Bing Crosby (p. 199) détendu, en pleine séance d'alchimie vocale dans un studio d'enregistrement.

Trois autres couples, chacun unique en son genre, méritent d'être mentionnés. La chanteuse Cassandra Wilson et le pianiste Jacky Terrasson (p. 202) forment un tandem musical parfaitement compatible. À leurs côtés, Jackie Cain et Roy Kral (p. 202/203), dont l'union tant musicale que conjugale a battu des records de longévité dans le monde du jazz. En plaçant Wayne Shorter (p. 240) et Herbie Hancock (p. 241) sur une même page, tous deux souriant et prenant manifestement du bon temps, Claxton illustre la longue amitié, musicale et humaine, qui continue d'exister entre ces deux grands artistes.

Outre la fascinante collection de portraits individuels et d'associations intrigantes, Claxton nous propose quelques séries qui se détachent du reste. Ainsi, la séquence au cours de laquelle il explora la Nouvelle-Orléans en 1960 (p. 98–108). Comme c'est souvent le cas avec les grands photographes, tels Cartier-Bresson et Claxton, ils sont là où il faut quand il faut. 1960 marquait l'aube d'une nouvelle ère. C'était l'année où John F. Kennedy fut élu président des États-Unis et où le mouvement des Noirs pour les droits civiques prit son essor.

Les images somptueuses d'une fanfare de rue revenant d'un enterrement illustrent un moment de paix, résonnant encore des traditions du passé, à une époque où les événements complexes, contentieux et souvent violents des années 60 se dessinaient à l'horizon.

Une autre séquence (p. 126–135) présente l'aspect granuleux des anciennes images télévisées. L'effet est approprié, car ces photos lointaines évoquent une brève période de l'histoire du jazz où celui-ci avait encore sa place à la télévision, où l'on pouvait encore trouver en pleine nuit des programmes exceptionnels avec Billie Holiday (p. 131), Peggy Lee (p. 134/135), June Christy (p. 132/133), Buddy DeFranco (p. 128) ou Jimmy Giuffre (p. 130). D'autres séries plus courtes sont tout aussi enchanteresses : les photos de Chet Baker (p. 137, 138/139, 140), surtout celle du milieu, qui immortalise les lèvres pleines et sen-

suelles du trompettiste, soulignant l'érotisme de son jeu qui faisait un des éléments essentiels de son attrait. On remarquera également les illusions d'optique des pages 245 à 254, quelques-unes des rares incursions de Claxton dans le domaine des effets spéciaux, particulièrement efficaces dans la juxtaposition du visage songeur de Brad Mehldau (p. 248/249) se réfléchissant dans les entrailles d'un piano.

La photographie et le jazz sont tellement inextricablement liés à l'expérience américaine – des images de la guerre de Sécession par Matthew Brady et de la musique de Duke Ellington à l'impact collectif et social de *Life Magazine*, du Swing et de 52e rue – qu'avec du recul, l'œuvre de Claxton offre bien plus qu'une succession de belles photos. Les pages de cet album témoignent d'une perception de l'essence américaine comparable à celle qui se dégage des plus belles œuvres de Walker Evans et de Robert Frank. L'énergie et l'individualisme qui émanent des visages, des mouvements et de l'intensité intérieure des musiciens de jazz, le sens de la communauté que l'on ressent en regardant ces instantanés de la vie quotidienne à la Nouvelle-Orléans, illustrent ce que l'Amérique a de mieux à offrir. L'individualisme, la communauté, l'imagination, la spontanéité et la joie créative sont des éléments souvent négligés dans l'image de dernière superpuissance mondiale que la nation a d'elle-même. Pourtant, ce sont les éléments essentiels de la vraie Amérique. En les saisissant, Claxton a immortalisé l'Amérique sous son jour le meilleur.

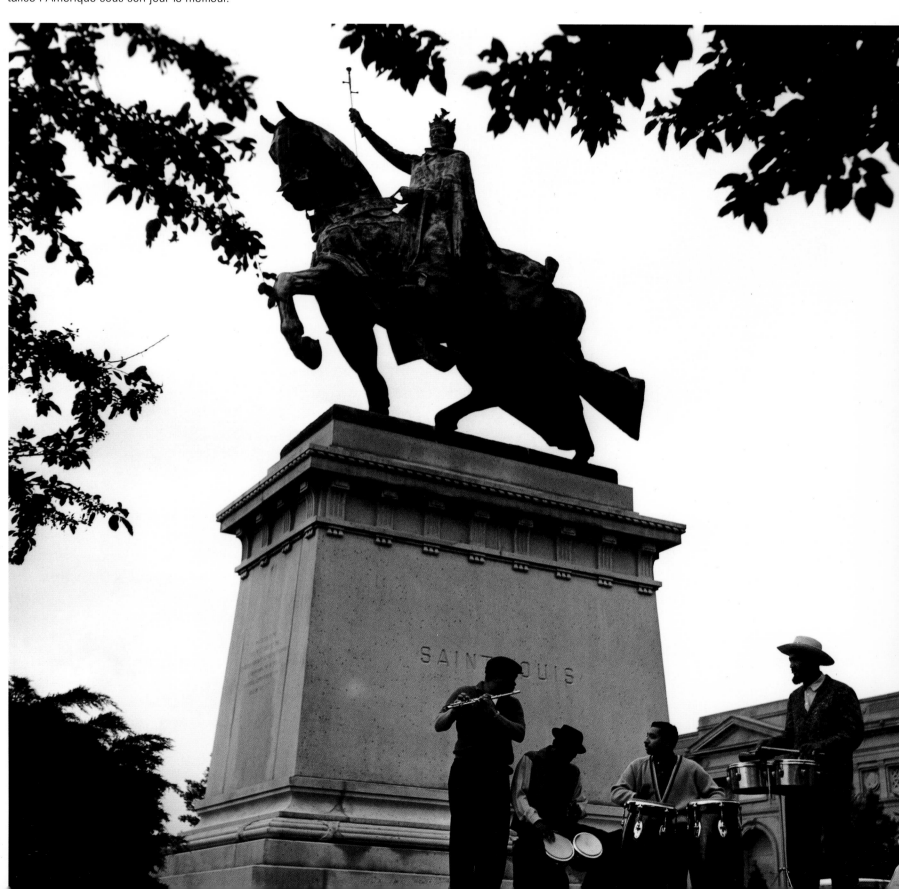

PAUL DESMOND [p. 23]

Si on me demandait : « En compagnie de quel jazzman préférerais-tu te retrouver échoué sur une île déserte ? », je répondrais sans doute aussitôt : « Bird, le génie du jazz d'aujourd'hui ». Mais à bien y réfléchir, compte tenu des problèmes de drogue de Charlie Parker et de toutes les histoires qu'il pourrait y avoir, je crois que je choisirais quand même Paul Desmond.

Paul était l'un des musiciens les plus spirituels, drôles et chaleureux que j'aie jamais rencontré. Incorrigible farceur, capable de faire les bons mots les plus brillants et les plus spirituels, il était ironique, inventif, charmant. Je nous vois assis sur cette île déserte : entre deux crises de rire, Paul jouerait un air subtilement swing et lyrique sur son magnifique saxo alto.

Par une journée chaude et pluvieuse à Washington D. C., Paul et moi nous sommes éclipsés d'un festival de jazz pour aller dans une boîte de strip-tease dans un quartier malfamé de Baltimore, abandonnant derrière nous Dizzy Gillespie, Gerry Mulligan et Thelonious Monk. À notre plus grande stupeur, la dernière strip-teaseuse du programme a commencé à se déshabiller puis, une fois en string, a sorti une clarinette et s'est mise à jouer l'air fétiche d'Artie Shaw, *Nightmare*, tout en zigzaguant entre nous et quatre autres types en imperméable. On ne peut pas échapper au jazz !

THE FIVE PENNIES [p. 40]

Cette photo a été prise pendant les répétitions pour la bande originale du film *The Five Pennies*, une biographie musicale du cornettiste Red Nichols et de son orchestre. Red Nichols était interprété par Danny Kaye, et c'est lui-même qui a appris à l'acteur à bien placer ses doigts sur l'instrument, mais c'est vraiment lui qui jouait sur la bande sonore. Pendant ce temps-là, Louis Armstrong et Danny Kaye n'arrêtaient pas des faire les pitres dans le studio.

DILLON O'BRIAN [p. 45]

L'univers de Dillon. Dillon O'Brian a grandi à Baltimore. La maison BMG/RCA m'avait demandé de m'y rendre afin d'y réaliser la pochette de son disque. Dillon et moi nous sommes baladés dans les rues et il m'a parlé de l'influence que sa ville et surtout son église avaient eue sur sa vie et sa musique. Après un long déjeuner bien arrosé, nous sommes revenus à l'église de son enfance et je l'ai photographié prostré au pied de l'énorme bâtisse néo-gothique.

RAY CHARLES, HOLLYWOOD, 1962 [p. 68]

Cette photo a été prise lors d'une séance d'enregistrement pour Atlantic Records dans les studios United à Hollywood. Pendant les longues heures d'enregistrement, deux événements m'ont marqué. À un moment, on décida de faire une pause café pour que l'immense orchestre et les Raylettes puissent souffler un peu. Je me suis soudain rendu compte qu'il ne restait plus que deux personnes dans le studio silencieux : le musicien aveugle Ray Charles et moi. Je me suis approché de lui. Il m'a pris par le bras et m'a demandé de le conduire à la harpe. Là, il s'est mis à la palper de haut en bas. « Je n'avais jamais vu une harpe d'aussi près ! » m'a-t-il dit. Puis nous nous sommes approchés des timbales, où il a recommencé, puis

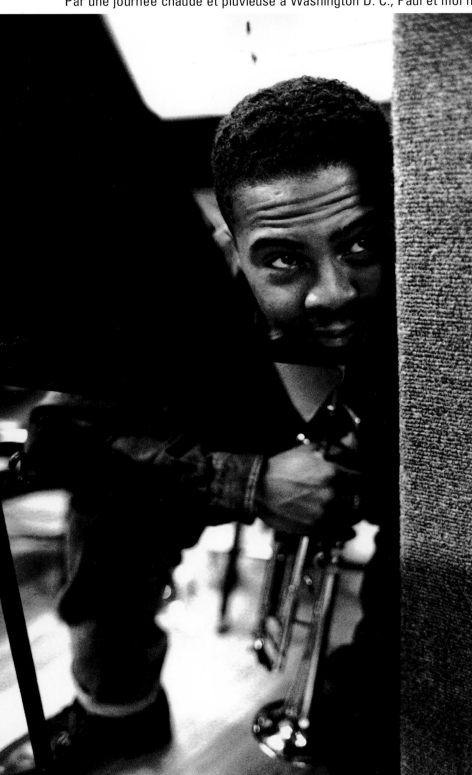

pareil aux cors. Ce fut une expérience très émouvante. L'autre incident fut plus mondain, plus comique. Au cours de la soirée, Frank Sinatra est entré avec Marilyn Monroe à son bras. Sinatra était en smoking. Marilyn portait une fourrure blanche et dégoulinait de diamants. Ils étaient venus jeter un coup d'œil sur « le génie de la Soul ». Seul problème, les gorilles de Sinatra ne m'ont pas laissé les photographier.

ROOSEVELT CHARLES [p. 94]

En 1959, un grand éditeur allemand m'a envoyé sillonner les États-Unis avec l'historien de la musique Joachim-Ernst Berendt pour enregistrer toutes sortes de musiques américaines, blues, folk, gospel et jazz, bien sûr. Nous avons visité des églises, des écoles, des théâtres, des night-clubs, des taudis perdus dans les bois et des prisons, enregistrant et photographiant une population bigarrée de musiciens.

Dans le pénitencier de la Louisiane, à Angola, nous avons été accueillis par le directeur et son personnel. Ils nous ont demandé de choisir entre la section « blanche » de la prison ou celle « des gens de couleur ». Les gardes nous ayant confié qu'ils n'entendaient jamais de musique émaner de la section « blanche », nous avons choisi l'autre. Le directeur nous a également prévenus que nous n'aurions pas d'escortes car les gardiens n'avaient pas de temps à perdre pour ce genre de visite. Joe (Joachim) et moi, nous nous sommes retrouvés entourés de détenus noirs dès que nous sommes entrés dans la cour de la prison. Nous leur avons expliqué que nous étions venus entendre de la musique et prendre des photos de musiciens. Aussitôt, un des détenus s'est porté volontaire pour nous servir de guide, disant qu'il connaissait tous les plus grands « talents » de la prison. Il s'appelait « Hoagman » et jouait de la guitare.

Lors de cette visite, nous avons rencontré toutes sortes de musiciens. Mais le plus frappant et original d'entre eux était un détenu condamné pour meurtre et appelé Roosevelt Charles. Il chantait a capella dans un style blues magnifique et composait des chansons sur sa vie en prison. L'une des plus belles racontait l'histoire d'un homme frappé deux fois de suite par la foudre alors qu'il travaillait aux champs.

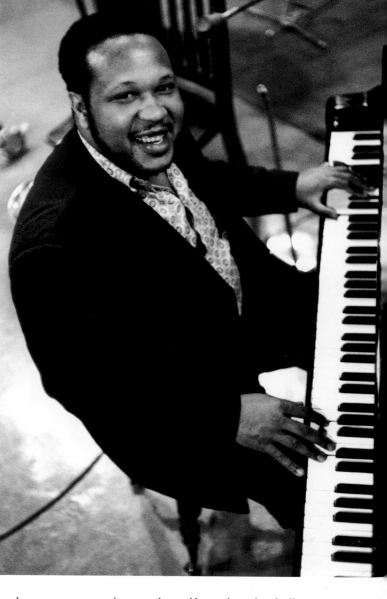

Voilà que le Seigneur me parle et dit : / Charles, t'es pas un homme comme les autres. / Il m'a frappé une fois, il m'a frappé deux fois / De sa puissante main en or. / Oui, le bon Seigneur m'a parlé et m'a dit : / Charles, t'es pas un homme comme les autres. / Sa poigne de feu m'a glacé le sang, / Mais sa lumière dorée a embrasé mon âme. / Oui, le bon Seigneur m'a parlé et m'a dit : / Charles, t'es un homme à part. / Aujourd'hui, je sais que j'suis meilleur : Parce que je vis toujours et que je sens encore / La brûlure de sa main. / Amen.

NOUVELLE-ORLÉANS, FANFARES DE RUE, 1960 [p. 96, 97]

Pendant notre voyage à travers les États-Unis à la recherche de photos pour notre livre *Jazzlife*, Joachim Berendt et moi avons passé près de deux semaines à la Nouvelle-Orléans. Là, nous étions particulièrement intéressés par les fameuses fanfares de rue, un phénomène plutôt unique dans l'histoire du jazz. La tradition veut que, lorsqu'un membre de leur loge ou de leur orchestre meurt, les fanfares jouent tout le long de sa procession funéraire. Elles jouent une marche funèbre pendant le trajet vers le cimetière, où le mort est enterré en grandes pompes, puis un air enlevé et swing sur le chemin du retour. Lors de cette joyeuse marche de retour, les « Second Liners » suivent la fanfare en dansant, chantant et en se pavanant. Les « Second Liners » sont des gars de la rue qui ne savent pas jouer d'un instrument mais tiennent coûte que coûte à participer à l'événement.

Ce ne fut pas facile de savoir quand exactement ces enterrements ou célébrations allaient avoir lieu. Grâce à notre ami Richard Allen, qui enseigne l'histoire du jazz à l'université de Tulane et sait absolument tout sur ces fanfares et leurs membres, nous avons pu assister à trois de ces processions avec les principales fanfares du moment. Il s'agissait du Tuxedo Brass Band, de l'Eureka Brass Band et du George Williams Brass Band.

HALIMA ET CHET BAKER, REDONDO BEACH, CALIFORNIE, 1955 [p. 136]

Par une chaude journée d'été de 1955, je suis allé photographier Chet chez lui à Redondo Beach pour une éventuelle pochette. Je n'avais au-cune idée de ce que je voulais faire mais, à mon arrivée, c'est une jeune femme nommée Halima qui m'a ouvert la porte. Elle était si fraîche et jolie dans sa robe légère que j'ai aussitôt décidé de l'inclure dans la photo. Je l'ai photographiée avec Chet dans une maison en travaux à côté. Je les ai fait asseoir sur le rebord d'une fenêtre pour avoir un éclairage doux en arrière-plan et j'ai demandé à Chet de murmurer à l'oreille d'Halima. L'ambiance était donnée.

BIRD, 1951 [p. 155]

J'avais entendu dire que « Bird » (Charlie Parker) passerait en ville. Si j'avais dû choisir une idole, ce n'aurait pu être que lui. Un samedi soir, j'ai pris la voiture de mon père, emprunté un appareil photo Speed Graphic 4 x 5 et filé au Tiffany Club, 8ᵉ Rue, au cœur de Los Angeles. Sur scène, Bird était accompagné par Harry Babasin à la basse, Lawrence Marable à la batterie, Donn Trenner au piano et un très pale et néan-moins très beau Chet Baker au saxo. Il m'a tout de suite fait penser à un boxer avec un visage d'ange. Naturellement, Bird a divinement joué. Chet avait un son totalement nouveau et frais. J'ai pris des photos et fait connaissance avec les musiciens. Lorsque le club a fermé, Chet est parti avec une jolie blonde et Bird m'a demandé si je connaissais un endroit pour prendre le petit-déjeuner. Tous les restaurants du quartier fermaient à 3 h 30 du matin. Dans mon souci juvénile de satisfaire au moindre désir du maître, je lui ai proposé (ainsi qu'à un groupe d'autres fans) d'aller chez mes parents dans la banlieue de Pasadena. Après tout, mes parents étaient partis pour le week-end.

Là, nous avons préparé le petit-déjeuner de Bird, puis il s'est assis dans une chaise longue avec un air de Bouddha, pendant que nous, ses jeunes admirateurs, étions assis à ses pieds. Ils nous a régalés d'histoires sur sa vie et de potins sur d'autres musiciens. Je lui ai demandé pourquoi il avait choisi d'être accompagné par un jeune inconnu comme Chet Baker alors qu'il n'avait que l'embarras du choix parmi tous les grands musiciens vivant à Los Angeles. Bird m'a répondu : « Parce qu'il est pur et simple. Il joue avec pureté et simplicité. Un peu comme Bix. Il a un son suave et sincère. Tu vois ce que je veux dire ? ». Après avoir entendu l'avis de Bird sur Chet Baker, nous avons tous écouté plus attentivement ce jeune musicien au beau visage de poids plume.

Mon célèbre invité est resté à la maison pendant tout le week-end, à nager, à manger. Il avait un appétit féroce. À un moment, je l'ai photo-graphié se tenant sur le bout du plongeoir au-dessus de la piscine. Il était entièrement nu, couvert uniquement de son saxophone sur lequel il jouait une version très drôle de *Moon Over Miami*. Malheureusement, le négatif de cette photo a été détruit dans l'inondation de mon studio quelques années plus tard. Le lundi après-midi, quand mes parents sont rentrés, j'ai accueilli ma mère tout excité en lui annonçant que le plus grand jazzman du monde avait passé le week-end à la maison. Elle a souri et répondu : « C'est très bien, mon chéri. Tu lui as offert quelque chose à manger ? »

THELONIOUS MONK, SAN FRANCISCO, 1961 [p. 170]

Orrin Keepnews, de Riverside Records, m'avait demandé de photographier Thelonious Monk à San Francisco pour la pochette d'un album qui serait enregistré dans cette ville. Orrin m'avait dit : « Essaie de prendre Monk sur un de ces drôles de petits trams ou sur n'importe quoi qui évoque San Francisco ». Il m'avait également prévenu que Monk n'aimait pas toujours les photographes et leurs idées.

À l'heure dite, ma fiancée Peggy et moi sommes passés prendre Monk à son hôtel. Tout se présentait bien, mais je sentais que Monk n'était pas de très bon poil. Trois heures de l'après-midi, c'est toujours trop tôt pour un musicien de jazz. Aussi, plutôt que de commencer directement les prises de vue, je lui ai proposé d'aller manger quelque chose. L'idée lui a plu.

On s'est retrouvé à la terrasse d'un café pittoresque dans le quartier de North Beach où on a commencé par des cocktails au champagne. À un moment, Monk s'est tourné vers moi et m'a demandé où nous allions prendre les photos. Je lui ai parlé de l'idée du tram et il a fait la grimace. « Non, ça ne me dit rien du tout, cette histoire de tram. Pas question. » J'ai commandé une autre tournée. Quelques verres plus tard, j'ai glissé dans la conversation : « Au fait, vous savez qu'on peut faire un bon jeu de mots avec votre nom ? Thelonious Monk donne Melodious Thunk (boum mélodieux) ». Ça l'a fait rire.

Après un certain nombre de cocktails au champagne et un petit repas, Monk s'est tourné vers Peggy et moi, il nous a porté un toast et a déclaré : « Cette idée de tram est plutôt drôle. Si on essayait ? » Nous avons fait les photos en nous amusant. D'ailleurs, la pochette qui en a résulté fut assez réussie. Plus tard, nous sommes passés devant une porte ouverte qui donnait sur ce qui ressemblait à une salle de concert vide avec un grand piano au milieu de la pièce. Monk s'est assis au piano et a joué pendant près d'une heure. C'est comme ça que Peggy et moi avons eu droit à un concert privé du grand Monk.

SONNY ROLLINS, 1957 ET 1997 [p. 185]

Dans les années 50, alors que la côte Ouest traversait une phase de renaissance du jazz, Sonny Rollins vint pour la première fois à Los Angeles où il fut très bien accueilli. Les Koening tenait à être le premier à lui faire enregistrer un album pour son label Contemporary Records. Je ne sais plus très bien si c'est Sonny ou Les qui a eu l'idée d'un portrait en cow-boy, mais j'ai emmené Sonny chez un costumier où nous lui avons loué un énorme chapeau de cow-boy, une ceinture, un holster et un pistolet. Puis nous sommes partis pour le désert de Mohave. Sonny et moi nous sommes bien amusés à faire cette série et la pochette de l'album est devenue célèbre. Quand Sonny est rentré à New York, ses confrères se sont moqués de lui à cause de sa pochette « ridicule ». J'ai su par plusieurs sources qu'il m'en voulait d'avoir choisi cette photo pour la pochette. Quarante ans plus tard, la direction de Rico Reed m'a engagé pour photographier Sonny en train d'utiliser une de leurs hanches. C'était pour une grande campagne publicitaire. Lorsque nous nous sommes retrouvés pour faire cette photo, Sonny s'est montré très aimable avec moi. Il m'avait pardonné pour la pochette de 1957 : *Sonny Rollins, Way Out West*.

MILES DAVIS [p. 186]

La première fois que j'ai vu Miles, c'était pendant l'été 1949. C'était ma première visite d'adulte à New York. Mon ami, le musicien Allen Eager, me faisait faire le tour de la ville. Un soir, alors que nous nous promenions dans le quartier des théâtres, au coin de Broadway et de la 44ᵉ Rue, j'ai aperçu Miles venant vers nous. Il portait un costume noir des Brooks Brothers, une chemise blanche et une mince cravate noire. Il était encadré par les deux plus beaux mannequins que j'aie jamais vus : Dorian Leigh était pendue à son bras gauche et la très blonde Sunny Harnett, à son bras droit. Les deux filles riaient aux éclats et tous trois dansaient presque dans la rue, occupant tout le trottoir. Allen et Miles se sont reconnus et tout le monde s'est présenté. Allen a dit : « Miles, voici mon ami de Californie, il s'appelle Clax. » Miles m'a serré la main et a déclaré de son inimitable voix rauque : « CLAX ! On dirait une marque de liquide vaisselle ! »
Des années plus tard, en 1965 pour être précis, j'ai revu Dorian Leigh. Elle dirigeait une grande agence de mannequins qui représentait ma femme, Peggy Moffitt, pour des photos de mode en Europe. Elle se souvenait de notre première rencontre et m'a raconté que Miles parlait toujours de moi en disant : « Ce cow-boy d'Hollywood au nom bizarre, Clax ! »

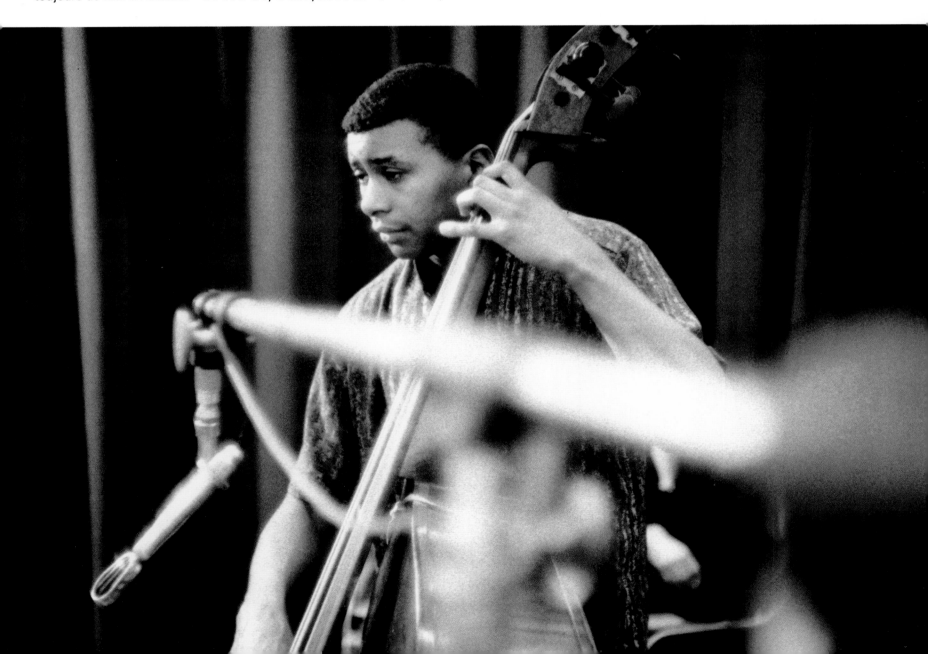

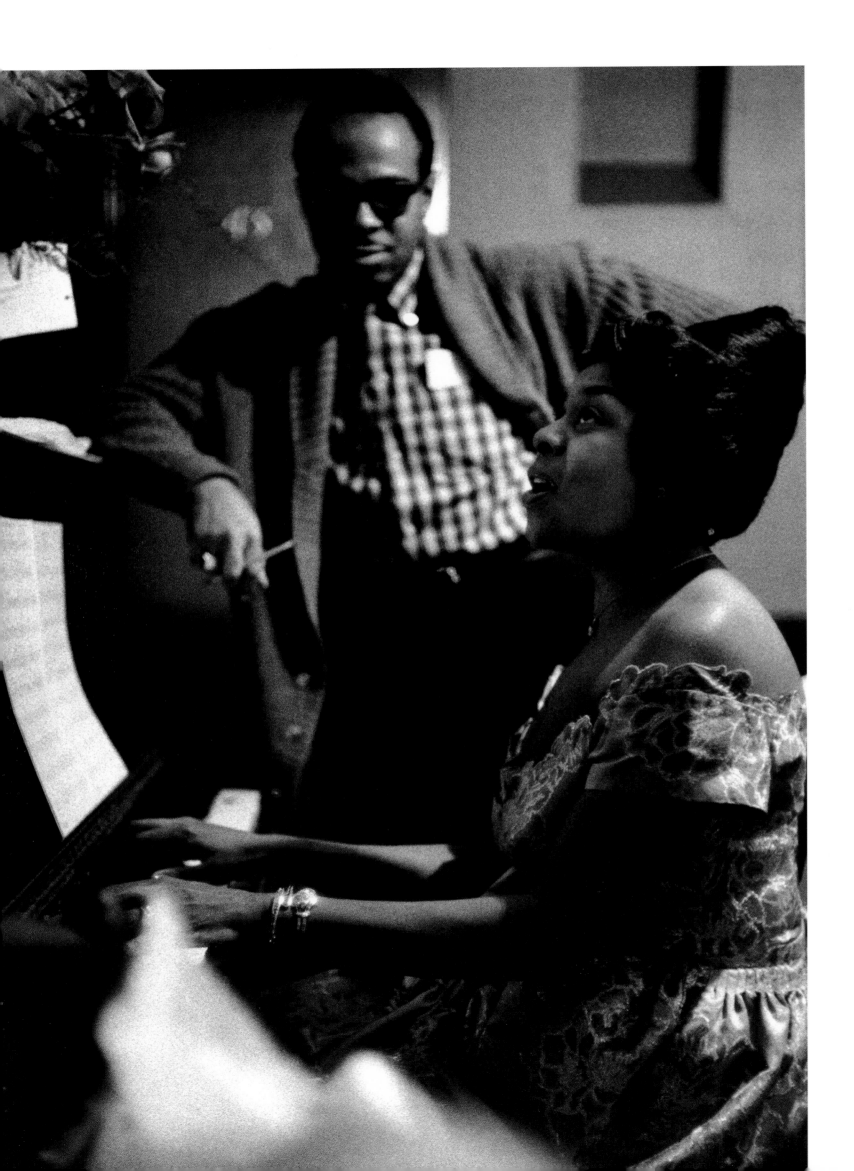

J'ai revu Miles en 1957. Columbia Records m'avait engagé pour le photographier pour son nouvel album, *Miles Ahead*. Il s'est présenté à mon studio vêtu d'une veste en daim brune, d'une écharpe en soie vivement colorée, d'un pantalon gris à pinces et de chaussures en daim assorties à la veste. Il semblait sorti tout droit d'un magazine de mode. Nous avons passé un moment merveilleux ensemble. Il aimait être photographié et les photos réalisées alors ont plu à la maison de disques.

Elles devaient faire la pochette de sa première collaboration avec Gil Evans depuis *The Birth of the Cool* en 1949. Malheureusement, lorsque le disque est sorti, sa pochette montrait une jolie fille en chapeau de paille assise sur un voilier. J'étais très déçu. Je suppose que les producteurs du disque s'étaient dit qu'une pin-up ferait augmenter les ventes. Ceci dit, *Miles Ahead* est tellement génial qu'il aurait été un grand succès quelle que soit l'image sur la pochette.

CANNONBALL SUR LA PLAGE [p. 196]

Au début des années 50, je me suis forgé une petite réputation en photographiant les musiciens de jazz dans des lieux inhabituels ou devant des toiles de fond inattendues. Je le faisais intentionnellement, pour m'éloigner de l'image stéréotypée des jazzmen, toujours montrés dans des lieux glauques à New York ou à Chicago. En Californie, il y avait du soleil, des plages, des décapotables, des collines, un temps superbe et toute une population obsédée par sa santé. Même les junkies mangeaient macrobiotique. C'est dans cette optique que j'ai photographié Sonny Rollins avec un chapeau de cow-boy dans le désert de Mohave, Shorty Rogers dans la cabane de son fils perchée dans les arbres, le trio Ramsey Lewis sur la Chicago Avenue au beau milieu de la circulation, Ray Brown, Barney Kessel et Shelley Manne sur des chevaux de manège pour la pochette de l'album *The Poll Winners Ride Again*, Chet Baker et son « équipage » sur un voilier dans la baie de Santa Monica, etc.

Quand Cannonball Adderley a vu la pochette que j'avais réalisée pour les Lighthouse All Stars, sur le sable de Hermosa Beach, il a voulu que je le photographie lui aussi sur la plage pour son album *The Cannonball Adderley Quintet at the Lighthouse*. Toutefois, il pensait que ce serait mieux d'être en « tenue de plage », à savoir en maillot de bain. Après réflexion, je m'y suis opposé. Tout d'abord, son orchestre n'aurait sans doute pas été présenté sous son meilleur jour en maillot de bain. Mais, plus important encore, je voulais qu'ils soient en costume et cravate debout sur la plage pour faire ressortir l'incongruité de la situation et ajouter une touche d'humour. Cannonball a accepté mais pas sans proposer un compromis : l'orchestre a donc posé en tenue de sport, mais j'ai ajouté un gros ballon de plage et les ai placés sous un grand parasol japonais en papier pour qu'ils aient l'air plus « cool ».

SINATRA, CROSBY, TONY BENETT, LENA HORNE ET LE JAZZ [p. 199]

D'aucuns mettent en doute le fait que ces quatre grands artistes soient vraiment des artistes de jazz. À mon avis, tous ont influencé le jazz par leur son, leur phrasé et, sans conteste, leur personnalité unique. Et tous se sont entourés de grands talents du jazz.

Parmi eux, Bing Crosby est, ou était, le plus proche du jazz et celui qui a exercé la plus grande influence sur les chanteurs de jazz. À ses débuts dans les années 20, il chantait avec les Rhythm Boys, un groupe vocal de jazz très swing.

Bing a toujours dit qu'il avait été influencé par Bix Beiderbecke et Joe Venuti. Il a enregistré des disques avec l'orchestre de Duke Ellington et a souvent travaillé avec Louis Armstrong.

Lorsque je l'ai photographié avec Bob Scobey, je l'ai interrogé sur sa période avec les Rhythm Boys. Non seulement il m'a régalé d'anecdotes merveilleuses, mais il a entonné en scat des passages entiers de chansons qu'il avait enregistrées dans les années 20 et 30. Il chantait à quelques centimètres de mon oreille. Ce fut un moment magique. C'était comme écouter un répertoire d'une autre période de la musique swing dans un casque, avec le volume à fond.

THE NEWPORT REBELS [p. 209]

Pour son édition de 1960, le programme du festival de jazz de Newport de George Wein affichait un nombre impressionnant de musiciens, mais beaucoup de grands noms du jazz avaient été oubliés. Charlie Mingus a donc pris les choses en main et a organisé une autre manifestation, plus petite, à deux pas, qu'il a baptisée « Les rebelles de Newport ». Ces derniers comprenaient de nombreux jeunes talents ainsi que de grands jazzmen reconnus.

Le site était superbe, perché sur un promontoire qui dominait le détroit du Rhode Island. Quant à la musique, elle était fantastique. C'était une manière formidable de monter une compétition de jazz. Parmi les musiciens, il y avait Thelonious Monk, Max Roach, Ornette Coleman, Abbey Lincoln, Allen Eager, Sonny Rollins, Gigi Gryce et Roy Eldrige.

ORNETTE COLEMAN, 1959 [p. 211]

On m'avait demandé de photographier Ornette Coleman pour la pochette de son premier disque. Le jour de notre rendez-vous, j'ai entendu un grattement timide à la porte de mon petit studio à Hollywood. Devant moi se tenait Ornette, avec son visage lisse et luisant, impeccablement habillé, très timide. Il venait de débarquer du Texas et a tout de suite précisé qu'il n'avait jamais posé pour un portrait auparavant.

Devant l'objectif, sa timidité a persisté, se muant presque en panique. J'ai essayé de le rassurer et de le détendre – peine perdue. Peggy, ma femme, l'a cajolé et lui a offert des rafraîchissements. Je me suis soudain rendu compte qu'il n'avait pas son instrument en main. Quand je lui ai demandé de sortir son saxo de son étui, il a sorti un saxo en plastique jaune ! Je n'ai pas pu m'empêcher de rire et Ornette s'est mis à rire à son tour. On est tombé dans les bras l'un de l'autre, pliés en deux. La glace était brisée. Après ça, il s'est suffisamment détendu pour que je puisse le photographier et la séance a donné cette pochette d'album pour Atlantic Records, *The Shape of Jazz to Come*.

JOHN WILLIAMS [p. 212]

Ce jeune homme à l'allure poétique assis devant son piano est John Williams. Il devait par la suite composer la bande originale de *La Guerre des étoiles* et de nombreux films de Steven Spielberg, dont *Les Aventuriers de l'arche perdue*, tout en dirigeant le Boston Pops Orchestra.

DUKE ELLINGTON, COULISSES [p. 218]

La première fois que j'ai vu l'orchestre de Duke Ellington sur scène, c'était au Orpheum Theatre de Los Angeles.

J'avais seize ans. L'orchestre était impressionnant. J'avais un fauteuil près de la scène et j'étais à deux pas de Johnny Hodges, Harry Carney, Lawrence Brown, Sonny Greer et Al Hibbler.

Lorsque le rideau est tombé et que le film a commencé, j'ai sauté sur l'occasion pour me glisser dans les coulisses pour voir le grand Duke. Je n'ai eu aucun mal à le rencontrer. On m'a fait entrer dans sa loge où il était en train d'ôter son costume lavande, sa chemise en soie rose et sa cravate violette pour enfiler une immense robe de chambre dorée. Il s'est montré très gentil et est resté un long moment avec moi. J'étais aux anges !

Après ça, chaque fois qu'il se produisait dans une ville où je me trouvais, je suis allé le voir en coulisses. J'emmenais souvent une petite amie. Le Duke se souvenait toujours de moi et nous accueillait chaleureusement. Puis il se tournait vers la jeune fille et s'inclinait en lui adressant un de ses célèbres compliments : « Ce devrait être interdit d'être aussi jolie ! » ou « On dirait une rose ! » ou encore « Les Dieux se sont surpassés quand ils vous ont créée, ma chère ! » – C'était le Duke tout craché.

ART PEPPER, 1956 [p. 227]

Art Pepper était très mal en point quand je suis arrivé chez lui, au sommet de la colline la plus escarpée de Los Angeles. C'était à Fargo Street, où les studios Keystone ont tourné pas mal de films policiers au début des années 20. Je venais le photographier pour la pochette de son nouvel album intitulé *The Return of Art Pepper*. Pendant que nous choisissions une tenue dans sa garde-robe, Art s'est plaint de douleurs au ventre. Il était en rogne parce que son fournisseur n'était pas venu comme prévu avec ses « médicaments » mais décida néanmoins de faire la photo. La séance de pose lui a changé un peu les idées. Il faut dire qu'il était très beau. Vers la fin de sa séance, j'ai décidé de le photographier en train de grimper vers le sommet de la colline. Pour moi, cela symbolisait son combat pour la survie.

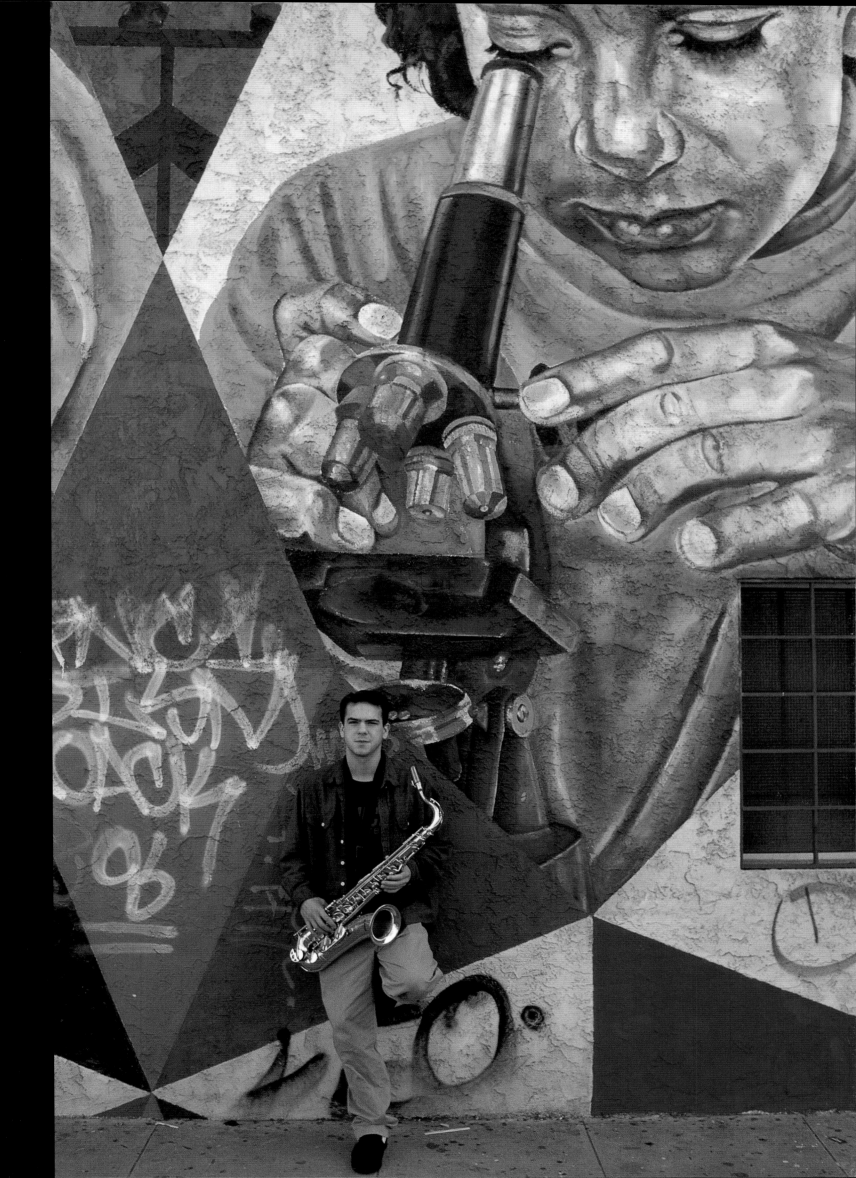

INDEX

The index lists all the groups and musicians featured in the photographs

ACKNOWLEDGEMENTS | DANKSAGUNG | REMERCIEMENTS

First of all, I'd like to thank David Fahey of the Fahey/Klein Gallery for introducing me to Benedikt Taschen. I would also like to thank the following people for making this book a reality:
Angelika and Benedikt Taschen, and Ute Kieseyer, my editor; Armando Chitolina and Giorgio Martinoli of the Studio Grafico in Milan; Don Weinstein and his staff at Photo Impact; Silver Lab in Los Angeles; the Lexington Lab in New York; Don Heckman for his elegant prose; Peter Fetterman; Bobbi Peacock, Ingrid Sischy, Cynthia Sesso; Steve Crist and Robbie Staley, my trusty assistants and friends; Bruce Lundvall, Tom Evered and Michael Lang, Ria Lewerke, Jeri Heiden, Michael Cuscuna and Charlie Lourie, and all my friends in the recording industry; Marysa Maslansky and her Visages Agence; Christian Caujolle and the Vu Agence in Paris; Thierry Demont, Ruth Price and Maurice Hall of the Jazz Bakery, and Dick Allen, my New Orleans connection; Joachim-Ernst Berendt with whom I travelled across America in search of music.
Much love and thanks to my wife Peggy Moffitt, who has always been the key light in my life; to my son Christopher for his love and much needed advice; and to Julian Benedikt in Munich who made the film "Listening with the Eyes" about my life and work.
A very special appreciation to all the jazz musicians of the world; without them there would be no book.

Zu allererst möchte ich David Fahey von der Fahey/Klein Gallery dafür danken, daß er mich mit Benedikt Taschen bekannt gemacht hat. Außerdem gilt mein besonderer Dank den folgenden Personen, die zur Verwirklichung dieses Buches beigetragen haben:
Angelika und Benedikt Taschen, Ute Kieseyer, meiner Lektorin; Armando Chitolina und Giorgio Martinoli vom Studio Grafico in Mailand; Don Weinstein und seinen Mitarbeitern bei Photo Impact; Silver Lab in Los Angeles; Lexington Lab in New York; Don Heckman für seinen erstklassigen Text; Peter Fetterman; Bobbi Peacock, Ingrid Sischy und Cynthia Sesso; meinen zuverlässigen Assistenten und Freunden Steve Crist und Robbie Staley; Bruce Lundvall, Tom Evered und Michael Lang, Ria Lewerke, Jeri Heiden, Michael Cuscuna und Charlie Lourie sowie all meinen Freunden in der Plattenindustrie; Marysa Maslansky und ihrer Visages Agence; Christian Caujolle und der Vu Agence in Paris; Thierry Demont, Ruth Price und Maurice Hall von der Jazz Bakery; Dick Allen, meiner Verbindung nach New Orleans; Joachim-Ernst Berendt, mit dem ich auf der Suche nach Musik quer durch Amerika reiste.
Meine ganze Liebe und meinen Dank an meine Frau Peggy Moffitt, den Stern an meiner Seite, der mein Leben stets erhellt; an meinen Sohn Christopher für seine Liebe und seinen dringend benötigten Rat; und an Julian Benedikt aus München, der mein Leben und meine Arbeit in dem Film »Listening with the Eyes« dokumentiert hat.
Meine ganz besondere Dankbarkeit gilt allen Jazzmusikern der Welt; ohne sie würde es dieses Buch nicht geben.

Tout d'abord, je voudrais remercier David Fahey de la Fahey/Klein Gallery de m'avoir fait rencontrer Benedikt Taschen. Mais je voudrais aussi exprimer ma gratitude aux personnes suivantes grâce auxquelles ce livre est devenu réalité :
Angelika et Benedikt Taschen, Ute Kieseyer pour le suivi éditorial ; Armando Chitolina et Giorgio Martinoli du Studio Grafico à Milan ; Don Weinstein et son équipe de Photo Impact ; Silver Lab à Los Angeles ; le Lexington Lab de New York ; Don Heckman pour l'élégance de sa prose ; Peter Fetterman ; Bobbi Peacock, Ingrid Sischy, Cynthia Sesso ; Steve Crist et Robbie Staley, mes fidèles assistants et amis ; Bruce Lundvall, Tom Evered et Michael Lang, Ria Lewerke, Jeri Heiden, Michael Cuscuna et Charlie Lourie, ainsi que tous mes amis de l'industrie du disque ; Marysa Maslansky et sa Visages Agence ; Christian Caujolle et l'Agence Vu à Paris ; Thierry Demont, Ruth Price et Maurice Hall de la Jazz Bakery ; Dick Allen, mon contact à la Nouvelle-Orléans ; Joachim-Ernst Berendt avec qui j'ai traversé l'Amérique en quête de musique.
Toute mon affection et mes remerciements à mon épouse Peggy Moffitt qui a toujours éclairé ma vie de façon décisive, à mon fils Christopher pour sa tendresse et ses conseils, ainsi qu'à Julian Benedikt, à Munich, auteur du film sur ma vie et mon travail intitulé « Listening with the Eyes ».
Mention spéciale à tous les musiciens de jazz du monde, sans lesquels ce livre ne serait pas.

William Claxton

© 1999 Benedikt Taschen Verlag GmbH
Hohenzollernring 53, D-50672 Köln

© 1999 for the photographs: William Claxton, Los Angeles
Gallery Representative:
Fahey/Klein Gallery, 148 N. La Brea Ave.
Los Angeles, CA 90036
Phone: 213 934 22 50
Fax: 213 934 42 43

Edited and designed by Armando Chitolina, Milan
Photo editor and continuity: Peggy Moffitt, Los Angeles
Layout: Giorgio Martinoli, Milan

Editorial coordination: Ute Kieseyer, Cologne
Foreword by Don Heckman, Los Angeles
French translation by Philippe Safavi, Paris
German translation by Hans-Jürgen Schaal, Germering

Printed in Spain
ISBN 3-8228-7868-5

SANCTUARY

ABRAMS, NEW YORK

SANCTUARY

GREGORY CREWDSON

Essay by A. O. SCOTT

SANCTUARY *is dedicated to Lily and Walker*

CONTENTS

WHEN IN ROME

GREGORY CREWDSON'S
SANCTUARY

by A. O. SCOTT

What I have in mind is a series of dreams based on a longing to visit Rome....
SIGMUND FREUD
The Interpretation of Dreams

You recognize this kind of dream. You are in a place that is at once familiar—named, known, specified by some curious annotative function of the mind—and utterly strange. You have never been here before, and yet you wander these byways with the unmistakable conviction of approaching a known destination. You proceed through a door or an opening, down a corridor or a street, and find yourself somewhere you did not expect: an alley opens into an enclosed chamber; a hallway leads into the open air. The walls, so solid from one perspective, turn out to be facades supported by flimsy timber and scaffolding—or maybe even illusions, superimposed on thin air. The style of architecture changes without warning, as if each successive courtyard represented a different era, a distinct ruined civilization heaped on top of the others without regard for chronology or coherence. Is that a temple? A parking lot? A rustic village square? A city street?

Are you indoors or out? The flat gray vault of the sky might be a painted back-drop, or an optical projection of some kind. And yet you feel an occasional stirring of breeze, note the grass and weeds sprouting underfoot, hear the crepuscular racket of birdsong: tokens of the natural world in the midst of what is obviously a constructed, artificial environment. Surrounded by those walls, you feel a profound sense of enclo-sure that is at once protective and confining. You are in a labyrinth without a center, and without an exit. There must have been an entrance, though. Surely you have not always been here. How did you get in?

Is anyone else here? Even though it is completely empty of people—an occa-sional statue tricks you for an instant into thinking that you are not alone, until its mute obduracy redoubles your solitude—this place is thick with implications of human presence. It feels haunted, its silent corners and promenades alive with associ-ations that are at once vivid and impossible to grasp. You know this landscape, where it is found on the map and what its features mean, but that knowledge lies just beyond the borders of this particular dream. You are not in a physical space at all, you under-stand, but a landscape of consciousness, arranged according to the paradoxical laws of the unconscious.

But maybe it is also something else. Surely these weeds and timbers, these stones and buttresses, are not the fabrications of your mind alone. It seems possible that you have crossed some dream boundary and arrived at the place—the literal, actual, physical place—where dreams are made, stored, discarded, and recycled. Maybe you're not dreaming at all.

"Asking the way," moreover, was a direct allusion to Rome,
since it is well known that all roads lead there.
—FREUD

You are indeed in Rome: the palpable, geographical Italian metropolis, thick with legend and choked with traffic. But this is a particular corner of Rome—a virtual, time bound empire tucked inside the Eternal City, a dream depository that has its origins in a historical nightmare.

The Cinecittà movie studio—aha! Of course! You knew it all along!—was built in 1937, commissioned by Benito Mussolini to serve the aligned causes of cinema and fascism. At its birth, this sprawling studio was consecrated to a monstrous imperial ambition. Like Joseph Goebbels, Mussolini and his henchman Luigi Freddi, Cinecittà's first administrator, conceived of movies as a potent instrument of propaganda and as the paradigmatic art form of a totalitarian state—"our strongest weapon." Cinecittà, an elephantine corporatist monument, would be both a factory and a showcase for this grandiose vision.

Like the Venice Film Festival, the other epitome of Il Duce's monstrous and ardent cinephilia, Cinecittà survived the collapse of his dictatorship, and achieved a glorious destiny in the postwar era, becoming the epicenter of a resurgent (if always chaotic) Italian cinema and a hub of international production. In the 1950s, the studio was known as "Hollywood on the Tiber." The chariot race in William Wyler's *Ben Hur*—at the time perhaps the most elaborate action sequence ever filmed—was shot in Cinecittà. Federico Fellini, who made most of his major films at least partly at the studio, adopted it as the explicit setting, you might almost say a featured character, in movies such as *8½* and *Intervista*. If you have seen those pictures—or Fellini's *Roma* and *Satyricon*, or any number of less exalted sex farces, historical epics, or Euro-American co-productions from the second half of the last century—you have traveled to Cinecittà.

Now, in the hard light of our own time, it is not what it used to be. The golden age of Italian cinema has long since waned, and parts of Cinecittà are not the hive of activity they used to be. Italian television programs (including the local version of the *Big Brother* reality franchise) are produced there, and every now and then an American production, lured by the vast available space, relatively cheap labor, and undeniable nostalgic cachet, will make use of the studio's back lots and soundstages. Martin Scorsese, pursuing the grand historical folly that was *Gangs of New York*, commissioned a replica of pre–Civil War Manhattan inside its walls. Wes Anderson confected portions of *The Life Aquatic with Steve Zissou* there. The HBO sandal-and-toga series *Rome* was shot on Cinecittà sets that evoked the glory of the ancient empire.

Much of the *Rome* set, damaged in a fire in 2007, still stands, a modern stucco-and-plywood ruin in a city full of ancient stones. Pieces of Scorsese's old New York also remain, and the presence of these half-remembered structures contributes to the weird sense of familiarity in some of Gregory Crewdson's new photographs, which were taken in idle zones of Cinecittà in the summer of 2009. But the power of the photographs hardly depends on the intimation of costumed movie stars moving through these still frames, nor yet on the particular cultural associations of their settings. Some inkling of memory is clearly conjured by these images, but the status of that memory—is it collective or personal? yours or someone else's? real or illusory?—remains enigmatic, even as the pictures present it with bracing, almost painful clarity.

III.

The possibility of creating composite structures stands foremost among the characteristics
which so often lend dreams a fantastic appearance, for it introduces into the
content of dreams elements which could never have been objects of actual perception.
—FREUD

In some obvious respects, *Sanctuary* represents a departure for Crewdson. Those familiar with his earlier work—collected in the books *Twilight* and *Beneath the Roses*, among others—will immediately note what is missing. Color, for one thing. People, for another. And also a less easily identifiable quality, an element of staging, of incipient drama, of narrative content.

Crewdson's photographs do not tell stories, exactly, but they tend to look as if they did. Elaborately staged and lighted, they appear to freeze action, precisely as if they were stills from imaginary movies. A rich sense of artifice pervades them, even as the images themselves—characters in houses or on the streets of ordinary neighborhoods, caught in postures of domestic distress or implicit violence—conform to an aesthetic we tend to identify as realism.

This is not to deny their surreal qualities, but the tremor of the uncanny palpitating in these pictures derives precisely from their vivid literalness. They might almost belong to the history of painting, in a line of quasi-narrative figuration that extends backward from Alex Katz through Edward Hopper and Balthus via Courbet and Manet to the Holland of Vermeer.

But the more powerful and immediate response, the commingled feeling of suspense, intimacy, mystery, and recognition that pulses through *Beneath the Roses*—the sense that what we are looking at is both actual and illusory—surely comes from the habit of movie watching. The saturated colors and chiaroscuro lighting; the free-floating intensity of feeling that animates the human figures, passes between them, and lingers in the air we could be looking at stills, or conjuring memories, from some lost artifact of 1950s Technicolor. Something by Alfred Hitchcock, Douglas Sirk, or Nicholas Ray; you can almost hear the sob and wail of a lush orchestral score fading as you turn the page. Crewdson's method has long been closely allied to filmmaking. His pictures are discontinuous and self-contained—no matter how quickly you flip the pages, they will not move—but to create them he marshals a machinery of illusion-making not very different from what you would find in a Hollywood (or Cinecittà) production.

In contrast, the smaller-scale, monochrome photographs in *Sanctuary* were shot on a digital camera with a minimal crew in a relatively short period of time. Except for a few cases where he brought a source of illumination into the frame, Crewdson used available light, shooting early and late in the day when the blazing of the Roman summer sun was fairly tame. He sprayed down the dust with water, and made puddles that served as reflecting surfaces, but otherwise everything you see in this tour of Cinecittà is as he found it. (Offers from the studio administration to trim weeds and clear out trash were politely declined.)

To some extent, then, this project represents a foray into documentary. Historical precedent can be found in the empty Paris streetscapes of Eugène Atget, or in Camilo José Vergara's studies of de-industrialized American cities. But the notable difference is that while those bodies of work contemplate the mute facticity of buildings and sidewalks in order to glean something about the social reality of cities, Crewdson peers into the soul of a place that, strictly speaking, never had any social reality at all. And yet its material presence—the brute quiddity of all that timber and metal rebar, the frayed edges and smooth surfaces of all that stuff—is undeniable.

One feature of the digital format is a hallucinatory depth of focus, so that the eye's natural desire to blur, foreshorten, and catalog is thwarted. And the space itself is not organized according to any conventional functional hierarchy. None of these structures has any function other than to be captured by a camera and to give an appearance, from a certain angle, of being something else. *Sanctuary* does not so much destroy that illusion—an illusion genetically connected to the visual fantasies of Crewdson's previous work—as sneak up on it. It takes you to the other side of the scenery, into the ordinarily invisible realm behind the visual artifice.

The phrase "behind the scenes" has rarely been so apt, or so irrelevant: it promises gossip, insider knowledge, demystification, none of which Crewdson provides. Behind the scenes there is nothing. But we are hardly staring into an abyss. The unconscious abhors a vacuum, and the mind will fill empty spaces with meaning and emotion. And it is their ability simultaneously to invite and to thwart this kind of speculation—the reverie of a solitary walker tiptoeing through secret places and dreaming fragmentary epics, romances, comedies, and histories—that gives the photographs in *Sanctuary* their power. That, and their intensely personal quality. These are not dream images, as Crewdson's phantom movie stills might have been, but rather images of what Freud called the dream work, or of its aftermath. A literal question—what is left behind when the movie has wrapped and the cast and crew have departed?—produces a symbolic analog. What is left of the world we dreamed up after we awaken?

IV.

A fourth dream, which took place shortly after the first one,
took me to Rome once more....
—FREUD

You are seeing the place, at last, as it really is: a place of refuge, where the violence of history, which built these edifices as if in a single day and wrecked them in the blink of an eye, has at last abated. The ruins provide comfort. The walls, encircling you in an irregular, accidental maze, don't so much block the outside as nullify the very idea of an outside. This is the place.

A sanctuary can also refer to a tomb, and the more time you spend here the more thoroughly ghost-ridden it seems. You remember, as if from another lifetime, a dark coffin-shaped room pierced by a single beam of light. The shadows on the wall were human figures, projections of a lost civilization. They smoked, whispered,

suffered, fell in and out of love. Their deaths were heart-rending and dramatic, but never permanent. And yet they were less substantial than the dark velvet air in which they circulated. And when they vanished you wondered where to look for them again.

You lost count of how many times you sat there gazing at them, and the stories and situations that seemed so consequential at first viewing blurred and dissipated as you moved on to other, more worldly habits. But certain moments, certain pictures persisted. The blond woman in the black dress descending into the Roman fountain. The room full of women, tormenting and tormented by that man in his jaunty hat and melancholy sunglasses. The coliseum with its angry throng.

No need to ask directions. You know the way. It is blindingly clear in your recollection: the studio gate, with its tidy little guardhouse flanked by two driveways. That was surely your entry point. You remember it so clearly: the woman sitting inside, as the man in pulls up in his car. A story is underway; the day's dream work is about to begin. Everything is about to fall into place; the hidden key that will make sense of it all is almost in your grasp. Because you know this one. You've seen it. The title is right on the tip of your tongue. You will pay close attention this time.

And then you are awake.

PLATES

PLATE 1

PLATE 2

PLATE 3

PLATE 4

PLATE 5

PLATE 6

PLATE 7

PLATE 8

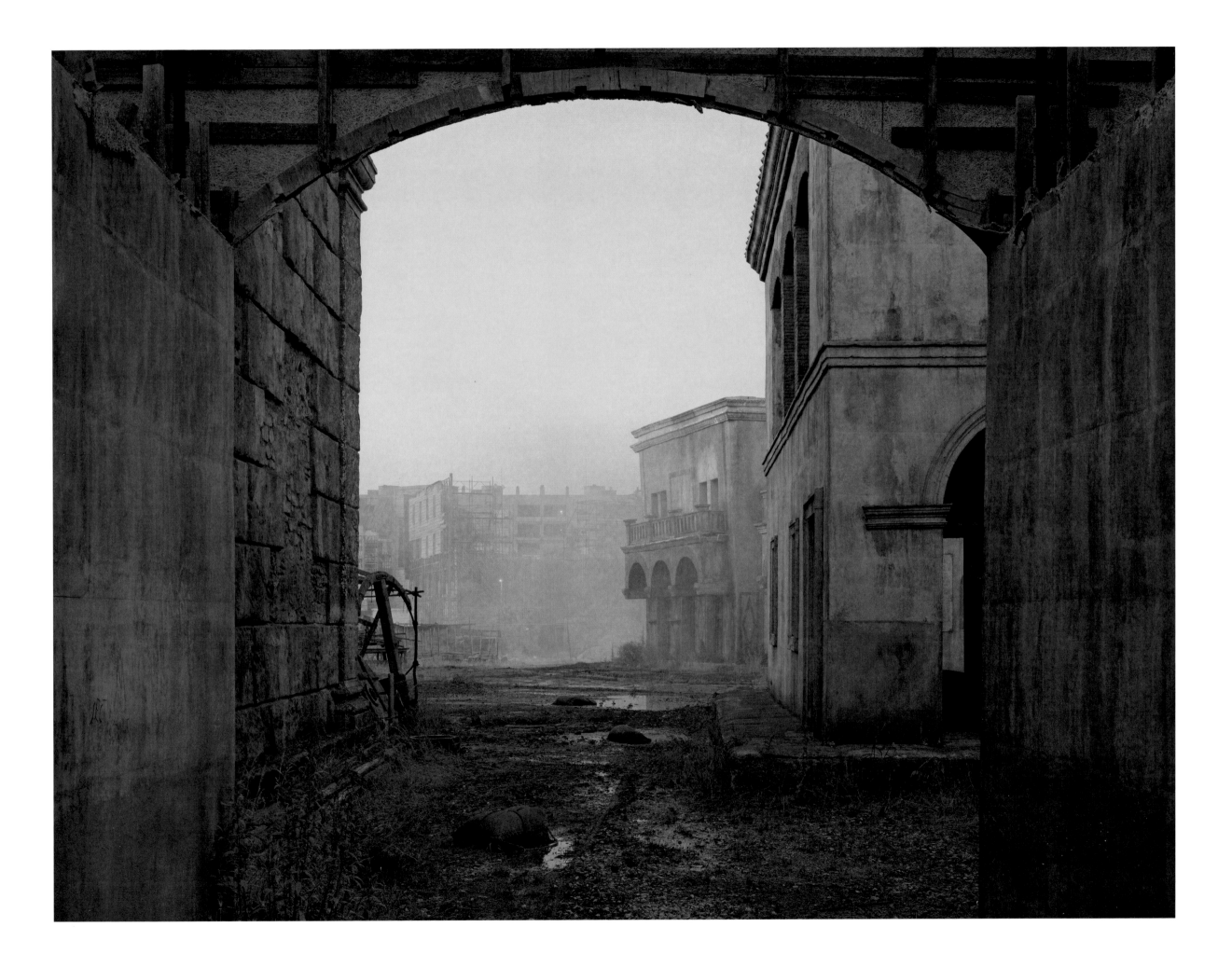

PLATE 9

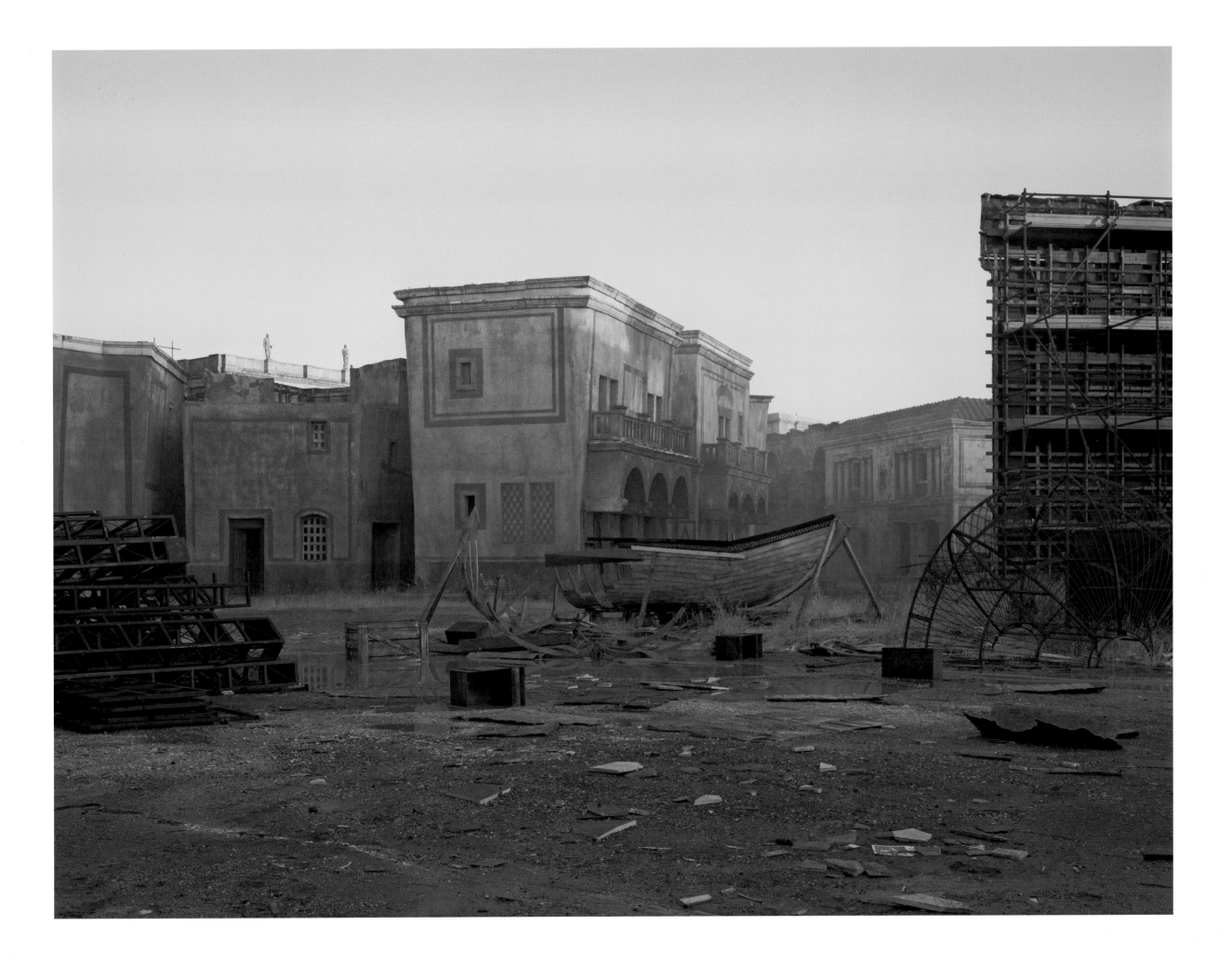

PLATE 10

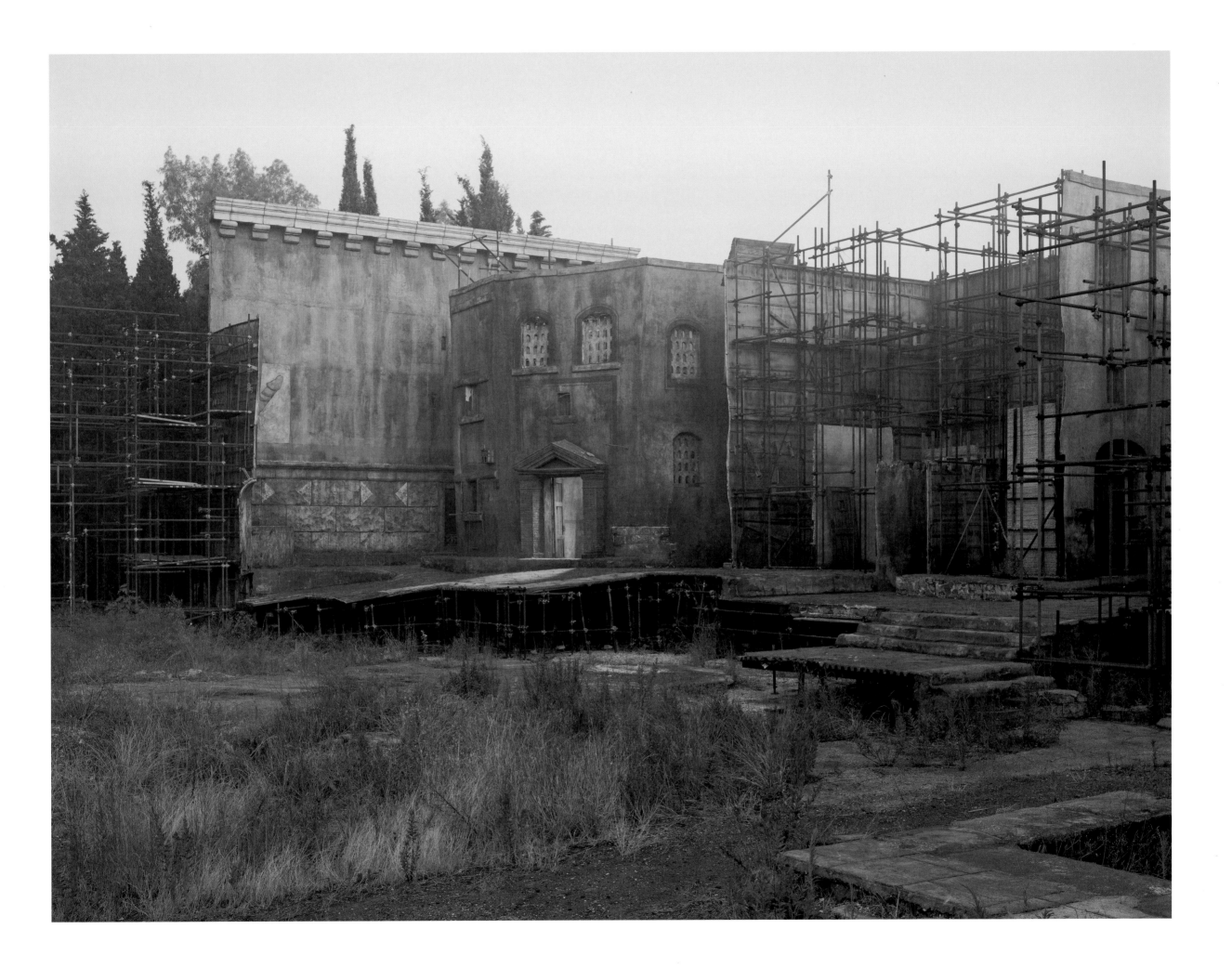

PLATE 11

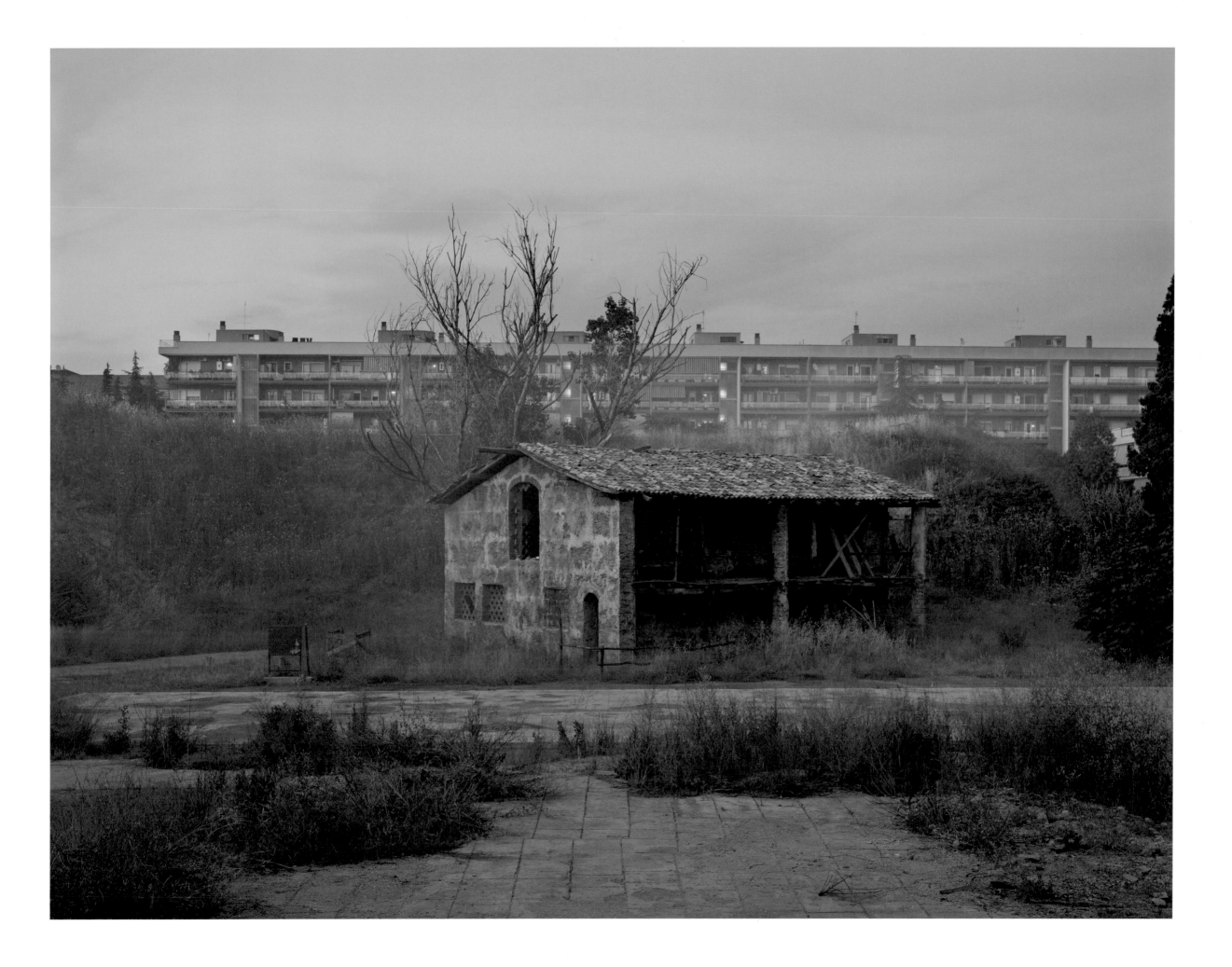

PLATE 12

PLATE 13

PLATE 14

PLATE 15

PLATE 16

PLATE 17

PLATE 18

PLATE 19

PLATE 20

PLATE 21

PLATE 22

PLATE 23

PLATE 24

PLATE 25

PLATE 26

PLATE 27

PLATE 28

PLATE 29

PLATE 30

PLATE 31

PLATE 32

PLATE 33

PLATE 34

PLATE 35

PLATE 36

PLATE 37

PLATE 38

PLATE 39

PLATE 40

The photographs in this body of work were made between June 1 and July 1, 2009, on the back lot of Cinecittà studios in Rome.

In these pictures I aimed to draw upon the inherent quietness and uncanny aspect of the empty sets. As with much of my work, I looked at the blurred lines between reality and fiction, nature and artifice, and beauty and decay. The facades and scaffolding were of particular interest to me, and I wanted to reveal some of their construction and underlying structure. I worked with predominantly ambient light, photographing at dusk and dawn. This project marked the first time that I made work outside the United States—an exciting but daunting departure.

I would have not been able to make these pictures without the cooperation of Cinecittà studios. In particular, I would like to thank Maurizio Sperandini, Fiorella Oldoini, and her assistant, Francesca Rotondo.

This project would have been impossible for me without the support and generosity of a number of people.

First, I would like to express my gratitude to my assistant, Costanza Theodoli-Braschi, who was involved in every aspect of this project. She was truly the guiding light in the making of these pictures. My thanks also go to my producer, Saskia Rifkin, director of photography Rick Sands, cameraman Daniel Karp, and Josh Brown, who worked on this project as digital coordinator.

I am indebted to the Italian team who helped make the pictures and facilitate the project: Ute Leonhardt, my Italian producer; her partner, Marco Pugini; and Diego Cavallo, Elvira Veron, and Giuseppe Santoni from Panorama Films. And, of course, to the crew: Alesso Alessandrini, Livio Alessandrini, Bill Amenta, Davide De Ioannon, Roberto Esposti, Luciano Folchi, Alberto Rogante, and Riccardo Serravalli. I would also like to thank James Barron and Jeannette Montgomery Barron for their support, and Benjamin Barron for interning on the production.

I am grateful to the additional crew who were employed solely to work on the entranceway picture: Andrea Di Biase, Constantin Ciudin, Roberto Marconi, Roberto Meme, and Rodolfo Montagnani.

For their involvement with post-production, I would like to thank John Lehr, for his exquisite printing work, and Sadie Wechsler for her assistance in the studio.

ACKNOWLEDGMENTS

I am indebted to Courteney Freedman-Monroe and Sandra Scott at HBO for granting us permission to shoot on their sets.

My deep thanks go to Larry Gagosian and Melissa Lazarov, for their generous support. Also to Pepi Marchetti and the staff at the Gagosian Gallery in Rome, Louise Neri and Putri Tan from Gagosian New York, and Charlotte Eyerman and Cecile Le Paire from Gagosian Beverly Hills. A special thank-you also to Alison McDonald, Kara Vander Weg, and Darlina Goldak, for their work on the limited edition version of this book.

My sincere gratitude goes to Jay Jopling, for his continuing commitment and support, and to Daniella Gareh, Tim Marlow, Craig Burnett, and Susan May from White Cube.

A big thank-you goes to Deborah Aaronson, my editor, Sarah Gifford, Jules Thomson, and everyone at Abrams for their involvement with the creation of this book. Also to Robert Hennessey for his painstaking work with the separations. My deep gratitude goes to A. O. Scott for his beautiful and generous words on the pictures.

I am thankful to Wes Anderson, Dr. Stephan Berg, and the late Herbert Muschamp, for their inspiration.

Finally, I would like to thank my family for their continuing love and support: my mother, Carole, my late father, Frank, my brother, Michael, and my sister, Natasha, and my wife, Ivy, and children, Lily and Walker.

All exhibition prints *Untitled*, 2009–10
Pigmented inkjet prints
22 × 28 inches (55.9 × 96.5 cm)

NOTE: The works do not depict normal conditions at the Cinecittà lot,
and reflect Cinecittà's compliance with the artist's request that the studio staff refrain from
carrying out standard cleanup and maintenance procedures at the relevant sites.

Editor: Deborah Aaronson
Designer: Sarah Gifford
Production Manager: Jules Thomson

Cataloging-in-Publication Data has been applied for
and may be obtained from the Library of Congress.

ISBN 978-0-8109-9199-6

Printed and bound in Italy
10 9 8 7 6 5 4 3 2 1

Abrams books are available at special discounts when purchased in quantity
for premiums and promotions as well as fundraising or educational use.
Special editions can also be created to specification. For details, contact
specialmarkets@abramsbooks.com, or the address below.

ABRAMS
THE ART OF BOOKS SINCE 1949

115 West 18th Street
New York, NY 10011
www.abramsbooks.com

3 1333 03909 4337